Fragments:
INCOMPLETION
&
DISCONTINUITY

New York Literary Forum acknowledges the support of the Division of Humanities and the
Arts, Hunter College, and the French doctoral program of the Graduate Center, C. U. N. Y.

Fragments:
INCOMPLETION
&
DISCONTINUITY

GUEST EDITOR
LAWRENCE D. KRITZMAN

JEANINE PARISIER PLOTTEL, General Editor

8-9

NEW YORK LITERARY FORUM

NEW YORK · 1981

Library of Congress Cataloging in Publication Data

Main entry under title:

Fragments—incompletion and discontinuity.

(New York literary forum, ISSN 0149-1040; v. 8-9)
Bibliography: p.
Includes index.
1. Arts—Addresses, essays, lectures. 2. Creation
(Literary, artistic, etc.)—Addresses, essays, lectures.
3. Aesthetics—Addresses, essays, lectures. I. Kritzman,
Lawrence D. II. Plottel, Jeanine Parisier, 1934–
III. Series.
NX60.F7 700 79-52614
ISBN 0-931196-05-1 AACR2

 # CONTENTS

Preface

Since the time of Aristotle we have been taught to strive for harmony, order, and unity at the expense of discordance, disorder, and dispersion. Consequently, fragmentary work has developed an indefinite status and been relegated to a marginal position in the great chain of art. Fragments appear to be an aesthetic and cultural aberration. However, studies have come to deal more and more with the disconnected and incompleted. This volume of *New York Literary Forum* continues, intensifies, and illustrates the ongoing debate on this subject.

Fragmentation implies breakage *(frangere)*, a part detached, separated, or isolated from a whole—an incomplete work or a portion of writing or composition that appears to be disconnected or disjointed, an interruption of the so-called aesthetic unity of an artefact. Recognizing fragmentation requires us to imagine that the work in question is sustained by an underlying, albeit sometimes invisible, ideal order. The product or work of art is perceived as being detached from this conceptual framework and manifests itself as the embodiment of breakage. Although modern art has tended to give valuable consideration to the fragmentary and the chaotic, the esteem of fragmentation can be traced back to the sixth-century Pre-Socratic philosophers. From the medieval epic poem to Picasso's functional sculpture, passing via the *nonfinito* in Renaissance art, the serial logic of the encyclopedia, the romantic ideal of hermaphroditic beauty, the surrealist collisions of incongruous images and the non-linear narrative of contemporary cinema, this volume explores the qualities, tendencies, and attitudes toward the multiple forms of fragmentary expression.

Part 1, "Theories and Traditions," examines both contemporary and classical perceptions of fragmentation. John Tytell's careful examination of the formal components of modernist style that substitute disorder for the more traditional comfort of Victorian omniscience serves as an excellent introduction to our present consciousness of the phenomenon. By illustrating how fragments move in and out of aesthetic contexts, David Rosand's "Composition/Decomposition/Recomposition" describes the reversibility of the transformational process. Examples are drawn from the mainstream of European art: the Renaissance torso that became

the symbol of the *nonfinito*, the unfinished in art; Titian's "incomplete" canvases; Zeuxis' celebration of Helen as eclectic ideal. Roger Shattuck's essay "The Alphabet and the Junkyard" introduces three categories—the absolute fragment, the linked fragment, and the ambiguous fragment—to describe three representative modes of anti-unity and antisignificance in the literature and the arts of the modern period. To better elucidate the inadequacy of contemporary critical language in determining the fragmentary nature of a medieval or classical work, Alain Renoir provides an oral-formulaic "nondefinition" of the fragment in epic poetry by suggesting the dangers of rigorously applying modern logic to plot development.

Three case studies of discontinuity in premodern French literature constitute Part 2 of this volume. The authors in this section work under the critical assumption that it is impossible to reduce a text to an underlying discursive unity regardless of how fragmented it may be. My own essay on Rabelais's *Quart Livre* focuses on the narrative strategies of the "open-ended" work. "In Disjointed Parts/Par articles decousus" explores the epistemological and textural implications of reading Montaigne's *Essais* as either a unified totality or as a collection of fragments. Steven Rendall demonstrates how logocentric metaphysics has denied the montaignesque essay the incompleteness that is its distinctive feature. Jack Undank's "Diderot's Egg: Life, Death, and Other Things in Pieces" directs attention to the destruction of narrative teleologies and conventional, foreseeable closures in Diderot's rhetoric, particularly *Jacques le fataliste.*

The "Poetics of Serial Logic," the subject of Part 3, features the problems derived from the quest to totalize and trace the circle of knowledge. Anna Balakian's article draws a parallel between the ways in which the poetic imaginations of Baudelaire and Breton transform reality into a veritable maze of associative thinking representing the exploration of the infinite. In "Fragment and Encyclopedia: From Borges to Novalis," Walter Moser studies the utopian project of achieving totalization through the cumulative and combinatory practice of writing. Moser proceeds backward in time to uncover the archaeology of romanticism, which, he hypothesizes has become the paradigm of modernity: a text that is paradoxically at once a fragment and a completed whole. Perry Meisel's deconstructive reading of Donald Barthelme's "Paraguay" uncovers the project of textual mapping. The seriality and openness of the temporally plotted map of the fictional diary stand as a response to, and a critique of, the figure of the map as a static structure and taxonomy.

Part 4, "Self-Reflection, Proliferation, and Deconstruction," returns us to some of the questions raised in Part 2 about the impossibility of coherence and wholeness. Here the stress is on philosophical and psycho-analytical investigations. Serge Doubrovsky discusses the concepts of *amour-propre* and the fragmented ego and reads various classical maxims—fragments—of La Rochefoucauld through Jacques Lacan's text. Lacan and Doubrovsky show that because the ego is structured through a series of alienating imaginary identifications—fragments of multiple discourses—

the constitution of a total self is but an illusion. Michel Pierssens has poetically composed his own fragmentary text "Detachment" which explores architecture and ruins, memory and oblivion. David Hoy's "Philosophy as Rigorous Philology" uses the question of how to read Nietzsche as a focal point about the nature of texts and their interpretation, including the sort of interpretation philology itself is. The philological interpretation of written texts—what Nietzsche calls "geneology"—becomes a paradigm case for philosophical self-reflection: treating any text as a work with a singular meaning is regrettable because it blinds the text's discontinuities and repressions.

The contributors to Part 5, "Spare Parts and Whole Bodies," speculate on the uncanny effect in sculpture, painting, and literature that arises from the representation of partial or fragmented anatomical features. Joel Black traces the historical development of "combinatory aesthetics" which for the eighteenth-century sculptors and painters meant an attempt to depict an ideal anthropomorphic form by abstracting exemplary physical features that were visible in nature and recombining them artificially in a composite ideal whole. "The Aesthetics of Gender" pays particular attention to Winckelmann's hermaphroditic ideal and the "synecdochic aesthetic" of the romantics which envisions a fully androgenous body whose wholeness could only be signified by a visible or verbal part. In a socio-cultural investigation of modern literature, Jennifer Waelti-Walters examines the theme of female "mutilation" and proposes that the objectification of women transforms them into victims whose anatomical parts are to be divided and "marketed" according to the demands of society. The dismantling motif and its relationship to the themes of deception and chicanery in American literature and folklore are the subjects of Arthur Kay's study. He explores the function of anatomical deception in which a live person is revealed to be not completely human but partially made-up of false parts. Naomi Schor's investigation of the hyperrealist sculptor Duane Hanson reveals the importance of the detail in his work and its power to shock and deceive through vestimentary realism. In "Truth in Sculpture" Schor emphasizes that the clothed figures in Hanson's work make it difficult to distinguish between the ornamental and the essential. The uncanny is produced through the reversal of the clothes-statue relationship.

Part 6, "Films: Signs into Meanin," explores the dynamics of cinematic narrative. Andrew Sarris grapples with the problem of how to read a film. He argues against Eisensteinian and Griersonian aesthetics in the name of a romantically individualistic "auteurism." Hanna Charney and Germaine Brée both direct attention to the everfluctuating interplay of story and memory in the elusive space-time dimension of narrative. The modulations of forgetting and remembrance in Rohmer's *The Marquise of O . . .* and Resnais's *Providence* undergo Hanna Charney's formalist analyses. Germaine Brée's study demonstrates how Marguerite Duras's *India*

Song recombines a group of previous works within a new fictional multi-media frame, *"texte-théâtre-ciné."*

The texts and documents of Part 7 close the volume with highly provocative interviews with Jasper Johns and Alain Robbe-Grillet.

Fragments: Incompletion and Discontinuity sets forth the variety and scope of his complex problem and should make us recognize that fragmentation occupies an inclusive space within the boundaries of Western culture.

Lawrence D. Kritzman

PART 1

THEORIES
AND
TRADITIONS

Epiphany in Chaos: Fragmentation in Modernism

JOHN TYTELL

Turning and turning in the widening gyre
The falcon cannot hear the falconer;
Things fall apart; the centre cannot hold;
Mere anarchy is loosed upon the world....

<div align="right">William Butler Yeats</div>

The fragment as a literary shock tactic has been integral to the modern writer's strategy since the turn of the century. We are all familiar with such telegraphic occasions as Gertrude Stein's "a rose is a rose is a rose," Conrad's "the horror! the horror!" or Eliot's "I can connect/Nothing with nothing." The fragment became one of the calling cards of the modernist movement, a recognizable, sometimes enigmatic means of creating impact and communicating message, a device that disturbed conventional notions of time and space in literary expression and corresponded to a new sense of the universe that began to emerge as the nineteenth century ended.

Einstein, after all, was replacing Aristotle. The classical notion of art

that persisted through the Victorian era depended upon the proprieties of harmonious parts cohering in a continuous whole. Art was decorous in its order; it used the means of integrated structure and ideology toward the end of clear distinctions. Even the prophets of the nineteenth century, figures such as Darwin, Marx, or Freud, saw history or the future in more-or-less orderly evolutionary terms. In nineteenth-century novels, time was governed by chronology and calendar, journeys were still geographical, action was consecutive and linear with one event logically causing its consequence, and organization was handled by the convenience of omniscient overview. Continuity in art was a reflection of the nineteenth-century belief in progress and the social Darwinism that implicity assumed the superiority of Western technology and religion.

Suddenly, however, the system began to collapse. Artists of all kinds and from many nations—musicians, painters, poets (Pound's antennae of the race)—started to respond to a sense of apocalypse and despair caused by the political stupidities that would result in the First World War, and their gestures became more flagrantly desperate. The terrible war itself— "laughter out of dead bellies" Pound wrote in *Hugh Selwyn Mauberly*, for "an old bitch gone in the teeth," "a botched civilization"—became a dividing line between the time when men could still understand history and Joyce's view of history as a nightmare from which he was constantly trying to awake. As Paul Fussell demonstrates in *The Great War and Modern Memory*, the permanence of traditional values and the reliability of such abstractions as God and country had been completely undermined by the debacle of the war.[1] But even before the war, artists were seeing the world differently: Picasso painted *Les desmoiselles d'Avignon* in 1907, preparing for a cubism that would rupture the consecutive image and confound perspective; Eliot, in the same year, heard Bergson lecture at the Sorbonne on time and discontinuity and started to write "The Love Song of J. Alfred Prufrock"; Kandinsky plunged into his first spontaneous watercolor abstraction in Munich in 1910, influenced by his friend Schoenberg who had already developed atonality, a fragmenting of the old harmonies; the painter Marcel Duchamp, in 1913 (the year of Proust's *Du côté de chez Swann* and Apollinaire's *Alcools*, the year when Einstein announced his theory of general relativity and Niels Bohr discovered atomic structure), wrote a musical score called "Musical Erratum," derived from chance arrangements of musical notes picked from a hat and set to the text of the dictionary definition of the verb "to print"; finally Stravinsky, in 1914, ironically echoed the beginning of the war with *Le Sacre du printemps*, which so outraged some members of its première audience that they ripped their seats from the floor.[2]

The new music was as jarring and dissonant as the sound of guns firing, painters were beginning to assemble objects in mosaics of incongruous juxtaposition with an absurd architecture that sometimes resembled the aftermath of a battlefield in an unsuspecting village, and poets were prepared to violate rules that had been perpetuated for generations.[3] Ezra

Pound, that maverick apostle of the new, was to declare a fragmented version of the new mood in a poem he called "L'Art 1910":

> Green arsenic smeared on an egg-white cloth;
> Crushed strawberries. Come let us feast our eyes!

Pound's cryptic and contracted little poem perfectly exemplified the future direction for a poetry that would depend on the radical juxtaposition of disconnected fragments. Poetry had been liberated from a metronomic meter by Whitman in America and by the *vers libre* of the French symbolists in the 1870s, but it was now to be extended in yet another direction by the circle of poets meeting in a London pub in 1910 who clustered around Pound and attended to his ideas. These imagists, as they came to be called, deliberately loosened the connections between what they saw (as the thought of arsenic is removed from the taste of strawberries); their associations were to be less "rational" than before, more figuratively and sometimes furtively inspired.

The new poetry seemed like a lesson in Bergsonian intuition and a rejection of Cartesian logic, behavioral psychology, and Newtonian physics. "L'Art 1910" aspired to the concision of Catullus and the Greek classical lyric and the immediacy of Japanese haiku. The Eastern influence was crucial, just as it was with the postimpressionist painters, because it presented the liberating possibilities of a different perspective, one that was unburdened with the particular unities of time, place, and action stressed by Aristotle, one that had developed independently of Aquinas's fealty through faith or Descartes's sense of the self as universal container. And Pound's work, with the Fenellosa manuscripts and his subsequent translations of poets like Li Po, introduced to Western poets a notion of unity that often depended on ineffable paradox, and that usually used the diversity of nature as a field. Classical Chinese poets often presented images as incoherent flashes without transitions, avoiding commentary and abstraction, even playing off contradictory images against themselves in the same line.[4] The painters had seen this first, and in 1910 Roger Fry organized the first exhibition of the postimpressionists at the Grafton Galleries in London. Pound's poem was a singular response to the new sense of color and design suggested by the new painting—a poem "smeared" and "crushed" as the borders of representative objects had been extended and redefined since Cézanne's *Rocks at Garonne* series. Pound may have been motivated by the art critics who denounced Matisse's painting *The Open Window* with the charge that Matisse knew nothing about color theory since the red and green he used are opposites creating conflicting intensities. But Pound's point was, not to tell overtly what he thought, but to render dramatically by relying exclusively on sensory images. Such deliberate avoidance of commentary or narrative elements prepared the way for a more fragmented structure while correcting what Pound saw as certain sentimental and moralizing tendencies of Victorian poetry such as

the "sea of faith" at the end of Arnold's "Dover Beach," or the platitudinous optimism of Tennyson's "Locksley Hall." For Pound and his imagists, all discourse and direct statement—traditionally part of the connective fiber of poetry—must be avoided. It was the beginning of a revolution in sensibility.

This extreme focus on the image itself, forcing it to become the poem's subject and sole speech, this almost obsessive emphasis on the concrete, the visual and the finite, may have seemed self-indulgent at the time, but it allowed poets to redefine the nature and scope of their tasks. No longer would the image exist for the sake of ornament. The narrative element organizing traditional poetry was now to be suspended in a new mosaic structure that would suggest feeling through sharply etched "objective" images, objects that would correlate—to employ Eliot's famous idea—to an unstated emotion:

> I should have been a pair of ragged claws
> Scuttling across the floors of silent seas

Prufrock laments, and the terrifying partialness of those claws suggesting so desperately a need to hold on in an image of such fragmented tenacity, and the ignominy of that scuttling movement, like Prufrock's perpetual evasion, all powerfully project a meaning that mere statement is too flat to provide. So the ragged claws image, detached as it is from a body, even that of a lonesome crab, exists as an early instance of what Eliot would later call an "objective correlative." The image itself is a fragment because it is only part of an unexplained whole, but it appears in the poem as a fragmenting interruption, almost a digression like the unanswered and unposed overwhelming question that also periodically intrudes to perplex the action. This kind of intrusion was to become practically a principle of violation by the time of *The Waste Land*, where images, ideas, snatches of conversation, and allusions are introduced only to precipitously give way to others, apparently unrelated, all presented without the destination and order afforded by a unified story. By fragmenting the action, by obscuring its immediate thematic connectiveness, Eliot profoundly affected the general sense of rhythm and structure understood by most of the poets of his time.

To appreciate how extensively Eliot relied on the use of the fragment as a structural principle, one need only consider the last stanza of *The Waste Land*, where the mosaic form is so perfectly illustrated:

> I sat upon the shore
> Fishing, with the arid plain behind me
> Shall I at least set my lands in order?
> London Bridge is falling down falling down falling down
> *Poi s'acose nel foco che gli affina*

Quando fiam uti chelidon—O swallow swallow
Le Prince d'Aquitane à la tour abolie
These fragments I have shored against my ruins
Why then Ile fit you. Hieronymo's mad againe.
Datta. Dayadhvam. Damyata.
 Shantih shantih shantih

These "shored" fragments can be seen as a coda and a synecdoche of the larger mosaic with its changing personae, abrupt shifts in mood and action, and return to certain central motifs such as infertility. The Fisher King and the parodied Grail legend occupy the first three lines; the motif of falling towers and the collapse of Western civilization are evoked in the nursery rhyme fragment, and are followed by an allusion to the classical tale of Philomena, turned to a nightingale by the gods to save her from a ravishing brother-in-law, interspersed with quotations from Dante, Gérard de Nerval, and Kyd's *Spanish Tragedy;* then a stream of Hindu words—all in all a pastiche of five languages, merging in one stanza without transitions, explanations, or the context usually provided by nineteenth-century omniscience.[5] Even Eliot's use of the literary tradition, his quotation of admired lines from the past, occurs as a fragmenting factor because the original context is usually so different from the place in Eliot's poem to which it is yoked—as in "Prufrock," when Eliot takes a heroic promise of potency from "To His Coy Mistress" and ironically compromises Marvell's intention with an ambiance of terror and incapability.

It seems acceptable, a half-century later, that in *The Waste Land*, a poem about breakdown (both cultural and personal—Eliot wrote the poem while recovering from a nervous collapse in a Swiss sanitorium), the poet should place such crucial reliance on spectacular fragments that create a surface of dazzling brilliance but little narrative cohesion. And *The Waste Land* was to become a model for the deployment of the fragment as rhythmic shard and structural principle—not exclusively as incomplete thought, but almost always divorced enough from any supportive narrative as to suggest the disjointed quality of an age, to jolt readers into a recognition that might transcend simple situational, developmental explanations of plot and circumstance.[6] Syntactically, the fragment works on the mind as a sort of linguistic shrapnel, a digressive explosion. Like infants' speech, it is a partial but basic communication, compressed, rhythmically spurting and exclamatory; but also immediate, seemingly instinctive and perhaps close to a subconscious level of response we might call "automatic."

The Waste Land appeared in 1922, the same year as Joyce's *Ulysses*, parts of which Eliot had read previously in *The Little Review.* Joyce, in developing stream of consciousness as an analogue to the way we actually perceive and register the world, using an associative flow of objects and ideas that proceeded chaotically, with random and illogical turns, had

fashioned a style that fused fragments with poetic effect. Edmund Wilson was the first critic to observe that novelists had begun to appropriate poetic devices and energies, especially in a new intensity of image.[7] Of course Joyce, in the beginning of *Portrait of the Artist as a Young Man*, had used snatches of baby talk, of nursery rhyme, and a mixture of Yeats's poem on Fergus and the unmediated *tabula rasa* of the infant's sensory perspective to introduce his readers to Stephen Dedalus' world. In *Ulysses*, the radical discontinuity and fragmented syntax of the stream-of-consciousness style tried to simulate an actual experience of thought and awareness while merging it with sensory data. Instead of the novel of traditional intrigue, what Robert Martin Adams has called the domestic story of manners, morals and money, Joyce perfected for the novel of sensibility a method of simultaneity, a new way of apprehending the world which would have enormous consequence for the future of fiction:

> All quiet on Howth now. The distant hills seem. Where we.
> The rhododendrons. I am a fool perhaps. He gets the plums and
> I the plumstones. Where I come in. All that old hill has seen.
> Names change: that's all. Lovers: yum yum.[8]

As an almost immediate response to Joyce, the fragment began to resound through the fiction of the twenties and thirties like some enigmatic echo. Often it occurred as a bewildering intrusion, with no apparent focusing purpose: "only connect" in Forster's *Howards End*, "Someone had blundered" in Virginia Woolf's *To the Lighthouse*, "Caddy smelled like trees" in Faulkner's *The Sound and the Fury*, the newsreel and "Camera Eye" sections of Dos Passos' *U.S.A.* But the responsibility for this emphasis on the elliptical and distorted conjunction of the fragment with the text did not rest entirely with Pound because of *The Cantos*, or with Eliot or Joyce—Joyce himself would demonstrate the sometimes perverse, amputated unreliability of the fragment and its potential for incommunicability in *Finnegans Wake*.[9] One primary characteristic of the modern era has been the unusual reciprocity of artistic influence—Apollinaire wrote the first intelligent book on cubism, Gertrude Stein wrote about cubist painters and collected their works—there are many such examples. As Hugh Kenner has so cogently stated, "When Picasso first dissected a mandolin, the stability of painted objects ended."[10] From the start, modernism had been an international movement and its vision has been a function of what Jung had called synchronicity—similar perceptions independently realized at roughly the same time in different places.

The ultimate assault on the old linguistic integrities came from the Dadaists and the surrealists in Europe. In 1870, Rimbaud appealed for the "hallucination of the word"; a half century later, Eugene Jolas argued that narrative was not mere anecdote but a "metamorphosis of reality." The Dadaists felt that reality was too elusive and incoherent to be represented by classical means and they actively sought to sabotage logical semantic

order and to mock ordinary thought progression. The surrealists were so
solipsistic and fluid that they would base verbal associations on sound
rather than on visual perception, seeking the rapidity of the flow, without
revision or inhibition. Such attitudes, exemplified by the experiments in
automatic writing by the surrealists and by Stein, Yeats and William
Carlos Williams (in *Kora in Hell),* hardly encouraged omniscient delinea-
tion or the unified presentation of conventional art.

One dramatic index of the new emphasis on the fragment occurred
on September 20, 1920, when the Rumanian poet Tristan Tzara read at
the Galerie Povolozky in Paris a new recipe for making poems:

> To make a dadaist poem
> Take a newspaper.
> Take a pair of scissors.
> Choose an article as long as you are planning to make
> your poem.
> Cut out the article.
> Then cut out each of the words that make up this
> article & put them in a bag.
> Shake it gently.
> Then take out the scraps one after another in the order
> in which they left the bag.
> Copy conscientiously.
> The poem will be like you.[11]

Tzara's act was a visible demonstration of what Lautréamont had earlier
characterized as the surreal image occurring as fortuitously as the meeting
on an operating table of an umbrella and a sewing machine. Novelists like
Djuna Barnes in *Nightwood* or Anaïs Nin in *Under a Glass Bell* began to
create dazzling textures of images which often did not seem to cohere.
Barnes defined the image as "a stop the mind makes between uncer-
tainties," and that was a clear departure from Pound's prewar idea of the
image as an emotional and intellectual complex in an instant of time.[12]

The postmodernist era dates from occasions such as Lucky's fractured
speech in *Waiting for Godot,* or the American poet Charles Olson's theory
of Projectivism in which the poem is seen as a field of action where a
perception is immediately and directly transformed by another percep-
tion that follows it. In our time, such poets as Robert Creeley and John
Ashbery and such novelists as Jorge Luis Borges and Donald Barthelme
have continued to depend on the fragment as a literary medium. In the
French *nouveau roman,* in which the structural model is often the laby-
rinth, the hall of mirrors, or the blind alley, the fragment can act as a
momentary searchlight in the obscurity.[13] As Alain Robbe-Grillet explains
it, use of the fragment has become considerably more instrumental in the
new novel than the surrealists, who used it mainly for purposes of isolated

surprise, could have dreamed. It has become the very idea of a new cinematic structure:

> It is not rare, as a matter of fact, in these modern novels, to
> encounter a description that starts from nothing; it does not
> afford, first of all, a general view, it seems to derive from a tiny
> fragment without importance—what most resembles a point—
> starting from which it invents lines, planes, an architecture; and
> such description particularly seems to be inventing its object
> when it suddenly contradicts, repeats, corrects itself, bifurcates,
> etc. Yet we begin to glimpse something, and we suppose that
> this something will now become clearer. But the lines of the
> drawing accumulate, grow heavier, cancel one another out,
> shift, so that image is jeopardized as it is created.[14]

Description, to "start from nothing," as Robbe-Grillet would have it,
pretends to a self-sufficiency that is uninterested in representing externals
or in mirroring the actual. Robbe-Grillet is asserting that he will self-
reflexively pursue the implications of an image as if it had an autonomous
existence which is independent of the observing eye of the writer. What is
in question here is the idea of control, and just as emotional self-control is
a touchstone of Victorianism, the attempt to violate such control in art is
a crucial element of rebellious postmodernism.

One of the most influential exponents of the kind of fiction that uses
fragmentation to create what at times might be called an anarchic field is
William S. Burroughs. With what he calls a cut-up technique, Burroughs
will juxtapose fragments collected from random reading and writers he
admires, bits of conversation he has recorded, newspaper items, recurring
motifs from his own work, and insert this collage into his own story in
hopes of achieving some revealing image or connection. In one sense, the
randomness of the procedure is part of Burroughs' deliberate attempt to
reprogram the way readers perceive the written word; in another sense, it
becomes a means through which he can objectively detach himself from
romantic or unconvincing images, from tenderness, personal associations,
and ties to his own words. The "cut-up" serves to eliminate habitual reac-
tions and conditioned reflexes, to separate words from traditional refer-
ents, and to question the normal syntax that influences rational behavior.
The end here, as with Robbe-Grillet, is liberation from controls. Burroughs
will risk obscurity in his attempt to jar the control of his readers' linguis-
tic conditioning.[15]

In very recent fiction, the fragment has been used with obsessive
emphasis and an almost visual vengeance. Novelists such as Jerzy Kosinski
stagger the reader with a visceral barrage of violence, and create a land-
scape covered with images like broken glass. Fragmentation now seems
endemic to contemporary fiction, practically the voice of a new geogra-
phy of parts that seek to conflict rather than to cohere. One representa-

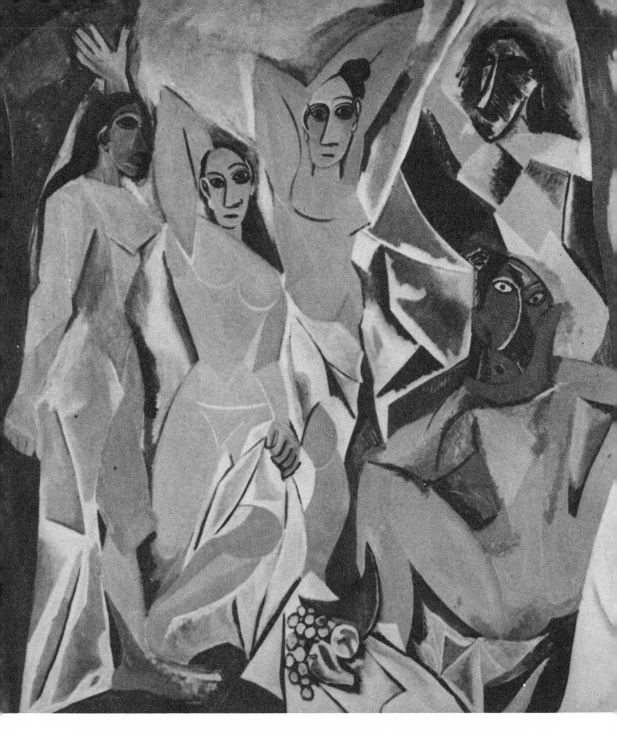

Fig. 1. *Les Desmoiselles d'Avignon* (1907), Pablo Picasso's first major reinterpretation of traditional perspective in painting, is a harbinger of new form in the age of Einstein and Freud and a new way of seeing.

tive locus is the Fiction Collective, a group of novelists who disrupt their stories with a series of games as part of a program to redefine the traditional masking functions of the authorial persona, and to deepen the illusion that the writer is offering some personal revelation. The writers in the Fiction Collective are old enough to have experienced the end of the Depression and World War II. Their primary esthetic influences are modernism, the theater games inspired by Artaud and Beckett, "new wave" cinema of filmmakers like Godard, pop art and the sense of audience reciprocation it invites, rock electronics, and what may be called loosely the liberation movement of the sixties. For the Fiction Collective novelists, fragmentation acts as an expression of the confusion and disorder that they see in the world around them. Their mode is the grotesque, and they frequently focus on auguries of apocalypse in a mode that may be called speculative fiction—what Robert Alter has called self-conscious fiction— where the writer's energy is more concerned with the twists and implications of the most bizarre possibilities than with character in action. One of their common ploys has been to challenge the traditional organizing role of the narrator (Fielding's controlling moralist who persisted in his organizing capacity through the time of Thackeray) by making the narrator a highly unreliable and often victimized quester who may know less than the reader and who destabilizes the action by his buffoonery. Some Fiction Collective writers, like Steve Katz in *The Exaggerations of Peter Prince*, have further fragmented the action by using devices like double or triple columns with stories that comment on each other, photographs, concrete poems, the kind of typographical gymnastics that Apollinaire invented to fragment his poems near the beginning of the century. The general sense of story in many such fictions has been eroded by comic shifts in point of view, by sudden metamorphoses of location and character, and the fragment has been the means of producing this new seamless reality.

Perhaps the most consistently interesting writer in the Fiction Collective is Ronald Sukenick, a novelist who would subscribe to Robbe-Grillet's contention that the didactic intent of new fiction is to encourage readers to invent themselves through an art that is unsatisfied with the exclusive limitations of imitation of life. The frontier implied by such a fiction bristles with the barriers of "art" versus "life" as the novelist tries to deemphasize the barriers. Sukenick tries to achieve what he has called a "simultaneous multiplicity"[16] by juxtaposing several apparently unrelated narrative threads, using devices such as parallel columns, collages, marginal notations, and characters who seem to intrude on the narrator and compromise his credibility. An illustration of the simultaneity Sukenick attempts through fragmentation is the conclusion of *98.6*, a novel that explores the paradoxical elements of nihilism in the communal spirit of the sixties:[17]

Thank you Mrs. Meir. Walkin with ma baby on the side

of San Francisco Bay I'm listening to the blues I'm about
to have A Moment of Luminous Coincidence I feel it coming
on it's coming together JESSELONECATFULLERJESSE
SEARLYLIFEWASSPENTRAMBLINGBETWEENGEORGIA
TEXASANDCALIFORNIAWHEREHEEVENTUALLY
SETTLEDALONGTHEWAYHELEARNEDSPIRITUALS
BLUESRAGSANDHILLBILLYSONGSHEADAPTEDT
THEMALLTOHISTWELVESTRINGGUITARSTYLEBUT
ITWASNOTUNTIL1950THATTHEDECIDEDTOSEEKOUT
WORKASAMUSICIANHEENCOUNTEREDTROUBLE
FINDINGRELIABLESIDEMENSOHEBECAMEAONEMAN
BAND playing all the instruments AT THE SAME TIME I'm
sitting in Laguna Beach with the cat on my lap listening to
The San Francisco Blues by Lone Cat Fuller AT THE SAME
TIME trying to finish my novel AT THE SAME TIME trying
to forget about it I pick and open a book at random Fuller
Buckminster quotes Fuller Margaret all attempts to construct
a national literature must end in abortions like the monster
of Frankenstein things with forms but soulless and therefore
revolting we cannot have expression till there is something
to be expressed AT THE SAME TIME trying to forget about
it a trip a bar in a distant city turns out to be called Frank-
enstein franks and steins AT THE SAME TIME this morning's
mail with an article by Ihab Hassan on Prometheus Franken-
stein Orpheus AT THE SAME TIME thinking when you try
to sew Orpheus back together what you get is Frankenstein
AT THE SAME TIME hearing on the radio Lon Chaney just
died a few miles away from here in San Clemente AT THE
SAME TIME reading this record jacket thinking yes ramble
around settle in California pick up this and that adapt it to
your style without sidemen the novelist is a one man band
playing all the instruments AT THE SAME TIME playing
along on a kazoo AT THE SAME TIME moving to San
Francisco AT THE SAME TIME entering The State of Israel
AT THE SAME TIME orchestrating the whole thing toward
those Moments of Luminous Coincidence when everything
comes together AT THE SAME TIME AT THE SAME TIME
sorry to leave Southern California the sun the waves the
mother tongue another bungled paradise AT THE SAME
TIME happy to be heading for San Francisco another chance
AT THE SAME TIME tying up my novel AT THE SAME
TIME my life is unravelling AT THE SAME TIME the novel
is bungled fragments stitched together AT THE SAME TIME
everything is seamless perfect not because because because
but AT THE SAME TIME playing the blues letting it go it
is as it is. Another failure.

The twentieth century has been characterized by an unprecedented artistic experimentation with esthetic principles that earlier had seemed practically inviolable. The genealogy of the fragment as a fictive device goes back at least to Sterne's *Tristram Shandy*, but it has emerged in our time as the voice of the modern. Some might call it the vice of modernism; the ambiguity, dense texture, and sometimes labyrinthian models encouraged by fragmentation can cause difficulty and obscurity. As does abstraction in painting, fragmentation demands a certain sophistication from its audience. Readers are forced to become actively engaged, to search for clues to interpretation and the transitions that old-fashioned narrators once cheerfully provided. For another kind of reader, fragmentation has successfully induced a more improvisational and spontaneous sense of play and suggested an illusion of participating in the psychic processes of characters who seem more autonomous than ever before. This may become a new frontier for fiction. Crucial to modernist sensibility, the fragment has introduced the general public to what the critic Kenneth Burke once called "perspective by incongruity." Modernism plunges us into a geometry of prismatic circularity in a world without comfortable absolutes, and fragmentation, like it or not, has been one of its most intrinsic and seminal features.

Notes

1. Paul Fussell, *The Great War and Modern Memory* (New York: Oxford University Press, 1975), p. 21.
2. See Roger Shattuck, *The Banquet Years: The Origins of the Avant-Garde in France* (New York: Vintage, 1968), p. 28; and Monroe K. Spears, *Dionysus and the City: Modernism in Twentieth-Century Poetry* (New York: Oxford University Press, 1970).
3. See Richard Poirier, "The Difficulties of Modernism and the Modernism of Difficulty," *Images and Ideas in American Culture,* ed. Arthur Edelstein (Hanover, New Hampshire: University of New England Press, 1979), p. 132. Poirier uses the battleground image for modernism and argues that its apparatus functions as metaphor for the difficulty and complexity of modern life.
4. See Pauline Yu, "The Poetics of Discontinuity: East-West Correspondences in Lyric Poetry," *PMLA* (March 1979), 94(2): 261-74; also James J. Y. Liu, *The Art of Chinese Poetry* (Chicago: University of Chicago Press, 1967).
5. A prototype for the discontinuity caused by this kind of fragmentation occurs in Browning's "Soliloquy of the Spanish Cloister," a poem that anticipates the convulsive intensities of stream-of-consciousness style.
6. One example illustrating the quick spread of the use of the fragmented image is William Carlos Williams' "Portrait of a Lady." Williams, engaged in a perpetual quarrel with Eliot in matters esthetic, should not be seen as an imitator. His poem parodies the literary convention of the portrait—a convention which Henry James, Eliot and Pound followed in a novel and two poems, respectively, all of similar title. Williams, however, dialectically frustrates his own inability to "portray" his own lady friend (who is swinging from an apple tree) with a series of ridiculously distracting images such as the "tall grass of your ankle." The poem becomes analogous to a stream of consciousness. Hugh Kenner, *The Pound Era* (Berkeley: University of California Press, 1971), p. 403, argues that Williams's use of the unfinished thought became a basic device of the period.
7. Edmund Wilson, *Axel's Castle: A Study in the Imaginative Literature of*

1870 to 1930 (New York: Scribner's, 1931), p. 221.

8. James Joyce, *Ulysses* (New York: Random House, 1934), p. 370.

9. Gertrude Stein, though less influential, worked in a related tradition. She portrayed a French society woman in this manner: "A little grass. Peal it first it shows clothes that means night gowns hours, loaves, feathers, feel hours, some more in, little thing, anything, pale letters." See *Portraits and Prayers* (New York: Random House, 1934) p. 121.

10. Kenner, *The Pound Era*, p. 155.

11. Elmer Peterson, *Tristan Tzara: Dada and Surrational Theorist* (New Brunswick, N. J.: Rutgers University Press, 1971), pp. 34-35.

12. Djuna Barnes, *Nightwood* (New York: New Directions, 1961), p. 111.

13. Roland Barthes declared that writing "is a blind alley because society is a blind alley." *Writing Degree Zero* (London: Jonathan Cape, 1967), p. 63.

14. Alain Robbe-Grillet, *For a New Novel: Essays on Fiction* (New York: Grove Press, 1965), pp. 147-48.

15. See William S. Burroughs and Brion Gysin, *The Third Mind* (New York: Viking, 1978).

16. Ronald Sukenick, *The Death of the Novel and Other Stories* (New York: Dial Press, 1979), p. 53.

17. Ronald Sukenick, *98.6* (New York: Fiction Collective, 1975), pp. 187-88. For more on the Fiction Collective see the *Partisan Review* symposium "Composure and Decomposition," with essays by John Tytell, Jay Martin, and Tony Tanner, *Partisan Review* (1979), no. 2, pp. 280-97.

2

Composition/Decomposition /Recomposition: Notes on the Fragmentary and the Artistic Process

DAVID ROSAND

You remember that bull's head I exhibited recently? Out of the handle bars and bicycle seat I made a bull's head which everybody recognized as a bull's head. Thus a metamorphosis was completed; and now I would like to see another metamorphosis take place in the opposite direction. Suppose my bull's head is thrown on the scrap heap. Perhaps some day a fellow will come along and say: "Why there's something that would come in very handy for the handle bars of my bicycle. . . . "
And so a double metamorphosis would have been achieved.

Pablo Picasso

Severed by time from its original functional context and now prey to the artist's creative seizure, the abandoned object suffers its painless rebirth, transmuted up to art; intended meaning yields to a new and more powerful transformative will. But the process is reversible; with time the cycle is completed.

> *Oh Time, who consumes all things! Oh envious age, you*
> *who destroy all things and devour all things with the hard teeth*
> *of the years, little by little, in slow death!*
>
> Leonardo da Vinci

Recognizing and accepting the challenge of that formidable adversary, Leonardo sets out to do battle with Time, his only weapon his painter's art: that "marvelous science which can preserve alive the transient beauty of mortals and endow it with a permanence greater than the works of nature; for these are subject to the continual changes of time, which leads them to inevitable old age." Behind the arrogance of such assertion we sense a nervous, disbelieving optimism, hopelessly naive, and we appreciate its poignant urgency. Leonardo's generation, after all, had witnessed that most dramatic unearthing of lost antiquity, the emergence of the celebrated but long buried *Laocoön*. Heir to the Petrarchan humanism that lamented the abandoned and desecrated ruins of ancient Rome, this generation in particular initiated the measured archeological recovery of those fortuitous survivors of time's destructive rampage, those *pezzi di figure*, headless and limbless, that offered such tantalizingly partial testimony to the grandeur of the ancients. And in those fragments they could not but read the double lesson of *virtù* and *vanità*, of the splendor of human endeavor and the fragility of its achievements.

Leonardo, whose ambitious *Last Supper* was a ruin within his lifetime, insisted—at least on the rhetorical level of the *paragone*—on combat with ravaging time. Most of his generation, however, more realistically sought accommodation with the adversary, and in that willing compromise they in fact more effectively conquered time for art. In those fragments from the past, *objets trouvés de l'antiquité*—the bicycle seats of antiquity—they discovered new esthetic possibilities. More than a memento of lost greatness, but never entirely without that significance, the torso acquired an integral poetic function of its own, as the positive assertion of the legitimacy of the *non finito*, the unfinished in art. The experience of the fragment, valued initially for its referential worth, led to a larger appreciation of the fragmentary, to a broadening of the very concept of art. The *Belvedere Torso* (Fig. 2), most famous of them all, could acquire full symbolic status as a form in itself: it could, indeed, stand for Art— whether in miniature as an attribute in Renaissance portraits or, the culmination of its signifying role, in its monumental inclusion in Rodin's *Allegory of the Arts* in Brussels, where it is set up almost as a trophy, the central figural element among the surrounding arms of lute, book, lamp, and other spoils of culture.

No matter how static its symbolic function, the torso inevitably carries with it the mark of its defining root attribute, time. Its reach, signifying and referential, is temporal. And its function can be more

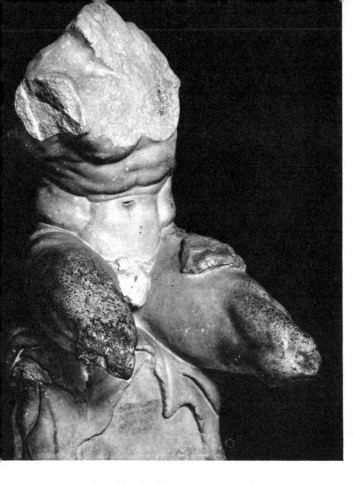

Fig. 2. More than a memento of lost greatness, but never entirely without that significance, the *Belvedere Torso* (Vatican Museum) acquired an integral poetic function of its own as the positive assertion of *non finito*, the unfinished in art. *Courtesy Columbia University, Department of Art History and Archaeology*

Fig. 3. By its very nature, the torso testifies to its own history, as in this drawing by Domenico Campagnola (?) (Rome, Gabinetto Nazionale). It speaks of decomposition, but such processes are reversible—for example, through the creative play of restoration, whether studiedly archaeological or more mimetically fanciful. *Courtesy Columbia University, Department of Art History and Archaeology*

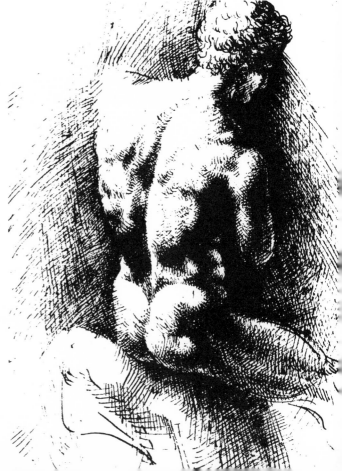

dynamic than iconic—active rather than passive, a participant in rather than a victim of time. For by its very nature the torso testifies to its own history; it speaks of becoming, of process. Initially that process was one of decomposition, but—as Picasso knew—such processes are reversible. Not merely in the creative play of restoration, whether studiedly archeological or more mimetically fanciful (Fig. 3), but in a more fundamental sense the torso served to articulate a new esthetic. If the fragment as decomposed, disintegrated form assumed a satisfying legitimacy in the esthetic eye, then the fragment as unachieved or becoming form could lay claim to similar status (Fig. 4).[1]

Reversing the Process

> *Have you ever seen a finished picture? A picture or any-*
> *thing else? Woe unto you the day it is said that you are finished!*
> *To finish a work? To finish a picture? What nonsense! To finish*
> *it means to be through with it, to kill, to rid it of its soul, to give*
> *it its final blow: the most unfortunate one for the painter as*
> *well as for the picture.*
> *The value of a work resides precisely in what it is not.*
>
> Picasso

The old master of the twentieth century continues an old debate. He gives it new force, and if we must beware of the danger of his words reflecting too strong a glare on the more muted alternatives of the past we must nonetheless acknowledge their relevance to the problems involved. Paying tribute to Protogenes, Apelles faulted him on one, essential, count: for not knowing when to take his hand from a picture—"a memorable saying," comments Pliny, "showing that too much care may often be hurtful" *(Nat. Hist.* 35.80).

It is Leonardo who first steps forward as spokesman for a modern vision, who gives earliest and clearest voice to the new sense of process that defines the esthetic of an entire generation, that which we call the High Renaissance. Raising the indeterminate and the fragmentary to a new level of awareness and potential, he counsels the active exploration of the tentative, describing his own discoveries along such vaguely charted paths: "I have even seen shapes in clouds and on stained walls that have roused me to beautiful inventions of various things, and even though such shapes totally lack finish in any single part they were yet not without perfection in their movements or other actions." In all its probing indecision, the sketch, a construct of tentative thrusts, emerges as the central event in the process of pictorial invention. "Sketch the subject quickly," Leonardo advises, "and don't give too much finish to the parts, locate their general position, which you can then finish at your leisure." Inspiration finds its form in the rough draft *(componimento inculto)*, which acquires its value precisely as the record of a special moment in the

temporal procedure of artistic creation and production, of that early moment, the first epiphany of pure idea—*il furor dello artefice*, as it would come to be more rhetorically phrased by Giorgio Vasari and other commentators of the later Renaissance.

Implicit in this appreciation of the sketch, in any medium, is an acceptance of the unfinished as self-sufficient statement. If the artist, mimic of God, creates like nature, it is not in his finished products that we recognize the analogy *(natura naturata)* but rather in the very processes of creation, of both the replication of old forms and the invention of new *(natura naturans)*. Throughout Europe by the turn of the fifteenth century, artists were establishing new models of form, a new sense of mimetic possibility. Leonardo's long trail of abandoned projects, lamented by a disapproving Vasari, bears witness to the new attitude: the artistic problem, once it has been defined and the barest lineaments of its solution indicated, ceases to interest; bringing the solution to finished form, the merely mechanical, servile realization of *idea*, no longer challenges the creative mind.[2]

Leonardo's contemporaries, if less deliberately radical in stance, nonetheless may have achieved a fuller expression of these same values by their more sustained investigations of formal openness, of the suggestiveness of incomplete form—consider the broken touch of Giorgione, or, in the Netherlands, Hieronymus Bosch's agitated transformation of his Eyckian heritage, or the scattered scratches of the Housebook Master's drypoint technique: what once might have been acceptable as a purely preliminary state of artistic development has acquired full expressive status.

Implicated here—and, as we shall see, in the obscuration of the new *sfumato*—is a corollary deepening involvement of the beholder, who is invited to complete the forms in his mind; the invitation, in effect, is to accompany the artist on his creative way, to participate in the process of an image's coming into being, to follow the line back, through levels of tentativeness, through sketches, to that moment of first inspiration, to the *concetto* in the mind of the artist. The good painter, according to Dürer, overflows with ideas, that is, with figures ("Dann ein guter Maler ist inwendig voller Figure"), which must find release through pen or chalk on paper—the aching head of Zeus pregnant with Athena. And the tension between idea and its material realization—finding expression in Dante *(Paradiso* 1.127-29) and, with more urgent relevance, in Michelangelo ("Non ha l'ottimo artista alcun concetto . . .")—assigns a special mediating function to the *non finito*, the work that stands between and hence signifies the opposite poles of this dialectic. From the vantage of the unfinished work we are invited to look in both directions: forward to the finished form implicit in its still organizing structures and back to its origins in the creator's mind.

Immanent within the unfinished work—cf. Joseph Gantner's notion of *Praefiguration*[3]—is the perfect realization of the *idea*—as Vasari and

Condivi explicity appreciated in the roughly carved figures of the Medici Chapel: "the roughness in no way hinders the perfection and beauty of the work." Its fragmentary state, *in statu nascendi*, assures the continuing link between *concetto* and *opera*, keeps it open and accessible. Final closure, as Picasso said, is death. Aperture means life: openness of form guarantees the vitality of our relationship to the work, for perception and interpretation demand active engagement. In turn, the work itself is possessed of its own momentum, an impulse toward completion—realizable only in our willing projection.

Vasari both recognizes and participates in this situation when, operating at his best as a reader of images, he responds to the miraculous transformations in Titian's late style, to the directness of the painter's broken brushwork—those great patches of paint that require proper distance to effect their mimetic purpose, even as they invite the viewer closer, into the creative chaos of their dense fabric. Caught between the poles of esthetic experience, between hardly formed matter and perfected idea, Vasari acknowledges the potential energy of the charged space he inhabits as viewer.

Titian's unfinished canvases, like Michelangelo's sculptures, were left to posterity to deal with as best it could. In many ways, the heirs created an esthetic specifically to accommodate the rough treasures that had been willed to them. But the dilemma is older, and its ancient history suggests the possibilities of a more fundamental significance in their, and our, response. "Another most curious fact and worthy of record," Pliny observes, "is that the latest works of artists and the pictures left unfinished at their death are valued more than any of their finished paintings. . . . The reason is that in these we see traces of the design and the original conception of the artists, while sorrow for the hand that perished at its work beguiles us into the bestowal of praise" *(Nat. Hist.* 35.145). How complex, how moving our involvement with the *non finito* seems always to have been, at least since classical criticism isolated the artist as a special phenomenon.

In our time we have recently experienced the dynamics of the fragmentary, its will to completion, in a mode of rare poetry, at the Museum of Modern Art's exhibition in 1977 of the late work of Cézanne. Especially before the great wall that carried the series of (unfinished?) images of Mont Sainte-Victoire we traveled the cycled route between idea and substance, imagination and sensation, canvas and paint. Following the indicative momentum of the individual works, further encouraged by their collective serial implications, we were free to move in either direction: to continue on the way to closure, to some formal resolution of the open structure, or to retrace the process of becoming, to subject the fragmentary to a further decomposition.[4]

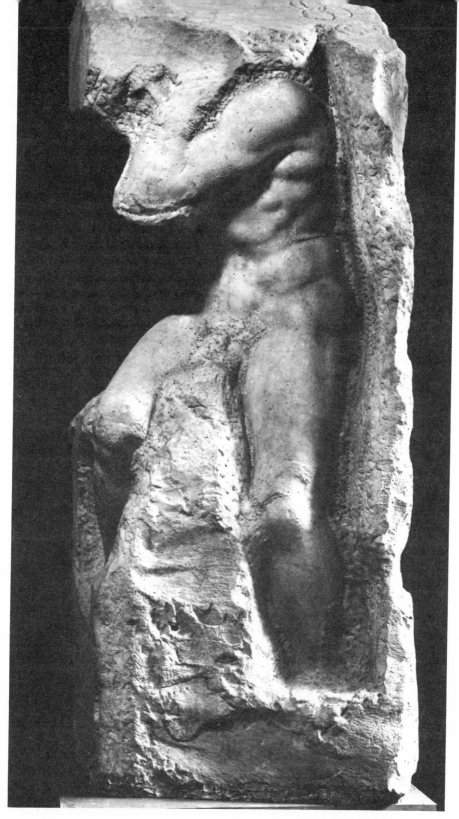

Fig. 4. If the fragment as decomposed, disintegrated form assumed a satisfying legitimacy in the esthetic eye, then the fragment as unachieved or becoming form could lay claim to similar status. (Michelangelo, *Slave*. Florence Accademia) *Courtesy Columbia University, Department of Art History and Archaeology*

*Zeuxis . . . thought that he would not be able to find so much
beauty as he was looking for in a single body, since it was not
given to a single one by nature. He chose, therefore, the five
most beautiful young girls from the youth of that land in order
to draw from them whatever beauty is praised in a woman.*

Leon Battista Alberti

Helping nature to overachieve, to realize its teleological esthetic end,
the Helen (or Aphrodite) that Zeuxis painted for Croton has become the
type of the eclectic ideal: beauty assembled from fragments. Preserved and
repeated by Cicero and Pliny, among others in antiquity, the story
assumed its position as a standard *topos* long before the Renaissance,
when it passed easily between art theory and poetry. For Ariosto
(*Orlando furioso* 11.71) the allusion to Zeuxis is sufficient to summarize
the full particulars of Olimpia's charms. And, in turn, the poet's enumera-
tion of the beauties of Alcina will reenter the literature on art as a modern
elaboration of the Zeuxis *topos:* Lodovico Dolce offers the descriptive
listing to painters as a perfect example of feminine beauty—as well as
proof that "good poets are also painters," Ariosto's coloring proving him
to be a Titian (*Dialogo della pittura intitolato l'Aretino* [Venice, 1557]).

On a more practical level and if not actually inspired by the Zeuxian
eclecticism at least demonstrating the empirical application of its princi-
ples, the first drawing books of the Renaissance illuminate the critical
role of the fragment in this rhetorical tradition. And they return us to
our essential art historical theme, the torso. Graphically realizing the
implications of the pedagogical activities of the sixteenth century, these
manuals taught the novice to draw the figure in stages. Standard prac-
tice—represented, for example, by Benvenuto Cellini's fragment of a
discourse *Sopra i principj e'l modo d'imparare l'arte del disegno*—guided
the beginner's course from the basic armature of the body, the bones of
the skeleton; assembling the skeletal structure and then covering it with
muscles and flesh, the young artist learned to construct the figure piece by
piece. As codified in the later manuals, the system offered collections of
such details—eyes, ears, mouths, noses (Fig. 5), hands, feet . . . and torsos
(Fig. 6)—fragments of the body.

Quite different in spirit from Leonardo's appreciation of the frag-
mentary as a spur to invention, as the articulation of a moment in the
creative process laden with potential, these pattern books anatomize
beauty, proportion, physiognomy. And yet, fragmentation inevitably
suggests its antithetic corollary, integration—in Leonardo's case, that
organic vision of the whole which required only the most summary
graphic notation to affirm itself; in the later drawing manuals, the skeletal
core that directed the assembly of the disparate parts.

From outside the immediate situation, beyond the moment of choice,

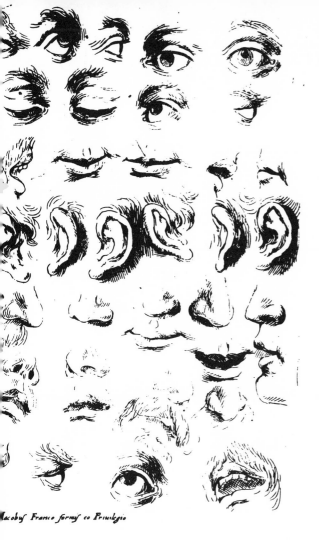

Jacobus Franco formis co Privilegio

Fig. 5. Offering fragments of the body as basic units in the curriculum, the drawing manual of the Renaissance taught the novice to draw the figure seriatum, as illustrated by folio 11 in Giacomo Franco's *De excellentia et nobilitate delineationis libri duo* (Venice, 1611). *Courtesy Columbia University, Department of Art History and Archaeology*

Fig. 6. Pattern books anatomized beauty, proportion, physiognomy as in folio 38 of Odoardo Fialetti's *Il vero modo et ordine per dissegnar tutte le parti et membra del corpo humano* (Venice, 1608). *Courtesy Columbia University, Department of Art History and Archaeology*

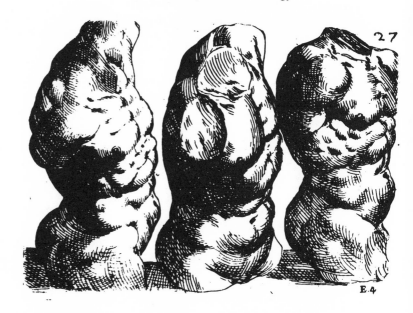

Fra Filippo. Filippino. Signorelli. Bramantino.

Mantegna. Giambellino. Bonifazio. Botticelli.

Fig. 7. Breaking down the painted image into its smallest constituents—unexamined details, "material trifles" such as fingers, ears, noses—the connoisseur seeks the hand of the creator, disintegrating the whole to discover the shaping force behind it. Fragmentation is a means toward knowledge. (Page 99 from Ivan Lermolieff [pseudonym for Giovanni Morelli], *Kunstrikritische Studies über italienische Maleri, Die Galerien Borghese un Doria Panfili in Rom* [Leipzig, 1890]) *Courtesy Columbia University, Department of Art History and Archaeology*

we now can look back and find in each case a key to our own critical concern, style—style in both the large and small dimension. On the scale of Leonardo's integration, we step back to comprehend the grand organizing vision that binds all the artist's work into one vast corpus marked by a single (albeit very complex) personality. The cataloguing of the drawing books, instead, invites us to approach more closely, to attend to the individual details whose selection will eventually determine some sense of style. Such response to particulars quite properly evokes the experience of the connoisseur in the examination of the more minute points of a picture.

Indeed, in the books of the nineteenth-century father of modern "scientific" connoisseurship, Giovanni Morelli, we meet illustrations that seem distant but unmistakable relatives of the drawing manuals (Fig. 7). But the process has again been reversed. In his search for the identifiable uniqueness of artistic personality, Morelli explored the world of the unexamined detail, those particulars learned and rendered automatically by the artist—"material trifles" such as fingers, ears, noses, etc. Breaking down the painted image into its smallest constituents, the connoisseur seeks the hand of the creator, disintegrating the whole to discover the shaping force behind it. Fragmentation is, again, a means toward knowledge.

In an incisive "critique of connoisseurship" Edgar Wind elegantly located Morelli's method in the larger, lingering romantic traditions of the fragment:

> Quite apart from questions of attribution, which would make him search for the unspoiled fragment, he distrusted the finished work as such because he disliked artistic conventions. Whatever smacked of academic rule or esthetic commonplace he dismissed as deceptive, hackneyed and unrewarding, and withdrew from it to those minute and intimate perceptions which he felt to be the only safeguard of pure sensibility. Clear-sighted about the logic of his method, he came to regard the study of drawings as more fundamental than that of paintings. The spontaneous sketch retained in its freshness what the labors of execution tended to stale.[5]

However much he may have spoken for his century and anticipated the prejudices of our own, Morelli, notwithstanding the precision of his focus, shared a still older heritage. Leonardo, in word and practice, had already lived the dilemma of the *non finito*, and Vasari regretted the surrender of creative fury in the progress from first sketch to finished work. The tension seems almost endemic to the self-conscious traditions of Western art.

Completing the Whole

> *For much imaginary work was there;*
> *Conceit deceitful, so compact, so kind,*
> *That for Achilles' image stood his spear,*
> *Griped in an armèd hand; himself behind*
> *Was left unseen, save to the eye of mind:*
> * A hand, a foot, a face, a leg, a head*
> * Stood for the whole to be imaginèd.*
>
> The Rape of Lucrece, ll. 1422-28

Shakespeare may well have known the image of the siege of Thebes described by Philostratus the Elder in his *Imagines* (1.4)—as E. H. Gombrich first suggested[6]—but here, too, we seem to confront less a rhetorical *topos* than a venerable tradition keenly and creatively aware of the "beholder's share" (to stay with Gombrich), of an indigenous will to completion that affords both poet and painter a fertile field for exploitation. Information withheld simultaneously frustrates and implicates; it forces active engagement. Leonardo, ever the voice of esthetic self-awareness, knew this as he elaborated the principles of *sfumatura*: obscuration is a form of seduction—consider Rembrandt's eyes of darkness.

Although given new direction and purpose in the Renaissance, the principle itself was not new. More dramatic than the *ekphrasis* of Philostratus is the ancient account of Timanthes' picture of the sacrifice of Iphigeneia. "Having represented all the onlookers and especially her father's brother as plunged in sorrow and having thus exhausted every presentment of grief, he veiled the face of her father for which he had reserved no adequate expression" (Pliny, *Nat. Hist.* 35.73). "Praised by the orators," the motif became indeed a standard *topos* in the rhetorical literature, renewed then by Alberti: cloaking Agamemnon's head, Timanthes "let his most bitter grief be imagined, even though it was not seen."[7] The unseen provokes eye, mind, and heart to fuller involvement in the image's fiction, each supplying a dimension to the endeavor of reconstitution.

This principle, of affective projection, assumes as axiomatic a fundamental continuity of experience, the tacit ground of all mimetic art. Because we know our own world, inner as well as outer, we can see into the darkness of its image, can supply from our fund of personal experience the information, pathetic as well as physical, that the image itself withholds.

On a more obviously structured level, and operating along a somewhat different set of coordinates, there is yet another factor in pictorial representation that fragments the world: the frame. That arbitrary bounding of a field of vision creates a situation of acknowledged fragmentation as it isolates a discrete part of a, theoretically, infinite continuum. Leaving aside the vicissitudes of the frame's form and function in Western art from antiquity through the Middle Ages, we may simply note that with the establishment of a mathematical system of perspective representation, which charged the picture plane with new significance, the frame assumed a heightened status as both determinant and mediating force in the mimetic game of picture-making.

Painting, in turn, when confronted with its own double, photography, discovered still further possibilities in the frame's function as artificial limit to the visual field—i.e., as aperture. The camera, it might be argued, taught a new mobility of vision; the creating viewer, painter or photographer, took new delight in the very arbitrariness of the frame—a quality inherent in the constructs of Renaissance perspective and exploited by artists even then. Framing meant composing, the selecting of parts from a larger whole. And yet that whole remained implicit in the parts: in compositions by Degas, for a prime example, figures and forms cropped by the frame continue beyond—in "the eye of mind"—and the same principle operates in Mondrian's fragmented abstract grids.[8]

"The dry quadrilateral, plunging into the hazards of nature's diffuseness . . . ," as Sergei Eisenstein phrased it in an essay on "The Cinematographic Principle and the Ideogram." And the great Soviet director, art historian as well as critic, found the image that epitomized both the principle and the particular moment in Western art that had so clearly articula-

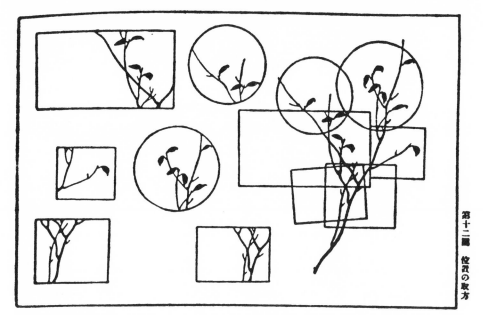

Fig. 8. "Here's the branch of a cherry tree. And the pupil cuts out from this whole, with a square, and a circle, and a rectangle—compositional units.

"He frames a shot!" (From Sergei Eisenstein's *Film Forum* [New York, 1949], p. 41 from *Jinjo Shogaku Shintei Gaten Dai Roku Gaku Nen Dan Sei Yo* [Tokyo, 1910]) *Courtesy Columbia University, Department of Art History and Archaeology*

ted it. From an elementary-school drawing manual issued by the Tokyo board of education in 1910 he republished example number 12, "How to choose composition" (Fig. 8).

> Here's the branch of a cherry-tree. And the pupil cuts out from this whole, with a square, and a circle, and a rectangle—compositional units.
> He frames a shot![9]

The very arbitrariness of the frame, not unlike the unfinish of the sketch—or the still more deliberate assemblage of apparently random but suggestively referential bits in our own century's art of collage—offers us a fragment, and we are content to be invited to participate in the game of completion. Indeed, we even demand such invitation, insisting on our right as beholders to participate, to be allowed our role in bringing the work to conclusion.

"The question of what will emerge is left open. One functions in an attitude of expectancy." In their opening statement for *Possibilities* ("An Occasional Review," no. 1, Winter 1947/48), Robert Motherwell and Harold Rosenberg, speaking for a new generation of explorers, extended the discourse. The state of openness, of indeterminacy, of potentiality, describes a larger situation; the fragmentary becomes more explicitly existential—but that had been tacitly assumed since Leonardo.

Composition/Decomposition/Recomposition

Notes

1. On the theme in general, see the contributions to the symposium, *Das Unvollendete als künstlerische Form*, ed. J. A. Schmoll gen. Eisenwerth (Bern, 1959), and the catalogue of the exhibition, *Torso, das Unvollendete als künstlerische Form* (Recklinghausen: Städtische Kunsthalle, 1964).

2. See E. H. Gombrich, "Leonardo's Method for Working out Compositions," in his *Norm and Form* (London: Phaidon, 1966), pp. 58-63; Jan Bialostocki, "The Renaissance Concept of Nature and Antiquity," in *The Renaissance and Mannerism*, Acts of the Twentieth International Congress of the History of Art (Princeton, N. J.: Princeton University Press, 1963), 2:19-30; David Rosand, "Giorgione e il concetto della creazione artistica," in *Giorgione*, Atti del Convegno Internazionale di Studi (Castelfranco Veneto, 1979), pp. 135-39.

3. Joseph Gantner, "Formen des Unvollendeten in der neuren Kunst," in *Das Unvollendete als künstlerische Form*, pp. 47-67, with reference to his earlier publications.

4. Cézanne was quite aware of the tension, ascribing it in part to old age: "Now being old, nearly seventy years" he wrote in 1905, "the sensations of color, which give light, are for me the reason for the abstractions that do not allow me to cover my canvas entirely or to pursue the delimitation of objects where their points of contact are fine and delicate; from which it results that my image or picture is incomplete." Quoted and discussed by Lawrence Gowing, "The Logic of Organized Sensations," in *Cézanne, The Late Work* (New York: Museum of Modern Art, 1977), p. 68.

5. Edgar Wind, *Art and Anarchy* (New York: Knopf, 1969), pp. 43ff. Cf. further Hubert Damisch, "La Partie et le tout," *Revue d'esthétique* (1970), 23:168-88; also Richard Wollheim, "Giovanni Morelli and the Origins of Scientific Connoisseurship," in his *On Art and the Mind* (London: Allen Lane, 1973), pp. 177-201; and Henri Zerner, "Giovanni Morelli et la science de l'art," *Revue de l'art* (1978), nos. 40-41, pp. 209-15.

6. Gombrich, *Art and Illusion* (New York: Pantheon, 1960), p. 211.

7. Leon Battista Alberti, *On Painting* (1435), trans. John R. Spencer (New Haven, Conn.: Yale University Press, 1956), p. 78.

8. See Meyer Schapiro, "Mondrian: Order and Randomness in Abstract Painting," in his *Modern Art: 19th and 20th Centuries* (New York: George Braziller, 1978), pp. 233-61; also David Rosand, "Frame and Field: Notes on the Lesson of Degas," in *Arts Magazine* (1967) 41, no. 5:18-29.

9. Sergei Eisenstein, *Film Form*, trans. Jay Leyda (New York: Harcourt, Brace & Company, 1949), p. 41.

The Alphabet and the Junkyard

ROGER SHATTUCK

I. First Flaubert

> *Travaille, médite, médite surtout, condense ta pensée, tu sais*
> *que les beaux fragments ne sont rien. L'unité, l'unité, tout est*
> *là! L'ensemble, voilà ce qui manque à tous ceux d'aujourd'hui,*
> *aux grands comme aux petits. Mille beaux endroits, pas une*
> *oeuvre. Serre ton style, fais-en un tissu souple comme la soie*
> *et fort comme une cotte de mailles. Pardon de ces conseils,*
> *mais je voudrais te donner tout ce que je désire pour moi.*
> (To Louise Colet, 14 October 1846)

> *Tu me parles de perles. Mais les perles ne font pas le collier;*
> *c'est le fil. . . . Tout dépend du plan.*
> (To the same, 1 February 1852)[1]

When Maxime Du Camp published *Madame Bovary* in *La Revue de Paris*, stripped of certain passages he feared would be offensive, Flaubert angrily disowned the maimed work and called it a "collection of frag-

ments." Over and over again his letters and his practice insist on a sense of the whole that precludes any gratuitousness or casualness in assembling the parts.

Yet this is the same author who kept an open file containing the dumbest platitudes he could grab out of the conversational environment; he merely lumped them together alphabetically without system or direction in the *Dictionnaire des idées reçues*. The "novel" *Bouvard et Pécuchet* does not even have the alphabet to provide a semblance of structure. It relates the desultory tale of two middle-aged clerks, retired to the country, who bumble through the surrounding culture subject by ponderous subject. Each project ends in frustration or catastrophe, like their scheme to write a biography of the Duc d'Angoulême. They can no more reconcile the conflicting sources on the duke's life than they can keep themselves informed about what goes on in their own eccentric household. Bouvard and Pécuchet are unable to fit the pieces of the world's puzzle together; they simply keep on picking up the next piece until it too falls from their clumsy fingers.

Eighty years later Flaubert's caricature of unrestrained *libido sciendi* reappears in *La Nausée*. Not only did Sartre have Roquentin despair of writing his biography of the Marquis de Rollebon; he also introduced the pastiche figure of the Autodidacte. This plodding inquirer pursues knowledge, not without plan as Bouvard and Pécuchet were willing to do, but rigorously and alphabetically, according to the arrangement of the municipal library of Boueville—the arrangement of the *Dictionnaire des idées reçues*. But what kind of order is this on which to string the pearls of a culture?

II. Next Diderot

Diderot looms large behind Flaubert and Sartre. Examined with any historical and philological acuity, Diderot's *Encyclopédie* reveals a very odd pedigree. Leland J. Thielemann states it succinctly.

> The fortunes of the encyclopedia may fairly be summed up as the history of semantic improvisations on a word coined by ignorance, dignified by classical authority, and transmitted by Christian theology to a scientific world of the eighteenth century which was already weary of all three.[2]

What attracted Diderot and his friends to this dubious tradition was their grasp of the way an encyclopedia could embody their deep Leibnitzean faith that, in human knowledge as in nature, *tout se tient, tout se lie* in a great circle or chain. In the "Prospectus" (1750) Diderot's principal figures invoke the essential continuity of knowledge: "les système figuré des connaissances humaines," "l'arbre de la connaissance humaine," and

"notre obligation à Bacon." In the "Discours préliminaire" (1751) D'Alembert writes of their intent in the Encyclopédie "exposer . . . l'ordre et l'enchaînement des connaissances humaines " and "ranger les idées dans l'ordre le plus naturel." Four years later Diderot opens the article "Encyclopédie" by stating: "ce mot signifie l'enchaînement des connaissances." He goes on to appeal to "le système général," an equivalent of the widely used seventeenth-century term, "science universelle." The great *Encyclopédie* would presumably replace the Christian cosmogony with a systematic order appropriate to the new dispensation of science.

Most of us have all too easily forgotten or refused to notice that instead of following any natural or scientific or systematic or even encyclopedic order, these stout eighteenth-century holists were swayed by expediency and a sense of the reader's convenience to adopt a perfectly arbitrary scheme. Their nonsystem was based on the alphabet and words in the French language. At the juncture we have come to call the Enlightenment, when one might expect to find a search for a new unity and coherence of the world and what is known about the world to replace the waning structures of feudalism and Christianity, Diderot & Co. produced a thoroughgoing fragmentation of knowledge into unrelated entries arranged according to the spelling of presumably key terms. They did so in the name of ease of reference and retrieval. In the "Discours préliminaire" D'Alembert had the embarrassing task of explaining how the editors could claim "concilier l'ordre encyclopédique avec l'ordre alphabétique." He makes much of the systematic table of the branches of learning printed at the head of the first volume, of the scheme of generic classifications employed to place articles in that table, and of the numerous *renvois* or cross-references. But these secondary devices do not redeem the *Encyclopédie* from its capitulation to the arbitrariness and illogicality of one language's alphabet.

It is distressing to listen to Diderot justify his betrayal of his own principles.

> Nous croyons avoir eu de bonnes raisons pour suivre dans cet ouvrage l'ordre alphabétique. Il nous a paru plus commode et plus facile pour nos lecteurs, qui désirant de s'instruire sur la signification d'un mot, le trouveront plus aisément dans un dictionnaire alphabétique que dans tout autre . . . si nous eussions traité de chaque science séparément et dans un discours suivi, conforme à l'ordre des idées, et non à celui des mots, la forme de cet ouvrage eut été encore moins commode pour le plus grand nombre de nos lecteurs, qui n'y auraient rien trouvé qu'avec peine; l'ordre encyclopédique des sciences et des arts y eut peu gagné, et l'ordre encyclopédique des mots, ou plutôt des objects par lesquels les sciences se communiquent et se touchent, y aurait infiniment perdu.[3]

The reader's convenience carries all before it; natural order and articulation be damned. The bad faith of the last sentence is appalling. There is no such thing as an "ordre encyclopédique des mots." The expression seeks to legitimize a blatant contradiction in terms and to palm off the pure convention of the alphabet as a system of nature.

France's major eighteenth-century undertaking to survey and correlate human knowledge according to new principles of unity and order ironically and surprisingly turns out to be a great intellectual diaspora, a scattering of knowledge into fragmentary entries under the then-current "dénominations." Hugh Davidson's observation strikes home: "Scientific order is logical, natural, and *forbidding;* while alphabetical order is illogical, conventional, and *inviting.* "[4] Convenience and speed of retrieval may represent a powerful principle of cultural entropy that we have not yet recognized and that continues to play a dominant role in a universe of computers.

III. Then Roget

A hundred and fifty years after Diderot we come upon another example of the way in which the alphabet can invade and lay waste to a systematic and logical order. P. M. Roget had cast his *Thesaurus* of 1852 within an overall topography of meanings projected by the language itself. This aerial map of English is one of the most revealing documents we have to tell us about the intellectual countryside we inhabit; it virtually diagrams the relationships of our words to our ideas, habits, and shared perceptions. Then, in the first two decades of this century, an American lexicographer, C. O. S. Mawson, recast Roget into an alphabetical format. Like Diderot he did so in the name of convenience for the reader, "above all if he is in a hurry." Nothing could be more inappropriate. Roget's great spectrum of words and meanings was hacked up into another list, and Mawson's "handy" version has now virtually driven out the original.

Once again a paradoxical and heavily ironic effect hovers over this event. Mawson was revising Roget's *Thesaurus* into a semblance of a *Dictionnaire des idées reçues* at the very moment when Saussurre was lecturing in Geneva on how the amorphous domain of ideas comes into relation to the equally amorphous domain of human sounds. Language itself serves as intermediary, Saussure affirms, and he illustrates his exposition with a figure that looks like two facing wave patterns. A word or sign

is an arbitrary form connecting *A* to *B*, and whose meaning arises primarily from its *valeur*—that is, from its relative position in the double continuum of ideas and of sounds, represented horizontally in the diagram. Words carve conventional chunks of meaning and corresponding sound out of the two proximate series; the *valeur* or meaning of our words can be best measured by situating them within these series, not by listing them as isolated items according to some other system. In other words, Roget's original *Thesaurus* is the closest we have come to a photograph of the language as a system of *valeurs*, of the dynamic and arbitrary relation between our thinking and our phonic representation of it. It too has succumbed to the fragmenting power of the alphabet.

IV. What Is Going on Here?

Is there a general force at work that impels the literary imagination to break up any system that might hold things together around a center? Do we seek out the fragment because it is more vivid and exciting than a unifying principle? Think for a moment of the significance Proust builds up around the tiny word *pan* (patch, panel) as an isolated, fleeting item of perception caught and magnetized by the artistic sensibility. Proust's *pan* bears a startling resemblance to Joyce's cry in the street—a brief awareness of a fleck of naked reality imprinting itself on our consciousness. The *pan* and the cry in the street finally lead, I believe, to the opening pages of Sartre's *La Nausée*, where they congeal into a fascinating-repulsive object—*le galet*. Roquentin's pebble has become so intensely and isolatedly itself, so removed from any accommodating environment that might give it a context, that it seems to assert a revolting existence of its own, to come alive in his hands. Sartre's extreme case inspires me to advance a vest-pocket theory of the fragment and its hugely ambivalent status in modern literature and art.

Roquentin's sickening pebble is a rare case of the *absolute fragment*. It remains isolated and cannot find its way to any larger order of things. Its collapse into itself expresses Roquentin's sense of decay, formlessness, disorder, entropy. Its self-containment does not lead back to the circles of nature and knowledge. This appalling thing becomes a kind of fissure or vortex in the real through which the whole universe will leak out. Such absolute fragments occur very rarely, because they challenge everything, contaminate everything. Beckett is probably the only author who has probed further in this direction, laughing derisively all the while. The sixteen *pierres à sucer* that Molloy carries allude directly to Roquentin's pebble. Molloy seems to stave off his nausea through the elaborate and obsessive games he plays in transferring the stones from pocket to pocket. In both cases the smooth pieces of mineral imply a complete disintegration of the Great Chain of Being. There is no order to redeem them from their isolation.

The *linked fragment* leads a totally different life. The archeologist's potsherd illustrates this category most satisfactorily. From one odd piece of ancient pottery the astute investigator can restore not only the original vessel but also, with other sources of knowledge, a whole culture. In this perspective nothing stands alone, and the tiniest fragment of the universe breathes forth its secret connections to everything else. No item is so small or insignificant that it cannot be a relic, a clue, a piece of the true cross. This is the universe of Swedenborg and Blake and Novalis, of Nerval and Baudelaire. The net of correspondences and implications weaves its way down into Mallarmé and Yeats and Stevens even as it loses a steady metaphysical or transcendent basis. Yet the cultural yearning for universal analogy holds firm. Very early Coleridge referred to this sense of things in his description of why the conversation of a superior mind, even on a trivial subject, impresses us..

> It is the unpremeditated and evidently habitual arrangement of his words, grounded on the habit of foreseeing, in each integral part, or (more plainly) in every sentence, the whole that he then intends to communicate. However irregular and desultory his talk, there is method in the fragments.
>
> ("On Method," *The Friend*, Essay 4)

However the real appeal of the fragment in the two centuries since Diderot's antiencyclopedia lies in its ambiguity. This double orientation emerges most immediately in the ethos of cubism. A detached ear or a floating moustache, one table leg or a few disembodied guitar frets, the lopped letters JOU—these scraps of everyday life drift about and withdraw into themselves as if they had lost their bearings and *raison d'être*. Yet at the same time each familiar detail shouts its incipient relation to everything else in the composition and in the world at large. The lines and planes of cubist design both isolate and connect the everyday motifs they manipulate. The *ambiguous fragment* contrives to be both absolute and implicate. The most extended instance is probably Marcel's scrutiny of Albertine's behavior in the later volumes of *A la recherche du temps perdu*. Her impulsive, or calculated, or casual, or perhaps meaningless actions will not fit together into a pattern that Marcel can recognize and categorize. Albertine is an uncrackable enigma, perhaps a cipher. Since he yearns for an order that refuses to declare itself in Albertine's acts, Marcel wears himself out in hypotheses and investigations that express his faith in the coherence and continuity of human character. There must be an explanation, yet he cannot find it.

The intellectual activity Diderot refers to as *libertinage* in the opening sentences of *Le Neveu de Rameau* rests squarely on this response to the fragment as ambiguous—both isolated and implicated. Baudelaire developed the attitude into the endemic activity of the dandy: *flâner*. The surrealists in their prose narratives of city promenades refined

flânerie into fine art, whose concrete esthetic reward took the form of an *objet trouvé* (see Breton's *L'Amour fou*). Walter Benjamin gathers up many of these strands in his essays on Baudelaire, and in his very special use of quotations both as disconcerting scraps obstructing his own discourse, and as the elements of a montage. The great master of the ambiguous fragment is of course the other Marcel: Marcel Duchamp, whose "works" or "jokes" flutter on the frontier between meaninglessness and deep metaphysical significance.

More than any other art, film has exploited the fragment. Kuleshov and Pudovkin demonstrated that they could assemble empty isolated shots into sequences that have unity and meaning. Eisenstein referred to cinema as "fragments standing in a row," and all his writings about montage insist on a dialectic of fragmentary shots played against one another. The sense of the fragment has bestowed on the arts a new openness of form which combines a refusal of traditional orders, deliberate ambivalence of meaning, acceptance of obscurity, comic playfulness, and deep self-irony.

Thus the fragment, which would first appear to be a mode of anti-structure, itself shapes the way we perceive the world and recast it into works of art. The most striking demonstration of that statement may be simply to quote the three principal modernist poets in English. Because things won't fit together, all three poets reach a point at which they allude affirmatively, even affectionately, to an ethos of the junkyard. They are satisfied to accept objects and words and ideas simply piled up without rhyme or reason. In "The Circus Animals' Desertion" Yeats, trying to find a central self beyond the successive personae, makes his ultimate appeal to "the foul rag-and-bone shop of the heart." In an early draft of *Canto II* Pound twits the "art-form" of his Sordello: "The modern world/ Needs such a rag-bag to stuff all its thoughts in." And Eliot closes *The Waste Land* with a terse description of its genre and form: "These fragments I have shored against my ruins."

Perhaps we have come to fear an overarching unity—even Flaubert's, unity of the work—more than we yearn for one. That might explain why many modern artists turn readily to the alphabet, the junkyard, *l'objet trouvé*, and montage as acceptable orders.[5]

Notes

1. Work, meditate, meditate above all, condense your thought, you know that lovely fragments amount to nothing. Unity, unity is everything! A sense of the whole, that's what's missing in all our contemporaries, great and small. A thousand lovely spots, not a unified work. Tighten your style, make it supple as silk, strong as a coat of mail. Excuse the advice, but I would like to give you everything I desire for myself.

 (To Louise Colet, 14 October 1846)

 You speak of pearls. But pearls don't make the necklace; it's the string Everything depends on the plan, the outline.

 (To the same, 1 February 1852)

2. From an unpublished article by Leland J. Thielemann, "Circles of Perfection: Diderot and the Encyclopedic Theory from the Renaissance to the Enlightenment." I am grateful to Professor Thielemann for having made his remarkable article available to me.

3. *Oeuvres complètes*, ed. John Lough and Jacques Proust (Paris: Hermann, 1976), 5:93.

> We believe we had good reasons to follow alphabetical order in this work. It seemed to us more convenient and easy for our readers, who, if they wish to inform themselves on the meaning of a word, will find it more readily in an alphabetical dictionary than in any other. . . . If we had dealt with each science separately in an extended treatment, following the order of ideas and not that of words, the form of this work would have been even less convenient for most of our readers, who would have had trouble finding anything in it. The encyclopedic order of the sciences and the arts would have benefited, and the encyclopedic order of words, or rather of the objects by which the sciences overlap and relate to one another, would have suffered infinitely.

4. Hugh Davidson, "The Problem of Scientific Order Versus Alphabetic Order in the *Encyclopédie*," in Harold E. Pagliaro, ed., *Irrationalism in the Eighteenth Century* (Cleveland: Case Western Reserve University Press, 1972).

5. Roland Barthes has some pertinent remarks about Michel Butor's *Mobile*, alphabetical order, and "le degré zéro des classements" in "Littérature et discontinu," *Essais critiques* (Paris: Editiones du Seuil, 1964).

4

Fragment: An Oral-Formulaic Nondefinition

ALAIN RENOIR

The *Oxford English Dictionary* defines the term *fragment* as "a part broken off or otherwise detached from a whole" as well as "an extant portion of writing or composition which as a whole is lost; also a portion of a work left uncompleted by its author; hence a part of any unfinished or uncompleted design." The fact that the editors have drawn their supporting evidence from texts ranging from the sixteenth century to the late nineteenth suggests that these definitions, whether formally expressed or otherwise, have been around for a long time, and a glance at almost any recent American dictionary will show that they reflect current usage on this side of the Atlantic as well. With the exception of those romantics who devoted their energies to the wholesale manufacture of unfinished poems and artificial ruins, people who bother at all with the matter tend to associate the concept of fragmentariness with that of imperfection, as illustrated in Samuel Johnson's *Dictionary* with the entry under *fragment:* " . . . an imperfect piece." This tendency has provided the excuse for many an architect to restore the lovely remains of ancient buildings into perfectly graceless embodiments of the modern imagination, and for many

a philologist to make use of ancient fragments in order to reconstruct texts which would horrify the original authors if they were still alive to be horrified.

The Apprehension of Fragments

Fragments, however, are very much like television images, whose pragmatic manifestations result from the interaction between broadcasting station and individual set. Practically every American today has had a confrontation with the recalcitrant set that refuses to show the whole image. A lone human head and shoulders appear on the right or left side of the screen while the rest of the scene remains hidden behind a snow-storm, and we are thus presented with the kind of "part . . . detached from a whole"—a fragment, according to the *Oxford Dictionary*. And yet we know full well that the whole scene is there: it is taking place at the broadcasting station, and it is being fully transmitted to our set, the faulty view of the scene prevents us from apprehending in its entirety the image that is actually there. In other words, we call the head and shoulders a fragment because a defect in our information retrieval system prevents us from apprehending a context which we expect and without which we are unwilling to interpret the image on the screen as an independent entity. Suppose, on the other hand, that our hypothetical head and shoulders were made of marble, placed on an appropriate stand, and displayed squarely at the center of the screen. Because we are used to seeing marble busts and therefore assume the piece to conform to the sculptor's intention, we would probably interpret the image before us as an independent entity although the material transmitted would actually be only a fragment of a whole human being. Suppose now that half of our bust had been smashed to bits in an accident but that the television producer had nevertheless decided to exhibit the unaffected half. We would probably call the image on the screen a fragment because, except when dealing with surrealistic art, we are not prepared to interpret half a marble bust as an independent entity. Furthermore, if the accident had destroyed everything below the neck, we should have no context to help us determine whether the fragment came from a head, a bust, or a standing statue, and we could accordingly not even call it large or small in relation to the whole from which it came. The hypothetical situations outlined above have presented us with a whole apprehended as a fragment, a fragment apprehended as a whole, and a fragment apprehended as a fragment. The lesson is that the pragmatic apprehension of a particular thing as a fragment depends at least in part upon the interaction between the thing itself and the agent of perception, and that perception is affected by the context.

Some Contexts of Fragments

The trouble with contexts is that they can be either empirical or implied and that implied contexts must usually be provided by the agent of perception. The relevance of this observation to a discussion of fragments may be ascertained by calling to mind a well-known painting entitled *Ia Orana Maria*, in which Paul Gauguin has represented three Tahitian women and an infant. Both the infant and the woman who carries him have faint circular outlines about their heads, and the other two women stand before them with hands in prayer position. We need not even know that the title inscription means "health to you, Mary," to realize that we are looking at a Madonna and Child. Regardless of our personal religious practices or lack thereof, we live in a predominantly Christian culture, and we are familiar with the story of Mary and Jesus because we have heard it, read it, and seen sundry parts of it represented in the visual arts and other media. Our preconditioned response to the mere suggestion of a halo in connection with a woman and child has prompted us to supply the context necessary to the interpretation of the scene before us. By thus linking in our mind the pictorial representation of one element with the entire story in its various forms, we have in effect produced a kind of interpretative symbiosis and assumed the painting to conform to its author's intention. From this point of view, I doubt that anyone would call Gauguin's painting a fragment, since it clearly belongs to a long tradition of paintings which have depicted the same or similar portions of a familiar story, and the change of locale even adds a new message for good measure.

In contradistinction to the foregoing argument, we may assume that a totally different culture would presumably have no means of supplying the Christian context which is so obvious to us. Had a painting similar to Gauguin's somehow reached Tahiti before the island was sighted by Pedro Fernandez Quiros in 1607, we may assume that the inhabitants would have seen the three women and the infant as clearly as we do, but they would have lacked the information necessary to supply the appropriate context and infer the author's intention, so that their interpretation must necessarily be different from ours. Even if they had succeeded in deciphering the title inscription, I like to think that they would have perceived the scene as a fragment of a larger scene which might have explained the circular outlines and the position of the hands. One may even imagine local historians attempting to reconstruct an entire literary, legendary, or historical context on the basis of the supposed fragment, just as some of our most respected literary historians at the beginning of this century attempted to reconstruct entire Odoacer and Offa legendary cycles on the basis of a few supposed fragments which may not have had anything to do with either Odoacer or Offa and whose fragmentary status no longer seems so certain as it did then.

Of course, the principle which I have been trying to illustrate is not so immediately obvious with literature as it is with the visual arts, because, on the one hand, the apprehension of an entire work of literature is a progressive operation which can be completed only at the end of the period of time necessary to read the text or listen to a reading thereof, whereas, on the other hand, the entirety of a painting may be apprehended at a single glance. The corollary of this difference is that the student of literature tends to apprehend the whole only after seeing the details, whereas the student of the visual arts tends to see the details only after apprehending the whole. But I submit that the relationship between our apprehension and the context which we supply remains roughly the same in either case. Although the natural human reluctance to endorse outrageous public statements may prevent us from agreeing with Stanley Fish's pronouncement that "the objectivity of the text is an illusion,"[1] common sense should prompt us to accept Norman Holland's view that in certain respects "a reader recreates his own literary work."[2] If such be the case, it follows that a given literary artifact could conceivably be a fragment because we see it as a fragment but that a different society might see it as an independent entity with a beginning, a middle, and an end.

The generally accepted notion among Americans and Western Europeans concerned with literature is that the beginning, middle, and end whose absence may turn a whole into a fragment are concerned almost exclusively with the plot of the story. When we look at Chaucer's *Cook's Tale* from the point of view of the plot, for example, we find only a beginning there, since the fifty-eight lines of the poem merely introduce us to an engagingly fun-loving, irresponsible, and light-fingered apprentice who has been discharged by his cautious master and is in the process of moving in with "a compeer of his owene sort" (1.4419).[3] Because the final three lines tell us that the compeer in question "lovede dys, and revel, and disport" (1.4420) and came equipped with a wife who "swyved for hir sustenance" (1.4422), we infer a great deal about the tone and nature of the subsequent action, but the fact that the narrative comes to an abrupt end at this point tells us that much of the plot of the story is missing, and the normal assumption that Chaucer intended to give us the whole story warrants our calling the piece a fragment.

The principle illustrated above is simple, but the application is not always so. The poems of Sappho, which are probably the most famous fragments in the literary history of the Western world, afford us ready examples of both the ease and the difficulty involved in determining whether a written text ought to be considered fragmentary or not. Let us examine the following four lines, which I quote from a diplomatic edition:

$$].a[$$
$$]a \acute{\iota} \gamma a[$$
$$].\delta o.[$$
$$] \quad [$$

<div align="right">(p. 30, frag. 17b).[4]</div>

Because I can make no sense whatsoever out of the seven letters printed above, but the editorial apparatus tells me that they were once part of a poem whose meaning presumably conformed to Sappho's intention, I have no hesitation in calling the text a fragment, in contrast to the following line:

$$\kappa a \grave{\iota} \ \pi o \theta \acute{\eta} \omega \ \kappa a \grave{\iota} \ \mu \acute{a} o \mu a \iota \ . \ . \ . \ .$$

<div align="right">(p. 18, no. 8).</div>

Because the line consists of two verbs ("to long" and "to be eager for") in the first person and each is preceded by the same conjunction or adverb ("and"/"also"), I make sense out of what I see, but the sense seems incomplete to me because of my assumption that the beginning of the action (the first person) and the middle (the verbs) ought to be provided with an end (an object) which is not there: the speaker tells me that he or she is longing and eager, and I should accordingly expect some mention of the object of his or her desire. Since the critical apparatus also tells me that several letters are missing after the second verb, I suspect that these originally conveyed the information whose absence bothers me, and I accordingly classify the piece as a fragment. Nevertheless, I must recognize the possibility that the missing letters may have had nothing to do with the extant words, that the contiguity may have been purely fortuitous, and that my classification may accordingly be unwarranted. It is significant in this respect that one of our finest translators seems to have had no difficulty in supplying an English equivalent for what he presumably considers an implied object in the Greek text, and accordingly rendering the piece as a whole poem under the title of "Ungiven Love":

> I am dry with longing
> and I hunger for her.[5]

This interpretation has by no means changed my mind, but it illustrates the fact that a given piece of writing may exhibit all the earmarks of a fragment and still leave room for argument.

Very much in the same manner, a piece of writing may appear now as a whole and now as a fragment to the very same reader without his or her ever shifting standards. The original conclusion of *Great Expectations*, for example, was clearly not a fragment until Dickens scrapped it and replaced it by the happier and less believable conclusion with which most readers are familiar today. Yet, from the instant it was discarded, it be-

came, as if by decree, a fragment deprived of both a beginning and a middle. Regardless of the circumstances, a substantial, though regrettably undetermined, portion of the presumed whole must be believed missing before we call the remainder a fragment. Every professional student of English knows that the only extant manuscript of *Beowulf* was so damaged by fire in 1731 that many words near the edges have subsequently become lost to us, but nobody would call the poem a fragment. In contrast, specialists in Old English will recall that folio 129^b of the *Exeter Book* has been so eaten by the worms that the poem known as "Riddle 89," which would print ten lines of verse in a modern edition, consists of only nineteen scattered words and diminutive bits of four more; we accordingly have no hesitation in calling it a fragment. Moreover, the process whereby we have reached our decisions about these three texts is similar to that which I illustrated earlier in respect to sculpture: whereas we have assumed that Dickens did not intend his discarded conclusion to be read by itself and that the author of "Riddle 89" had words where there are now worm holes, we have also assumed that the scop who composed the extant version of *Beowulf* intended it very much as it now stands. In other words, our decision to call one text complete and the others fragmentary has been made largely on the basis of our subjective perception of a context which includes the underlying assumption that the wholeness of a work of literature depends upon the extent to which the action therein conforms to the author's presumed intention. This principle explains why we do not call Homer's *Odyssey* and Zola's *La Bête humaine* fragments, although the former accounts for only a fragment of the Trojan cycle and the latter accounts for only a fragment of the story of the Rougon-Macquarts.

Plot and Form

In calling attention to perfectly obvious facts, my aim has been to emphasize our concern with plot and to suggest by implication our relative disregard of form. Modern apprentice writers setting out to compose a tragedy would probably agree with the Monk of *The Canterbury Tales* that they must produce "a certeyn story . . . of hym that . . . endeth wrecchedly" (ll. 1973-77), but they would almost certainly balk at the immediately subsequent statement that the stories in question "ben versified communely" (l. 1978). In contrast, earlier stages of our culture displayed what may well seem to the more liberated spirits among us an obsession with form, as illustrated in Ovid's facetious account of the circumstances that led him to write the *Amores:* he was about to compose a poem on arms and warlike deeds (1.1.1-2),[6] when, "it is said, Cupid began to laugh and stole a foot on the sly" (risisse Cupido / Dicitur atque unum surripuisse pedem—1.1.3-4); thus deprived of the appropriate metrical form, the poet had no choice but to give up his heroic project and write about love instead (1.2.19-53). Likewise, anyone who has read a little

outside the mainstream of recent American and Western-European literatures knows that this concern with the relationship between form and content must not be thought endemic to any single place and time and that our own way of looking at literature may not necessarily be the only legitimate one in the world.

The Oral-Formulaic Theory

One of the ways in which other cultures look at literature seems especially relevant to our understanding of the nature of fragments because it offers a criterion other than the presence or absence of the beginning, middle, and end of the plot of the story. This way may best be understood from the point of view of what anthropologists, folklorists, linguists, and medievalists are wont to call "the theory of oral-formulaic composition." The principles involved were first hinted at by Johannes Kail in 1889, developed and tested in the field between the two world wars and thereafter by Milman Parry and later Albert Lord with respect to both Homeric Greek and South-Slavic traditional poetry, and applied to Old English by Francis Peabody Magoun in the early 1950s. Since 1960 and the publication of Lord's *The Singer of Tales*, a veritable swarm of studies has elaborated upon the theory and applied it to almost every language and period of history taught at American universities.[7] Contrary to the earlier view that oral composition was by definition the province of quaint but unsophisticated rustics whose shapeless utterances were doomed to remain in the embryonic stage until the day when the advent of literacy might give them the chance to expand into a respectable art, the theory argues that oral literature is a completely separate phenomenon with a sophisticated rhetoric of its own and that its bibliography includes many recognized masterpieces which ought accordingly to be examined in the light of critical canons radically different from those which we apply to written literature. Since most aspects of the theory have been tested empirically against the actual performances of living oral poets composing in languages as different from one another as Serbo-Croatian and Bantu, the only really theoretical part thereof is the possibility that certain anonymous works may have been composed orally rather than in writing as was previously believed. Although the most rudimentary test tells us that the *Odyssey* and *Beowulf* were composed according to oral-formulaic principles, no test yet available has been able to demonstrate whether the authors of these works composed pen in hand or gave oral performances which were recorded by scholars as, according to the Venerable Bede, seems to have been the case with Caedmon's poetry.[8] The only thing that is certain is that the proponents of each alternative have entertained the philological world with years of lashing out at each other, both orally and in writing.

For the present purpose, we need only consider the fundamentals of

the theory, according to which the fully trained oral poet in the European tradition normally controls a stock of extremely flexible paradigms which function at three essentially different but mutually supportive levels of composition and enable him to produce on the spot poems of various lengths with a controlled structure. He has at his disposal (a) *metrical paradigms* which make it possible to turn practically any sentence or part thereof into a proper verse, (b) *themes* which make it possible to select and organize verses into coherent narrative units often called type-scenes, and (c) larger *traditional topics* which make it possible to select and organize individual themes into an entire story whose duration may be adjusted to the expectations of the audience. Since these paradigms came to be labeled formulaic because they were repeated, we may assume that the normally intended audience would be attuned to these paradigms and accordingly sensitive to such elements as may be missing in a given performance, although those elements may have absolutely nothing to do with the plot. The corollary is that a text which seems quite complete according to the standards of written composition may prove an obvious fragment within the oral-formulaic context and vice versa, as the following examples will illustrate.

Oral-Formulaic Whole and Fragment

From the point of view of a modern reader, the following excerpt from Matthew Arnold's *Sohrab and Rustum* consists of two complete statements telling us that one person spoke and another threw a spear instead of answering:

> He spoke; and Rustum answered not, but hurled
> His spear. . . . (ll. 399-400)[9]

Such is not the case, however, from the point of view of oral-formulaic composition as we find it attested in Old English poetry. Here, the practice of beginning a verse with the statement that someone spoke is so common that Jess Bessinger's monumental *Concordance to the Anglo-Saxon Poetic Records* lists forty-three instances of it, but what is significant for the present argument is the ways in which these differ from Arnold's initial line: All of them identify the subject of the verb by name in the first hemistich, thirty fill the second hemistich with an appositive that specifies either the speaker's identity or the circumstances under which he or she is speaking, eight do the same thing with a variation on the statement in the first hemistich, and five repeat the process with a statement as to whom the speaker addresses himself or in what manner he does so; but not a single one of them shifts the point of view to the interlocutor's reaction, which must wait its turn until the beginning of a new metrical unit. Were I to come upon Arnold's line in an Old English text, I should find it lacking the speaker's name in the first hemistich as well as

the expected information in the second; I should accordingly call it a verse fragment and probably blame the fact on scribal ineptitude. Conversely, modern students coming to Old English without previous knowledge of oral-formulaic techniques tend to question the presence of what they consider superfluous information in the second hemistich of verses telling us that someone is speaking.

The same principle applies to larger topics as well. Much as Erich Auerbach has taught all of us to cherish the scene in which Eurycleia recognizes the scar of Odysseus, most readers of the *Odyssey* would be at a loss to produce a logical reason for the disguise assumed by the hero when he returns to his home in Ithaka. Surely, Athena's argument does not hold when she says that his looks must be changed so that nobody may know him as he prepares to massacre the suitors. Common sense reminds us that he has been twenty years away, so that no one is likely to recognize the young man who left long ago in the middle-aged man who has now returned, especially as the suitors whom he wishes to take by surprise are themselves young men who must have been mere boys when he left for Troy, and the hardships which he endured at a time when the restoratives of modern medicine were not there to ensure eternal youth must have taken a sufficient toll to render him unrecognizable even to his closest friends. However felicitous Homer's treatment may be, modern logic must declare it superfluous to the action of the poem. In contrast, we have no such problem with logic when we consider the poem from the oral-formulaic point of view, for the *Odyssey* is a treatment of an oral-formulaic topic known as the hero's return, and treatments of this topic are normally expected to include the theme of the hero's disguise.[10] In other words, just as Old English poets might appropriately react to a hypothetical query about superfluous materials in the second hemistich by saying that this is the way one constructs a verse about someone who speaks, so Homer might appropriately react to a hypothetical query about Odysseus' superfluous disguise by saying that this is the way one composes a poem about the return of a hero. By the same token, an audience well trained in the ways of oral-formulaic narrative would expect the returning hero to assume a disguise whether he needs it or not, and they might well pin the label of a fragment upon a version lacking the theme which our logic considers superfluous.

Whether the narrative consist of only a few words (someone spoke and. . .), as in the case of *Sohrab and Rustum* and the Old English verses, or of twenty-four books, as in the case of the *Odyssey*, the examples given above illustrate a fundamental difference between our concept of what a fragment is and the oral-formulaic concept of the same thing. Whereas the former considers the plot of the story from the point of view of modern logic, the latter considers elements whose presence is required by the form rather than by the plot and which may accordingly seem logically superfluous to us. By the same token, a piece of literature which we would consider a fragment because it lacks part of the plot of the story

might be considered a whole from the oral-formulaic point of view if it included the elements required to form the paradigm of its narrative unit. This process is particularly detectable at the level of the theme: unlike the story, whose development may require thousands of lines, the theme is usually expressed within a small compass which makes for easy analysis; unlike the verse, whose meaning and grammatical coherence most often depend on other verses that precede or follow, it enjoys a kind of structural and narrative independence from its environment.[11] The medieval German *Hildebrandslied* is a case in point, and even the briefest look at it from the point of view of oral-formulaic theme composition will suggest the critical implications.

The Case of the *Hildebrandslied*

The *Hildebrandslied* prints fewer than seventy lines in a modern edition, but its prominence as the earliest extant heroic poem of Germany has provided ample warrant for making it the subject of innumerable historical, philological, and literary studies conducted with unabated vigor from the nineteenth century to the present. One of the side effects of this attention has been to earn it such an unchallenged reputation as a masterpiece that one of the most respected German literary scholars has felt free to call it "die Krone unsrer germanischen Dichtung" and that a British counterpart has recently awarded it "an undoubted Alpha."[12]
Yet even the most fervent admirers of the poem are wont to accept the common view that the only known manuscript text is a fragment which does not lend itself to thorough critical evaluation because it lacks a conclusion to the action; and a number of editors and translators have taken it upon themselves to remedy this deficiency by providing conclusions of their own. As the barest outline will show, the action clearly lacks the kind of conclusion which our standards have led us to expect: *Two warriors named respectively Hildebrand and Hadubrand meet alone between two armies. In answer to the former's inquiry, the latter says that he is the son of Hildebrand, who long ago left his wife and infant child to follow Dietrich von Bern in exile and who must now be dead. Realizing that he is facing his own son, Hildebrand tries to make peace by offering him precious rings, which the other refuses insultingly. Hildebrand then comments on Hadubrand's fine armor, and the text comes to an end with the two warriors locked in mortal combat.*[13] From the point of view of an audience concerned with the plot of the story, the narrative is sadly incomplete insofar as its failure to account for the outcome of the combat leaves us waiting for a resolution that never comes. Inasmuch as literary historians know that there is indeed a conclusion to the episode because references in the Old Norse *Asmundarsaga Kappabana* and Saxo Grammaticus' *Gesta Danorum* assure us that the son is killed by the father, the temptation to call the poem a fragment is nearly irresistible.

But the text of the *Hildebrandslied* reveals an extremely high density of oral-formulaic elements and may accordingly be supposed to have been composed according to principles vastly different from those of modern written literature. As it is an earlier version of the Persian story which Arnold adapted into his *Sohrab and Rustum*, the juxtaposition of the English verse already discussed ("He spoke . . . ") to its approximate counterpart in the German will enable us to infer the extent of that difference: "Hiltibrant gimahalta, Heribrantes suno" (45 [a-b] —Hildebrand spoke, the son of Heribrand). Not only does the German convey information omitted in Arnold's verse, but, in so doing, it conforms precisely to the most frequently attested of the oral-formulaic verse paradigms mentioned above in connection with the English poem. For the present argument, however, the important fact is that the text of the *Hildebrandslied* as it now stands happens to conform likewise to the paradigm of one of the best known and most thoroughly studied oral-formulaic themes of Germanic literature. The point becomes evident when we superimpose the paradigm in question on the outline of the poem: *A hero* (Hildebrand) *in the presence of his companions* (the men in the same army with him), *between two different environments* (Hildebrand's army on one side and Hadubrand's on the other), *at the beginning or end of a journey* (Hildebrand has been following the wanderings of Dietrich von Bern and has only now reached the place of the meeting), *notices a shining object* (Hadubrand's armor). Since the poem comes to an end with the beginning of the combat but before the father kills the son, it is relevant that the theme outlined above almost always occurs immediately before the mention or actual account of some kind of killing.[14] In other words, fragmentary though the *Hildebrandslied* may seem from the point of view of the plot of the story, it need not be considered so imperfect as Johnson assumed fragments to be. Precisely because of what it does not tell us, it constitutes the embodiment of a complete oral-formulaic theme and may accordingly be considered as much of an independent entity conforming to its author's intention as the hypothetical bust which I invoked at the beginning of this essay. In keeping with the proper form of the theme which it embodies, it breaks off without telling us how Hildebrand will fare in the combat that has only begun, very much as the *Odyssey* breaks off without telling us how Odysseus will fare on the land journey he is about to take with an oar on his shoulder.

As I tried to hint in the title of this essay, my intention has not been to formulate a definition of the term *fragment* from an oral-formulaic point of view, but rather to show that our usual definition may occasionally prove inadequate when applied to the critical interpretation of literary works not composed here and now in our own language. In view of the bulk of oral-formulaic literature which has come down to us from the past and is still being composed in various parts of the world, the eclectic critic may occasionally find it worthwhile to know that a fragment in

London, New York, or Paris today might well have been a whole in archaic Greece or medieval Germany and still be considered as such in certain parts of Yugoslavia today.

Notes

1. Stanley E. Fish, "Literature in the Reader: Affective Stylistics," *New Literary History* (1970), 2:140.
2. Norman N. Holland, *Poems in Persons* (New York: Norton, 1973), p. 100.
3. Citations from Chaucer are from *The Works of Geoffrey Chaucer*, 2d ed., ed. F. N. Robinson (Boston: Houghton Mifflin, 1957).
4. Citations from Sappho are from *The Fragments of the Lyrical Poems of Sappho*, ed. Edgar Lobel (Oxford: Oxford University Press, 1925).
5. Willis Barnstone, ed. and trans., *Sappho: Lyrics in the Original Greek with Translations* (Garden City, N.Y.: Doubleday, 1965), p. 71.
6. Citations from Ovid are from *Ovid: die Liebeselegien*, ed. Friedrich W. Lenz (Berlin: Akademie-Verlag, 1966).
7. Johannes Kail, "Über die Parallelisten in der angelsächsischen Poesis," *Anglia* (1889), 12:21-40; Milman Parry, *L'Epithète traditionelle dans Homère* (Paris: Les Belles lettres, 1928) and *Les Formules et la métrique d'Homère* (Paris: Les Belles lettres, 1928), with posthumous English versions in Adam Parry, ed., *The Making of Homeric Verse* (Oxford: Oxford University Press, 1971); Albert B. Lord, "Homer and Husso II: Narrative Inconsistencies in Homer and Oral Poetry," *Transactions of the American Philological Association* (1938), 69:439-45, and *The Singer of Tales* (Cambridge, Mass.: Harvard University Press, 1960); Francis P. Magoun, Jr., "The Oral-Formulaic Character of Anglo-Saxon Narrative Poetry," *Speculum* (1953), 28:446-67. A particularly informative analytical account of the history and state of oral-formulaic studies will be found in the introduction to John Miles Foley's editions, *Oral Traditional Literature*, (Columbus: Slavica Press, 1980), pp. 236-54.
8. *Bede's Ecclesiastical History of the English People*, eds. Bertram Colgrave and R. A. B. Mynors (Oxford: Oxford University Press, 1969), 4(24), 416-19.
9. Matthew Arnold, *Sohrab and Rustum*, in *The Poems of Matthew Arnold*, ed. Kenneth Allot (London: Everyman's Library, 1965), pp. 302-31.
10. See, for example, Lord, *Singer*, p. 121.
11. Ibid., p. 94, for example.
12. Georg Baesecke, ed., *Das Hildebrandlied* (Halle: Niemeyer, 1945), p. 7, and A. T. Hatto, "On the Excellence of the *Hildebrandslied:* A Comparative Study in Dynamics," *Modern Language Review* (1973), 68:837.
13. Citations from the *Hildebrandslied* are from the text in Wilhelm Braune, ed., *Althochdeutsches Lesebuch*, rev. Karl Helm (Halle: Niemeyer, 1949), pp. 72-73.
14. The theme outlined here was first identified by David K. Crowne, "The Hero on the Beach: An Example of Composition by Theme in Anglo-Saxon Poetry," *Neuphilologische Mitteilungen* (1960), 61:362-72; the outline provided here is based on my own elaboration upon Crowne's essay, in "Oral-Formulaic Theme Survival: A Possible Instance in the *Nibelungenlied*," *Neuphilologische Mitteilungen* (1964), 65:70-75. The oral-formulaic nature of the *Hildebrandslied* was pointed out by Edward R. Haymes in his "Oral Poetry and the Germanic *Heldenlied*," *Rice University Studies* (1976), 62(ii): 47-54. Detailed supporting evidence for the arguments which I can only sketch here will be found in my "The Armor of the *Hildebrandslied:* An Oral-Formulaic Point of View," *Neuphilologische Mitteilungen* (1977), 78:389-95; "The English Connection Revisited: A Reading Context for the *Hildebrandslied*," *Neophilologus* (1979), pp. 84-87; "The Kassel Manuscript and the Conclusion of the *Hildebrandslied*," *Manuscripta* (1979), 23: 104-08; and "Germanic Quintessence: The Theme of Isolation in the *Hildebrandslied*," in Margot H. King and Wesley W. Stevens, eds., *Saints, Scholars, and Heroes: Studies in Medieval Culture in Honour of Charles W. Jones* (Collegeville, Minn.: Saint John University Press, 1979), 2:143-78.

PART 2

THREE RHETORICS OF DISCONTINUITY: RABELAIS, MONTAIGNE, AND DIDEROT

5

Rabelais's Splintered Voyage

LAWRENCE D. KRITZMAN

The ostensible purpose of the Pantagruelists' journey in Rabelais's *Quart Livre* is to consult the Oracle of the Holy Bottle to determine Panurge's matrimonial fate.[1] Despite the fact that the voyage is teleological in nature, Panurge's companions never reach their proposed goal, and instead, take endless detours to islands inhabited by grotesque characters. These encounters have little bearing on the quest for the sought-after answer. In fact, Panurge's peregrinations have no evolution and they ultimately interfere with the shaping of a tightly knit narrative fabric. The voyage thus becomes a series of delays in which the absence of a final destination disrupts the conventions of logical sequence and closure.

The episodic framework of the *Quart Livre* confronts the reader with a large number of juxtaposed sequences, often containing descriptions of prismatic worlds; each constitutes a self-contained "island fragment," dealing with a different set of characters or actions, and surpassing the narrative continuity stressed in the preceding books.[2] In an attempt to undermine the noncontingency of linear discourse, Rabelais invented a loose-shifting narrative with an open structure that authorizes digressions

and textual excrescences. The fragmentation of episodes creates a textual mosaic in which each tableau is seemingly denied any necessary link with what precedes it and what follows. However, because there are within the text multiple beginnings, narrative progression from one "island fragment" to the next creates the impression of the gratuitous mobility of the whole.[3] The parameters of Rabelais's scriptural map are rendered amorphous by a textual voyage that transcends the limits of a finite narrative space.[4] In short, the book demonstrates a long suspension of closure; there is ostensibly no reified end in view of which the narrative may be consumed.

The *Quart Livre* is indeed a satire in the true etymological sense of the word: *satura*, a salad, a medley, a mixture of disparate elements.[5] Any underlying coherence that may be derived from the sea voyage *topos*, is permutated by long and short episodes recounting visits to surrealistic islands, by stories within stories, by word lists such as the 212 features of *Quaresmeprenant* (Lent Observer) or the 138 dishes offered by the *Gastrolatres* to their God.

In this essay I shall discuss the following aspects of Rabelais's fragmentary writing: (1) characterization; (2) book division; (3) storytelling; and (4) the *copia verborum*. I will illustrate how various chapters or parts of chapters exhibit a kind of cellular isolation from a larger whole. My reading of Rabelais's *Quart Livre* will not be a simple journey through it in search of a final product (story, representation, sense), but rather a response to the author's use of fragments of knowledge as the instrument by which he introduces into literature the plurality and diversity of cultural discourse.

Prismatic Worlds

Rabelais's *Quart Livre* may be regarded as an encyclopedia of the grotesque. Many of the islands' inhabitants possess a single dominant trait, a social eccentricity that isolates them from the rest of humanity.[6] For the most part, they act out roles which become outlets for the indulgence of their insatiable egotistical appetites. Each grotesque creature is victim of an *idée fixe* that predetermines his behavior, that transforms characters into one-dimensional puppetlike beings whose imperfections take the form of satirical portraits.

On the island of *Procuration* ("sentence-serving"), Pantagruel visits the *Chicquanous* ("Catchpoles") who earn their living by seeking quarrels and being beaten up by angry defendants against whom profitable actions are brought for assault. Rabelais not only presents a reverse satire of legal procedure, but he also makes clear the *Chicquanous'* feverish greed for money.

[Frère Jean asks] Qui veut guaingner vingt escuz d'or pour

estre battu en Diable?—Io, io, io, respondirent tous. Vous nous affollerez de coups, monsieur, cela est sceur. Mais il y a beau guaing.[7]

The emphatic repetition of the utterance "Io, io, io" reveals the extent to which egocentric desire operates and becomes the *modus vivendi* that institutes imprisonment on the island of the self. The bailiffs' behavioral automatism—created in part by the exaggerated passion of their utterances—reveals how they are manipulated by an unsatisfied pecuniary greed that culminates in self-destruction.

In the episodes recounting the visit to the Island of Tapinois, Rabelais describes its ruler *Quaresmeprenant* ("Lent Observer"), whose unnatural abstinence transforms him into "une estrange et monstrueuse membreure d'home, si [says Pantagruel] home le doibs nommer" (135).[8] Unlike Rabelais's other satirical portraits in which the characters' obsessions are defined by their actions and verbal dynamics, Quaresmeprenant's caricature emerges instead in a lengthy description of his physical and moral attributes spoken by another, Xenomanes, who enumerates a catalogue-like series of similes that portray Quaresmeprenant's grotesque anatomical features as parts of a dismembered whole:

> Les orteilz avoit comme une espinette orguanisée.
> Les pieds, comme une guinterne.
> Les jambes, comme un leurre.
> Les genoulz, comme un escabeau. (130)[9]

Quaresmeprenant's self-denial goes beyond the moral perversion and rigidity reflected in the character's physical anormality; negation reveals itself in gratuitous behavior that is totally useless. The search for things that cannot be leads to nothingness and isolation: ". . . travailloit rien ne faisant, rien ne faisoit travaillant" (134).[10]

When the Pantagruelists arrive on the isle of the Papimanes ("Papimaniacs"), they are greeted by religious idolaters who live only to see the pope. "Le avez-vous veu, gens passagiers? l'avez vous veu?" "Qui?" demandoit Pantagruel. . . ."ne cognoissez vous l'Unicque?" (179)[11] And shortly thereafter we learn that "l'Unicque" is the pope, the *quasi Deus in terris* (180) whose invisible power determines the field of vision of the Papimanes who see only what they wish to see.[12] And when Panurge claims that he has seen three popes, the absurdity of the Papimanes' behavior is illustrated by the fact that had *they* been allowed to view the pope, they would have been mesmerized and kissed his "cul sans feuille, et les couilles pareillement" (180).[13] In short, the proper yet invisible object of worship—the Supreme God who rules in the heavens—has been superseded and replaced by a more temporal power.

The Papimanes are governed by Bishop *Homenaz* ("Stoutmoron") who worships both the pope and the sacred Decretals, books of papal

ordinances in reply to questions addressed to the Holy See. Homenaz'
hyperbolic praise of these epistles illustrates dramatically the degree to
which he is victim of an abstract fanaticism that transforms religious zeal
into uncontrollable fantasy, reality into the lyrical euphoria of fiction.

> O seraphicque *Sixiesme!* . . . tant vous estes necessaire
> au saulvement des paouvres humains!
> O cherubicques Clementines! comment en vous est proprement
> contenue et descripte la perfaicte institution du vray
> Christian!
> O *Extravaguantes* angelicques, comment sans vous
> periroient les paouvres ames,
> les quelles, ça
> bas, errent par les corps mortelz en ceste vallée de
> misere!
>
> .
>
> .
>
> .
>
> Mais, o grande doctrine, inestimable erudition,
> preceptions deificques, emmortaisées par les
> divins chapitres de ces eternes Decretales! (190-91)[14]

The "supposed" book of truth realizes the impossible in the utopia of
the mind.

Rabelais engages in a caustic religious satire against the Vatican in
chapter 53 where Homenaz ironically praises the power of decrataline
law to subtly draw gold out of France and direct it to Rome. The bishop
legitimizes this unscrupulous greed and transforms petulance into the
anger of the righteous against sin, selfishness into religious duty, innate
narcissism and self-interest into lofty detachment from things of the
world. The hypocrisy of the papacy in its quest for material gain under-
mines whatever possible "moral" precepts might be found in the Decretals,
and paradoxically makes them objects of ridicule.

Homenaz' censorious attack on those who condemn the Decretals—
the heretics—translates abstract bigotry into a frenzied enumeration:

> Encores ces diables haereticques ne les voulent aprendre et
> sçavoir. Bruslez, tenaillez, cizaillez, noyez, pendez, empallez,
> espaultrez, demembrez, exenterez, decouppez, fricassez, grislez,
> transonnez, crucifiez, bouillez, escarbouillez, escartelez, debe-
> zillez, dehinguandez, carbonnadez, ces meschans Hereticques
> Decretalifuges, Decretalicides, pires que homicides, pires que
> parricides, Decretalictones du Diable. (197)[15]

If indeed Homenaz wishes to protect the faithful from the heretics, it is
so that he may have more power over the "true believers" and isolate

them from social and religious differences. The moral system of the Papimanes thus becomes a closed circle incapable of being penetrated by logic and diversity of thought; the constraints of the singular obliterate the contradictions of the plural: ". . . je vous supplie à joinctes mains ne croire aultre chose, aultre chose ne penser, ne dire, ne entreprendre, ne faire, fors seulement ce que contiennent nos sacres Decretales et leur corollaires" (197).[16]

The Gaster chapters (57-62) constitute another "closed" universe which illustrates the *topos venter auribus caret.* The *Gastrolatres* who inhabit this autonomous island worship their master *Gaster* ("Sir Stomach") as a God, and live only to fill their paunches. Rabelais's concern here is to satirize the Gastrolatres' gluttony and to portray the omnipotence of their appetites as the ultimate abuse of Pantagrueline moderation. Although Gaster, inventor and creator of mankind's technology, is regarded as a beneficial influence, his subjects, on the contrary, provoke disdain. The Gastrolatres are described as idle "do-nothings" who avoid work at any costs and whose every action is motivated "tout pour la trippe."

Rabelais's transfiguration of the real world produces insular figures who appear as deformed representations of the moral and religious perversions that threaten society. The pathological appetites of these character types reveal the greed that motivates their behavior and contrasts strikingly with the concepts of health and moderation proposed in the prologue: "Mediocrité a esté par les saiges anciens dicte aurée, c'est-àdireprecieuse, de tous louée en tous endroictz agréable" (14).[17]

In portraying immoderate behavior Rabelais illustrates how the aspiration towards an absolute belies reason and good sense. Within the text, an island is a refuge for a particular mania; it is a separate little world, a cellular community unaware of the "otherness" existing outside the confines of its own territory. The narrative segments under scrutiny are fragments of a universe where fantasy reigns. Each encounter constitutes a differential rewriting of a particular case of obsessive antisocial behavior; in each we recognize the others. Every textual "detour" establishes its nonprimary originality by elaborating a principle of repetition, where repetition does not imply identity but rather alterity. The *Quart Livre* is founded on the play of a series of variations on the theme of excess: the Chicanous can only be happy if they are beaten; Quaresmeprenant is hopelessly rigid in his self-abstinence; the Papimanes see only that which is invisible; and the Gastrolatres live for gastronomic pleasure alone. These characters are one-dimensional, incomplete, and incapable of evolution; their likes and dislikes are partial and unique. In these episodes, then, the Pantagruelists witness characters who are exiled in worlds unto themselves, autonomous communities where singularity forces these scriptural creatures into the benumbed lifelessness of mental imprisonment and oppression. The space of the journey thus symbolizes the separateness that divides the phenomenal world into differentiated noncontingent entities that act only according to their own parochial laws.

The construction of the *Quart Livre* represents an activity of literary bricolage, a handful of novelistic fragments which constitute a fabric knit from a multitude of strands. The sixty-seven chapters in the book form twenty episodes of which eight come to dominate: Dindenault (four chapters); the Chicanous (five); the tempest (seven); Quaresmeprenant (four); the Andouilles (eight); the Papefigues (three); the Papimanes (seven); and Gaster (six).

The external configuration of the *Quart Livre* is episodic.[18] As we have seen, a good part of the narrative is devoted to the description of the behavior and actions of the characters encountered in the prismatic worlds. More often than not, the action that takes place in these lands is self-contained and ultimately has nothing to do with the outcome of the quest. Furthermore, although the *Quart Livre* demonstrates no overall sense of closure, individual episodes do. Beginnings and endings of episodes have much in common since both are disjunctions in an apparently continuous sequence of events. External narrative division may not simply be determined by movement from one chapter to the next; instead, the chapters that frame the sustained sequences splinter the book into fragments which have little or no connection with past or future events. One needs only to examine the narrative development of the first nine chapters of the text to comprehend their discontinuous arrangement.

Chapter 1 begins with the Pantagruelists' departure to visit the Oracle of the Holy Bottle. From the start, we are told that Xenomanes had left with Gargantua his great and universal hydrographical chart, a fact that indirectly points to the inevitability of an endlessly truncated narrative itinerary. The second chapter, recounting the visit to the island of *Medamothi* ("Nowhere"), foreshadows the nonexistent pretexts for many of the subsequent episodes: the wind gusts and the travelers suddenly find themselves in sight of an unknown island—they thus have an excuse to stop and visit. No sooner does the journey begin once more when Rabelais again interrupts the narrative. Chapters 3 and 4, containing two Ciceronian letters exchanged between Gargantua and Pantagruel as well as a learned disquisition on carrier pigeons, act as narrative divergences in the context of the pseudoepic, discrete units situated within the intradiegetic mode. Ironically enough, the book which should relate the dynamic movement of an adventure story falls victim to its own narrative inertia.

The meeting between Panurge and the sheep merchant Dindenault in chapters 5 through 8 is arbitrarily motivated: "Au cinquième jour, ja començans tournoyer le pole peu à peu . . . descouvrismes une navire marchande faisant voile à horche vers nous" (47).[19] And once Panurge has finished playing his nasty trick on Dindenault, we are left with the impression that the action in the episode can no longer continue. "Retirons nous," cries Panurge.[20] At the start of the visit to the island of Ennasin, the reader is signaled that this episode is indeed a new beginning,

another spatial displacement which propels the narrative beyond the confines of one specific locus. "Zephyre nous continuoit en participation d'un peu de Garbin, et avions un jour passé sans terre descouvrir. Au tiers jour . . . nous apparut . . . l'isle Ennasin" (59).[21] In the epic convention, the wind's force assures narrative continuity, but the filling of the sails with air in the *Quart Livre* engenders disruption and excludes any hope of reaching the *Dive Bouteille*.

The succession of landings appears to be haphazard—it neither adheres to linear pattern nor contributes to the overall development of the book.[22] Thus each time something new is sighted the voyage is deflected and another adventure begins; recognition of a ship at sea or a newly discovered land serves as pretext for a new beginning that signals the closure of the preceding sequence. Most often, episodes begin with an arrival and end with a departure. The opening lines of a tale propel the narrative to a different milieu, each time affording the reader new landscapes, a different set of characters, and more eccentric routines. One might envision a maritime space contiguous to each episode, separating one series of *tableaux* from another, connecting beginnings and endings in a non-Aristotelian manner.

Many of the episodes in the *Quart Livre* could conceivably be displaced without interrupting narrative syntax. For example, the classic epic storm scene (chapters 18-24) is unjustifiably situated between the visit to the isles of Tohu and Bohu ("Vacuum" and "Void") and the sojourn on the isle of the Macraeons. Even though both episodes contain discussions of the way in which men die, there is no direct structural relationship established between them; in fact their sequential order could be reversed without disrupting the progression of the narrative. The storm scene might better follow the calm at sea (chapters 64-65) where the Pantagruelists compete *haulser le temps* (to pass time or to make the wind rise). Yet the order of these sequences forces us to view the storm scene as just another isolated fragment—an island—within the narrative. The description of the huge mounting waves at the beginning of the sequence has the direct effect of creating another break in the text's narrative thread. "Soubdain la mer commença s'enfler et tumultuer du bas abysme; les fortes vagues batre les flans de nos vaisseaulx" (94).[23] And the account of the storm ends—although a discussion of it ensues between Panurge and Frère Jean—just as the others do: " 'Terre, terre,' s'escria Pantagruel, 'je voy terre! . . . Je voy le ciel . . . commence s'esparer' " (105).[24]

Throughout the text Rabelais teases the reader by his refusal to explicitly formulate the motives for the direction the Pantagruelists' journey takes; the boundless voyage across the textual sea frustrates the reader's desire to understand why episodes appear where they do. Rabelais's text is troubling because the continuity we expect to find in it is missing; thus we are forced to read the book without recognizing the direction it is taking. In short, the journey progresses and yet it remains unfinished; although

daylight almost never ceases, time moves on as the travelers pass from one prismatic world to the next.

Storytelling

The internal structure of the episodes in the *Quart Livre* is both disjointed and digressive. In the various tableaux we discover what Floyd Gray terms a "book within a book," embedded stories or anecdotes drawn from either classical sources or from the personal lives of the characters.[25] Rabelais's created persona, the narrator "François Rabelais docteur en Medicine," exhibits an inability to stick to the main plot of individual episodes due to his multiple interruptions and disregard for the general flow of the book. Moreover, unlike Rabelais's earlier books where the characters function both as participants in the action and as raconteurs, the characters in the *Quart Livre* spend more time listening to and narrating stories; Pantagruel has no less than thirteen stories to tell.[26] The account of the journey is deliberately sidetracked and deferred by character-narrators *(homme-récits)* who substitute conversation for travel. In chapter 11, for example, it becomes clear why Glauser aptly labels Rabelais's journey an anti-voyage.[27] The episode which takes place on the isle of Cheli constitutes a story session and not a detailed description of what the travelers encounter in that land. In fact, a short time after the Pantagruelists' arrival, Pantagruel excuses himself on the grounds that the weather is calm and the winds favorable. On their return to the ship, instead of hoisting the anchor and preparing for departure, the characters spend the time in responding to Frère Jean's remark "Que signifie . . . que tousjours vous trouvez moines en cuysines?" (68)[28]

> "Est ce," respondit Rhizotome, "quelque vertus latente
> et proprieté specificque absconse dedans les
> marmites et contrehastiers, qui les moines y attire . . .
> "Je vous diray," respondit Pantaguel. . . . "Me soubvient
> avoir leu que Antigonus roy de Macedonie . . .
> "Je dameray cesty cy," dist Panurge, "vous racontant ce
> que Breton Villandry respondit un jour au seigneur
> duc de Guyse." (68-69)[29]

The transition from one anecdote to another is in principle effected by the act of narration which makes the reader conscious of the shift to another degree of fictionality. Each character's intervention announces a stop in the story flow, a break which sets the text off on a new course and which endlessly jolts the reader out of a previous encompassing frame. Accordingly, these tales splinter the voyage into a series of independent narratives that betray Rabelais's wholesale pillaging of secondary material.
As early as the prologue to the *Quart Livre* the reader witnesses a

cropping together of tales in which the transition from one story to the
next is not explicitly articulated. Rabelais's prologue contains five seem-
ingly unrelated narrative units:

A. The author-narrator's personal story about his vision problem
 and the necessity of good health. In this unit the narrator tells
 two anecdotes: (1) Zacchaeus' prayers to see the Lord, with its
 moral about moderation and (2) the anecdotes of the prophet's
 son who loses his hatchet. Time of the author-narrator as
 sole speaker; extradiegetic level.

B. The story of Couillatris's lost hatchet and his prayers to Jupiter
 for its restitution; intradiegetic level.

C. The story of Jupiter holding council on Mount Olympus; this
 story functions as a narrative pause within unit B; metadiegetic
 level.

D. Priapus' disquisition at Jupiter's court concerning the relation-
 ship between the Ramus-Galland controversy and the Fox-Dog
 incident; this discussion constitutes a story within narrative unit
 C; secondary metadiegetic level.

E. Priapus' obscene play on the word "coingnée"; this section is
 also inserted within narrative unit C; secondary metadiegetic
 level.[30]

After an introduction (unit A) in which the narrator speaks about himself
and addresses his readers directly, the narrative then passes to the primary
story (unit B) onto which secondary and tertiary stories will be grafted
(units C, D, E). Embedding these Montaignesque *farcisseures* in the primary
narrative results in the fragmentation of the scriptural space. For example,
the Couillatris story is abruptly interrupted by the story of Jupiter's
council. One story line displaces another and the resolution of narrative
unit B is left in suspense while a new story takes shape.

> "Ma coingnée, Juppiter, ma coingnée, ma coingnée;
> rien plus, ô Juppiter, que ma coingnée ou deniers
> pour en achapter une autre!" . . . "Que diable, demanda
> Juppiter, est là bas qui hurle is horrifiquement?" (16)[31]

The transition between unit B and unit C is achieved by means of narra-
tive dissolve; the reference to Couillatris' cries to Jupiter for the restitu-
tion of his lost hatchet fade out in one sequence only to reappear in the
next. As I have attempted to demonstrate elsewhere, movement from
one narrative level to the next is often characterized by spatial displace-
ment and shift in narrative voice.[32] The break in narrative flow seems el-

liptical and may be compared to the straight cut in film because of the insertion of another situational level.

Further along in the prologue a word and not a situation generates another digression. At the meeting of the gods in council, Jupiter is considering the most important cases awaiting his verdict when Couillatris' prayers for his lost hatchet once again reach his ears. Priapus' wish to know precisely just what coingnée Couillatris is in search of generates a SML, a narration (unit E) inserted within an embedded story (unit C) which takes us one step further away from the primary story (unit B: Couillatris' affairs).

> Roy Juppiter, on temps que, par vostre ordonnance et particulier benefice, j'estois guardian des jardins en terre, je notay que ceste diction, *coingnée*, est equivocque à plusieurs choses. Elle signifie un certain instrument par le service duquel est fendu et couppé boys. Signifie aussi . . . la femelle bien à poinct et souvent gimbretiletolletée. Et veidz que tout bon compaignon appelloit sa guarse fille de joye: ma coingnée. Car, avecques cestuy ferrement . . . ilz leurs coingnent si fierement(21)[33]

In this digression the ambiguity of the word *coingnée* (hatchet or woman laid on her back) produces a pause on the PML. Transition from one sequence to the next is achieved through homophonic equivocation which in turn leads to a discussion of the obscene meaning of *coingnée*.

The tortuous account of Couillatris' tale with its multiple interruptions divides the prologue into a series of "story islands," each of which is either a broken-off part of an original whole, or the fragment of another story grafted onto these textual remnants. One might conceivably describe Rabelais's activity of embedding the text with narrative excrescences as the "fold-in method": a primary story is fragmented by shorter or longer narrative passages. Almost every character whose name comes up has his own story to tell: the author-narrator, Couillatris, Jupiter, Priapus. The discontinuous narrative line—created from a complex network of intersecting texts—reflects Rabelais's refusal to honor the "closed book" form and foreshadows the internal structure of the book that follows. The author's hesitation in presenting his material brings out the partial, the fragmentary and indefinite dimension of his work.

In my analyses of the embedded stories and anecdotes in the *Quart Livre* I have found four primary mechanisms that trigger narrative detours. Many stories are *conversation* motivated; they are provoked by a question asked by one character of another or a matter-of-fact response to the stimulus of a preceding remark. When in chapter 10 Frère Jean explains his reason for avoiding the kissing ceremony at Cheli, he elicits from Pantagruel the remark "Quoy" which triggers the monk's story.

Other tales are *event* motivated, as in the case of "Comment le diable

feut trompé par une Vieille de Papefiguiere'' (chapter 47). The narrator's Balzac-like comment ''La maniere feut telle'' (178)[34] signals a shift in both time (an external analepsis) and space; it opens a new narrative frame that leads straight to an explanation of how that event came about.

A character's reference to a *learned source* also splinters the narrative through the insertion of a previously written text into the unfolding of the plot. Just as Panurge is completing the story of Basché and the Chicanous (4:16), Pantagruel interrupts with an anecdote that illustrates the subject under discussion. ''Il me soubvient, dist Pantagruel à ce propous, d'un antique gentilhomme Romain, nommé L. Neratius'' (85).[35] And in the very next chapter when the narrator reappears, he catalogues a series of strange deaths mentioned in association with the bizarre passing of *Bringuenarilles, avalleur de moulins à vent* (''Slitnose the Windmill-swallower''). In this episode the Rabelaisian text precedes by a to-and-fro movement between the present *récit* and the fragmentary remnants of a past civilization; a sea voyage becomes a scriptural odyssey, a journey through texts that recount the fables of history.

> Et estoit le noble Bringuenarilles à cestuy matin trespassé, en façon tant estrange que plus esbahir ne vous fault de la mort de Aeschylus. . . . Plus de Anacréon poëte, lequel mourut estranglé d'un pepin de raisin. . . . Plus de Philomenes. . . . Plus de Spurius Saufeius, lequel mourut humant un ceuf mollet à l'issue du baing. (89-91)[36]

The long *récit* of strange deaths transforms the land of Tohu and Bohu (Vacuum and Void) into islands of knowledge. The world is no longer traced on maps; it is inscribed, instead, in the encyclopedia of expirations that occupy the narrative space.

Another catalyst of embedded tales is the *narrator switch*—when a character described in one story suddenly becomes the narrator of yet another story. While Panurge is in the process of explaining Basché's sadistic treatment of the subpoena servers (PML), he interrupts his own tale and relinquishes the role of narrator to Basché who, in turn, recounts how Villon derived pleasure from cruelty (SML). Both Panurge's and Basché's stories are heterodiegetic in relation to the main plot as well as to each other; that is to say, they have different characters and independent story lines.

> [Panurge speaks]: '' . . . beut [Basché] avecques eulx en grande alaigresse, puy leurs dist. [Basché speaks]: ''Maistre François Villon, sus ses vieulx jours . . . ''. (74)[37]

As in the prologue, the emergence of a new narrator announces a break in the course of the narrative and temporarily curtails the rendering of the

preceding story. A frame that was heretofore considered stable—Panurge's story—turns out to be transitory. The SML ends when Panurge intervenes and brings the reader back to the PML: "Quatre jours aprées . . . Chicquanous alla citer Basché" (78).[38] Panurge's remark recalls an event from the text's past: the Chicquanous's bashing. The new material appearing here goes on developing the previously constructed frame of the PML.

The superabundance of embedded material within an extensible framework bears witness to Rabelais's attempt to widen the parameters of narrative space. To be sure, the introduction of relatively short and independent narrations does not significantly advance the voyage. Many of the episodes do not recount events related to the main plot but contain a rather high number of inserted tales and anecdotes that are independent from the intradiegetic level. Instead of acting, the character-narrators fall victim to logorrhea which obliges them to substitute an avalanche of words for suspense and drama. The long hiatuses that result from the countless stories and anecdotes that appear in the book reveal Rabelais's experimentation with the open book form. The work is built up cumulatively through the division and dispersion of embedded tales and the grafting and reframing of textual fragments present in other works.

Word Lists

Following in the tradition of Homer, Virgil, and Cato the Elder, Rabelais deploys the *copia verborum* as a narrative medium. In the *Quart Livre*, the author devotes three chapters (30-32) to a detailed description of Quaresmeprenant's anatomical features. The shift to an enumerative discourse signals a pause in the narration of fictional events and a realignment of the book's typographical disposition. Xenomanes intervenes as narrator and forces us to read Rabelais's text vertically. The description of Quaresmeprenant's body is presented as a heterogeneous list of disconnected entities, each discursive point constituting an autonomous unit which emblematizes the mechanical rigidity of the monstrous "half giant."

In a first series of enumerations Xenomanes compares the concrete anatomical features of Quaresmeprenant to corresponding sets of objects. Rabelais lays down a series of connecting wires between things not joined before; the elements brought into confrontation form a textual collage, a catalogue of discrete elements that are associative but not organic. Each simile composes a two-phased model: one gives a "realistic" description of the body in conformity with anatomy, and the other its violation in the framework of the fantastic plot. Empirical objects appear as dismembered anatomical parts. Through the power of the word, the body becomes something other than it is; and the metaphor through which it is transformed draws its objects not from parallel spheres, but from forms that distort it. Xenomanes' endless catalogue of deformities—which reminds the reader of Antiphysie and her brood—creates an almost liturgical

solemnity in its dismembering of the body.[39]

> L'estomac, comme un baudrier.
> Le pylore comme une fourche fiere.
> L'aspre artere, comme un gouet.
> Le guaviet, comme un peloton d'estouppes.
> Le poulmon, comme une aumusse. (128)[40]

A second set of similes compares disparate items that describe the mental characteristics of Quaresmeprenant; this time, however, abstract entities are deformed by concrete objects which portray that character's gloomy stupidity:

> La memoire avoit comme une escharpe.
> L'imagination, comme un quarillonnement de cloches.
> Les pensées, comme un vol d'estourneaulx,
> L'entendement, comme un breviaire dessiré.
> Le jugement, comme un chaussepied. (130)[41]

The development of the narrative is derived from the repetition and variation of a paradigmatic series of elements that is syntactically independent from what precedes and follows. The alignment of these elements vertically, into islands of similes, produces a declension of the grotesque which leaves the reader the impression of pieces rather than of an organic whole. Although the writing of the text takes shape in paradigmatic progression, it is elliptical in its play of repetition and difference. Individual fragments are not related to one another by an organizing principle of formal development; they are part of a discontinuous whole. Enumeration, as it is used here, expresses separateness rather than wholeness.

The *Quart Livre* also contains lists arranged according to what Marcel Tetel terms "un désordre organisé."[42] In the chapter that describe the *Andouilles'* ("Chitterlings") war against the Pantagruelists, Rabelais parodies the *Iliad's* Trojan horse episode and recites a list of sixty-four valiant cooks who conceal themselves inside a sow so that they may counterattack the enemy. The chefs' names are tautologically derived from various words associated with foods. The author escorts us across a scriptural battlefield where we encounter regiments of words whose prefixes and suffixes indicate membership in the same lexical infantry; the army of words is built upon a succession of echoes.[43] A collection of words disintegrates, fragments, and reappears in other forms that manifest a lyrical unconcern for accepted modes of signification.

Lardonnet,	Saulvelardon,
Lardon,	Archilardon ...
Croquelardon,	Balafré,
Tirelardon,	Gualimafré,
Graslardon,	(157)[44]

The soldiers are not merely named but rather they are signified by their metonymic function. Segments of words effect one another; the derivatives "lard" and "afré" are vertically displaced, thereby producing contiguity based on either semantic or phonological association. Each "word-fragment" stands individually as a synecdochal representation of a textual process the essence of which is the deferral of completion.

When Rabelais uses the *copia verborum* to introduce multiple personae, he provides the reader with a narrative without a plot if indeed we think of a story as a text of a succession of sentences depicting action. Character motivation as well as novelistic linearity are totally disregarded here; they are replaced by a mosaic in which characters are reduced to a series of predicate nouns emerging from the scriptural space.

In the chapters treating the festive sacrifices of the Gastrolatres, Rabelais presents the longest menu in the history of world literature.[45] The encyclopedia of foods intrudes sharply upon the limits of the textual space. Rabelais categorizes foods according to their corresponding taxonomies: breads, soups, charcuterie, meats, fruits, cakes and other sweets.

<div style="display:flex;">

Pain blanc,
Pain mollet,
Choine,
Pain bourgeoys,

Andouilles,
Saulcisses, . . .

Eschanches à l'aillade,
Patés à la saulse chaulde, . . .

Caillebottes, . . . (215-19)[46]

</div>

Although the author deliberately brings into contact highly differentiated elements in the culinary groupings, each category constitutes, nevertheless, an independent paradigm based on similarity of content and assigned order in the syntax of eating; the sequential presentation of the paradigms adheres to the grammar of the meal.

Every time that Rabelais replaces sustained narrative sequences by word lists, he demonstrates a refusal to order his text according to a single mode. The words that constitute the lists form independent paradigms. And yet within the lists, heterogeneous lexical entities displace one another by their disparity. Each time a new subclass is added the whole becomes more disintegrated due to the insertion of items which expand the focus of the original paradigm:

Turbotz,
Pocheteau,
Soles,
Poles,
Moules,

Homars,
Chevrettes, . . .(221-22)[47]

The addition of shellfish to a list that had been limited to other seafood disconcerts the reader because of the "centrifugal force extended upon lexical choice";[48] the discourse undermines the reassuring continuity of the taxonomy. This phenomenon results in the breakage of the *copia verborum*, a widening of the lexicon, which further splinters an already heterogeneous paradigm. Rabelais's refusal to substitute the singular for the plural, his inability to impose parameters on the scriptural quest, enables him to effect a writing practice which incessantly seeks self-transcendence.

Rabelais's *Quart Livre* offers itself as an open-ended construct, as a series of cellular frames that disrupts the continuum of the text. Successively superimposed narrative units function as splintering agents capable of disintegrating the linear patterns of writing through endless scriptural detours. The exigency toward closure is indeed a signal of a new beginning, an incessant attempt to displace the center of fictionality. To be sure, the author expresses no apparent difficulty in digressing wherever he pleases; the fragmentary text which he produces hovers between incompletion and closure—the abrupt beginnings and sudden endings are the antithetical correlates of logic and coherence. The successive encounters with grotesque creatures, the multiplicity of embedded stories, the centrifugal extension of the *copia verborum*—all embody a break with previous structures. Sustained narrative development is replaced by the juxtaposition of parts which function either as the remnants of former wholes (intertextual references) or as incomplete wholes (the extended lexicons). The narrative space is thus composed of disparate elements that adhere to a verbal mode of disjunction and incompletion. In short, Rabelais cultivates a narrative discourse whose heterogeneity will always accomplish a momentary disruption, a "euphoric" relief from the constraints of linearity. The condition for such a discursive practice is, as we have seen, the insertion of fragments—stories, anecdotes, intertextual references, words—which rupture a text already permutated by discrete entities. The parade of these disconnected pieces through the book exemplifies verbal openness.

Notes

1. The court-fool Triboullet's return of an empty bottle (3:47) prompts Panurge to decide that he must seek the word of the *Dive Bouteille* (the "Oracle of the Holy Bottle").
2. The narrative continuity of the first three books has been studied by Alfred Glauser, *Rabelais créateur* (Paris: Nizet, 1966), and Jean Paris, *Rabelais au futur* (Paris: Seuil, 1970).
3. "The entire action is gratuitous." Leo Spitzer, "Rabelais et les rabelaisants," *Studi Francesi* (1960), 4:419.

4. Glauser, *Rabelais créateur*, p. 87, adapts Thibaudet's notion of *lopinisme* in Montaigne's *Essais* and uses it to characterize the discursive features of Rabelais's four books. Michel Foucault in *Les Mots et les choses* (Paris: Gallimard, 1966) defines the dominant episteme of the Renaissance as "connaissance par entassement" (knowledge through accumulation). More recently, Barbara Bowen affirms in *The Age of Bluff: Paradox and Ambiguity in Rabelais and Montaigne* (Urbana: University of Illinois Press, 1972), p. 5, that "renaissance literature is marked by dispersion." According to Richard Lanham, *The Motives of Eloquence: Literary Rhetoric in the Renaissance* (New Haven: Yale University Press, 1976), p. 165: "[Rabelais works by] scene rather than narrative progression."

5. In *Rabelais: A Critical Study in Prose Fiction* (Cambridge: Cambridge University Press, 1971), Dorothy Coleman refers to the *Quart Livre* as an example of Menippean satire. I implicitly accept Coleman's generic classification, but my study focuses more on the "open form" of Rabelais's book.

6. Glauser, *Rabelais créateur*, p. 238, refers to the islands in the Rabelaisian universe as "îles mentales." On the subject of satire see Michael Seidel, *Satiric Inheritance: Rabelais to Sterne* (Princeton, N. J.: Princeton University Press, 1979) pp. 60-94.

7. François Rabelais, *Oeuvres complètes*, ed. Pierre Jourda (Paris: Garnier, 1962), 2:86. All subsequent references will be to this edition and will be indicated in the body of the text. The Cohen translation of this quote is as follows:

"Who'd like to earn twenty crowns for taking the devil
of a beating?" "Io, io, io!" they all cried.
"You'll knock us out all right, sir. Sure enough
you will. But there's good money in this."

J. M. Cohen, transl., *The Histoires of Gargantua and Pantagruel by François Rabelais* (London: Penguin Books, 1955), p. 486.

8. "a strange and monstrous anatomy of man, if I should call him a man" (Cohen 519).

9. His toes like the keyboard of a spinet.
His feet like guitars.
His legs like snares.
His knees like stools (Cohen 516).

10. ". . . while doing nothing he worked, and while working he did nothing" (Cohen 519).

11. "Have you seen him, good passengers? Have you seen him?" "Whom?" asked Pantagruel. . . . "Don't you know the One and Only?" (Cohen 550).

12. "Papimanie signifie optomanie" (Popimania signifies optomania). François Rigolot, *Les Langages de Rabelais* (Genève: Droz, 1972), p. 110.

13. "bare bum and his ballocks to the bargain" (Cohen 551).

14. O seraphic *Sixth* . . . how vital that book is for the salvation of humanity!
O cherubic *Clementines*, how neatly the perfect life of a true Christian is contained and described in that fourth book!
O angelic *Supplementaries*, without you all poor souls would perish, who wander here aimlessly in mortal bodies, about his vale of tears! . . .

.
.

.

Oh what great learning, what inestimable erudition, what godlike precepts, are packed into the divine chapters of these immortal Decretals! (Cohen 557-58)

15. And yet these devils of heretics won't read them and learn them. Burn them, nip them with pincers, slash them, drown them, hang them, impale them, break them, dismember them, disembowel them, hack them, fry them, grill them, cut them up, crucify them, boil them, crush them, quarter them, wrench their joints, rack them, and roast them alive, the wicked Decretaligue, Decretalicide heretics (Cohen 562).

16. " . . . I beseech you with clasped hands to believe no other thing, to have no other thought, to say, undertake, or do nothing, except what is contained in our

sacred Decretals and their corollaries" (Cohen 562).

17. "The wise men of old have called moderation golden, that is to say precious, universally praiseworthy, and pleasing in all places" (Cohen 440).

18. Narrative fissuration, as Raymond La Charité has pointed out, does not imply lack of esthetic choice. The order in which some of the chapters appear suggests a binary pattern: Quaresmeprenant/Andouilles; Papefigures/Papimanes. Raymond C. La Charité, "Chapter Division and Narrative Structure in Rabelais's *Pantagruel*," *French Forum* (1978), 3:268.

19. "On the fifth day, as we were gradually beginning to circle the Pole . . . we sighted a merchant ship approaching us to our port side" (Cohen 460).

20. "But let us sail on" (Cohen 467).

21. "The west wind went on blowing, changing occasionally to that breeze from the south-west which is called the *garbino*, and a whole day passed without our discovering land. . . . On the third day . . . we sighted Alliance Island" (Cohen 468).

22. "Les îles impliquent une dispersion dans l'espace plus qu'elles ne constituent la fiction d'une continuation dans le temps." Floyd Gray, *Rabelais et l'écriture* (Paris: Nizet), p. 199.

23. "Suddenly the sea began to swell and rage from the lower depths. Mighty waves struck the sides of our ship" (Cohen 491).

24. "Land, land!" cried Pantagruel. "I see land . . . I can see the sky beginning to clear" (Cohen 498).

25. Gray, *Rabelais et l'écriture*, p. 178. "Everything in the manner of creation points to a storytelling atmosphere." Abraham Keller, *The Telling of Tales in Rabelais: Aspects of His Narrative Art* (Frankfurt: Analecta Romantica, 1963), p. 39.

26. Funius (4); Antigonus and Antagoras (11); Herod (26); Death of Pan (28); Physis and Antiphysis (32); Charles VI (36); Alexander at Tyre (37); Death of Pompey (37); Paulus Aemylius (37); Cicero's wit (39); King Tarquin (63); Diogenes' Repartee (64); Aesop's Basket (65).

27. Glauser, *Rabelais créateur*, p. 231.

28. "What's the meaning of this . . . and why is it that you always find monks in kitchens?" (Cohen 474).

29. "Do you think there's some latent virtue," put in Rhizotome, "some specific and hidden property, in kettles and spite that draws monks . . . "
"I'll tell you," said Pantagruel. . . . "I remember reading once that Antigonus, King of Macedonia . . ."
"I'll crown that story," said Panurge, "by telling you how Breton of Villandry answered the Duke of Guise one day" (Cohen 474).

30. I adapt the terminology of Gérard Genette in *Figures III* (Paris: Seuil, 1972). To simplify matters, I shall use the following letters when referring to the various narrative levels: Intradiegetic level (IL); Primary Metadiegetic Level (PML); Secondary Metadiegetic Level (SML).

31. My hatchet, my hatchet! Only that! Only my hatchet, Jupiter, or the money to buy another! . . . What devil is it down there, asked Jupiter, howling so horribly? (Cohen 442)

32. For a slightly different approach to this problem, see my essay "On Narrative Transitions in the Prologue to Rabelais's *Quart Livre*," *The Structuralist Review* 2 (New York: Queens College Press, 1980).

33. King Jupiter, in the days when, by your ordinance and special favour, I was keeper of the gardens on earth, I noted that this hatchet was in several ways equivocal. It signifies a certain instrument used for cutting down and splitting timber. It also signifies—at least it did so of old—a female . . . laid on her back. In fact every good fellow called the girl who gave him his pleasures, my hatchet. For they employ this tool to boldly and stoutly to drive in their wenches' helves (Cohen 444-45).

34. "The way it happened was this" (Cohen 549).

35. "I am reminded of ancient Roman gentleman called Lucius Neratius" (Cohen 485).

36. . . .the noble Slitnose had passed away in so strange a manner that Aeschylus's death will now seem quite a natural occurrence. . . . You need not wonder either at the death of the poet Anacreon, who choked over a

grape-pit. . . . Philemon's death need not surprise you either. . . . Spurius
Saufeius's end need not surprise you either, though he died of eating a
soft-boiled egg as he came out of the bath (Cohen 488-89).

37. [Panurge speaks] ". . . he drank with them together in high glee. At the end
of the meal he told them this story": [Basché speaks]: "In his old age Master François
Villon. . . . " (Cohen 478).

38. "Four days later another Bum-bailiff came to summons Basché" (Cohen
481).

39. Leo Spitzer, in *La enumeración caótica en la poesía moderna*, trans. R. Lida
(Buenos Aires, 1945), views word lists such as these as parodies of Christian litanies to
God. Also see Terence Cave, *The Cornucopian Text. Problems of Writing in the
French Renaissance.* (Oxford: Oxford University Press, 1979).

40. His stomach like a belt.
 His pylorus like a pitchfork.
 His trachea like a sickle.
 His throat like a ball of tow.
 His lungs like a fur-lined hood (Cohen 514).

41. He had a memory like a scarf.
 His imagination like a peal of bells.
 His thoughts like a flight of starlings.
 His understanding like a ragged breviary.
 His judgment like a soft slipper (Cohen 515).

42. Marcel Tetel, "La valeur comique des accumulations verbales chez Rabelais,"
Romanic Review (1962), 53:97.

43. See my article "La Quête de la parole dans le *Quart Livre* de Rabelais,"
French Forum (1977), 2:199.

44. Baconrasher Savebacon
 Lardon Archbacon
 Gnawbacon Slashface
 Pullbacon Hashface
 Fatbacon (Cohen 534).

45. Mikhail Bakhtin, *Rabelais and His World*, Hélene Iswolsky, trans. (Cam-
bridge: MIT Press, 1968), p. 280.

46. White bread Chitterlings
 Soft bread Sausages
 Choice bread
 Common bread Legs of mouton in garlic
 Cold pies in hot sauce

 Curds and cream (Cohen 575-76).

47. Turbot
 White skate
 Soles
 Dover soles
 Mussels
 Lobsters
 Prawns (Cohen 578).

48. Jeffrey S. Kittay, "From Telling to Talking: A Study of Style and Sequence
in Rabelais," *Etudes Rabelaisiennes* (1978), 14:154.

In Disjointed Parts/
Par articles decousus

STEVEN RENDALL

Unity

"A hodgepodge of various items" (201; "une galimafrée de divers articles," 265),[1] "an ill-fitted patchwork" (736; "une marqueterie mal jointe," (941), "bundle of so many disparate pieces" (574; fagotage de tant de diverses pieces," 736), "grotesques and monstrous bodies, pieced together of divers members, without definite shape, having no order, sequence, or proportion other than accidental" (135; "crotesques et corps monstrueux, rappiecez de divers membres, sans certaine figure, n'ayant ordre, suite, ny proportion que fortuite," 181): so Montaigne describes his *Essais.* But he also writes "my book is always one" (736; "mon livre est tousjours un," 941), and "my ideas follow one another, but sometimes it is from a distance, and look at each other, but with a sidelong glance. . . . It is the inattentive reader who loses my subject, not I" (761; "mes fantasies se suyvent, mais par fois c'est de loing, et se regardent, mais d'une veuë oblique. . . . C'est l'indiligent lecteur qui pert mon subject, non pas moy," 973). Critics like to think of themselves as attentive readers, and in this century, at least, they have often maintained that the

fragmentary character of the *Essais* is merely apparent, masking, a "deep and hidden plan," as R. A. Sayce puts it, so that "superficial disorder conceals underlying unity."[2]

The deconstructive criticism of the past decade has tried to show the implications of assuming such an underlying unity and of attempting to reduce the surface of the text to it. Whether they claim to reveal a general structure governing the book as a whole or merely local structures governing individual chapters or groups of chapters, such attempts imply a natural totality preceding the text and existing independently of it, to which the text refers and from which it derives its own totality. They imply, that is, a unified *logos* and/or self present to itself, which the text represents by means of its signs. To the extent that this assumption is inseparable from the language we must use even to deconstruct it, one cannot not make this assumption. For instance, the very notion of a fragment cannot be used without evoking the corresponding notion of a whole that includes and determines it. But one can also exploit the inevitable paradoxes involved in logocentric logic and language; one can point out, for example, that the principle of noncontradiction binds the traditional critic in a way that it does not, cannot, bind the deconstructive critic. If we do not seek to establish the unity of the *Essais*, contradictory assertions such as those quoted in the preceding paragraph pose no problem; indeed, they become confirming evidence, since assertions of unity as well as of disunity might be considered necessary to ensure the irreducible diversity of the text.

This diversity also ensures the availability of the *Essais* to a virtually limitless variety of readings. Few texts lend themselves more easily to divergent interpretations; one can find evidence for almost any view of the *Essais* one wishes to take. But it is equally easy to find evidence to contradict almost any view. Perhaps this accounts in part for the apparently inexhaustible potential of this text that has continued to fascinate casual readers and critics alike. It also reminds us that any reading of the *Essais*, including this one, constitutes the text in its own image. This is true, however, of any reading of any text, and need not concern us too much here. What is of greater interest is to see what is involved in reading the text as a unity.

The "evolutionary" reading proposed early in this century by Pierre Villey, Fortunat Strowski, and their followers rationalizes contradictions and inconsistencies in the *Essais* by attributing them to the various stages (usually seen as three) in the development of Montaigne's ideas and attitudes over the twenty-odd years he spent composing his work. It attempts to salvage the myth of a unitary *logos* underlying the diversity of the text by temporalizing it, a strategy sometimes adopted by Montaigne himself. But the implication remains the same: the unity, and hence the meaning, of any particular segment of the text is determined by its reference to a thought coeval—or *almost* coeval, separated only by the inevitable gap between conception and representation—with it. Moreover, for the

evolutionist, the text as a whole can be characterized as a linear develop-
ment, and thus as teleologically unified. The deconstructive critic rejects
the notion of history as a progress through various stages toward a pre-
ordained goal, maintaining rather the discontinuity of history conceived as
a goalless process of repetition and displacement. On such a view, the later
parts of the *Essais* do not continue or complete a process begun in the
earlier ones; neither can the diversity of Montaigne's text be subsumed by
such a process. The notions of *origin* and *goal*, as well as the notion of
history or evolution as a linear process linking origin and goal, belong to
the conceptual apparatus of the logocentric metaphysics deconstructive
criticism seeks to put into question.

In *The Rhetoric of Fiction*, Wayne Booth recognizes the fragmentary
quality of the *Essais* and suggests that what unity they have is derived
from "the consistently inconsistent portrait of the author himself, in his
character as writer." What is more, Booth goes on, "if we look closely at
the 'Montaigne' who emerges from these completed pages, we cannot help
rejecting any simple distinction between fiction and biography or essay.
The Montaigne of the book is by no stretch of the imagination the real
Montaigne, pouring himself onto the page without regard for 'aesthetic
distance.' " On the contrary, the "Montaigne" of the book is a fictional
construct, a creature of the encounter between the text and the reader's
imagination, and "it is this created fictional character who pulls the scat-
tered thoughts together."[3] This view is much more in tune with current
critical theory, though some would want to add that the Montaigne who
"emerges" from the text is not always the same, and that the "real
Montaigne" is also a construct. However, Booth's conception of rheto-
ric—"the author's means of controlling his reader"—not only "arbitrarily
isolate[s] technique from all of the social and psychological forces that
affect authors and readers," as he admits in his preface, but also commits
him to "the author" as the independently existing origin of the text and
to the view that the reader's construction of the text's meaning is "con-
trolled" by the author's intentions as encoded in the text. That is, it
implies a view of the unity of the *Essais* not fundamentally different from
that held by the other critics mentioned. It is true that if we took "the
author" to mean "the implied author," i.e., the image of the author con-
structed by the reader, the logocentric implications of Booth's formula-
tion would be attenuated. But to do this would be to open a study of the
fictions of rhetoric rather than of the rhetoric of fiction.

Nevertheless, Booth's remarks have the advantage, from the point of
view I am adopting here, of suggesting that the unity of the *Essais* is con-
structed by the reader. Like Stanley Fish, I shall assume that the con-
straints on the reader's construction of meaning are imposed not by the
author or by the text "itself," but rather by the interpretive strategies
brought to the act of reading. On this assumption, the unity—or dis-
unity—of a text is a function not of its inherent characteristics but of the

interpretive strategy that constitutes it. Booth's notion of a persona or implied author unifying the *Essais* is part of one such strategy; more recent critics have exploited different strategies that assume, as Geoffrey Hartman has put it, "the nonhomogeneity of the fact at hand, the arbitrariness of the knots that bind the work into a semblance of unity," in order to show "what simplifications, or institutional processes, are necessary for achieving any kind of unitary, consensual view of the artifact."[4] It is with the latter sort of view that I wish to associate myself in this essay.

Reading and Linearity

It is not necessary, however, to call upon contemporary deconstructive criticism to find a strategy for reading the *Essais* as a collection of fragments. Several scholars have recently pointed out that Renaissance readers generally did not assume that the meaning of any given segment of discourse was dependent upon its place in the overall structure of the text in which it occurred. Historically, this may be related to the persistence well into the seventeenth century of modes of reading established when literacy was less common and before the invention of the printing press made it possible for large numbers of individuals to have their own copies of the books they read. In the Renaissance, books were still frequently read aloud to audiences, sometimes by quasi-professional readers. This custom depended, as William Nelson has observed, on the ability of the audience to make sense of isolated episodes considered by themselves, since it was usually impossible to read all of the text at one sitting, and since individuals might miss one or more sessions.[5] A reading of one of the immensely popular and immensely long novels of D'Urfé or Mme de Scudéry might thus take the form of an oral recitation of part of the text, after which members of the audience would discuss the moral and psychological problems it posed, and attempt to relate these to general principles and to their own current concerns. The question of how these episodes related to each other or to a general structure encompassing the whole book would under these circumstances be both irrelevant and virtually impossible to answer.

This kind of reading had, moreover, a classical warrant in such authors as Plutarch, whose *Moralia* were widely read in the sixteenth century and among Montaigne's favorite books. As John Wallace has shown, Renaissance authors generally followed Plutarch in viewing the process of reading and interpreting as a matter of drawing from the *exempla* offered by the text the moral rules or precepts these *exempla* could be said to illustrate.[6] Thus Montaigne urges tutors to provide their pupils with such examples for interpretation, since "to the examples may properly be fitted all the most profitable lessons of philosophy, by which human actions must be measured as their rule" (117; "aux exemples se pourront propre-

ment assortir tous les plus profitables discours de la philosophie, à laquelle doivent toucher les actions humaines comme à leur reigle,'' 158). These moral precepts were then to be "transferred and applied" to the reader's own concerns. I have explored elsewhere the implications of this view of reading for the theory of interpretation;[7] here I want only to stress that it assumes that the meaning and value of a particular segment of a text is to be determined by reference to a variety of structures and situations "outside" the text rather than by reference to the other elements of the text in question or to the author's intention. On these principles there is no reason why texts must be read "whole" or in a linear order; such a strategy of reading constitutes every text as a collection of disparate or at least separable elements.

Why, then, should the *Essais* not be read as Montaigne read them and as he read the works of others? When he is in his library, he says, "I leaf through now one book, now another, without order and without plan, by disconnected fragments" (629; "je feuillette à cette heure un livre, à cette heure un autre, sans ordre et sans dessein, à pieces decousues," 806). In the essay "Of the Art of Discussion," Montaigne remarks that, at the request of a friend, he has read Tacitus through from start to finish at one sitting, and comments that "it has been twenty years since I put one whole hour at a time on a book" (718; "il y a vint ans que je ne mis en livre une heure de suite," 919). He admires the epigrams of Catullus and Martial, Plutarch's *Moral Essays*, and Seneca's *Epistles* because they have "this notable advantage for my humor, that the knowledge I seek is there treated in detached pieces that do not demand the obligation of long labor, of which I am incapable. . . . I need no great enterprise to get at them, and I leave them whenever I like. For they have no continuity from one to the other" (300; "Ilz ont . . . cette notable commodité pour mon humeur, que la science que j'y cherche y est traictée à pieces decousues, qui ne demandent pas l'obligation d'un long travail, dequoy je suis incapable Il ne faut pas grande entreprinse pour m'y mettre; et les quitte où il me plait. Car elles n'ont point de suite des unes aux autres," 392).

From passages such as these it can be seen that Montaigne's usual mode of reading was not linear, or at least that he seldom read a book as a linear totality. His own book is not only broken into discrete chapters, but even within chapters his discourse is continually interrupted by digressions, quotations, anecdotes, and asides. Anything approaching chronological continuity is disrupted by his practice of inserting later marginal additions into his text. He rejects the sustained periods of the Ciceronian style, preferring the short sentences of the "curt" style or the paratactic juxtapositions of the "loose" style; in both of these the relations between clauses are omitted, leaving each clause as a syntactically independent unit. Similarly, he dislikes the orderly, linear structures of traditional oratorical composition, and indeed few of his essays can be reduced without difficulty to this classical scheme.

As J. Hillis Miller has observed, "The image of the line tends always to imply the norm of a single continuous unified structure determined by one external organizing principle. This principle holds the whole line together, gives it its law, controls its progressive extension, curving or straight, with some *arché, telos,* or ground."[8] Montaigne frequently uses the image of the line or thread—but it is almost always a *broken* thread. "Je viens de courre *d'un fil* l'histoire de Tacitus," he remarks in the passage mentioned above, adding that he rarely reads in this way. He repeatedly refers to Plutarch's, Seneca's, and his own works as collections of "pieces décousus" ("unsewn pieces"). "Décousu," like the English "unsewn," signifies the state of pieces of fabric that were once attached but have come apart, and thus may imply an antecedent totality that has been fragmented because the threads connecting its parts have broken or unraveled. But both words may also signify the state of bits of cloth or other items which are not, and have never been, connected. *Décousu/unsewn* thus operates in a double semantic field, standing at a point of articulation between unity and disunity, indicating an empty space between elements that have/have not been connected. It subverts the opposition between part and whole, and thus resembles words like "supplément," "pharmakon," and "entame," of which Derrida has written that they "resist and disorganize" the binary oppositions of logocentric metaphysics *"without ever* constituting a third term, without ever occasioning a solution in the form of speculative dialectics" which would reestablish a unitary *logos.* Both the French *coudre* and the English *sew* are related etymologically to the Greek *hymen,* which is, as Derrida observes, "neither confusion nor distinction, neither identity nor difference, neither consummation nor virginity, neither the veil nor the unveiling, neither the inside nor the outside."[9] Montaigne's unsewn pieces are neither independent monads nor parts of a lost whole, neither connected nor disconnected.

Intuition and Continuity

In a well-known chapter of his *Mimesis: The Representation of Reality in Western Literature,* Erich Auerbach argues that the opening page of Montaigne's essay "Of Repentance" is governed by the deductive structure of the syllogism—a linear structure *par excellence.* But he admits that "the order is repeatedly broken, that some propositions are anticipated, and that others are altogether omitted so that the reader must supply them."[10] What the reader must supply here, I would add, is not only the omitted links but the reading strategy that views the passage as a continuous argument. Let us read this famous page again:

Others form man; I tell of him, and portray a particular one,

very ill-formed, whom I should really make very different from what he is if I had to fashion him over again. But now it is done.

Now the lines of my painting do not go astray, though they change and vary. The world is but a perennial movement. All things in it are in constant motion—the earth, the rocks of the Caucasus, the pyramids of Egypt—both with the common motion and with their own. Stability itself is nothing but a more languid motion.

I cannot keep my subject still. It goes along befuddled and staggering, with a natural drunkenness. I take it in this condition, just as it is at the moment I give my attention to it. I do not portray being: I portray passing. Not the passing from one age to another, or, as the people say, from seven years to seven years, but from day to day, from minute to minute. My history needs to be adapted to the moment. I may presently change, not only by chance, but also by intention. This is a record of various and changeable occurrences, and of irresolute and, when it so befalls, contradictory ideas: whether I am different myself, or whether I take hold of my subjects in different circumstances and aspects. So, all in all, I may indeed contradict myself now and then; but truth, as Demades said, I do not contradict. If my mind could gain a firm footing, I would not make essays, I would make decisions; but it is always in apprenticeship and on trial. (610-11)

(Les autres forment l'homme; je le recite et en represente un particulier bien mal formé, et lequel, si j'avoy à façonner de nouveau, je ferois vrayement bien autre qu'il n'est. Mes-huy c'est fait. Or les traits de ma peinture ne forvoyent point, quoy qu'ils se changent et diversifient. Le monde n'est qu'une branloire perenne. Toutes choses y branlent sans cesse: la terre, les rochers du Caucase, les pyramides d'AEgypte, et du branle public et du leur. La constance mesme n'est autre chose qu'un branle plus languissant. Je ne puis asseurer mon object. Il va trouble et chancelant, d'une yvresse naturelle. Je le prens en ce point, comme il est, en l'instant que je m'amuse à luy. Je ne peints pas l'estre. Je peints le passage: non un passage d'aage en autre, ou, comme dict le peuple, de sept en sept ans, mais de jour en jour, de minute en minute. Il faut accommoder mon histoire à l'heure. Je pourray tantost changer, non the fortuen seulement, mais aussi d'intention. C'est un contrerolle de divers et muables accidens et d'imaginations irresoluës et, quand il y eschet, contraires; soit que je sois autre moymesme, soit que je saisisse les subjects par autres circonstances et considerations. Tant y a que je me contredits bien à l'adventure, mais la vérité, comme disoit Demades, je ne la contredy point. Si mon ame

pouvoit prendre pied, je ne m'essaierois pas, je me resoudrois; elle est tousjours en apprentissage et en espreuve. (782)

To read this passage as a syllogistic argument ("I describe myself; I am a creature which constantly changes; ergo, the description too must conform to this and constantly change") one must "fill in the gaps." These "gaps" owe their existence, however, to the assumption that the passage is logically structured in a certain way and represents or communicates a single sequence of thoughts existing independently of it. Both the "gaps" and the logical continuity they are seen as interrupting are produced by the interpreter's assumptions concerning the nature of the text he is reading. Once this is recognized, the question whether the deductive structure Auerbach discerns in this passage is typical of the *Essais* "as a whole"—he implies, I think, that it is—no longer concerns inherent features of the text but rather the ability of the interpreter to persuade others to adopt an interpretive strategy that constitutes the text in this way.

If we accept Auerbach's reading of this passage, however, we can then go on to point out that the argument he finds in it undermines itself. One of the conclusions Montaigne draws is that his description of his opinions and attitudes is valid only for the moment in which he describes them, since both the objects he discusses and the perspective from which he views them may change from moment to moment. If we then reflect that this passage is part of the description it describes, we can see that it produces a *mise en abyme* of the text. It cannot claim to stand outside the text and give it its law, or to provide a privileged vantage point from which the text as a whole may be surveyed. Since it is part of the text, its argument applies to itself as well: it is no more than one moment of Montaigne's description, and may be contradicted by others. What is more, these contradictory passages will have just as much force as this one; Montaigne affirms his commitment to this kind of textual democracy on several occasions. The additions he makes to his text are not to be taken as corrections, superseding what he has written earlier, for there is no reason to think that the change in his opinions is necessarily a change for the better, i.e., that it is part of a linear *progress*. "Myself now and myself a while ago are indeed two; but when better, I simply cannot say" (736; "Moy à cette heure et moy tantost, sommes bien deux; mais quand meilleur? Je n'en puis rien dire," 941). Of course, by the same token we cannot regard *this* statement as privileged, either; one does not so easily escape from the abyss. The logical thread Auerbach discerns is not merely broken and twisted but reveals itself to be only one strand in an irreducibly complex textual fabric.

The passage Auerbach reads as a linear argument can, moreover, also be read as a justification of the fragmentary character of the *Essais*. In it Montaigne founds the authenticity of his self-portrait on the coincidence of a present moment of consciousness with the moment of writing, thus

grounding his project in a familiar logocentric metaphysics: "I take it in this condition, just as it is at the moment I give my attention to it." His account is to be a kind of written speech, "the same on paper as in the mouth" (127; "tel sur le papier qu'à la bouche," 171), a direct translation of thought into script, producing a book "consubstantial with its author." He presents his book as a record ("un contrerolle") of a series of discrete moments of intuition, in which thought is directly present to itself. Although some critics have maintained that phrases like "from minute to minute" suggest the temporal continuity of Montaigne's record, it seems equally possible to argue that they suggest discontinuity, as he does not imply that these states succeed each other according to any single rule or order. It is precisely the lack of any such regularity that makes efforts to predict human actions so futile, as he constantly points out. The apparent implication of temporal or narrative continuity in the use of phrases such as "je recite," "mon histoire," and (a little further on in the same essay) "je raconte" is unfounded; in sixteenth-century French all three could be used to refer to description as well as to narration, a usage preserved in modern expressions like "histoire naturelle." A similar conflation of synchronic and diachronic perspectives can be found not only in the pairing of the verbs *réciter* and *représenter* in the first sentence of the passage quoted, but also in the very notion of a *portrait* of a ceaselessly changing, never self-identical subject. The lines of his portrait may all depict Montaigne's thoughts, as he claims, but where, when "is" Montaigne? He claims only to grasp himself in the present moment of intuition; he can describe neither the unity nor the continuity of his being; he can describe only fragments of his experience "having no order, sequence, or proportion other than accidental."

Memory and Method

Discursive unity is constituted through memory, and Montaigne's assertions of his lack of memory are often linked to his inability to keep different items in his mind and make them cohere with each other. Thus, for example, he explains that he is a bad liar because a liar must have a good memory to keep the various elements of his lie from contradicting each other (23; 36), and in another place he observes that his lack of memory prevents him from following a long and complex statement: "What anyone wants to propound to me must be propounded piecemeal. For to answer a discourse in which there are several different headings is not in my power" (492; "Ce qu'on veut me proposer, il faut que ce soit à parcelles, car de respondre à un propos où il y eut plusieurs divers chefs, il n'est pas en ma puissance," 632-33). Grasping the coherence of an extended textual structure depends on memory, and as I have already noted, Montaigne prefers aphoristic, fragmentary forms, which do not require a prolonged effort of attention. One reason he claims to describe

only his present state of mind in the *Essais* is that he does not trust his memory of past states; he may remember wrongly, or he may forget the complexity and even the contradictions of his experience, for memory can produce a spurious unity achieved through selective omission (see, for example, "Of the Inconstancy of Our Actions" and the end of the essay "Of the Art of Discussion"). The *Essais* are, among other things, a substitute for memory, the trace left by "so many chimeras and fantastic monsters, one after another, without order or purpose" (21; "tant de chimeres et monstres fantasques les uns sur les autres, sans ordre et sans propos," 34), which serves to aid Montaigne in recognizing the diversity of his opinions.

The role of memory in connecting a series of present intuitions in an extended logical structure is discussed by Descartes in his early *Regulae ad directionem ingenii (Rules for the Direction of the Mind)*, a work which, like many of his writings, bears the mark of his reading of the *Essais*. Descartes admits two ways of arriving at knowledge, intuition and deduction. Intuition is the power of telling the true from the false— the "capacity for sifting truth" (499; "capacité de trier le vray," 641), as Montaigne calls it—when it is perceived clearly and distinctly. Deduction is the linking of a series of intuitions in a logical chain that cannot be present in its entirety to the mind in a single moment of intuition. Hence, Descartes writes in Rule III, "We can distinguish this mental intuition from deduction by the fact that into the conception of the latter there enters a certain movement or succession; into that of the former there does not."[11] Intuition is a synchronic operation, deduction a diachronic one, and as Descartes goes on to point out, the certitude of deduction thus depends on memory in a way that intuition does not. Like Montaigne, he distrusts memory, and remarks that "deduction frequently involves such a long series of transitions from ground to consequent that when we come to the conclusion we have difficulty in recalling the whole of the route by which we have arrived at it." To compensate for "this weakness of the memory," he proposes to run through the steps of the argument several times as quickly as he can, "keeping the imagination moving continuously in such a way that while it is intuitively perceiving each fact it simultaneously passes on to the next; and this I would do until I had learned to pass from the first to the last so quickly, that no stage in the process was left to the care of the memory, but I seemed to have the whole in intuition before me at the same time." In this way a diachronic sequence of separate steps is to be made into a synchronic intuition of the whole. But everything depends upon the continuity of this process; "this movement should nowhere be interrupted," for "it is certain that wherever the smallest link is left out the chain is broken and the whole of the certainty of the conclusion falls to the ground" (Rule XI).

For Descartes, as for Montaigne, we have certain knowledge only of what is *present*. Memory represents the past, but it may play us false, and thus it lacks the reliability of present intuition. Yet discursive structures

can be perceived only through memory, and thus the science Descartes seeks to found must depend upon this unreliable faculty to the extent that its demonstrations cannot be reduced to a single intuition. The demon Descartes imagines in his *Meditations* hardly poses a more serious problem than this demon of the *Regulae;* in fact, from another point of view, it is the *same* problem, and the same demon in another guise. The distinction between them depends on the premise that the gap separating a "present" intuition from the memory of it is abolished in the intuition itself. Derrida and others have argued, however, that this gap or *différance* can never be closed, that we are always confronted not by a presence but by the trace or spoor of a presence that is always already absent, always already *past.*

Montaigne and Descartes both assume the presence of thought to itself in the moment of self-consciousness. On this foundation—on the foundation of the *cogito*—Descartes proposes to erect the structure of a new science by means of a *method* that will rightly conduct the reason from one present intuition to another. Although acknowledging regularity as an ideal, Montaigne repeatedly affirms that it is beyond human reach, and mocks the efforts of "philosophers" to produce a systematic science. Trusting neither memory nor method, he remains content to record the moments of his thought without trying to grasp them as a unified whole.

Conclusion

Etymologically, "method" is a way or road followed, and images of travel are prevalent in both the *Essais* and Descartes's *Discourse on Method.* But whereas in Descartes the emphasis is on the continuity of the voyage and on its goal, in Montaigne the emphasis falls rather on the voyage itself, which is often represented as having neither origin nor goal external to it: "I undertake it neither to return from it nor to complete it; I undertake only to move about while I like moving. And I walk for the sake of walking" (747; "Je ne l'entreprens ny pour en revenir, ny pour le parfaire; j'entreprens seulement de me branler, pendant que le branle me plaist. Et me proumeine pour me proumener," 955). The journey, not the arrival, matters. No longer teleologically determined, the traveler's way can be diverted, reversed, interrupted at any point. Like his discourse, to which he often compares it, Montaigne's journey need not follow a straight or single line to a predetermined conclusion. Every point at which he arrives can be a beginning as well as an end. "My plan is everywhere divisible," he writes; "it is not based on great hopes; each day's journey forms an end. And the journey of my life is conducted in the same way" (747; "Mon dessein est divisible par tout; il n'est pas fondé en grandes esperances; chaque journée en faict le bout. Et le voyage de ma vie se conduict de mesme," 955). Each segment of his text, his voyage,

his life is potentially discontinuous with the others, and does not depend upon them for its meaning or its value.

The *Essais* can end, Montaigne observes, only with his death (721; 922-23). But "death is indeed the end, but not therefore the goal, of life; it is its finish, its extremity, but not therefore its object. Life should be an aim unto itself, a purpose unto itself" (805; "c'est bien le bout, non pourtant le but de la vie; c'est sa fin, son extremité, non pourtant son object. Elle doit estre elle mesme à soy sa visée, son dessein," 1028). The *Essais* are, moreover, open to endless extension not only through Montaigne's marginal additions but also through appropriation by other readers and writers. Every text, including the *Essais*, has a reserve of additional meaning that overflows any reading of it, and permits its use in a variety of contexts. Montaigne repeats or appropriates the texts of others, and expects his own to be appropriated in the same way.[12] For Montaigne, neither death nor the "final" chapter of his book is a goal that orders and subsumes what precedes it. The *Essais* have no conclusion.

Closure is incompatible with Montaigne's project and with his general view of the human condition, though its absence determines both. Being, totality, completion are the names of God, with whom we have no communication. Being lies outside human reach; it is the outside that defines our inside and reveals human existence as a fragment of the divine whole. We can never conclude, but only essay and essay again. The notion of a fragment is inherently nostalgic to the extent that it implies an antecedent unity which has been broken. The essay, as Montaigne understands it—i.e., an attempt, an inconclusive test—is not nostalgic in the same way. It does not look back to a lost presence, and although it tends toward a goal, this goal is never achieved by it, but remains on the horizon. The gap between the essay and its object is never closed and conclusions are indefinitely deferred. "There is no end to our researches; our end is in the other world" (817; "Il n'y a point de fin en nos inquisitions; nostre fin est en l'autre monde," 1045).

The essay does not achieve a totality which its very concept precludes (and includes). Order, unity, and completeness are the marks of an unattainable knowledge of being to which Montaigne does not pretend. What he has to say demands a different form: "I speak my meaning in disjointed parts, as something that cannot be said all at once and in a lump" (824; "Je prononce ma sentence par articles decousus, ainsi que de chose qui ne se peut dire à la fois et en bloc," 1054). An ending is not a conclusion, but another part; like the others, it is subject to displacement and repetition.

Notes

1. English quotations are from Donald M. Frame's translation, *The Complete Works of Montaigne* (Stanford, Calif.: Stanford University Press, 1957); French from

the *Pléiade* edition of Montaigne's *Oeuvres complètes* by Albert Thibaudet and Maurice Rat (1962; rpt. Paris, 1967).

2. R. A. Sayce, *The Essays of Montaigne, A Critical Exploration* (London: Weidenfeld and Nicolson, 1972), pp. 261, 262.

3. Wayne Booth, *The Rhetoric of Fiction* (Chicago: University of Chicago Press, 1961), pp. 226, 228.

4. Geoffrey Hartman, "Crossing Over: Literary Commentary as Literature," *Comparative Literature* (1976), 28:261.

5. See William Nelson, "From 'Listen, Lordings' to 'Dear Reader,' " *University of Toronto Quarterly* (Winter 1976-77), 46:110-24.

6. See John M. Wallace, " 'Examples Are Best Precepts': Readers and Meanings in Seventeenth-Century Poetry," *Critical Inquiry* (December 1974), 1:273-90.

7. In *"Mus in pice:* Montaigne and Interpretation," *Modern Language Notes* (1979), 94:1056-71.

8. J. Hillis Miller, "Ariadne's Thread: Repetition and the Narrative Line," *Critical Inquiry* (Autumn 1976), 3:69-70.

9. Jacques Derrida, "Positions," *Diacritics* (Winter 1972), 2:36.

10. I quote, Willard R. Trask's translation (Princeton, N. J.: Princeton University Press, 1953), ch. 12.

11. I quote from *The Philosophical Works of Descartes*, trans. E. S. Haldane and G. R. T. Ross (New York: Cambridge University Press, 1931, rpt. 1955).

12. For a fuller discussion of this point, see *"Mus in pice:* Montaigne and Interpretation," mentioned in note 7 above.

Diderot's Egg:
Life, Death, and Other
Things in Pieces

JACK UNDANK

Volvitur Ixion et sequiturque fugitque.
 Ovid, Metamorphoses

J'ai été, je suis, je serai.
 Diderot, De la durée du monde

Only old Dame Mass with her twin dugs of
Stuff and Tickle persists, suffering her
long slow split into pure light and pure
carbon!
 Robert Coover, Pricksongs & Descants

Diderot's rage over the order of things is so fine, so unwilled, and even in
a revolutionary age, so radically subversive, that it had to be muffled, dis-
placed into a substance as allusive and ambiguous as dreamwork—into one
of those signs or words that, according to him, has a way of suddenly
piercing the "door" of a text to light up, however flickeringly, "the inte-

rior of the apartment."[1] It crops up, if not for the first time then most elegantly, in a few lines of *Le Neveu de Rameau,* lines so bland that their meaning explodes silently. MOI, the narrator, full of contempt for the "do-nothings" who play chess at the Café de la Régence, almost immediately asks the nephew, LUI, "What have you been doing?" (Qu'avez-vous fait?) And LUI replies: "What you, I, and everybody else does: good, bad; and nothing. And then, I've been hungry, and I ate, when I had the chance; after eating, I got thirsty, and sometimes I drank. Meanwhile my beard grew, and when it grew, I had it shaved" (Ce que vous, moi et tous les autres font: du bien, du mal; et rien. Et puis j'ai eu faim, et j'ai mangé, quand l'occasion s'en est présentée; après avoir mangé, j'ai eu soif, et j'ai bu quelquefois. Cependant la barbe me venait, et quand elle a été venue, je l'ai fait raser).[2] Most everything here is paratactic, the substance and the form, childlike or brutal in its disjunctive and accumulative tedium. Beginning with a shrug that forces the narrator into a complicitous association of equals who willy-nilly accomplish good deeds and bad (so that no moral definitions are, in the end, necessary), the nephew, after a semicolon, sounds the fateful word: "nothing." And this ultimate and insolent dark hole gets filled, so to speak, with the vacuous but intermittent successivity of growing hungry, growing thirsty, and growing hair—a round of physical necessities, ending with a small concession to either vanity or propriety: getting shaved.

It would be wrong, without a good deal of shading, to ascribe the nephew's response entirely to a philosophy of deterministic materialism, bearing as it does the full weight of a long tradition of *accidie* and *ennui* that blooms perennially and even to this day in authors from Flaubert to Beckett and Ionesco, and most radiantly in Valéry's "weariness of living" (l'ennui de vivre), a mood that sees "things as they are . . . come together, limit one another, linked in the most rigorous and deadly fashion" (les choses telles qu'elles sont qui se rejoignent, qui se limitent, et s'enchaînent de la sorte la plus rigoureuse et la plus mortelle).[3] It is nevertheless the strongest eighteenth-century formulation of a vew that cannot, in spite of a countervailing belief in progress in other areas and on other levels of consciousness, release itself from the darkness of the cyclical ways of things and the unchanging ways of the self. My point, in any case, is not to enlist Diderot in a banality, but to set the stage for his annoyance at all things required, automatic, or redundant, and to indicate that even here a certain amount of exasperation surfaces, and with it, a kind of enraged, though covert, solution. Already in the *way* the nephew parries the narrator's questions, something vastly important is taking place. MOI asks a conventional question: "What have you been doing?"—having already asked, "Are you wasting your time like these wood pushers?" (Est-ce que vous perdez aussi votre temps à pousser le bois) and having received "No" for an answer. MOI's persistence and curiosity now make LUI swerve. Instead of providing the detailed or even casually historic answer, any answer, LUI deliberately vaults into abstraction and then draws out a

tissue of symbolic incidents. MOI has mildly called for a reciprocity of response, an alignment of understanding, and LUI, taking flight on the polysemous crosscurrents of language—in this case, on the verb "to do" (faire)—slips away from his intention, from predictabilities, niceties, answers compelled by social and verbal decorum. (Incidentally, when MOI refers to the chess players as "wood pushers," reducing human activity and investment to merely physical energies expended upon an inert substance, he plays a similar linguistic game.) If there are powers, physical, economic, and moral, that must be obeyed in life, the nephew's language refuses to be appropriated. It is in fact a language that eventually and desperately turns to gesture and mime—or, as Kristeva proposes, to the only resource available to its transcendent project: music[4]—to suggest, ambiguously, a deflection from the univocal to an otherwise impossible simultaneity, from the linear and simple to compound mystery, the rich suspensiveness, equipoise, and deviance of art confounding the demand for clear and distinct answers—or the demands of clear and distinct necessities. It is not only by nature, as Diderot might have us believe, quoting Horace's *Vertumnis quotquot sunt natus iniquis*, that the nephew happens to show us different faces, but through design and in anger. He takes, when he can (as Diderot's Jacques will after him), the high, thoroughly absorbing, and playful road of mimesis, a road that leads to a world displaced from ordinary space, time, and circuitry. Paradoxically, in its bumpy progress, it takes him where he wants to go, and far enough, economically and esthetically. But within our context, and most dramatically, as the journey jolts and spins the prism of the self and its discourse, it has the effect of intensifying one kind of attention by partially sublimating another, aggrieved one.

There are two things that have to be noted here: both the nephew's worlds are discontinuous, constantly interrupted; they interfere with one another or alternate. Though certain elements of Diderot's esthetics and historic purposiveness call for a single, sustained, resonant "action,"[5] and he, in his own life, longs for affections and activities steady and whole, the nephew's bifocalism, the duality of his intercepting worlds (and within each, the plurality of urgencies) continues to haunt him and his fiction as, in recent times, it does Bellow's Herzog. The difference between these worlds lies in the fact that the sphere of appetites and shaving, the *hic et nunc*, propels us into similitude and repetition, a teleological unity that cannot be broken—except, one would think, by death. And yet for Diderot death, which might spell an end to the implacable round of all necessities, the source of this particular rage, is itself only a temporary halt, not a full stop, and so, eventually, as I hope to suggest, another, more hidden cause for grief and protest. Even when he is not, in his private letters, playing flirtatious or sentimental games with it, occasionally drawing the *idea* of dying into a notion of self-congratulatory fulfillment in the present, and when he is not invoking posterity and his famous historic chain of human testimony and struggle, death appears to him with none of the trappings and

terrors of tragedy.[6] In the "immense ocean" of matter recycling itself
through time, as Diderot describes it in *Le Rêve de d'Alembert*, gener-
ations rise and sink; each species and individual, walled into its accidental
constitution and ephemeral presence, disintegrates into inanimate but
potentially sensate dust (molecules). Dreaming this, d'Alembert, Diderot's
spokesman, submerged in the tossing ocean of his prepared mind and so
discursively reproducing—as if embodied in—the spontaneous turbulence
of nature, cries out, just before he ejaculates: "O the vanity of our
thoughts! O the wretchedness of our glory and our works! O the empti-
ness! O the pettiness of our views! There is nothing certain but drinking,
eating, living, making love, and sleeping" (O vanité de nos pensées! ô
pauvreté de la gloire et de nos travaux! ô misère! ô petitesse de nos
vues! Il n'y a rien de solide que de boire, manger, vivre, aimer et dormir,"
300). There's no need, I think, to point to the relationship between
d'Alembert's involuntary orgasm and the nephew's sprouting stubble, nor
to indicate that eating and drinking, for both, take on value as a summa-
tion of rock-bottom realities in the surge of cosmic time. Nature's Eros
seems to make puppets of us all, but it also eroticizes the imagination.
(Not only d'Alembert, but his listeners, Dr. Bordeu and Mlle de L'Espi-
nasse, are aroused.) And this imagination, with the vast, awesome, and
rhythmical epic it develops, numbs and blankets the implications of its
own hypothesis. Not merely fiction, but the seductions of telling and
being heard, of imitation itself, somehow compensate for and distance the
specifically human reality of death. The ingenuity, indeed the late rococo
asymmetry and surprise of this cyclical ontology,[7] in which death is but a
halfway station to who knows what not-entirely-predictable life, defuses
what is potentially mortifying in the image. And there is some not un-
related pleasure in thinking of the steady Spinozist or Dom Deschampsian
ALL that frames it and gives every sacrifice its home and purpose.

The sting of this "devil of a philosophy" (diable de philosophie),[8]
when our books are closed or when, for Diderot, he has put down his pen,
cannot be sucked so easily. Only two years after the *Rêve* and about
nine after *Le Neveu*, Diderot had already begun *Jacques le fataliste*, a
novel that opens with a series of questions to the reader, formally reminis-
cent of MOI's question to LUI: "How did they meet? By chance, like all
of us. What were their names? What do you care? Where did they come
from? From the closest spot. Where were they going? Do we know
where we're headed?" (Comment s'étaient-ils rencontrés? Par hasard,
comme tout le monde. Comment s'appelaient-ils? Que vous importe?
D'où venaient ils? Du lieu le plus prochain. Où allaient-ils? Est-ce que
l'on sait où l'on va?) The narrator's own answers, like the nephew's, lift
(as Hegel would say) these innocuous and empirical questions to vertigi-
nous heights, heights where only readers of Ecclesiastes and the gods can
properly breathe, and from which everything—identity, locale, all move-
ment, encounter, and striving—is reduced to indistinction and mere nomi-

Fig. 9. Jean-Baptiste Greuze *Broken Eggs* (1756) *Courtesy The Metropolitan Museum of Art, bequest of William K. Vanderbilt, 1920*

nalism, to an unnameable ALL, whose rushing and colliding fragments are
driven along beneath a cloud of unknowing. The sublunary collisions are
important: characters, narrators, and their words collide with things and
with one another, morally, physically, semantically, with a violence that
either fractures legs, makes heads spin, dents a mind and heart, or throws
a life, a story—or a reader—off course. Nevertheless, characters are apt to
seem, at least from the outside, and in spite of these misadventures, like
remarkably enduring objects: Jacques' head, for example, like a bruised
but unbroken pitcher, a "cruche . . . sans fêlure" (559); unlike objects
themselves, the milkmaid's pitcher, let us say, that smashes irretrievably
and reminds us of so many similarly ruined or scattered items in the paint-
ings of Greuze: mirrors, eggs, and the very same pitcher, things held in a
hand or on an arm, but morally attached to inner being.[9] In this novel,
where there is no dying; where, as part of an inscription on the allegorical
château of what I take to be Nature,[10] we read: "You were here before
you entered, and you will be still, after you leave" (Vous y étiez avant que
d'y entrer, et vous y serez encore quand vous en sortirez, 513); and where
pain is witnessed as a pratfall or absorbed as a contusioned shock, life and
death stage a subterranean and elusive battle. There are no victories here.
It is as if the various glues of power, desire, will, convention, habit, speech,
etc. held the oddly assorted yet complementary pieces together—and not
only the characters or the narrators and their listeners, bound in symbiotic
relationships, but consciousness itself, and consciousness and its world.
The characters are in fact metaphors for some ongoing, self-sustaining
process, including the workings of mimesis and its corseting traditions—a
steady state energized by the elemental reactions and affinities within its
own substance. Their names or personal identities are strictly adventitious.
It no more matters that the hostess's dog is called Nicole or that it is in
fact a dog and not a woman (as our travelers thought) than that the
Captain's friend duels, after the Captain himself disappears, with another
gentleman whose name may or may not be de Guerchy. The dog's bruises
and the fact of the duels, the acts, the signs of violence, agitation, dis-
junction, mistaken, mysterious, or absent identity are what score the
point.

Reunion and dispersion are indeed what this novel is about at one of
its ultimate levels, the one causally linked to the other, like the eternal
round of matter. It is partially in this light that, to be literal for a mo-
ment, the many incidents of real but pointless dueling can be understood.
The Captain (nameless) spars with his "friend" (also nameless), a friend
from whom he cannot separate without pining. But does he die? "Do
you think so?" (Vous le croyez? 731), the narrator teases, and it leads
him to consider as well the case of the abbé Hudson: "He is dead or alive,
as I see fit" (Il est donc mort ou vivant, comme il me plaira). Yes, the
comments are typically vengeful; yes, they tell us that Diderot, the
Creator, is in control, that this is after all fiction; but they also imply that
in the larger order of things the question is idle. Here only the encounter,

the momentary adhesion, and the disintegration count, and the relentless
rebirth of the Similar—or at least of a similar configuration, in the episode
of the "nailer" (cloueur) and the "nailed" (cloué). The Captain's friend
fights on, against either a phantom someone, anyone, or a certain "de
Guerchy," the gathered cloud of identity wafting about and potentially
precipitating its useless, evanescent charm. The special imagery of their
duels spreads a stunning sexual allusiveness over all the love-hate relation-
ships in the novel, as if Eros, that "little bit of testicle hidden in our most
sublime feelings" (un peu de testicule au fond de nos sentiments les plus
sublimes),[11] had worked its way into the thrust of every noble sword,
every word and longing. No lunge is fatal. And so we are not surprised
that dueling should surface again toward the end of the novel, but this
time with an unaccustomed and intentional finality, which will, I think,
allow Diderot his moment of climactic rage. After so many duels, literal
and figurative, a fist is purposefully clenched, and three people die. Die
for good?

Diderot has Saint-Ouin slain in the fitful jabs of two breathless sen-
tences that reflect the Master's pent-up fury; but the incident, which
begins with a break in one of Jacques' sentences and is symbolically
scored by the snapping of a horse's bridle and both the horse's and the
Master's scattering bolt from the fateful, bundled center of commotion, is
not so telling as the one involving Desglands. Desglands had, we remember,
fallen in love with a "beautiful widow," whose husband [sic?] remains
contingent or expendable but also strangely necessary. He is, we might
say, both dead and alive. (Diderot's oversight, if it is that, is an auspicious
blindness.) As such, he presides over a human as well as an institutional
desire for fidelity and union, and over its opposite, the inevitable dissolu-
tion of desire itself. His (widowed) wife has told him that she is incapable
of constancy, and he sagely submits, as does she, to the cosmic ebb and
flow of unity and collapse. Desglands, riding the crest of a wave and
lusting, in spite of all knowledge, for perpetuity, stays on long enough to
see his rival (unnamed) at a dinner party. The incident is so extraordinary
and yet passes so quickly, our minds drawn toward the emotions of the
players, that nobody has noticed the detail of raw eggs at the table. But
this is the lesser of Diderot's improbabilities. Watching his mistress as
she eyes his rival, Desglands, who happens to be holding an egg, smashes it
in his fist. By some anti-Newtonian principle, the contents land on his
rival's face; and this, in turn, like the impulsive slap of a glove, triggers a
series of duels in the course of which the rival is enfeebled to the point of
death and the widow dies of grief. Because the presence of the egg and its
behavior are unseemly, even defiant, Diderot's second "blunder" deserves
attention. Neither the crushing of the egg nor the yellow mess on the
rival's face are imaginatively fortuitous. Desglands's "convulsive move-
ment, occasioned by jealousy" (mouvement convulsif, occasionné par la
jalousie, 752), that is, by a necessary concatenation of desires, the
widow's and his own, destroys—after all of Diderot's ironically distanced

patterning, after so many "necessary" quid pro quos, weird but natural antagonisms and dislocations—the very symbol of ALL and its merciless unfolding. No reader of Diderot, who repeats the theme of infidelity in almost every work of the early 1770s, in his stories, the *Supplément au voyage de Bougainville*, and in his own letters, can fail to detect in this particular exasperation the final straw and solution, the masked expression of an irreducible wrath. (Like rocks that fall into dust, Diderot was ruefully fond of writing, our promises die and our affections alter: matter and feeling suffer similar change and for the same reasons.) But reading this egg—a mirror image of Lucretian eggs that "turn into live fledglings" (in pullos animalis vertier *[De rerum natura* 2.927]) and help us infer that "sense can be generated from the insentient" (ex non sensibu' sensus, l. 930), close cousins to the "Spinozist" egg that demonstrates the development of "living and feeling creatures" (un grand corps sentant et vivant) from an "inert body" (corps inerte)[12] —we know, even without these references and the eggs that open onto *Le Rêve* (pp. 267-68, 272-77), that eggs mean beginnings, or rather, beginning again. Diderot's egg may draw its biology from a materialist turn in the natural sciences, but the most affecting part of its meaning goes back to antiquity, or to Montaigne's version of it: "Both the Greeks and the Latins, and we ourselves, use eggs for the most express example of similarity" (Et les Grecs, et les Latins, et nous, pour le plus exprès exemple de similitude, nous servons de celuy des oeufs).[13] Not identity, but similarity touches the heart of the matter and provides, moreover, the key to the metaphoric structure of the novel. Desglands's gesture seeks to put an end to repetitions and replacements of any kind, to matter itself, to life and its feminine principle. Fittingly, he wears, as he repeatedly fights his rival, a round patch of black taffeta on his cheek and so plays the role of an Angel of Destruction to his rival's egg-splattered, life-marked presence, and to the widow's helplessly life-coveting and life-given desire. The black spot is also, clearly, the sign of his shame or ridiculousness; and as he cuts it back with each victory, he cuts into the paradox of natural as well as conventional expectation: diminishing his shame in order to "live," he annihilates nature and its contradictory accomplishments.

At this level of interpretation, the novel invites the most elemental or mythical reading. The tedium of the Whole, whole tellurian realities or teleological and linear fiction, impel their own smashing or fragmentation. "Death does not put an end to things"—so Diderot's beloved Lucretius— "by destroying the component parts, but by breaking up their conjunction. Then it binds them in new combinations and causes all things to alter their shapes and colors" (Nec sic interemit mors res ut materiai corpora conficiat, sed coetum dissupat ollis; inde aliis aliud conjungit, et efficit omnes res ita convertant formas mutentque colores, 2.1002-05). Every bonding and simultaneity—to enlist temporal events and even mental ones, thoughts held with equal and antithetical passion, that "rush forward, collide, and scatter one another" (se pressent, se heurent, et se

chassent, *Entretiens* 98)—temporarily and often desperately brackets an agitation of centrifugal energies. In Diderot's works, especially those of these later years, we have to do not only with a chain of being but with chained beings, lovers, soldiers, friends, speakers and their audience, masters and servants, the "cluster" (Diderot's term) of consciousness itself, all of which separate at their peril and may or may not be individually reborn again to locate a necessary and metaphoric replacement with which to coalesce. There is, in short, no rest; and simulacra of death struggle endlessly with the resurgent and profuse exhalations of life. It was J. J. Bachofen, the brilliant Swiss amateur of archeology, writing on "The Three Mystery Eggs" found on an ancient columbarium painting in Rome, who provided the archetypal clue to all of this—to Desglands's egg and its ancestry. Romulus and Remus, the sons of Oedipus, and countless other legendary pairs "at once hostile and friendly" figure, he says, "two opposites joined in a unity," like the egg, half black, half white, of Orphic-Bacchic mysteries celebrating the flow of life: two complementary and, we could add—thinking of Zeus dividing an egg in the *Symposium*—Platonic parts "yearning to be reunited," containing the *fatum* inherent in fecund matter, inherent that is in the symbolic egg or mother. And Bachofen quotes from Plutarch's *Isis and Osiris* to the effect that "there are two fundamental beings and opposing powers, one of which leads with the right hand and straight ahead, while the other turns about and leads backward."[14] These two beings are trapped, much to Jacques's annoyance, in his horse, which although constrained to advance straight ahead, uncontrollably, dialectically, and subversively sways its head from left to right and right to left. Polarities, human coupling, like the braiding and twining of the Eroses of life and death, or like Jacques's horse, cannot be undone or subdued, nor time and fiction removed from their successivity without preternaturally turning back, dispersing, splintering themselves, as it were, as they relentlessly move onward. *Jacques's* narrator alone can, at least partially, manage this by reversing or delaying his progression and by turning back upon himself, reflexively and self-consciously. But that Angel of Destruction, Desglands, cannot reach behind to unweave his and the widow's monstrous offspring from the tapestry of the novel in which, ironically, the boy precedes him. But destroying the once and future egg, he signals Enough! and leaves an imprint not merely of Diderot's anger, but of the destructive impulse that went into the shaping of the fragmented and digressive structure of the novel, composed, like Rameau's responses, to escape—it is, like Desglands's, a symbolic gesture only—from the confinement and predictabilities of what is inscribed in the scroll "up there" (là-haut), but also in the forms of novels and their readers down here. Dispersion or dislocations of semantic levels or texts, of narrative consciousness and tone, the smashing of a Whole, an egg or feminine principle of another sort, is the only "mortal" blow that can figuratively be dealt to fiction—the complement or blood brother of every sustained and vigorous anecdote or imitation that is, in the novel and by Diderot's standards, true

to "life." And this death, as we might expect, engenders only a different mimesis, true to the "life" of consciousness grappling with its own destructiveness and yet making fictions not unsimilar to those that came before it. We pore with special interest, of course, over the mutations.

As for the characters, it becomes apparent that the steady consciousness or self is doomed. People who can neither swerve nor split away from a given mind set, like Mme de la Pommeraye, Father Hudson, or even Desglands, fully formed chickens, with what Diderot would have called strong "faisceaux" or mental centers, have the resources of neither life nor destruction, but something nevertheless of both.[15] Attention (or language) long focused and strictly logical or coherent—it is Rameau's, Jacques's, Gousse's, and Diderot's secret—induces a kind of rigor mortis that victimizes more than the sinuous and often punishing give-and-take in the nature of things. In spite of his theoretical attacks on the tyrannical control of other "organs" of perception in *Le Rêve* and *Le Paradoxe sur le comédien*, Diderot's literary manner (as well as his social behavior rendered through the figure of Hardouin in the autobiographical comedy, *Est-il bon? Est-il méchant?*) proves the need, in the face of determining power networks, human and cosmic, indeed in the face of the consequences of his own thought, to digress and deviate by promoting alternate or residual impulses that fissure, multiply, and reissue the self and its realm of discourse.

Diderot's or Desglands's rage has, to be sure, an altogether amazing epilogue in the writings of Sade. But posterity, namely the twentieth century, bypassing or deliberately squashing Bachofen's dreamy mortuary eggs and the secularized Marian cults (Stendhal, Michelet, Comte, Flaubert, etc.) of the nineteenth, has unwittingly reached not only for the ideology of that rage and its esthetic of fragmentary disorder and reflexiveness, but for the egg itself. George Bataille, who embroiders on Sade in *Madame Edwarda* and prefaces it with these lines from Hegel: "Death is what is most terrible, and sustaining the work of death is what requires most strength" (La mort est ce qu'il y a de plus terrible et maintenir l'oeuvre de la mort est ce qui demande la plus grande force), gives eggs their unkindest jolt.[16] Simone, in *Histoire de l'oeil*, has undreamed of, actually fully oneiric and surrealist, recipes for their use. (Even Arrabal's *La Pierre de la folie*, which arranges eggs besides nuns, transforms them into iron spheres that threaten to bowl him down, into houses that blow away, heads of infants, circles on a belly, and above all, public and scornful eyes, cannot compete.) Simone breaks them spasmodically between her buttocks as she reaches sexual climax, she urinates on them in her bidet, she imagines her girlfriend in a bathtub half-filled with them, smashing them under her weight and mixing them with her urine. Jean-Luc Godard opens *Weekend* with a woman describing how she broke an egg between her thighs and enjoyed its slow, downward, mucilaginous drift. And even more recently, Alain Robbe-Grillet, in his *Glissements progressifs du plaisir*, has one

naked, dark-haired lesbian crack a bowl of eggs, one by one, over the navel of her reclining, red-headed lover. The room is empty, modern, and spotlessly white, so that any echoes of Courbet's magnificent canvas are muted. But what all of these wretched eggs have in common is their delicious vulnerability—the fragility of life certainly, and, in Bataille's words, "the imbecility of death" (l'imbécillité de la mort, 125), but more pointedly, the fragility of codes and taboos, whether religious, moral, cinematic, or literary. The sacred emblem of life and death or, more restrictedly, as in paintings by Greuze and Mieris or prints by Le Prince and Schenau, of virginity, sacred among these authors in only the social and therefore conventional sense, has to be defiled and eradicated to make room for an unrestricted, classless, or ethically unlabeled breath of life—or death. No breath, however, is a full one, since in the process and esthetically, in all four instances, short sequences create a hallucinatory, chaotic, ad hoc time. But this too recalls *Jacques*—and Diderot, who once wrote, in a piece called *De la durée du monde:* "If one considers the being of creatures in general, there is, for them, neither past nor future. Their being does not end, their being has no future. Their being is now" (Si l'on considère l'être de la créature en général, il n'y a ni passé ni avenir pour elle. Son être ne cesse point, son être n'a point d'avenir. Son être est maintenant).[17] When everything springs and unfurls its existence from within, imminence stalks the immanent, and breaking eggs affords no relief, only the theory of one. The single moment available to consciousness is now, and make what we will of it, it remains, as Cortázar knows, only a snapshot, to be arranged in some crafty and fragmentary mosaic, among others.

Notes

1. The full text of this citation is to be found in a neglected fragment published as an Annex to volume 9 of Diderot's *Correspondance*, eds. G. Roth and J. Varloot (Paris: Editions de Minuet, 1955-70), p. 246. Diderot is speaking of the way we judge character, but as usual he broadens the topic, here to include the subject of things intuited in oral or written language: "I think of certain words spoken or written as holes suddenly pierced in a door, through which I see the whole interior of an apartment, as rays of light that suddenly light up the depths of a cave and then are extinguished" (Je regarde certain mot dit ou écrit comme un trou percé subitement à une porte, par lequel je vois tout l'intérieur de l'appartement, comme un rayon qui éclaire subitement le fond de la caverne, et qui s'éteint). All translations are mine.
 2. References to *Le Neveu de Rameau* and *Jacques le fataliste* are drawn from *Oeuvres romanesques*, ed. H. Bénac (Paris: Garnier, 1959); to *Le Rêve de d'Alembert*, from *Oeuvres philosophiques*, ed. P. Vernière (1956); to *Entretiens sur le Fils naturel*, from *Oeuvres esthétiques*, ed. P. Vernière (1959). For Diderot's letters, I have used the Roth-Varloot *Correspondance* (see n. 1), henceforth abbreviated as CORR. The present reference is to pp. 398-99; all further references to these works by Diderot will appear, parenthetically, in the text, as will references to other works by him or by others, after their first citation.
 3. Valéry, *L'Ame de la Danse*, ed. Jean Hytier in *Oeuvres II* (Paris: Gallimard, Edition de la Pléiade, 1960).
 4. Julia Kristeva, "La Musique parlée ou remarques sur la subjectivité dans la

fiction, à propos du 'Neveu de Rameau,' " in *Langue et langages de Leibniz à l'Ency-clopédie*, eds. M. Duchet and M. Jalley (Paris: Union Générale d'Editions, 1977), pp. 153-206.

5. Only a yearned-for "sentimental" life and a strongly regulated art, about which Diderot theorizes in his *Entretiens sur le Fils naturel*, can, as Aristotle prescribed with quite another aim in mind, reduce this kind of polyphony to a plainsong and eliminate secondary "actions" that "cut into the principal action. . . . To mix two plots is alternately to stop each of them" (coupe[nt] l'action principale . . . et mêler deux intrigues, c'est les arrêter l'une et l'autre [p. 84]).

6. In major eighteenth-century authors, death is, for not entirely different reasons, thoroughly domesticated; rhetorically, sentimentally, or symbolically tended; compelled by an idea or fictional necessity; and deprived of the existential or metaphysical weight it had in Renaissance and baroque writers.

7. Whatever inroads progressive cultural history may have made in the eighteenth century, another kind of history, phylogenic and ontogenic, is being born, and it is already, like the dominant mode of moral history, cyclical, and like Christian spiritual history since Augustine, linear and evolutionary. The biological and earth sciences (Buffon, Maupertuis) invent their own hypothetical, ineluctable, but blind eschatology.

8. CORR. 9:154.

9. Greuze's paintings are, in themselves, fascinating reminders of a sentimental principle that we will soon see operative in Diderot's works: a momentary utterance or desire, an accident of being and behavior disrupts a plenitude that may never be restored. Scenes like those in *La Lecture de la Bible, La Bénédiction paternelle, Le Gâteau du roi,* and *L'Amour paternel,* where people come together and no unit, except mindless children, escapes the enveloping mood, alternate with portrayals of disorder and implied disjunction, as when girls lose or contemplate losing another kind of wholeness or integrity (in *La Vertu chancelante, La Cruche cassée, Le Miroir cassé, Les Oeufs cassés*) or boys violate family solidarity *(La Malédiction paternelle).* Most interestingly, for our purpose, the effect of the breakage may be associated with death—one's own or another's, as in *Jeune fille qui pleure la mort de son oiseau* and *Le Fils puni.* See also the tragic end of Thibault in Greuze's outline for a novel in pictures, *Bazile et Thibault,* published in Anita Brookner, *Greuze* (Greenwich, Conn.: New York Graphic Society, 1972), pp. 156-61.

10. In "Sens, contresens et non-sens: l'allégorie du château dans *Jacques le fataliste,*" a contribution to the Ira Wade *Festschrift* called *Essays on the Age of Enlightenment,* ed. J. Macary (Geneva: Droz, 1977), pp. 31-37, Jacques Chouillet argues, with Cartesian generosity, that the château may symbolize Truth and even, though less probably, the Literary Text. Before him, Francis Pruner had proposed that it symbolized the Earth. All three possibilities are good ones, even complementary. It is not unlike Diderot to *slip,* within the same narrative unit, from one intention, imaginative idea, or metaphor to another related one. If Chouillet cannot fully accommodate Pruner's interpretation, it is because he asks for a rational, interpretive coherence in the critic that may not correspond to the modulations—I am avoiding the term contradictions—of the text. There is, however, a metaphoric tenor or nexus that unites Truth, Earth, Text, and Nature: matter and language, and the forces within them.

11. CORR. 3:216.

12. From the article "Spinoziste" of the *Encyclopédie,* in *Oeuvres complètes,* eds. H. Dieckmann, J. Proust, J. Varloot (Paris: Hermann, 1975-), 8:328

Eighteenth-century egg lore can best be explored by first consulting A. Vartanian's *Diderot and Descartes* (Princeton, N. J.: Princeton University Press, 1953) and Jacques Roger, *Les Sciences de la vie dans la pensée française du XVIIIe siècle* (Paris: A. Colin, 1963). In the article "Oeuf" of the *Encyclopédie,* we learn that "most moderns are inclined to believe that all animals and men are engendered that way," that is, through one or another form of egg (the *oviste* theory), and that the ancients took the egg as their symbol of the world. We, still more modern no doubt, can only wonder that anatomists named Harvé (Harvey), Graaf, and Kerkringus as well as doctors named Olivier, Wormins, Bartholomin, Lauzonus, Bonnet, Rhodius, and Virsungius all gave witness to women who laid eggs—one, an entire "plate" of them, resembling a bunch of grapes!

13. "De l'expérience," *Essais*, ed. M. Rat (Paris: Pléiade, 1958), 3:312.

14. Bachofen, *Myth, Religion, & Mother Right*, trans. R. Manheim (Princeton, N. J.: Princeton University Press, 1967), pp. 27, 29.

15. Diderot uses similar words in his Encyclopedia article "Epicuréisme" (DPV 7:279) to describe the changeless, unbending gods of antiquity, who lead a "sterile existence" because they're missing an adaptive "principle of activity, which is the fertile source of all destruction and all reproduction" (principe d'activité, qui est la source féconde de toute destruction et de toute reproduction). Even the survival of the gods obeys a Darwinian principle.

16. Bataille, *Madame Edwarda, Le Mort, Histoire de l'oeil* (Paris: Pauvert, 1973), p. 6.

17. H. Dieckmann, *Inventaire du fonds Vandeul et inédits* (Geneva: Droz, 1951), p. 261.

Diderot is here viewing things, like Fontenelle's famous race of roses (which cannot remember the death of a gardener), from within the subjective experience of a finite consciousness. In the *Rêve*, as in the far earlier *Lettre sur les aveugles*, he moves dialectically from this restricted arena to an imaginative, heuristic transcendence. When Diderot rises to these hypothetical heights, his sense of time, human destiny, and death spans millennia and leads to the affirmation of either the deathlessness of philosophical and scientific testimony (see the "Prospectus" of the *Encyclopedia*, which addresses itself "TO POSTERITY AND THE BEING THAT NEVER DIES" [A LA POSTERITE ET A L'ETRE QUI NE MEURT POINT]) or the deathlessness of matter and natural production (see his article called "Production" in which there is "no absolute destruction [aucune destruction absolue] and the article, possibly not his, called "Impérissable," in which "the destruction of a thing has been, is, and will ever be the generation of another" [la destruction d'une chose a été, est et sera à jamais la génération d'une autre]). Consciousness celebrates its own imaginative reach and the mission of its artifacts or it notes, starkly, the confinement of. its prescribed precincts. A novel like *Jacques* registers both these inside and outside perspectives and from their conflict generates its thematic center.

PART 3

POETICS OF SERIAL LOGIC: BAUDELAIRE, NOVALIS, BRETON, BORGES, AND BARTHELME

Fragments on
Reality by Baudelaire
and Breton

ANNA BALAKIAN

A telling parallel can be noted between Charles Baudelaire and André Breton when they try to tackle the crucial notion of reality: they both falter into fragmental writing. Baudelaire's *Puisque réalisme il y a*[1] and Breton's *Introduction au discours sur le peu de réalité*[2] remain introductory, tentative, luminous in an irritating, flickering way, quotable but inconclusive. They both attest to the importance these two poets attributed to the question of reality as it relates to the functioning of the imagination.

In 1856, in a letter to Alphonse Toussenel, Baudelaire writes, "the imagination is the most scientific of all the faculties"; Breton in another fragmentary piece, entitled "Il y aura une fois," says that "the imaginary tends to become real." In both cases, unusual definitions of the imagination assign equally unusual connotations to the words signifying *the real*.

Baudelaire's context for the discussion of reality is Champfleury's theoretical stipulations about realism in art, particularly occasioned by the 1855 exposition of Gustave Courbet's paintings. With regard to "realism," Champfleury made it clear that he did not set much stock in the termi-

nology itself; he considered it "a word of transition which will not last more than thirty years [is] one of those equivocal terms which lend themselves to all kinds of uses that can serve as a crown of laurels or a crown of cabbage." Moreover, his disrespect for the word stemmed from what he called "the little taste I have for classifications."[3] The book of essays in which these comments appear is of 1857 vintage, the same year as the publication of *Les Fleurs du mal.* Whereas Champfleury's aim was to discredit the excessive use of the label, Baudelaire attempted to dislodge the word from its demotic meaning in order to give it a substitute meaning pertinent to the artist's creative function. By dedicating his poem "Le Voyage" to that other spokesman for realism, Maxime Ducamp, Baudelaire further confounds his reader in this demonstration of what makes a voyage not really a voyage. In fact, we see how the creative act of imagination receives and absorbs the impact that the dream has on ontological awareness. But Baudelaire's total incompetence as a philosophical theoretician impeded the development of his inherent, fundamental idea: that in the interstices between standard immanence of being and event and their transformations into unsubstantial ideals, the world of the artist can operate a system of correspondences which need not depend on supernatural interpretations. These correspondences could establish a reality in poetry between thought and the figurations of language under the control of the barometer of an interior climate. In Baudelaire's case the process was particularly successful in the Spleen poems where *linguistically* "temps" is identified as both weather and time, one visible, the other invisible, and correspondingly construct together "spleen and ideal"—that intermittence of the subliminal and the depressant for which Baudelaire did not yet have the kind of psychological terminology we have since acquired. Elsewhere, particularly in "Le Poème du Haschisch," where he is dealing with more concrete features of the transformers of the apperception of reality, he can make a more extended development of the process whereby the rational can be manipulated to create physical modifications rather than spiritual transcendences of reality.

But to come back to his naked, abstract fragment of a treatise on the subject, his inability to develop a systematic philosophy limits him to sentences, solitary if potent in their discontinuity. The admission of reality immediately draws attention to the need to deal with it, and not, as in the case of earlier romantics, to reject it. Perhaps the very fact that Baudelaire was seduced, in those poems grouped under the caption *Tableaux parisiens,* by the most grippingly lurid aspects of that nonrejectable reality, afforded him the greater elasticity which enabled him to spring back from the murky, humid, and putrid aspects of reality without having to land on the other side of the clouds!

In two articles in the series of the Salon of 1859 entitled "La Reine des facultés" and "Le Gouvernement de l'imagination" he remodels the word "realism" in a more explicit way than in *Puisque réalisme il y a.*

The imagination veers away from the domains of fantasy and instead its target becomes material reality: "It decomposes all creation, and, with materials amassed and distributed according to rules . . . it creates a new world, it produces the sensation of newness."[4] This is indeed the preliminary step to Breton's more drastic and frequently quoted statement identifying the imaginary with the real.

Some critics have mistakenly insisted that Baudelaire was hostile to the notion of "realism." Actually, he challenged the doctrinaires of "the natural" not with any kind of antinaturalist reaction but with his contention that they did not know what Nature truly was. If it means "the Universe without man," then, according to Baudelaire, naturalism is the archenemy of the artist. But if it means the representation of nature as man *really* sees it (the emphasis is Baudelaire's), according to his own nature, then realism takes on a new meaning or becomes a word with "double entente." In fact, we can add that it points to the future definition of "surrealism." Baudelaire explains his attitude by the analogy of the dictionary, which contains words but does not present them in any systematic fashion. It is the organic use one makes of the dictionary that is the creative act just as the selective choice of the elements of nature constitutes the poet's realism and gives him the audacity to say: "I want to illuminate things with my mind and project its reflection on other minds."[5] From what more direct source than this statement could Rimbaud have derived his own process of illumination?

The objectives of the defaulted treatise are easier to understand in the light of these two articles from the Salon of 1859. If in *Puique réalisme il y a* Baudelaire begins with the name of Champfleury it is because he realizes that this so-called spokesman for the realist school was distorting its meaning in his backhanded attention to it: "Admit, naughty child, that you are enjoying the general confusion." In fact, Champfleury had said that he would have preferred to speak of "reality" rather than of "realism": "If I inscribe it as the title of a volume, the fact is that having been adopted by philosophers, critics, magistrates, preachers, speaking of *reality* would expose me to being misunderstood." He went on to say: "I do not like schools, I do not like flags, I do not like systems, I do not like dogmas; it is impossible for me to park in the little church of *realism* even if I were to become its god." But with one foot in reality and the other in realism, as he pictured himself, he offered his own unconventional definition of realism. He could not imagine a so-called realist work which was meant simply to satisfy the senses. "The book is not made for the eyes but for the mind, the same holds true for all the arts: painting which appeals only to the eyes, music only to the ear, do not fulfill their missions."[6] To make his point, and perhaps to astonish his reader, Champfleury gave as an example of true realism a passage from Gérard de Nerval's *Les Filles du feu*.

So, Baudelaire is not very far from Champfleury when he includes the dream in his own notion of the englobing dimension of realism. And

in "Le Gouvernement de l'imagination" he elaborates on this view in connection with the distinction he makes between a good painter and a great one; the larger realism of the great painter includes the immaterial reality of the interior landscape exteriorized through the translation of "the language of the dream."

In *Puisque réalisme il y a*, Baudelaire's references to Champfleury are followed by several references to the works of Courbet, whom Baudelaire views as being an accomplice of Champfleury in the effort to attribute a delusive meaning to realism. Always considering poetry and painting as collaborative ventures that use related techniques, Baudelaire conjectures that a serious discussion is pending on what constitutes true realism in its application both to the poet and to the painter. When he launches his own consideration of the subject with the unexpected pronouncement "Every good poet is a *realist*" (emphasizing realist), he is reiterating Champfleury's statement that "it is impossible to admit that a writer whose whole life consists of developing the sensitive side, should deny aspirations toward reality of which he should be one of the most fervent adepts."[7] In fact, what they were both combating in their idiosyncratic use of the word "realist" was the burden of rhetorical embellishments heaped on poetry and painting. We might say that they were trying to peel the onion!

Although Baudelaire was not able to develop the subject in his fragmentary piece, he suggested that Champfleury's failure as a hierophant had not precluded further probing of the subject. Again, it is only in the context of the other two articles cited above that we can understand the most daring statement of the fragment, which otherwise would remain a paradox:

> Poetry is more real than anything else, what cannot be completely true except *in another world*.
>
> This world, a hieroglyphic dictionary.

It is easy temptation to relate these two sentences to the Swedenborgian philosophy which had such strong impact on romanticism; yet precisely what Baudelaire never explained systematically but implies in his articles on the imagination and asserts in his fragment on reality is his awareness that this "other world" of the artist in the mid-nineteenth century has already shifted its empire from the mystical to the human interior world of imponderable visions. Thereby Baudelaire envisages a system of hermeneutics according to which the signifiers are totally under the control of the artist as he projects them onto the white page or the exterior canvas.

The last statement in the fragment, given in parentheses and so tantalizing in its presentation as a project proposal, was, alas, never to be implemented. Simply, and gigantically, Baudelaire proposed at some

future time to undertake an "Analysis of Nature."

In his prose poems he came the closest he ever got to the development of this idea. In prose, he was less able to rely on the esthetic witchcraft of hypnotic word combinations and synesthetic word collages possible in verse. He had to satisfy his need for the transformation of a man-free reality into an artistically controlled one through more overt verbalizations, such as can be observed in "L'Etranger" or "La Chambre double." The images of the necessary transfer are less subtle here than in some of the poems, for instance the one in the Spleen series: "Je suis comme le roi d'un pays pluvieux," in which the substitution of a rainy Paris day by an interior image is made in terms of a young medieval king. (How misguided have been scholars in trying to identify the king as one in the succession of French dynasties, when the purpose of the poet was precisely to slip not only out of contemporary reality of day and month but also out of the specific range of kings and their ascertained solitudes!)

The fragment *Puisque réalisme il y a* itself, in its frank admission of Baudelaire's inability to deal with an ontological problem, is an important document, for it shows the obsessive concern of the poet with the subject of reality as an existential rather than exclusively esthetic matter. In this very rudimentary form, he threw the question to future poets even as a message in a bottle. It reached those poets of the French lineage who like him harbored epistemological ambitions, that lineage without parallel in any other sequence in the annals of poetry: from Baudelaire, to Rimbaud, Mallarmé, Apollinaire, Breton. It is indeed their grappling with this problem of the deeper meaning of reality that distinguishes these five French poets from all the literary schools which they may or may not have affected in their passage.

Baudelaire's piece was a concession to a word, to an esthetic movement, it was a deconstruction of a common signifier, an aborted philosophical treatise. Breton's fragment was an even more grandiose fiasco. It is called "Introduction" to a "discours" on the "peu de réalité" —this title projects a lengthy work, of Cartesian format, and a lesser concession to established philosophies: the attempt is not to play with the meaning of "reality" but to minimize it. Its intent is of a more ontological nature—the word used is the more comprehensive "reality" rather than "realism," and thus refers to a more comprehensive connotation. The title promises an aggressive confrontation with accepted concepts rather than a discussion of literary terminology. The attitude conforms to the fundamental surrealist need to challenge traditional values and cognizance. Dated 1924, the year of the first surrealist manifesto, it was not published until 1927 (a reprint appears in *Point du Jour)* and was obviously retouched in the interim, as there is a reference in the text to 1925. In the manifesto Breton refers to the yet unprinted work and bids his friends to destroy the entire edition of the *Discours* at his death. These surprising instructions would seem to suggest his dissatisfaction

with the unfinished, tentative, disorganized piece of writing. Or was the subject so close to his being that he had to take it away with him to the grave?

One would have assumed, indeed, that Breton would have been more successful in dealing with a theoretical subject than was Baudelaire. His academic training was more rigorous and certainly more oriented toward the process of rational scientific thinking even in the treatment of irrational subjects. Of course, those who know the totality of Breton's work are aware of the fact that in his most theoretical book, *Les Vases communicants*, in his semitheoretical prose, *L'Amour fou*, and in his ideological manifestos, there is an absence of logical organization. Robert Champigny has cleverly demonstrated the point in his "Une Définition du surréalisme" in *Pour une Esthétique de l'essai*. But it might be argued that we do not go to Breton for logic; what grips the reader is the passion, the combative spirit of the piece, the erethism of the rebellion in an era that was noted for its passive anxieties or its ideological rigidities.

Actually Breton's treatise on reality begins with an image of something real but imperceptible: "Sans fil"—the wireless, functional without being visible; was it not the perfect illustration of what he was defining as "surrealist"? The wireless was in fact one of the scientific miracles of the historical moment in which he was writing. The age of the radio, unreal in terms of previously admitted realities, yet not fantastic—in fact a brilliant example of "the imaginary that tends to become real," a superior form of reality, perhaps, but a reality nonetheless. The analogy between the radio-wireless and the poet's reality put him in league with the scientific searchers on the brink of adventure; and taking the analogy one step further he associated them with the ancient searchers for gold—but not for tangible gold; had he not just learned from the invention of the wireless that something can exist without being visualized? His own search would be for an intangible gold: "the gold of time."

"I am searching for the gold of time" becomes the fragment's crucial and syntactically simple sentence, which was later to be engraved on Breton's tombstone. He had affirmed that there were levels of awareness and that the unperceivable need not be relegated to the other side of the rainbow.

The theme of *quest* leads Breton to identify himself with Theseus, but his passage through the labyrinth needs no thread; it is indeed "sans fil"; nor is the journey undertaken in darkness, for the labyrinth is made of crystal. The process, which was to be used often by Breton in future writings, consists of taking an old and recognizable image and, instead of developing it, producing a mutation that belies its recognized properties. After destroying the image familiar to his readers he reconstructs it in terms that contradict the major quality of the standard image. In this case the labyrinth of darkness and confusion turns into an illumination and a state of liberation from strings. The process is analogous to Baudelaire's transformation of the old concept of *realism* into something quite the op-

posite of the generally accepted definition.

In Breton's case we proceed to imagination "sans fil," i.e., free of the bonds to what is attestable. Its essential power is to shake man out of the unavoidable givens which control his life. Was this not preliminary to Breton's own proclamation of rebellion against the slavery of the routine life and its invariants in *Nadja*, which was composed shortly after the first draft of the *Discours?*

After the theme of "sans fil," the inner landscape changes as if it were the transcription of a dream, and the poet penetrates into a castle where, with a light that is not very bright, he illustrates the notion of "l'or du temps." The voyage outside of the reality of the given data takes him to an ancestral epoch in which he attempts to experience a form of atavism to prove the flux of reality but discovers instead that imagination falls short of the power to modify the image which the mirror reflects: "Imagination has every power except that of identifying us in spite of our appearance with a character other than ourselves."

Again, the philosophical question in Breton's mind is cast in metaphoric form: can the concrete armor one may fit to size interchange personality? The answer is no. What ensues could have become a dialectic of essence and existence such as one can read in the dialogues of Yeats and Valéry. But in Breton's case the problem is quickly dissolved into a rhetorical distinction between substance and soul; the verbal expression of *absence* occurs through the use of the preposition "sans," placed before nouns denoting the substantial properties of the body and/or of its environment. The concrete designations and their verbal cancellations give a sense of the meaning of "soul" in the contradictory attributes of existence and nonexistence linked together.

Breton realizes that the leap of the imagination is of short range as he admits himself to be a creature of habit, pinned down to certain unavoidable contacts with reality. It is with horror that he faces the dearth of unexpected coincidences in the average life style from which he is not exempt in spite of the assistance of the dream.

But the treatise, which at this point might well sound like a proof of the persistence of reality rather than of its paucity, resumes an ascending sign, which in the years to come was to be the characteristic direction of Breton's philosophy of life. He asserts his own particular *cogito, ergo sum* in the figurative presence of an instigator against apathy whom he calls "ma pensée." Vigilantly it monitors the poet, patiently listens to him so that he in turn feels obliged to give an accounting of his passage. Characteristically he uses the word "pensée" rather than "esprit" because of his preference for the feminine genre of the word, which he highlights by using henceforth the pronoun "elle"; thus the feminine principle guides him from darkness into light—a procedure which was to prevail throughout his life. And if at the end of this brief passage we have the impression that he is still very much the slave of a dominating reality, the imperial factor controlling his state of mind

has the agreeable appearance of a "sad queen."

Lapsing again into the dream, this time he transcribes a shipwreck; the splendors and the retrieved debris of the dream are brought back to everyday cognizance in a coffer whose key is not in his possession. We pass from the point of view of the dreamer to that of the viewer of the dreamer, whose apocalyptic visions are shared with an illusionary partner.

Without transition Breton proceeds from the particular dream event to considerations of the general power of mystification; this in turn leads him to the identification of the greatest of all mystifiers, the poet. Poetry is then characterized as the perennial negation of *nature*. "Nature, elle nie tes règnes." It is interesting to note that as an example of the antinaturalist Breton evokes Gérard de Nerval, who was classified as the supreme realist by Champfleury. But this is a contradiction of words rather than of ideas, for Breton's notion of the antinaturalist is virtually synonymous with Champfleury's and Baudelaire's notion of the realist. Breton asserts that the use of words delimits our realities, and that the current mediocrity of our universe is due to our clumsy use of them. Were we to set the words free, we would eliminate our own bondage.

At the end of his ideological meanderings Breton associates his rejection of reality with notions of the millennium. He foresees the emergence of the Orient which, by demolishing the dominant Latin civilization (he is speaking in the 1920s), would create the possibility of an illogical determination of reality. Failing a philosophical conclusion, defaulting in his literary representation of the "peu de réalité," Breton moves to the sociopolitical plane; in this early, disconnected piece of writing he already gives clear evidence of his vision of the inseparable union between the new literature and social revolution.

The fragment in this case is long-winded, unlike Baudelaire's telegraphic style; it is a veritable maze of associative stream of consciousness, with peaks of exaltation and depths of frustration. It is a search for a formula, and in spite of Breton's initial declaration that he is a Theseus in a crystal labyrinth, we see him tapping half-blindly, intuitively, on a vague terrain where dream and cognizance are linked together through nothing more than the miraculous string of language. For if the "peu de réalité" becomes invaded with the reality of the dream, the pact is not logically persuasive even if verbally ascertained by the exercise of the poet's own brand of nonlogic: with the claim that the existence of things depends on what he calls them.

In the total body of Breton's work this early fragmental attempt to tackle a very large and gnawing ontological problem is perhaps significant only for the quotable "Je cherche l'or du temps," for most of the ideas were to be more clearly enunciated in subsequent writings. Yet, it is also an interesting piece of writing for the prophetic insight into the poet's development. If in this piece Breton deplored the dearth of natural coincidences in life, he was to show in the ensuing years in his important analogical[8] prose works, how the imperial factor of his thought was to

effect coincidences provoked by the author in a form of writing indeed suggestive of wireless telecommunications.

What do these not-so-distinguished fragments by two of the most important poets of their times tell us about the unfinished literary text?

I think that whatever conclusions we would be tempted to draw from them would be as fragmental and inconclusive as the texts themselves. Neither poet produced a Schubert's Unfinished Symphony! Both illustrate T. S. Eliot's statement (made in an article on Dante): that philosophy in a poet's writing must needs endure virtually a physical modification. We have here two good examples that poets who aspire to philosophical thinking diminish themselves as poets, and we can observe that the poet who defaults in the process of trying his hand at a genre alien to his talent is victorious in the fact that he can only produce a fragment. But ironically, Baudelaire and Breton left within these otherwise minor fragments some of their most quotable aphorisms—thus the works have a reference value which they would otherwise not have merited.

We find here no self-indulgent preservation of leftover random thoughts. Instead, in each case there is an obsessive concern for what each poet believed to be a legitimate objective of poetry: the epistemological search, the desire to redefine reality. If for more substantial illustrations of Baudelaire's and Breton's fundamental notions on reality we have to go to more elaborated texts, the inconclusive character of efforts at definition of reality/realism could have found no format more suitable than the amorphous, unedited, and open-ended medium of the fragment.

Notes

1. Baudelaire, *Puisque réalisme il y a* in *Oeuvres complètes* (Paris: Pléiade, 1954), pp. 991-93.
2. Breton, *Introduction au discours sur le peu de réalité*, in *Point du jour* (collected essays) (Paris: Gallimard, 1934).
3. Champfleury (Jules Husson), *Le Réalisme* (Paris: Slatkine Reprints, 1967). p. 5. Originally published 1856. This and all other translations in this essay are mine.
4. Baudelaire, "La Reine des Facultés," in *Oeuvres complètes* (Paris: Pléiade, 1951), p. 773.
5. "Le Gouvernement de l'imagination," p. 780.
6. Champfleury, *Le Réalisme*, pp. 2-3, 105.
7. Ibid, p. 190.
8. A term I coined in my book, *André Breton: Magus of Surrealism* (1971) to describe a form of prose where narrative sequence is replaced by the movement of analogical thinking.

Fragment and Encyclopedia: From Borges to Novalis

WALTER MOSER

To deal adequately with the fragment as a topic we must consider the concept of totality. From Plato *(Parmenides)* to Kant, in the "Antinomies of Pure Reason" *(Critique of Pure Reason),* our philosophical tradition has seen this problem in binary and even dialectic terms: the multiple and the one, the parts and the whole. To fragment, to make a fragment, to leave something in a fragmentary state are meaningful gestures only when opposed to the act of totalizing. They can be understood as a loss of totality, as a rejection or an incapability of totalization, or as a deferred and dialectic way of totalizing. Thus the fragment, over the centuries, has been variously seen as the antagonistic term for a whole series of objects, concepts, and fantasies that all imply the project of a written whole. Be it a book, a poem, a novel, an encyclopedia, or a library—it stands for the utopian project of achieving a totality through writing.

More than any other modern author, Jorge Luis Borges has dealt with virtually all the themes of totalization by developing them in conflict with the forces of fragmentation. A critical look at his "bestiaire" of the totalizing fantasy will serve as the starting point for this inquiry into

the relationship between fragment and encyclopedia.

After I discuss the generic program of the encyclopedic undertaking, as a continuing and never-ending project, I will focus on German romanticism because its authors have developed a special interest in both the fragment as a literary genre and in the encyclopedia as a totalizing system of knowledge. Novalis, and particularly the fragments of his unfinished encyclopedia, are at the very center of this special configuration.

My decision to move backwards in time, from Borges to Novalis, thus practicing to some extent an "archeology" of romanticism, is motivated by the hypothesis that there exists a romantic paradigm which, with some significant alterations, has become the paradigm of modernity.

Jorge Luis Borges: Fantasies of Totalization

Although it would not be quite accurate to say that Borges writes fragments, his short stories in *The Aleph* as well as in *Fictions* do have a fragmentary character.[1] They usually begin with a mysterious event or with an enigma of some kind, which is then developed on two levels. On the episodic level of the narrative action, the initial problem is usually solved and the narrative concluded. On the level of reflective thought, the mystery—manifested as the thinking either of one of the characters or of the narrator—acquires the dimension of an infinite and insoluble philosophical question. It is this ambivalent balance between the open-ended and the concluded that Borges's narrative pieces share with the genre of the fragment. To it, we have to add an even greater ambivalence that results from the contrast between the short, quasi-fragmentary narrative forms and their thematic content of totalization. This content is the common denominator of the five stories I shall briefly consider here: "The Library of Babel" (LB), "The Aleph" (AL), "Tlön, Uqbar, Orbis Tertius" (TU), "The Writing of the God" (WG), and "The Garden of Parting Ways" (GP).[2]

These stories constitute an encyclopedia of the thematic, tropological, and narrative fantasies of representational totalization that our culture has accumulated over the centuries. The list of these fantasies contains, for instance, the divine word which is completeness and "cannot be inferior to the Universe or less than the sum of time" (WG, A118). Another version is the inextricable, endless, "chaotic novel" (GP, F107) whose author makes the novel infinite—that is, like a labyrinth—by simultaneously choosing all alternative narrative crossroads and following all possible unravelings of the plot. Twice, and in quite different contexts, Borges mentions the circular or cyclical book in which last page and first page would be identical and lead to an indefinitely repetitive continuation of writing and reading (LB, F86 and GP, F106). Then we have the encyclopedia that is the total representation of all knowledge; it is the proof that man, like god, is "able to conceive a world" (TU, F30). Finally,

there is the total library containing all the books that have existed, that exist now, and that can possibly exist (LB, F90).

"The Library of Babel," to take but the most extended example, is a fantasy structured entirely on the principle of "variations with unlimited repetition" (LB, F89). It is a treasure of completeness:

> When it became publicly known that the Library contained all the books in existence, there was at first a reaction of overwhelming happiness. Everybody had the feeling of being the owner of an intact and secret treasure. There was no problem— of either a personal or a general nature—that would not find its eloquent solution. (LB, F90)

In the fictional reality, this library is a given totality; it just exists. It must have been created "once upon a time," yet the process of its construction is not narrated. Thus, it has neither an individual nor a collective author. Borges devotes many pages to its description: all the books are different; they are made from all possible combinations of 25 typographic symbols with 410 pages per book, 40 lines per page and 80 symbols per line. The architecture, on the other hand, is an infinite repetition of the same combination of a few basic elements.[3] The endless juxtaposition of hexagonal galleries produces an edifice of unlimited spatial and temporal dimensions.

As a product of cumulative (endless addition of the same elements) and combinatory (combination of a set of basic elements) summation, the library lends itself to precise and technical description. As soon as Borges considers the inhabitants of this gigantic maze, narration comes into play, as stories are told about the activities that have taken place inside the library over the centuries. For example, there is the endless search for the key book that would give the reader divine knowledge of the whole: "People were arguing that, in some shelf of some hexagon, there must exist a book that would be the cipher and the compendium of all the others" (LB, F92). This particular book—it is called "el libro total" (LB, F95)—presents a new kind of totalization. This "total book" is not a mere addition and combination of elements but also a key to the global ordering, to the set of relations that determines the structure of the library. Put in paradoxical terms, it is a part of the library yet it contains all of it. This book has not been found, however, and although "somebody has proposed a regressive method" (LB, F92) of finding it, the narrator believes it to be a mere superstition. In fact this method implies a process of searching through references from book to book in the endless chain of an intertextual *mise en abyme* or recursion.

At this point we start to see the negative side of this treasure. We always see man within this labyrinth of books; he is never the author but always only the interpreter. He never succeeds in finding the key book, in fully grasping or understanding the whole of the library. Within the

total surrounding structure, his intervention is always fragmentary. His life span might allow him to move a few hexagons away, but his effort is endless and unproductive. Introducing human beings into this perfect and total system leads only, on the level of the narrative imagery, to fragmentation through limitation, and ultimately conflict and madness. On the level of logical structures the system produces paradox, *mise en abyme*, and the Hegelian "bad infinite." The library, with its mathematically and architecturally well-ordered interior, then, turns out to be an Escher-type space, a maze, and even a prison.

In spite of a rather pleasant fantastic and playful atmosphere, the text is ultimately dominated by the negative. However, the use of the metaphors of the circle and the mirror partly counteracts this negativity. Both metaphors appear frequently in Borges's texts and could—in Charles Mauron's terminology—be labeled "obsessional metaphors."

The circle traditionally expresses perfection, but perfection through closure. In the circular movement the ending always coincides with the beginning; thus the closed space of totality is created. Tracing the circle of knowledge is the original meaning of "encyclopedia." Borges attributes to the mystics the realization of the book as a circle: "a huge circular book with a continuous back that runs all around the walls" (LB, F86). This circular book functions as a totally closed system. It imprisons any human subject who enters it, be it as character, reader, or interpreter. A life in an immense circular maze, or book without any outside opening, and a life limited to a fragmentary perception and knowledge of the world, such is Borges's figure of the human condition.

Nevertheless, there are moments of ecstasy, exceptional moments of total awareness with a global vision of the universe. Such moments are usually manifested as absolutes in time and space, paradoxical moments or points of total expansion allowing the smallest fragment to engulf the whole. The Aleph, for instance, is "the point in space which contains all points" (AL, A160). Looking into or through this point permits the narrator to experience a total and simultaneous vision of the universe.

> In this gigantic moment I saw millions of delightful and atrocious acts; none of them overwhelmed me as much as did the fact that they were all occupying the same point, without being superposed or transparent to each other. What my eyes saw was simultaneous. (AL, A164)

This "gigantic moment" constitutes the center of the story, but Borges qualifies it as "the ineffable center," the "beginning of his desperation as a writer" (AL, A163). This total vision becomes a nightmare when an attempt is made to reflect it through writing. Here the theme and metaphor of the mirror come into play.[4] The principles of repetition and difference are introduced. Given an original reality—for instance, the experience of the Aleph—the language mirror can duplicate it by producing a

copy. The copy, however, is never identical to the original and is onto-
logically inferior. What is figured in this specular trope constitutes the
basic problem of mimetic representation. The subject of the Aleph expe-
rience is aware of a radical problem that makes it impossible for him to
shape the total vision in writing. He speaks of a twofold difficulty: "What
I have seen with my eyes was simultaneous: what I shall transcribe, succes-
sive, because of the very nature of language" (AL, A164). How can the
predicates "simultaneous," "total," "perfect," be translated into the order
of discourse whose predicates are "successive," "fragmentary," "imper-
fect"?[5] "Moreover, there is no solution to the central problem: how to
enumerate, only partially, an infinite ensemble?" (AL, A164).
Enumerative discourse—and somehow human language, the raw material
of discourse, is by nature enumerative—will never be able to capture the
infinite.[6] Compared with a total and infinite reality, language as a means
of representation will always produce only a fragmentary copy, an ap-
proximation of something that remains beyond its reach.

Such is the basic dichotomy implied in the metaphor of the mirror.
But Borges further elaborates it through repetition and inversion. The
first is the *mise en abyme* process of specular relations. The second is
more radical: it questions the possibility of a clear-cut distinction between
the original and its copy. The difference between a given reality and its
representation may become indistinguishable. Borges indulges in all kinds
of textual games in order to invert and subvert the ontological hierarchy
underlying representation. The reader is thereby continually led to ask
such questions as: What is true, false, fictional, imaginary, or real?
Is the world a book or is the book a world? All these questions remain
unanswered. Borges likes to conclude his texts with this ontological un-
certainty.[7]

One example of this major question appears in the very first sentence
of "The Library of Babel": "The universe (which others call the Library)
is composed of an indefinite, and maybe an infinite, number of hexagonal
galleries . . . " (LB, F85). Is the universe (like) a library, or is it the other
way around? Another example is the dramatic center of "Tlön, Uqbar,
Orbis Tertius": the story of the puzzling inversion of world and encyclo-
pedia, original and copy, creation and representation. Here again, the end
of the story brings only an interruption and no solution to the specular
game, with its inverted positions, which ideally goes on indefinitely.

Borges's short fictions are an intellectually intriguing and esthetically
pleasing way of playing with mirror and circle. But they also have a des-
perate aspect: on the conceptual level, they always reach the aporia that
underlies the attempt to produce a total human text. As logical construc-
tions they lead into the cul-de-sac of the paradox and its corollary, the
"bad infinite." Borges's self-conscious, but also self-defeating, narrative,
in undertaking to capture this endlessly totalizing process, adds but one
more level of consciousness to the open-ended *mise en abyme* of text
performance and philosophical reflection. The stories deal with the break-

ing up of the perfect circle—a perfection postulated on the thematic level—into the fragmentary moments of an endless specular process. At the same time, Borges's short fictions themselves interrupt, and therefore fragment, this continuous mirroring process by bringing it to a close in the circularity of the text. To break this kind of closure, one more story will have to be told, with different characters, historical and geographical background, but with the same set of obsessive themes, metaphors, and logical problems. There is no final synthesis in this formulation of the dialectic of fragmentation and totalization: this is the negative aspect of Borges's work. Yet the storytelling has to go on. Philosophical aporia translates into narrative creation: this is its positive aspect.

Encyclopedia: The Persistence of a Project

This self-conscious mode of creating fiction has much in common with the romantic heritage. It sounds like an epilogue to two romantic projects that are closely related to the romantic theory of transcendental "Universalpoesie,"[8] the novel and the encyclopedia; both are versions of the totalizing text. I shall restrict my investigations to the encyclopedia—thus I may focus on one single object of total representation, probably the most persisting one in our history, and at the same time broaden the perspective, as encyclopedia entails and develops in an interdiscursive context all the fantasies which, in Borges's short stories, are limited to literature.

Before turning to an actual romantic text, I shall approach encyclopedia first on the abstract level of its rudimentary generic rules.[9] Ideally, the encyclopedia includes three different elements: System, Map, and Dictionary. System and Dictionary exist in a relation of complementarity. The Dictionary constitutes the main body of the encyclopedia. It is a collection of single units, called articles, each of which sums up a fraction of the total knowledge represented in the whole work.[10] These articles are usually written by specialists, in their corresponding discourse practice,[11] and put together in alphabetical order of subjects. The Dictionary, then, is a heterogeneous, heteronymic, and fragmented text. It represents the result of the breaking down of the total amount of knowledge and information into units that are manageable for the reader.

The System is a radically different kind of text, having a quite different function. It is usually written by a single author, usually in philosophical discourse, and it is continuous and homogeneous. It assumes the systematic ordering of the materials accumulated in the Dictionary by establishing a network of relations that accounts for the coherence and unity of the whole work. In a complete encyclopedia, the System occupies only a small part of the whole in terms of text volume. It might be contained in only one of a great number of articles, or figure as a preface, as in the case of the "Discours préliminaire" written by D'Alembert. But, since it proposes the englobing network for the whole work, it

represents the paradoxical case of a part that contains the whole.

The Map is, so to speak, the System presented in a synoptic table.[12] Given the complementarity between System and Dictionary, this third element would seem to be but a duplication of the System, and therefore superfluous. In reality the Map is an important part of encyclopedia, and differs fundamentally from the System, as it presents the totality of the System through a visual synopsis. This is a new kind of representation, a pictorial one, which frees the author of the Map from the necessity of translating totality into the successive order of discourse. Ideally, the Map would be a one-page encyclopedia that presents in synoptic form the equivalent of many volumes of writing. This is, of course, a fantasy which, although—or because—it has never been realized, has remained in the mind of many an encyclopedist over the centuries. It corresponds to the fantasy of the divine glance that embraces everything at once. Going one step further, namely reducing the table or page to a single point, we have Borges's Aleph.

None of these three elements alone makes an encyclopedia. The act of assembling in one place all knowledge, namely all existing books, as in the Library of Babel, would result only in the constitution of a collection of material, albeit the most complete one imaginable. This collection would only become an encyclopedia if somebody would write or find the key book which contains the System or the Map of this immense library. Hence the endless search, in Borges's story, for such a book. Neither can the System alone be taken for an encyclopedia, as it gives only an abstract network of relations with empty spaces to be filled in by concrete materials.[13] It cannot be consulted for any specific knowledge. Because it is usually written by a philosopher, in philosophical discourse, it is not accessible to the general reader. This is even more true of the Map which, if realized, would be the text that could only be read in an adequate, that is simultaneous, way by a genius or by God.

There are two conceptual dichotomies that come into play in any encyclopedia. One is (in Kantian terms) the opposition between system and aggregate, and the other the opposition between knowledge as a closed inventory on the one hand and as an open process on the other.

The first is implicit in the distinction between System and Dictionary. It proposes two different ways of conceiving the process of totalization. This process can be a cumulative one, consisting of an infinite series of basic elements which are added by mere juxtaposition. In this case, what is produced may be a complete collection, but its units are only fragments so long as they are not integrated into a unifying system. According to Queneau, this is the "storehouse conception" of encyclopedia. Or it may be a synthetic process, carried on in what Queneau calls the "real encyclopedic spirit." The quality of the encyclopedia depends then on the coherence of the system, which, in its turn, is guaranteed by the density of interrelations between the concrete units.[14]

Secondly, the totalization of knowledge can be conceived either as a

complete and closed inventory of all past and present human knowledge, or as an open-ended process than can never be concluded. In the latter case, the totalization of knowledge becomes an activity that is always in progress, and each totality of a given historical moment is then only a fragment of a totality to come. The making of the encyclopedia has to follow the progress of knowledge and becomes itself a historical process. Indeed, according to Diderot, even the writing of the encyclopedic text will go on improving indefinitely. He explains eloquently how much better the second edition will be than the first, thus introducing into encyclopedia a consciousness of its fragmentary nature and a utopian dimension.

There are two more dichotomies which, in a very broad sense, are concerned with the social function of encyclopedia and might therefore carry political and ideological connotations.

Should the encyclopedic text be considered the accurate representation of a given reality or rather as the construction, the modeling of it? Borges, as we have seen, "resolves" this alternative into an insoluble problem. Either the encyclopedia is the result of a mimetic activity, in which case its internal order would have been derived from an order outside itself: world, nature, universe. This mimetic strategy is ideological insofar as it masks the arbitrariness of the encyclopedic order, which has to confirm the established social order. Alternatively, one could not only assume this arbitrariness, but also see it as a creative force. Encyclopedia would then not reproduce the order of a given reality, but produce a new one, or at least offer the ordering principles capable of modeling reality. It thus becomes pure *poiesis*, an innovative and creative activity that proposes not what is, but what can be and is going to be; not a *speculum mundi*, but a model of the world.

A last dichotomy appears if we look at the discursive system that underlies encyclopedic totalization. Encyclopedia always includes a plurality of discourses, yet how do they relate to each other? On one hand, they might reproduce—and by doing so respect—the units of discourse practice as they are given by the social and institutional order. In this case the encyclopedia contributes to the legislation of this order. Its impact is a stabilizing one, because it helps to establish the jurisdiction of each discourse by determining its objects, concepts, methods, and its pragmatic insertion into social action. All the existing discourses thus confirmed by the encyclopedist are interrelated in a complex system but do not interfere with each other. But on the other hand, the encyclopedist can take advantage of the fact that he is producing a text that embraces a variety of discourses, and establish a dynamic relation among them: exchange, interaction, conflict. He engages then in an interdiscursive practice that operates across established discursive border lines, has a destabilizing effect on discursive legislation, and, as an experimental activity, has the potential to transform a given discursive system.

The different features and choices I have enumerated certainly do

not constitute the complete generic picture of encyclopedia. They fall short of establishing the perfect formula of a genre and therefore of accounting for all past, present, and future encyclopedias. Nevertheless they are general enough to come into play in any encyclopedic undertaking, and give us an instrument with which to approach an extremely difficult text, the *Brouillon for an Encyclopedistic* by Friedrich von Hardenberg, alias Novalis.[15]

Novalis: The Romantic Version

What the German editors have entitled *Das Allgemeine Brouillon, Materialien zur Enzyklopädistik 1798/99*[16] is a sketch of what would have been the most complete but also the most puzzling of encyclopedias, had it ever been finished. The *Brouillon* is a collection of 1151 entries of extremely uneven elaboration.[17] It is one of the most difficult texts imaginable. Its material constitution—a heterogeneous ensemble of fragmentary reflections on all kinds of topics—does not justify its status as a single textual object. Indeed, by having been treated and edited as a single text, the materials of the *Brouillon* have raised considerable difficulties. Be they Wasmuth, or Kluckhohn and Samuel (in collaboration with Mähl and Schulz), editors have always been confronted with what they felt to be its unacceptable fragmentary nature.

We have to separate Novalis' *Brouillon* as an unfinished text from those fragments that Novalis wrote as such for publication, for instance in the *Athenäum*. It is this incompleteness that most editors and critics cannot accept. They resort to totalizing strategies which they impose on this scandalously heterogeneous textual material—usually claiming to have found them in it—in order to make it fit their own implicit definitions of the work or of the text.[18] The hermeneutic category of intention is usually invoked to provide the loose aggregate of textual pieces with a conceptual unity, and thus to neutralize its unbearable nature. This manipulation is necessary, to a certain degree, as a text becomes the object of a cognitive operation. All collections of fragments or of unfinished texts undergo this treatment in the process of being edited or interpreted.

The instinctively defensive attitude of editors and critics toward the textual pieces of the *Brouillon*, and their insufficiently considered impulse to give them the status of a unified textual object, symptomize a fundamental aspect of the fragment as perceived in our philosophical and literary tradition: the fragment is some kind of a conceptual monster. It is a scandalous phenomenon because its very existence radically challenges the cognitive categories (order, unity, identity, etc.) as long as it has not been integrated into a totalizing scheme.

Of the editors of the *Brouillon*, Wasmuth was the most eager to impose on it a unifying conceptual scheme.[19] Even the editors of the *Schriften* who, according to Wasmuth, chose to reproduce the *Brouillon* in its "natural chaos," formulate the hermeneutic necessity of taking into

consideration the appropriate global context in order to get on the right interpretative track.[20] I instead prefer to bring out the textual order of the *Brouillon*, even though this order may appear in a fragmentary and uneven form. My aim is not an interpretation,[21] but a description of that textual order, and I shall try not to be troubled by either its incompleteness or its chaotic appearance. This attempt, of course, has to face up to the challenge any fragment poses to any rational discourse.

Novalis's encyclopedia grew out of an extremely intense concern with contemporary scientific discourses. Most of the entries of the *Brouillon* are more-or-less direct commentaries on—and elaborations of—Novalis's scientific and philosophical reading. It was an undertaking with one specific goal: to totalize by producing an interplay of heterogeneous elements, or, to use one of Novalis's preferred metaphors, taken from the discourse on chemistry—to "mix the heterogeneous." As this entry states: "We owe the greatest truths of our day to the contact whch has been established between the members of a Total Science which have been separated for a long time" (199). I propose to call the members or units Novalis mentions here "discourses." His encyclopedia would then be the textual locus where this truth-generating contact of discourses could become a systematic and dynamic practice. It is, thus, a gigantic inter-discursive experiment. It consists of the cutting out of fragments from the surrounding discourses and their encyclopedic redistribution.

Many entries deal with the textual and even the material objects in which this experimentation would have to take place and manifest itself. Here we touch on a common denominator of all of Novalis's totalizing projects; one which Borges's fantasies have in common with them: the ideal of a total book, of *the* Book.[22] As in Borges, in the *Brouillon* this idea has different names: novel, encyclopedia, Bible,[23] or library. But the specific problems Novalis is formulating about it are always the same: how does a book as a totalizing system function? What are its different parts? How are these parts interrelated? These are problems with which he deals in great detail. He demands "a complete list of all members of a book" (573) and he provides one, although dispersed among different entries (240, 550, 571, 573, 588, 599). His interest in the numerous elements of the book that concern only marginal[24] or merely technical aspects fits into his methodic investigation of the relationships of complementarity, repetition, inclusion and exclusion between part and part, part and whole—in sum of the internal functional differentiation of a totalizing system of writing:

> What ought a preface to be, or a title, an epigraph, a table of contents, an introduction, a footnote, a text, an appendix (copper plates, etc.), an index, and how should they all be differentiated and classified? The table of contents is the combinatory formula of the index, the text its execution. The preface is a poetic overture, or an announcement for the reader

as well as for the bookbinder. The epigraph is the musical theme. Instructions for reading the book, its philosophy, are presented in the preface. The title is the name. Double title and explained title. History of titles. Definition and classification of the name. (550)

We can recognize in this text the traditional elements of the encyclopedia. The table of contents, seen as a combinatory formula, corresponds to the System, whereas the main body of the text has the function of the Dictionary. The synoptic tables assume the function of the Map, the exceptional importance of which Novalis confirms as a superior mode of representation:

The less easily a book can be translated into a synoptic table, the worse it is. (240)

The pictures and tables are signs of a superior nature—they are part of the superior acoustics—transition from writing to picture. (571)

From the point of view of the generic program, the Book Novalis was planning to write was intended to be a complete encyclopedia. But, given the gigantic dimensions of such an undertaking, could it be completed by one single author?

. . . if my undertaking proved to be too ambitious, then I should only give the method of procedure, and examples; the most general part and fragments chosen from the particular parts. (526)

Given a lack of time and energy, Novalis decided to concentrate on the System, and to produce the Dictionary only in a fragmentary way. This decision was not surprising around 1800, when philosophy was taking over the encyclopedic project with a tendency to consider its most philosophical part, the System, as being the most important.

Usually this approach is expressed with a heavy organic metaphorization of the system: the tree with its branches as a figure for systems of binary logic; the germ *(Keim)* as a figure for the inclusion of the whole in the part. Besides using these traditional metaphors of totalization, Novalis also resorts to others which, at first glance, seem to contradict organic conceptualization. He combines this with mathematics as a metaphorical register; this combination is another trait he shares with Borges. But mathematics interests Novalis only insofar as it provides him with a conceptual tool, one which enables him to represent the generation of something new out of a limited set of known elements and relations. He aims at the elaboration of a generative *and* genetic formula, and thus obtains an

intersection of mathematics and organicity. Yet he distinguishes the formula quite clearly from that which can be produced by it. Hence a distinction which, as far as I know, is Novalis's own: The introduction is the "encyclopedistics" of the book, perhaps the philosophical text which goes with the table of contents (599). He makes an important distinction between encyclopedia and what he calls "encyclopedistics." This latter is what he is concentrating on. It is (like) the introduction of the book. It provides the generative formula of the encyclopedia, even of all future encyclopedias. But as such it is not just a meta-discourse on how to produce an encyclopedia. It is "a real and ideal sample, and the germ of all books" (557). Written on future interrelations of discourses and sectors of knowledge and at the same time composed of the materials taken from all surrounding discourses, it mixes System and Dictionary. It has the reality of an actual encyclopedia and contains the ideal force to produce all future encyclopedias.

It is here that we reach the parting of the ways between Novalis and Borges. For Novalis, this future production of the totalizing text as inscribed into the *Brouillon*—fragmentary though it may be—is a progressive, not a purely repetitive activity. Its self-consciousness, instead of having a self-defeating effect, instead of opening up the "bad infinite" of the *mise en abyme*, generates a process of elevation, later called "potentiation." This process makes it possible for the human subject to become the creating (poet) *and* knowing (scientist) subject of the whole system. In the ensuing entry, Novalis seems to prefigure Borges's version of encyclopedia, and at the same time, reject it as a negative development;

> Mere analysis—mere experimentation and observation—lead into endless spaces and finally into the infinite. If the infinite is of poetic nature and intention, then we may accept it. Otherwise we absolutely need a purpose—rightly call "finis"—or we have to posit it, in order not to get lost in this speculation like a madman in a labyrinth. This is where the seat of the famous speculation—of the maligned and erroneous mysticism—lies, as well as the foundation which makes people believe in the investigation of things in themselves.
>
> Criticism shows very precisely the need for limitation—determination, temporary interruption—it points to a specific objective and transforms speculation into a useful and even a poetic instrument. (906)

We can read in this text a clear rejection of that mere speculation of which Borges's endless mirroring process is only a variation. Novalis's encyclopedic activity has a definite and positive utopian dimension. Although it is conceived of as a permanent process, it always has concrete, limited objectives. Very explicitly it aims at a modification not only of the scientific, but also of the social praxis. Both have to be perfected and com-

pleted in accordance with the formulas and statements of the "encyclo-pedistics."

Such a strongly utopian orientation might be explained at least in part as a heritage from the Enlightenment.[25] Nevertheless, it is a rather unusual phenomenon in an encyclopedia. The *Brouillon* is not only not limited to being an inventory of present and past knowledge,[26] it also proposes and has the object of producing something new in science and society. It is therefore not enough to see in it only a mirror of a dynamic moment in the history of science.[27] Novalis does more than just copy what he finds around him, he intervenes in the existing system of dis-courses, he experimentally modifies it, even though his intervention may have had little or no impact on the history of science.[28]

The *Brouillon* at one and the same time describes, induces, and generates future perfection. In the light of this performative[29] and utopian aspect it is, so to speak, acceptable to have an extremely frag-mented text, as long as it contains both the general and the generative formula for totalization. But totalization becomes, by definition, that which is going to take place in the future. The *Brouillon* includes it as a project, as a program, as a combinatory, logical, and metaphoric formula, but does not carry it out. It is like the introduction to that type of book whose text will always be in the process of being written. Therefore, the *Brouillon*, as an "encyclopedistics," is that part of the future Encyclope-dia that encompasses this future totality. It is another part that contains the whole.

Does every part in this system have this special relation to the whole? Before answering this question we have to find out how the units of the system are constituted. These units are, in the first place, the different scientific disciplines and discourses. Each of them is perceived as an indi-viduum which, in its turn, functions as a system. Sciences, individuums, systems can be complete or incomplete:

> One can rightly say that the complete natural system of a complete individuum is a function of all other complete indi-viduums, as well as a function of the universe. This might constitute the character of a complete individuum. An incom-plete individuum will have an incomplete natural system the indications of which are: striving, a state of dissatisfaction, a lacuna, a lack of limits. In a complete system there is perfect activity, without any need, without restlessness. Each member is linked to the next one, the system is closed in itself and circles in a fixed, regulated, autonomous trajectory around a higher system, if there is one, with which it may constitute a new, bigger system, if they are united through a common purpose, with the same dignity. (460)

Quite a few elements are of extreme importance here: first of all, the

units are integrated into a two-dimensional frame of reference. To iden-
tify them we have, on the one hand, to know their degree of completeness.
It is interesting that the predicates of incompleteness coincide with those
of the fragment; both are defined not in a negative and static way, but
rather by their potential of activity and by their striving for completeness.
On the other hand, what counts is their position in a hierarchical order
(higher vs. lower) which might coincide with the dimensional order
(bigger vs. smaller).

This means that the single unit can only be conceptualized as taking
part in, and even being constituted by, a network of interdependence, with
a twofold open-endedness. In other words, there is by definition no single
unit, because its definition has to be relational, not intrinsic. How can a
unit, a science, be constituted then? Only through integration into the
two dimensions of the encyclopedic system, thereby immediately giving it
a universal quality:

> Double universality of each real science: one universality is
> generated when I use all other sciences to form this specific one.
> The other, when I change it into a universal science by establish-
> ing its own internal hierarchy, that is when I consider all other
> sciences as its modifications. (155)

There is a two-directional itinerary to be followed, as we see quite clearly
in this entry:

> The philosophy of a science is created through the self-criticism
> and the self-generated system of this same science. A science
> is being applied when it serves as an analogous sample as well as
> an impulse in the specific self(re)production of another science.
> Through potentiation each science can reach a higher, a philo-
> sophical series, and enter it as its member and function. (487)

The first operation is called application *(Anwendung auf)*. Put in tra-
ditional metaphoric terms, it takes place horizontally between different
sciences. It is a transfer of objects, concepts, methods from one unit to
another and always implies a relation of analogy. As an analogical inter-
connection of heterogeneous units, or elements of units, it becomes the
most important technique of the interdiscursive experimentation Novalis
has undertaken in the *Brouillon*.

Application across the borderlines of the different provinces of
knowledge is achieved in many ways, from metaphorlike formulations to
elaborate correlations. It covers all sciences, but there is always the same
principle of analogical transfer at work. This interdiscursive practice
destabilizes the traditional system of discourses. At the same time, it
proposes a new system with a maximum of coherence, thanks to the
intimate interconnectedness of parts and whole:

Application of the system to the parts—as well as the parts to the system and the parts to the parts. Application of the state to its members, the members to the state, the members to the members. Application of the whole man to its members, the members to the man, the members and elements to each other. (460)

Here the encyclopedic system shows a total internal transitivity, based on analogical transferability.

The second operation is called potentiation ("Potenzierung"), a metaphorical generalization of a mathematical term, which stands for a process of abstraction by generalization. This permits the acquisition of an encompassing overview. Potentiation works on the vertical space axis—this metaphor is quite explicit in Novalis—and proposes a movement from low to high, from material to spiritual, from particular to general.[30] It also works within the framework of a hierarchy of discourses in which philosophy holds the highest position: "Each science might be seen as only a variation of philosophy. Philosophy is, so to speak, the substance of science, a substance sought everywhere, omnipresent, but never visible to the seeker" (343). This sounds like a mere confirmation of the rather stable hierarchy of discourses already established in the eighteenth century. But Novalis destabilizes this system. On the one hand, he postulates an absolute mobility on the vertical axis and gives ethical importance to striving for the highest position, to permanently transforming the "lower" discourses into philosophy. On the other hand, philosophy is itself integrated into the general process of analogical application. Like all other units, it too is a moving unit. Its autonomy and completeness is paradoxically established through an exchange with other discourses such as the poetic and the religious ones.

Finally, although in single entries we find very definite statements in this respect, from the point of view of the encyclopedic system itself we have to admit that no one single discourse is superior to all others, because, according to the self-generated rules of the system, each unit can occupy the position at the top. At this point Novalis's system may appear illogical, but I should say rather that it transcends certain logical laws which it posits and uses. This is one of the main features of Novalis's discourse practice; its performance not only produces but *is* also the dynamic force of the system. He introduces elements that obey the laws of binary logic (dichotomies, hierarchical order, monodirectional movements) only to show that these laws are incomplete, that they have to be transcended in order to produce a new order in discourse practice as well as in the world.[31]

The logical functioning of Novalis's system—as described *and* performed in the *Brouillon*—shows many similarities with three-positional systems in contemporary philosophy. It can be approached, for instance, from and through the works of Fichte, Schelling, and Hegel. Nevertheless

it has a puzzling effect on the reader, which the works of those authors do not have, because it has given rise to a performative text which defies my own undertaking to describe it rationally. The system's strong coherences seem to be contradicted by the fragmentary incompleteness of the text. One cannot infer the whole system from just one or a few single entries. Given the general mobility of the text, it would be too easy to find other entries that would contradict the first one(s) and invalidate the inference. It is only through the interplay of all entries that one can acquire knowledge of the functioning and the structural coherence of the whole system. To appear as such, this system needs no projection from the outside of a totalizing meaning. Despite the apparently unbearable fragmentariness of the text, its productive force as a generative formula, as well as its utopian dimension, are very much intact.

According to the laws of his own system, Novalis was quite right to state that "as soon as I have completed a real piece (member) of my book, the main work will be done" (555). Thus he anticipates the completion of a single unit of his system. By so doing, he proposes a very special kind of fragment. But he never produced this "real piece." No individual science was ever presented by him in an encyclopedic, and therefore completed, way. He chose rather the other alternative, which he also anticipated: to give the general method with fragments out of the particular part (see 526). This is a kind of fragment he could and did in fact produce. But he would not have been able to complete a "real piece" of his encyclopedia. This approach postulates a text that would have been at once a fragment and the completed whole—a fragment, because it could only represent one of many units that constitute the encyclopedia, and a completed whole, because the single unit can only be established through all its relations with all other units.

This fragment is the fantasy of the perfect—or impossible—fragment, a utopian fragment. It can be taken either for an anachronistic answer to all the fantasies of the totalizing text by Borges, or for their common matrix. It sums up the dialectic of fragment and encyclopedia. To write it is indeed equivalent to "scaling the main peak" as the text says literally. It is therefore equivalent to the utopian writing of the whole encyclopedia, because this is the fragment that could not have been completed before the completion of the whole work.

Notes

1. Jorge Luis Borges, *El Aleph* (Buenos Aires: Emecé Editores, 1957); *Ficciones* (Buenos Aires: Emecé Editores, 1956). In my discussion of Borges, I concentrate on these two collections of short stories. References in my text are to *El Alph* (A) and *Ficciones* (F), followed by the number of the page. Translations are mine.
2. To a certain degree the choice has been made at random, but the sample is large enough to show the rich variety of treatments to which the basic problem is susceptible.

FRAGMENTS

3. They are: hexagonal galleries, railings, ventilating shafts, shelves, lounges, and winding stairs, always combined in the same manner in numberless hexagonal units.

4. See Jaime Alazraki, *Versiones, Inversiones, Reversiones: El espejo como modelo estructural del relato en los cuentos de Borges* (Madrid: Gredos, 1977). Alazraki is interested in the mirror as a feature of narrative technique and structure, rather than in the trope and in its philosophical implications.

5. Only divine language would be an exception to this law about discursive temporality: "I thought that in the language of God every single word would contain this infinite concatenation of the facts, not in an implicit, but in an explicit manner, not in a progressive, but in an immediate manner" (WG, A118).

6. Enumeration, it should be noted, is an important stylistic feature in Borges's texts.

7. I have to leave it open to speculation whether this kind of uncertainty can, or has to, be linked to the principle of uncertainty in modern physics. Since I am working on the basis of a general interrelation of all discourses existing at a given time, my hypothesis is that there must be a link to be explored between the discourses of modern physics and those of modern literature (also literary criticism) with respect to the principle of uncertainty.

8. Friedrich Schlegel has formulated what we might call the "manifesto" of this new conception of poetry in the extremely concise form of a fragment: *Athenäum Fragmente* 116.

9. These extremely concise remarks are the result of an examination and compilation of different sources: (1) studies on the encyclopedia and its history—for instance Robert Collison, *Encyclopedias: Their History throughout the Ages* (New York: Hafner, 1964) and Ulrich Dierse, *Enzyklopädie* (Bonn: Bouvier, 1977); (2) the encyclopedias themselves; they usually include a self-reflective moment either in the introduction—e.g. Jean D'Alembert, *Discours préliminaire de l'Encyclopédie* (Paris: Gonthier, 1965); Raymond Queneau, "Présentation de l'Encyclopédie," pp. 85-111 in *Bords: Mathématiciens, precurseurs, encyclopédistes (*Paris: Hermann, 1963)—or in one of their articles—e.g. Denis de Diderot, "Encyclopédie," in his *Encyclopédie* (Lausanne: Sociétés Typographiques, 1782) 12:341-88.

10. In his article "Encyclopédie," Diderot discusses the making of these units. He sees it as a special case of what modern linguistis call "text processing" and he stresses the need for utmost condensation.

11. My use of "discourse" and "discourse practice" is closely related to Michel Foucault's—see his *L'archéologie du savoir* (Paris: Gallimard, 1969) and *L'ordre du discours* (Paris: Gallimard, 1971). Discourse is a rule-governed use of language that divides into different units or types of discourse practice (usually called "discourses" here) which can be defined in terms of linguistic (use of concepts, themes, tropes, style, etc.) as well as pragmatic (ritual settings of communication, social screening of discursive subjects, etc.) features.

12. The Map is called "système figuré" by D'Alembert and Diderot; "Tafel" by Novalis.

13. What many early nineteenth-century philosophers have called encyclopedia is in most cases only the System of an encyclopedia. This is the period when the System was thought to be by far the most important part of the whole undertaking, so much so that the philosophers considered the Dictionary to be of minor importance and left it to the scientists.

14. In his article "Encyclopédie," Diderot is so concerned with "the best concatenation" (p. 360) that he is not satisfied with having D'Alembert represent it in the "Discours préliminaire," and in the "système figuré"; he also introduces into the Dictionary an additional network of references (pp. 366-71). His ideal is to "form an ensemble which is extremely tightened, extremely connected, and extremely continuous" (p. 369), in which "no empty interval" (p. 370) would weaken the strength of concatenation.

15. One remark should be made here: the presentation I have made of clear-cut dichotomies does not imply that encyclopedic texts will present binary structures exactly in that clear-cut way. The dichotomy is only a heuristic tool of investigation. It makes things appear clearer than they are in reality. This is particularly true in the case of Novalis, who constantly defies and transcends the logical laws that posit

dichotomies, by postulating and producing systematically the *tertium datur*.

16. The title has been taken from entry 231 where Novalis refers to his undertaking as "das allgemeine Brouillon."

17. I shall refer to the numbers given by the editors of the text units and henceforth call them "entries." The translations are mine.

18. In this respect, see Foucault's critique of totalizing concepts, such as "author" and "work," in *L'archéologie du savoir*, pp. 31-43.

19. Novalis (Friedrich von Hardenberg), *Werke, Briefe, Dokumente,* vol. 3, E. Wasmuth, ed. (Heidelberg: 1957).

20. Novalis (Friedrich von Hardenberg), "Das allgemeine Brouillon: Materialien zur Enzyklopädistik 1798/99," in H. J. Mähl, R. Samuel, and G. Schulz, eds., *Schriften*, vol. 3: *Das philosophische Werk II* (Stuttgart: Kohlhammer, 1960), pp. 205-478. For the purposes of my study, I shall use this last edition, as I consider it to be the best one.
When Mähl concludes, in his introduction, that "the Brouillon represents a unified ensemble of manuscripts with internal coherence" (p. 215), he bases this unity on biographical and historical considerations rather than on the intention of the author.

21. This is to avoid the prefixed scheme of totalization the hermeneutic operation by definition brings into play.

22. After Novalis and before Borges, Flaubert and particularly Mallarmé also gave thought to, and worked on, this idea.

23. In entry 557 Novalis calls his project "eine szientifische Bibel."

24. To a certain degree one could say that Novalis has anticipated Derrida's interest in "les marges" as well as in the "hors livre."

25. This is Helmut Schanze's thesis in his "Romantische Enzyklopädie," pp. 114-50 in *Romantik und Aufklarung* (2d ed., Nürnberg: Hans Carl, 1976), and it could be documented by certain entries that sound like the eighteenth-century gospel of progress. See, for instance, entry 1134.

26. See the double objective formulated by Queneau for the *Encyclopédie de la Pléiade:* "to present modern man with an exhaustive and synthetic picture of modern science, and, at the same time, trace again the course of the history that mankind has already completed" (p. 86).

27. On this see Schulz in his introduction to the third volume of the *Schriften*, p. 32.

28. On this specific point, Schulz (pp. 32-33) is quite right.

29. I take this term from J. L. Austin *(How to Do Things with Words*, J. U. Urmson, ed. [New York: Oxford University Press, 1973], see p. 8) and use it in a more general and logically less rigorous way than he does. In what I call a "performative text," the uttering of the text is the performance of what the object of the utterance is. To a certain extent, the performative text always implies a refusal of the metadiscursive hierarchy.

30. See his frequently used terms like *"höhere* Wissenschaft" (higher science), "Grad*erhöhung* der Wissenschaft" (self-reflective elevation of the science), etc.

31. Here I must mention Novalis's frequent use, when he represents future perfection, of what he calls the "isochrony" of the opposites, which is an application of his postulate of the *tertium datur*.

Mapping Barthelme's "Paraguay"

PERRY MEISEL

> *Therefore we try to keep everything open, go forward avoiding*
> *the final explanation. If we inadvertently receive it, we are*
> *instructed to (1) pretend that it is just another error, or (2) mis-*
> *understand it. Creative misunderstanding is crucial.*
> Jean Mueller, in "Paraguay"

To choose among Donald Barthelme's many stories and sketches a single
one that could be called central or paradigmatic to his achievement as a
whole is to enter that vortex of metacritical speculation and display that
is often the precise subject of his fiction. Barthelme's novels, *Snow White*
and *The Dead Father*, full of deadpan improbabilities and allegorizations
of referents of which we have no secure notion, help us less here than we
might expect; they don't organize and focus Barthelme's considerably
larger and more characteristic project as a short-story writer so much as
they caution us about the easy certitude with which we may seek or offer
a single mythological formula—for example, pop or ideological in the case
of *Snow White*, Oedipal in the case of *The Dead Father*—to explain or

account for the vicissitudes of any discourse at all.

So we have to narrow the search to those tales that are overtly and exactly metacritical, that take the problem of coherence and organization as their own proper subjects, too, by reproducing the project of finding a plan or discovering a key or pattern as their manifest aim. Perhaps such stories can provide us with clues as to the grammar or structure of the imagination that produces them, and so designated, certify themselves as the central or privileged kind of tale we wish to find.

Some stories in particular stand out from this point of view, as clues to Barthelme at large—"The Expedition" *(Guilty Pleasures)*, "The Discovery" *(Amateurs)*, "The Explanation" *(City Life)*. These, however, are boldly, baldly burlesque, easy parodies of the questing sensibility and low on "endthusiasm"[1] compared to the genuinely paradigmatic "Paraguay," the arguable centerpiece of *City Life* and a story that takes—and takes seriously—as its organizing conceit the exploration and ordering of an alien terrain whose intractability, like that of Barthelme's own prose, emerges only gradually to its navigator.

Apparently the narrative of an anonymous speaker who recounts his experience among strangers in a strange land in the unruffled tone of a cosmopolitan visitor or an ethnographer, "Paraguay" is an uneasy but highly formalized, at times parodically scientific, charting of the alien terrain and society its title seems only to name. Like the unexplained intimacy with which his Paraguayan hosts, Jean and Herko Mueller, greet him and show him about, the narrator's own coolness under obvious pressure imparts to us an unspoken assurance as to Paraguay's existence and coherence, despite its fantastic conditions and alarming incoherence—its "red snow" (39), for example, or its "flights of white meat" moving "through the sky overhead" (30).[2] Organized by a series of titled entries, each one part diary, part field report, the story's composure seems to flow from no more than its confidence in its own manifest ordering devices, overcompensatory attempts as they are to keep organized what cannot be organized, to impose the structure of a familiar discourse on a culture whose rules differ markedly from the familiar.

As discursive map or ethnography, of course, the story looks like an informal taxonomy, an attempt to understand the codes common to any foreign country, no matter its exact geographical location. So in its action, at least from this point of view, the story internally doubles its reader's relation to it. Here the story itself becomes an act of criticism or interpretation like the one that tries to apprehend it, as the reader attempts to elucidate its only partially transparent discourse much as the narrator whose apparent diary he reads tries to do the same in relation to his fugitive, and perhaps phantom, Paraguay. "Paraguay," in short, is about how to read "Paraguay."

Diary and ethnography at once, this slight oscillation or shifting in the story's representation of itself as a map or charting of an alien culture and terrain reveals a constituent feature of Barthelme's language that helps

to guide us in its interpretation. Highly figured behind a surface of simplicity, Barthelme's prose is intentionally multivalent or overdetermined, a transistorized or "software" (34) discourse that pressure-packs a store or inventory of various information systems even in a single term or trope like that of the map. Barthelme's reader may tease out or unpack those systems latent within it, and so discover the various implicit tropological options or possibilities by which his fiction represents itself through even a single such organizing—and already teased out or implied—figure.

The result, in "Paraguay" at least, is that bifurcated notion of organization in which the figure of the map has two simultaneous meanings or interpretations, one dependent on space, one dependent on time. The map of the ethnographer is a taxonomic table, a structural figure that accents the spatial and the synchronic in its quest for a set of rules by which a culture—or a text—generates its effects at any given moment. The map of the diarist, by contrast, is temporally inflected, an organization or mapping in time rather than space. Let us take up each subfigure of the map, then—table and structure on the one hand, diary and temporality on the other—and unpack the ways in which each one directs "Paraguay" and its attempt to provide a map or representation for the problem of fictional organization itself.

As a place to map, of course, the tale's referent appears to be no undiscovered country at all, but—naturally, or so it seems—Paraguay, the Paraguay designated by the story's title. We all know Paraguay; or do we? Barthelme has a surprise for us in the second entry, "Where Paraguay Is":

> Thus I found myself in a strange country. This Paraguay is not the Paraguay that exists on our maps. It is not to be found on the continent, South America; it is not a political subdivision of that continent, with a population of 2,161,000 and a capital city named Asunción. This Paraguay exists elsewhere. (30)

Like Borges's Uqbar and Tlön, or like Barthelme's own "Robert Kennedy Saved from Drowning" in *Unspeakable Practices, Unnatural Acts*, Paraguay, in Barthelme's signification at least, has no referent as such—no preexisting set of codes to which it points as a signifier, and certainly no discoverable, self-sufficient, extrasemiotic reality to which its name merely appeals the way the ordinary map or diary appeals to places and events we all know, at least from our reading. As static representation or ethnographic project, the story has no proper objects to work upon, since Paraguay is not a given space or place that can be quantified or categorized, but a place—an "elsewhere"—whose constituent terms are given only by the language of the story itself. Accordingly, Barthelme parodies and exhausts the notion of the grammar or table in the closing entry. As the tale concludes, Herko Mueller at last presents the narrator with "the plan," the chart or grammar the story as taxonomy has sought. "It

governs more or less everything," says Herko. "It is a way of allowing a very wide range of tendencies to interact" (40). Instantly, however, "the bell rang and the space became crowded" (40). With "the plan" a failure the moment it is invoked, "marshals" must try to "establish some sort of order" (40) all over again.

What "Paraguay" maps, then, is the project and problem of mapping itself. By Barthelme's own testimony, mapping cannot be a straight-forward, automatic reference to a self-sufficient world outside language that language simply points to. If Paraguay is not Paraguay, if it "exists elsewhere," we need to begin reading the story all over again to see how it constitutes its terms, how it manages to map—to fashion—a place that exists in a purely imaginative, purely Barthelmean "elsewhere." Here the figure of the map as static representation or as taxonomic table begins to give way to the rival dominance of the map as diary, and to its accent on the way language generates its referents temporally.

The bland description of the approach to Paraguay with which the tale opens turns out to be, as Barthelme's footnote tells us, a "slightly altered" citation from an old travelogue description of Tibet (30). This deadpan representation of a standard narrative opening, however, has curious results, skewing as it does the very teleology of journeying at the moment it calls it into play.

Although we expect proper names like that of Paraguay to point to their customary referents whenever they are used, Barthelme interrupts—even before he says so in "Where Paraguay Is"—the self-evident, apparently natural power with which they are invested at the start of the tale, in its title, by placing under the heading of the proper name "Paraguay" a description that properly belongs to Tibet. Of course, the story goes on to restore the name Paraguay at the close of the Tibetan passage, even though at this point such a restoration turns out to be not a restoration at all, but a fresh violation, a violation of the news that the description is really proper only to Tibet.

Surely this byplay suggests that "Paraguay" is interested in how easy it is to sever names from their proper referents, though just as surely this is not its principal thrust. No, what is interesting about this split, uneasy start that is not a start at all is that it makes the same kind of mistake at least twice—Paraguay is Tibet, but Tibet is also Paraguay. The boundaries of each one, in other words, are brought into relief only at the moment of their transgression, making each the effect of its crossing by the other. Hence it is the difference the names plot against themselves that allows us to think that the property referred to in each case is something different, even though it is, of course, (also) the same. Without Barthelme's footnote, we would otherwise be misled, happily and unknowingly, into reading about Tibet while journeying into Paraguay, and would very probably take the Tibetan place names the passage uses as nonsense or as a parody of the exotic. What the intentional confusion has wrought, in other words, is a sense of proper names as the product, not of their links

to a real piece of property, but of their differences from one another. What allows "Paraguay" to signify Paraguay is also what allows it to signify Tibet, though to confuse the two, to violate the law that keeps each one in its place, is also to establish the law, to bring its operations to light.

Even more, the very act of reference here turns out to be a temporally plotted one, like the reference to a subject enacted by the diary with which temporality is figurally allied in "Paraguay." Like the place to which "Paraguay" as a map refers, its narrator, the subject to which it refers as a diary, is equally unavailable, or at least available only in the way the "elsewhere" of Paraguay itself is available: as a linguistic function temporally installed. Even the proper referents of real diaries and autobiographies acquire their coherence, their existence, only proleptically and analeptically—as temporally constituted productions of the texts that claim only to report or narrate them. Reference or legibility in Barthelme turns out to be a similar process. In order for Barthelme's reader to fix the "elsewhere" of Paraguay, the reader must fashion what he can differentially, laterally, within the signifying chains or "cables" (to use the graphic vocabulary of *The Dead Father*) the story's surface texture provides. Hence the reader tries to line up signifier with its repetition according to the very law that is violated by the frustrated prolepsis of Paraguay when it is analeptically replaced by Tibet. Challenging itself as well as its reader in a double wager, the story charges us, as the price of its legibility, to seek retroactive confirmation of its signifiers in a process that allows us to discern its various possible systems of meaning.

Indeed, the temptation to call fugitive the objects a map or taxonomy like "Paraguay" wishes to coordinate or classify is by no means a simple response to the story's murmuring moral lament that language is too weak to grasp the elusive real; it is, rather, evidence that we have fallen, from one point of view at least, directly into the story's clutches, prey to its ability to convince us, despite its warnings, that language and the world are things apart from one another, and that language's sole function is to try its best to correspond to the world despite the usual "modernist" difficulties in doing so. To call the apparent objects of Paraguay fugitive is to invest them, analeptically, with a self-sufficient existence whose presence is in fact no more than the effect of its touted absence. Even the paradigmatic notion of structure itself, of the taxonomic chart or table, is complicit with those logocentric effects that produce the sense of an elusive real that escapes the text, for structure here becomes a logocentric referent, too, as impossible as those "attached photographs of the human soul" that appear in *Guilty Pleasures*.[3] Like those *méconnaissances* that impute presence to the Freudian unconscious in the name of denaturing it, the interpretation of "Paraguay" as a text about a synchronic structure of reference simply reconstitutes the very type of referentiality the story excludes. Reference is not a site or structure to be discovered, but a process always in movement. Indeed, any such moment of

rest is always subject to its reinsertion in another series of differences in which the cards may be reshuffled and a new combination of signifiers produced to decenter the momentary statis of what came before. As *The Dead Father* tersely puts it, "a static 'at rest' analysis" gives way "to super series of unpredictable mathematical frequencies."[4]

The story even gives us terms for this second or alternative self-representation, a demystification of how the temporally organized process of reading actually proceeds, and how the sense a text ordinarily enjoys is really procured. The terms are to be found in a mundane but resonant remark characteristic of Barthelme's "software" prose: "Temperature," says the narrator, "controls activity to a remarkable degree" (31). Measures, that is, are a function of a threshold ("degree") of re-mark-ability. So climate conditions in Paraguay and the kinds of measures or "temperature" by which its conditions can be known suggest that things emerge as such in its world only to the extent that they may be re-marked or repeated—to the extent that they can be identified a second time, or, to put it another way, to the extent that a mark can find its repetition. Not until its second appearance, not until the moment of re-marking or repetition, can anything even appear as such for the first time, a function as it is of its own repetition or ability to repeat itself.

Hence the legibility of the text ebbs and flows depending upon the re-markability a given element may have in the various signifying chains or cables that may be seen or said to support it. Indeed, Barthelme's prose is habitually overdetermined and yet still oblique because its overdeter-minations don't as a rule add up in the same columns at the same time. Not only does "Paraguay" set such traps—Paraguay is Tibet, Tibet is Paraguay, and so on. This is also how Barthelme stories such as "110 West Sixty-first Street" or "The School" in *Amateurs* garner what readability they may have, constituted as they are along a series, for example, of puns ("bar," "will," "kidded"). These ambiguous notations or polyphonic registers (the "scales," "colors," and "table" in "The Indian Uprising" in *Unspeakable Practices* are at once names for the process and examples of it) create coherence as well as confusion—"a gigantic jiveass jigsaw puzzle."[5] Thus, too, the burlesque—or not?—of the process of re-marking in the self-duplicating columns of a repeated word like "butter" in "Eugénie Grandet" in *Guilty Pleasures*, or its outright problematization in the list (?) of which *City Life*'s "The Glass Mountain" is composed.

One overweening example of the process and its productive and deferred effects lies in the way the transparent discourse of the old-fashioned travelogue citation grows dramatically rich and problematic once it is re-placed under the heading of a Barthelme story. Suddenly, belatedly, the description of Tibet takes on the intricacies and wit of a page from Blanchot, finds itself amplified in ways it never knew before, and so exemplifies the precise kind of re-markable legibility "Paraguay" itself recommends. Hence the ingenious web of rhetorical strategies the passage (now) deploys to establish time, places, events that have not

been—and apparently cannot be—supplied directly ("the plain that we had crossed the day before was now white with snow"; "the night as still as the previous one and the temperature the same"; "agreed-upon wage"— 29-30), all this together with the self-emptying device of "now white with snow," as though this (belatedly) postmodern text is intent to erase its coordinates even as it establishes them.

Now we can assemble the two parts or versions of the story's self-representation and see how they both oppose and require one another. The difference between table and diary, of course, corresponds to a difference in the story's very notion of reference itself. Is the story's notion of reference—its model for its own style of organization or readability— the synchronic one suggested by the taxonomy, a structure that is uncovered or discovered within or behind the language of the story, and that accounts, as a grammar would, for all its effects? Or is its notion of reference the temporal one suggested by the figure of the diary and founded on a process of repetition or re-markability that makes any stability or fixity of reference always a product of, always dependent on, a series of temporal operations within a system of differences? These alternative notions of reference also correspond to the difference from itself the tale has already displayed at its skewed outset. If the map as static structure or taxonomy presumes stable objects beyond the text which the text merely apprehends—even if that object is the structure of reference a narrative taxonomy can claim to find—the map as diary, by contrast, assigns all "discovery" to the effects of a differential system that generates the logocentric effects that we call the elusive real. What the clash of the taxonomic figure and the figure of the diary enact, in other words, is the antinomy or difference between an epistemology that discovers and one that produces.

Moreover, what is gained by denying the text a logocentric dimension is precisely what opponents of such a position claim such analysis loses: reference itself. For "Paraguay" is by no means a nonreferential or even self-referential text. Not only is the story capable of referring to those codes of social reference that allow us to produce a text's public meanings, it also takes that very possibility as the requirement for its own reading: only by attempting to read the story "straight"—taking Paraguay as the real Paraguay, and so on—do we find out the peculiar and particular nature of its own brand of serial lawfulness. The level of law at which the story operates requires the violation of customary linguistic lawfulness for its discovery. For Barthelme, language does not express or represent; it situates within systems of serially constituted differences. To find this out, Barthelme's reader must read according to the old model in order to gain access, through a mistake, to the new.[6]

And just as the story requires that normal codes of reference be observed so that their violation may constitute a new system of law, it also requires that we restrain our desire to endorse, as we have, one side

of its double epistemology at the cost of the other. For, like the inter-
dependence of Fatherhood and childhood in *The Dead Father*, the figures
of the table and diary, structure and series, are, of course, interdependent,
too, each one making the other possible:

> Arbiters registered serial numbers of the (complex of threats)
> with ticks on a great, brown board. (37)

The labor *(arbeit)* of the random (arbitrary) series constitutes a "complex"
or constellation of "threats" to the purity of the synchronic table or
"board," here infected by time ("ticks," as in clocks) and so "brown"
rather than white.

What Barthelme here criticizes under the name of whiteness, "blank-
ness" (35), empty signification—the model is the Le Corbusier design de-
scription he cites in the section entitled "The Wall," "Paraguay" as
Borgesian Book of Sand—is that ideal of a purely formal structure of
structure as the goal of a postmodern, metacritical fiction. Allied as such
an ideal is with the synchronic and the structural, it is corrected or
opposed by the story's rhetoric of temporality in an extended series of
figures for Paraguay's climatology akin to the trope of "temperature" and
its remarkable effects. Like the "white snow" we have misread as a sign
for the story's self-erasure, or like the properly Paraguayan "red snow"
that John Leland reads as a sign for "the machinery of ordering,"[7] the
"sand" that the narrator is surprised to find in his clothing (and that takes
the rather opaque form of a "sand dollar") is supposed to be "sifted
twice daily to remove impurities and maintain whiteness" (32). Like the
"silence," "white noise," or "white space" that comes with "the softening
of language" (36), or, indeed, like the "vast blind wall" and its "expanse
of blankness" that Barthelme cites from his Le Corbusier (35), the sifting
of sand bespeaks the story's desire to keep its meanings free and open—to
keep itself clean or *propre*—by referring, it seems, only to the structure of
signification itself.

And yet the very mechanism of this s(h)ifting process by which the
perpetually new reading—the sifting—is made possible by the shifting
status of the same signifiers is premised, temporal as the process must be,
on the very residue or impurity it wishes to sift or clean away. Hence the
residue represented by the "sand dollar" reminds us of what sifting costs.
For to constellate the same trace differently on different readings is pos-
sible not because its semantic inventory has been cleansed, but because
its inventory continues to provide new possibilities for the establishment
of new signifying chains that may be set into operation by those fresh
series which constitute subsequent readings.

The story's larger, more motivated self-interpretations or thematiza-
tions are regulated by the same oscillation between its figural systems, be-
tween static ideal and temporal praxis. As a self-conscious piece of (post)
modern fiction, after all, we would expect "Paraguay" somehow to render

its judgment as to the state of both its language and the modern culture in which it is inscribed, though we should expect, too, that such judgment(s) will be delivered in the inevitably double or opposed terms with which we are by now familiar.

Hence two possibilities. On the one hand, the story's Wastelander or modernist option, that matrix of misreading in which the story situates itself as a story whose promise of narrative teleology and closure is constantly interrupted, waylaid in the face of the fugitive real. Here the world is fractured, fragmented, a world in which "men wander," "trying to touch something"; a world in which a misreading of Barthelmean semiotics advises that "everything physical . . . is getting smaller" ("walls thin as though"), and which occasions that nostalgia for touch or presence expressed in Paraguay as a "preoccupation with skin," "possibly," says the narrator, "a response to this" (38).

On the other hand, however, emerges the story's anti- or postmodernist thematization in which Wastelander fragmentation turns out to be a misreading of serial abundance. Books of Sand are testimony, as are Freud's interminable analysis or Pynchon's paranoia, to the unending possibilities of interpretation, the broken or shattered texts really "calculated mixes" (36), as Barthelme's finally pop or mass vision puts it, "dispatched from central art dumps to regional art dumps, and from there into the lifestream of cities" (34). Moreover, it is the minimalism or "microminiaturization" (38) of such art that is witness for the abundance—rather than witness for dessication—since postmodern, minimalist "software" is really an exercise in the transistorizing that Barthelme calls, with some irony, "rationalization":

> Rationalization produces simpler circuits and, therefore, a saving in hardware. Each artist's product is translated into a statement in symbolic logic. The statement is then "minimized" by various clever methods. The simple statement is translated back into the design of a simpler circuit. (34)

Hence "the softening of language," says the narrator in an exemplary moment of antimodernist candor, "usually lamented as a falling off from former practice is in fact a clear response," like "The Balloon" in *Unspeakable Practices*, "to the proliferation of surfaces and stimuli" (36). "Software," in short, is "more durable than regret."[8]

Our interpretations, of course, are by necessity serial ones, too, relevance of particular signifying chains in the story at the cost of others, inevitable *méconnaissances* as are any acts of reading in the world of Barthelme's fiction. Indeed, to represent the story as a sequence through which its design emerges, or even to represent it as the opposition of two styles of self-representation, is to repress much of what it enacts. Even our retention of terms disallowed by the story's serial critique of structurality ("story," for example, or "structure" itself) requires their

erasure despite their necessity to us, although it should also be said that deconstruction, too, needs the closure against which it is always articulated. For like the mediating figure of the map itself, which allows for a structural and serial epistemology at once, the story for which the map is both metaphor and metonymy also allows, indeed requires, that its alternative self-representations be read as a constitutive difference rather than as a conflict to be won or lost by one model or the other.

And yet if we wish to acknowledge the relative dominance of the figure of the temporal map or diary next to that of the static map or table in "Paraguay," it allows us a radical notion of the continuity between Barthelme's fiction and the reflexive realism—that of Updike, say, or Bellow—with which it is customarily contrasted. Now that the temporal plottings required in any t(r)opological coordination of a map are manifest, the diary's association with the figure of subjectivity reminds us that Barthelme's arguably privileged style of temporal ordering is also the style of (dis)order by which we know even the romantic self. Barthelme is different only in the position of the gaze, not in the articulation of its structure. Although Barthelme is to be distinguished from more customary writers in his lust for the aleatory rather than the determined, only the pressure of a determination superior to chance—or at least required by it—can account for the energy of his insistence.

Notes

1. Donald Barthelme, *The Dead Father* (New York: Farrar, Straus and Giroux, 1975), p. 171.
2. All references and citations from "Paraguay" are from the Quokka edition of *City Life* (New York: Pocket Books, 1978). References from other works by Barthelme will be given separately in the notes.
3. See "The Photographs," *Guilty Pleasures* (New York: Delta, n.d.), p. 153.
4. *The Dead Father*, p. 50. The equivalent opposition in *The Dead Father* is that uneasy coexistence of a series of fathers in "A Manual for Sons" with the Dead Father's own claim that his particular paternity is privileged. See also John Leland's reading of Barthelme's *Snow White* as a serial text in which seriality and openness are responses to and critiques of the closed structure of the myth proper of Snow White ("Remarks Re-marked: Barthelme, What Curios of Signs!" *Boundary 2* (Spring 1977), 5:795-811).
5. "I Bought a Little City," *Amateurs* (New York: Pocket Books, 1977), p. 66.
6. Hence Lévi-Strauss's notion in the "Overture" to *The Raw and the Cooked* that seriality is without double articulation collapses here in accord with Eco's critique (see Umberto Eco, "Pensée structurale et pensée sérielle," *Musique en jeu* 5:45-56), because the very *méconnaissances* that put the story into play at the outset, and which the reader must traverse in order to accede to the story's serial logic, are, of course, drawn from the public codes the story puts into play in order to violate. This, of course, deconstructs their propriety, and so meets Eco's requirement that seriality denature the apparently natural or proper status of its first level of articulation.
7. Leland, "Remarks Re-marked," p. 797.
8. See "Alice," in *Unspeakable Practices, Unnatural Acts* (New York: Pocket Books, 1978), p. 123.

PART 4

SELF-REFLECTION, PROLIFERATION, AND DECONSTRUCTION

Statements on *Amour-Propre*: From Lacan to La Rochefoucauld

SERGE DOUBROVSKY

1.

During this period, one of those frivolous minds who plays parlor games—in which, sometimes, some very surprising things begin—trivial pastimes, giving rise to new phenomena—a really funny guy, who hardly fits the stereotype of a classical writer, La Rochefoucauld by name, suddenly decided to teach us something unusual, something we haven't paid much attention to, something which he calls *amour-propre* ("self-interest"). It is strange that this seemed so scandalous because, after all, what was he actually saying? He laid emphasis on this fact: even our most seemingly selfless acts—even passionate love or virtue—are motivated by the most modest self-glorification.

2.

Among these funny guys there are doubtless elective affinities that

span all of history. The long digression that Lacan devotes to La Roche-foucauld and *amour-propre* in his Seminar of 1954 on "The Ego in Freudian Theory and Psychoanalytic Techniques" is not an isolated obser-vation; it refers to the "Index of Quoted Names" in the *Ecrits*, in which it will be noted that La Rochefoucauld is cited far more often than any other author. Whereas La Bruyère, Proust, Rabelais, or Racine are cited once, Baudelaire and Hugo twice, Mallarmé three times, and Pascal four, La Rochefoucauld is mentioned six times. These numbers alone have, of course, no absolute value but they are useful indications. Thus, the continuous debate with the "great" analysts of the first and second generations which seems to underlie the formation of Lacanian doctrine, is characterized by the frequency of allusions to psychoanalysts (eight to nine times for Kris, Balint, Fenichel, Ferenczi, Anna Freud, Glover; twelve for Melanie Klein; and fifteen for Jones) and to philosophers (six quotations from Heidegger, ten from Saussure and Lévi-Strauss, eleven from Plato and twenty-two from Hegel). The quantitative factor is insufficient unless it is coupled with a qualitative evaluation. "Tell me *whom* you cite, and I'll tell you who you are" has to be completed by "Show me *how* you cite, and I'll tell you how you stand." In that vein, Poe and his *Purloined Letter* (of capital importance) undoubtedly serve the same purpose that Oedipus or Hamlet do for Freud: myth that prompts the very action that explains it. Hugo uses Booz's "gerbe" to illustrate, with more restraint, how metaphors work. Proust is cited in a fleeting comment. La Rochefoucauld's presence, however, is of a differ-ent order. First, the author of the *Maximes* faithfully accompanies the author of the *Ecrits*, from the first texts on "Aggressiveness in Psycho-analysis" or "Remarks on Psychic Causality," to the major essays "Function and Scope of Speech and Language" and "The Freudian Thing." Next, the constant invocation reveals the insistence on a parti-cular reference: although La Rochefoucauld's sponsorship intervenes at various doctrinal points, it can be summed up, or rather subsumed, under the heading *amour-propre*.

3.

What La Rochefoucauld thereby comes up with, by a markedly strange paradox, is a *concept* or, at the very least, a *category* missing from the analytical framework (unless I'm mistaken, La Rochefoucauld is never quoted by Freud, whereas he is quite often by Nietzsche). "One of those frivolous minds who plays parlor games" would thus supply an important theoretical element to an enterprise characterized, as we know, by imper-turbable seriousness. First, let us examine Lacan's use of the "funny kind of guy," the position, and the meaning he gives to quotations from the *Maximes* in the development of his own thought: we will then see that they do not simply adorn and reinforce the Lacanian text with classical

allusions; instead, they form a *system of meaning*, one that we will have
to articulate. Then we will see that this grouping of quotations becomes a
questioning of the very discourse that contains them.

4.

"During this period, one of those frivolous minds. . . ." *Amour-propre*,
indeed, does not belong exclusively to La Rochefoucauld; it is a concept
or category *of the period*, one that he shares with his contemporaries.
Paul Bénichou, in an admirable chapter of his *Morales du Grand Siècle*,
which still holds true, clearly shows that the "destruction of the hero"
around 1660 was a team effort. The most accurate definition is doubtless
that of Pascal: "The nature of self-interest and this human *me* is to love and
consider only oneself." And La Rochefoucauld says: "*Amour-propre* is
love of self and of all things for oneself. . . ." Definitions (a scholarly
search would surely discover others) that overlap are not alike. Whereas
for Pascal the essence of *amour-propre* (a *me* capable of loving only itself)
is summarized by a grammatical process that places the reflexive pronoun
in the position of the object), La Rochefoucauld opens the door of a
radical otherness to Desire's dispersion: *amour-propre* can be love of *all
things*, on the condition, of course, that it be in one's own interest. It is a
movement that is both perpetual and immobile ("it never stays outside
of itself"), relentlessly unfocused toward a multitude of contradictory
objects ("it is inconstant . . . it is bizarre . . . it is all things opposite to
each other . . . ") but invariably centered in its mainspring *(amour-propre*
is lighted from within itself rather than from the beauty or merit of what
surrounds it), the mecanism of *amour-propre* can function only if it is
unconscious. Because if "all of life is a great and perpetual action" of
amour-propre, if "its machinations cannot be expressed, its transforma-
tions surpass those of the metamorphoses," when loving *all things* it cannot
realize that this is *for itself: blindness* (a word from La Rochefoucauld)
occurs in this very *nonrecognition* (another word from his lexicon).
Actually, the famous text on *amour-propre* (later censured, curiously
enough: did he say too much?) anticipates two modern definitions of
the unconscious: the first, one might call architectonic or archeological
(the unconscious which dissembles "depth," "shadows," "abysses,"
"thick obscurity"—one could find the metaphorical equivalent in several
Freudian texts). At the same time, there is a structural conception:
"amour-propre" is "invisible to itself" to the extent that it is "similar
to our eyes, which see all, and yet see not themselves." Blindness is,
therefore, more specifically, a blind spot, a structure of our psychic
geometry. Love can no more realize its own loving than the eye can see
itself see, unless there is some act of reflection, mirroring, or maxims.

5.

It is not surprising that it is the second topic or structural model of the unconscious which attracts (in a mirror) Lacan's eye. To continue our reading of the passage from the *Séminaire* quoted earlier: "What exactly was he saying? Was he saying that we do it for our pleasure? This is a very important question, because, in Freud, everything hinges on it. If La Rochefoucauld had said only that, he would have done nothing but repeat what has always been taught for years in the schools. . . . But La Rochefoucauld makes a different point—that while acting in a supposedly disinterested fashion, we assume that we free ourselves from immediate pleasure and seek a higher good, but we are really kidding ourselves. This idea is what is new with La Rochefoucauld." Later on, Lacan elaborates: "The outrageousness of La Rochefoucauld's position results, not from his asserting that self-interest underlies all human behavior, but from the belief that it is deceiving. There is a hedonism belonging to the *ego* which is exactly what deceives us, that is to say, which frustrates both our immediate pleasure and the satisfaction we might obtain from our superiority with respect to this pleasure." The conclusion is particularly important in that it places the psychoanalytical enterprise within the area of Western culture by means of a very specific link: "This conception belongs to a tradition parallel to that of the philosophers, the moralists' tradition. . . . This tradition finishes up with Nietzsche's *Genealogy of Morals*, which remains completely in this somewhat negative perspective according to which human behavior, as such, is deceptive ["leurre"]. Into this niche, in this bowl, Freudian truth will be poured. You are lured, no doubt, but the truth is elsewhere. And Freud tells us where it is."

6.

Thus, by a double blow, this short study is not near to exhausting its strategic consequences: psychoanalysis is inscribed in the central path of the moralist tradition (which, inevitably, has repercussions in the method and goals of the cure); but, in its turn, this tradition is cleared up retrospectively in the light of its final destination, Freudian truth, which allows us a posteriori to understand better what the moralists were groping for unknowingly. It is a curiously Hegelian vision of a historical dialectic resolved in the manifestation of a truth (but was not Hegel quoted twenty-two times in the Index). A curiously "virile" truth as well, which "pours itself" into the hospitable "niche" of a tradition, perhaps in order to better impregnate it, one might say; but since this "niche" where the phallodiscourse lodges itself is a "bowl," one clearly recognizes the form of the sadistic-anal compulsion. The genealogy of morals or, at least, of the moralists, less ironic there than it seems, participates in a

dialectic of the discipline in which Lacan, via Freud, intends to remain the Teacher/Master (let us not forget that we are dealing with a seminar). What La Rochefoucauld, summoned to his historical place, brings into his discourse on *amour-propre* is the putting-into-circulation, one might almost say the putting-into-service, of the key notion of the "decoy-deception" [leurre].

7.

If, indeed, it is a question of a "Freudian" truth, this truth does not belong to the latter's vocabulary. Neither "decoy-deception" ["leurre"] nor "nonrecognition" ["méconnaisance"] appears in the classic *Vocabulaire de la psychanalyse*, reedited by Laplanche and Pontalis. It could be argued that the notion is, to a certain degree, implied in such traditional categories of "idealization" or "denial" ["déni"], but it is really not separated except in Lacan's perspective. I do not intend to examine here the status of this notion, to determine its conceptual fate, but in a simple or complex manner to see how the said notion articulates the various quotations of La Rochefoucauld in Lacan's text, or how the latter is articulated there. Quotations and their vicissitudes

8.

All of that begins strangely, in the order of presentation of the *Ecrits*, by a remarkable *mise en abyme* ["quotation in a quotation"], on page 21. In his Seminar on *The Purloined Letter*, Lacan quotes Dupin, famous detective or detector of Poe's truth, as quoting:

> a case of showing us clearly the names of La Rochefoucauld, La Bruyère, Machiavelli, and Campanella . . . and of going on and on about Chamfort. . . . Poe is undoubtedly enjoying himself. . . . But we do suspect something: this display of erudition, is it not meant to make us understand the master-words of our drama? Does not the magician perform his act right in front of us without tempting us by explaining the trick but reinforcing his bet that we will understand his machinations, however, without letting us see anything? That is probably the highest achievement of the illusionist's art: to have us *truly deceived* by a being of his fabrication.

Formidable status of an "honest deception," that Lacan's remark itself does not escape: the gesture, which here purports to dissipate the illusion, perpetuates it. For, at the moment Lacan declares that Dupin quotes these kyrie trick names as a decoy whose purpose is to divert attention

from the real message (like the famous logic of Freudian *Witz* recalled by Lacan on the preceding page, where a Jew lies to his chum on the train station platform, telling him he's going to Cracow, so that the other will think that he's going to Lemberg, while he's really going to Cracow), does not Dupin's false citation expose Lacan's position for what it really is? Indeed, Dupin's quotation is not so distorted that it can't release from an imaginary tongue this *lineage of moralists* whose ultimate goal, as explained in the *Séminaire*, is psychoanalysis. This affiliation is entirely interwoven with the idea of the "decoy-deception." We are, therefore, not surprised to see, on this same page 21, and without any reason, two important items: La Rochefoucauld (and his synonyms) and *deceiving*—an appearance which has its very being in what it attributes to the other: "Is not this show of erudition supposed to explain the master-words of our drama?" A drama which, to all appearances, links *ethics* with *illusion*, but because of the dissimulation which it practices, points out the area of nonrecognition. Yet, criticism has, for a long time, insisted upon how difficult it is to go from the theory of *amour-propre* to the practice of *honnêteté*, which the theory itself renders impossible. We find exactly the same difficulty in the psychoanalytical field, where, today, the idea of "cure" has been discredited, although, in truth, that has not helped in defining the cure's goal, depending as it does on the death instinct.
"It is for this being of nothingness that our daily task is to re-open the path of his meaning in a discrete fraternity" *(Ecrits*, p. 124). But, given the insertion of the subjective constitution in a necessary, aggressive circuit, this touching appeal for a "fraternity," even a "discrete" one, is as problematic as is La Rochefoucauld's wish to promulgate a morality of *honnêteté*, after having qualified everything human with the fury of *amour-propre*. Theoretical discussion on the activity of the unconscious is limited by its very own law; that which has become impossible to find in Freud applies just as much to Lacan. That which appears in the twisted ambiguity of the cited discourse is the truth that is hidden in the discourse which cites, in accordance with Lacan's own method, where the one who transmits (here, Poe's commentator) receives from the Other his own message in an inverted form—a method which is reduplicated by having been borrowed by Lacan from another: "a formula which we had only to take back from the objector's mouth to recognize the impact of our own thought." *(Ecrits*, 298) In the case under discussion, there is no communication. Lacan refuses to acknowledge the position given to Poe's detective for his own detection: the position of the moralizing deception, which is also the psychoanalyst's position. As pointed out in the moral of *The Purloined Letter*, a story of glances watching each other watch others, Poe puts Dupin on stage, where he is seen by the critical eye, which would like to become the master eye.

9.

Continuing with our task, we note that the following two quotes from La Rochefoucauld which appear in the text "Aggressiveness in Psychoanalysis" *(Ecrits,* 107, 199). Before coming to the quotations, it makes sense to put them in their proper place. Having defined the analyst's stance ("the ideal of impassibility") and his method ("to provide the dialogue with a character as stripped as possible of any individual characteristics; we erase ourselves . . . in order to set up an inert base from which our interpretative intervention shall take a kind of oracular relief"—106), Lacan brings in La Rochefoucauld's *amour-propre* as a trap:

> What seems here like suffering's haughty claim will show its face—and sometimes at a rather decisive moment in the "negative therapeutic reaction" which caught Freud's attention—in the shape of *amour-propre*'s resistance, to use La Rochefoucauld's term in its fullest sense, and which, often, admits being like this: "I cannot accept the idea that anyone but myself can set me free."

The second quotation, which alludes to the maxim (113, ed. Truchet) on the "incompatibility of marriage and pleasures," comes up with an important development where lies the definition of what Lacan calls "narcissistic passion," the formation of the ego not by some "reality principle," but by a series of alienating, imaginary identifications (mirror stage, transitivism, dialectic of relationships like to like), which induce a correlative aggressiveness in even the subject's formation, to the extent that "lack of sufficiency ["adéquation"] in the 'other' prohibits any identification" *(Ecrits,* 141):

> One cannot emphasize strongly enough the irreducible nature of the narcissistic makeup . . . no human oblation *[sic]* could possibly liberate its altruism. And that is why La Rochefoucauld was able to formulate the maxim.

If, indeed, marriage is the institutionalized coupling of the ego and the other, it enacts the primordial drama of relationship to others. In the rare cases where it succeeds, marriage remains the illustration not of a harmonious fusion of two entities (pleasures), but of the more or less raised tolerance threshold of mutual frustration. Two Narcissi who manage to put up with each other: that is a "good marriage." In particular, the analyzed and analyst couple. Or the quoter and quoted.

10.

Thus can be compared the "depth" that Lacan attributes to

La Rochefoucauld's thought, which is naturally the former's own as well, seeing itself in what it admires. The moralist's patronage is presented in two essential points of Lacanian doctrine: the theory of the ego and obstacles; and the nature and limits of ethics. These two points articulate precisely the field of the psychoanalytic enterprise: its means and ends. The third text, "Remarks on Psychic Causality," does not bring any new perspective, but, in a polemical note aimed at the psychiatrist Henri Ey and the believers in an Ego which creates a "psychic causality," working in an *active* relationship towards reality, he stresses the acted-out character of the Ego, blindly led by its only passion:

> All this does not stop me from behaving toward others selfishly, always unconscious of my conscious Subject. For if I do not try to attain the dizzying sphere of oblativity so dear to French psychoanalysts, my naïve experience will not supply me with any more to say about that common thread detected by La Rochefoucauld's perverse genius, which runs through all human feelings, even love, and which is called *amour-propre*. (159)

It is, however, in a totally new way, one closely related to the elaboration of Lacan's thought, that the following quotation appears in a major text, "Function and Field of Speech and Language," and at an essential point, "that the subject's unconscious is the discourse of the other" (265). After denouncing with his usual sarcasms the "mythology of instinctual maturation" and the "paucity of terms" used to characterize the subject in *ego psychology*, Lacan recommends an altogether different tradition:

> In order to follow established tradition, perhaps we should interpret La Rochefoucauld's famous maxim in which he says that there are people who would have never fallen in love, had they not heard of love, not in the romantic sense of a completely imaginary "realization" of love which would become a bitter objection to it, but as an authentic recognition of what love owes the symbol and of what the word takes away from love. (264)

The interpretation Lacan gives here of maxim 136 and the shift he causes in its apparent meaning indicate a major turning point. Generally speaking, the first texts in *Ecrits* attempt to define the laws of the imaginary makeup of the me; nothing could be more tempting or easy than to see the mimetic mechanisms of imaginary identification in what La Rochefoucauld was saying; what I take to be *my* love is, in fact, nothing more than the *other*'s desire. But the important term becomes *speaking of love*. The subject's desire is not simply the other's *desire*, but his unconscious *discourse* of the other; therein lies the reason why the said subject belongs

to the symbolic order and is torn from the imaginary order. Later on, Lacan says: "Therefore, man speaks, but only because the symbol made him man" (276). In this sense, man loves to the extent that he hears love *spoken of*, in other words, that love, escaping from the channel of fascination and seduction, is capable of attaining the level of a *discourse* and entering into a code and a law. One may doubt that this positiveness attributed to language is or remains within the meaning of maxim 136; it might even be thought that Lacan has La Rochefoucauld saying the opposite of what he means. Inverting a thought does not at all mean reversing it; it is a question of bringing out, in the very inversion itself, what he meant to say without being able to, what he was saying at the antipodes of his speech. That is how this curious inversion/divergence by Lacan of the other's discourse works, something that J.-L. Nancy and Ph. Lacoue-Labarthe analyzed so well *à propos* of Saussure, Jakobson, even Freud, in their remarkable study, *Le Titre de la lettre*. It is hardly inconsequential that their work derives from *The Purloined Letter*.

11.

In the text on "The Freudian Thing" finally, La Rochefoucauld and *amour-propre* make their last appearance, at the very spot where we saw them show themselves in the Seminar:

> If Freud's only contribution to the knowledge of man was the fact that there *is* a truth, then he discovered nothing. Freud would then just take his place in the long line of moralists in whom is embodied a tradition of humanistic analysis, a Milky Way in the sky of European culture where Baltasar Gracián and La Rochefoucauld shine as top-ranking stars. (406-7)

> This interest in the ego is a passion whose nature was already noticed by the long line of moralists who called it *amour-propre*, and whose dynamics in its relation to the image of the body proper, psychoanalytical investigation alone could analyze. (427)

This "long line of moralists," whimsically evoked by Dupin in Poe's story, returns with a vengeance, even though it is there that we must *re-place* the point of view which tries to encompass all others. The essential thing is to assure the position of this new "view" *(theoria,* in Greek) which is both "privileged," since it is the Truth's place, and historical, since it represents the end of an affiliation. Inheritance is the issue here: we would like to find a "property right" by legitimate succession, but without concealing the origins of the "Freudian Thing." Within the aforementioned "lineage," the "title of the letter" does indeed

play its role. Such is the lesson of La Rochefoucauld according to Lacan. When we imagine that we are seeking a higher good, we are mistaken. But then it is difficult to understand how psycho-analytical investigation can be an exception to its own theories and can place its interest in the truth beyond the reach of self-interest.

12.

Thus, the quotations from La Rochefoucauld do not randomly spruce up the text of the *Ecrits;* instead, they form a system of meaning that reflects essential points of the doctrinal journey, a *cyclical* journey on the level of the voice that brings the chain of events back to its start-ing point, whereas, oddly enough, on the level of the proven fact, there is an attempt to establish the lineage of a genealogy. The center around which this circle turns, its axis, is *amour-propre.* Throughout our read-ing we have noticed quotations from Lacan that function literally as trans-lations of classical maxims into modern jargon: "One cannot emphasize sufficiently the irreducible character of the narcissistic structure . . . no human oblation could possibly liberate its altruism" recalls irresist-ibly maxim 81: "We can love nothing except in its relation to us, and when we prefer our friends to ourselves, we are only pursuing our own taste and pleasure." Likewise, the theory linking the imaginary formation of the ego and our basic aggressiveness towards others was admirably stated by Pascal: "In a word, the *ego* has two characteristics: it is unfair in its essence, in that it makes itself the center of everything; it is hurtful to others, in that it wants to exploit them: because every *ego* is the enemy and would like to rule tyrannically all others." After these preliminary remarks, where shall we turn our study? Actually, it can go in different directions. One, historical, might seek to establish rigorously what Paul Bénichou suspected: a criticism of the testimony of conscience and a veritable theorization of the eighteenth-century moralists' unconscious, related specifically to the hero's destruction or the ego's deflation. A transversal or transhistorical communication could then be set up with the most up-to-date advances in analytical thought, insofar as in Lacan's work it is reincorporated, by vocation, into a similar possibility. Those [French readers] fond of "influences" might even suggest, in this instance, a tradition that is "really our own," one obviously inaccessible to Freud, and that bespeaks a psychoanalysis waving the French flag. A more theo-retical temperament could lean toward the specificity of the notion of *amour-propre,* and ask himself, for instance, how it differs from Freud's conception of narcissism: how it supplements the latter, inasmuch as it is lacking in it and complements it. This study, albeit fascinating, is not our task here. What game are we playing? Are we showing La Roche-foucauld's "depth," finding in him, *mutatis mutandis,* as we do, certain

reminders of today? Do we "explain" La Rochefoucauld "with" Lacan, as we "explained" Racine or Baudelaire "with" Freud? It would presuppose that the latest theory is always the best one; it would assume the absolute privilege of that historical place occupied by Freud or Lacan which, not without reason, they claim as their own, but which is precisely *in question* here. For a long time, psychoanalytical criticism held that a literary work was something which, to be understood, required a method pretested elsewhere. Such was Charles Mauron's psychocriticism, which, all things considered, had its merits. Today, the game gets more complicated, for we now know that the literary object (something Proust knew perfectly) is a kind of optical instrument through which the psychoanalyst, just as any reader, becomes, "in his reading, the reader of himself": the relentlessly narcissistic machinery put in place by this formula from *Le Temps retrouvé* turns the vision of the Other's image into a reflection of *amour-propre.* This appropriation of the letter, which furthers the circuit opened by *The Purloined Letter*, is the hidden, isolated ["celée, esseulée"] essence (Proust went on to say that reading is "receiving communication from another thought, all the while remaining alone") of the reader's every act.

13.

From the moment we stop thinking of a psychoanalytic reading of literature as being an "explanation" of literature by psychoanalysis, and see it more as a special kind of reading, that is to say, as the mirroring or the infinite opposing of two discourses to each other, each one retaining its specificity, the true meaning or its appropriation no longer works in a one-way circuit. This leads to the abolition of the psychoanalyst's grip on meaning, and the loss of any authoritative position. We have come a long way since Freud first joyfully feasted on Dostoevski, or Marie Bonaparte on Poe. *La Rochefoucauld (with) Lacan:* the optical machine allows us to see through both ends of the tube. After looking at La Rochefoucauld in Lacan's mirror, it is only fitting that we look at Lacan in the mirror of La Rochefoucauld.

14.

Certainly, there are countless ways of looking at something. Because we are concerned here with mirrors (therefore, images), the first thing that strikes us is a *position:* the moralist's *position,* which is not at all simple. As L. Van Delft reminds us in a useful historical conclusion, the classical moralist wears many hats: "Naturalist, painter, traveler with diary, spectator, theoretician." Among these diverse aspects, we will keep two here: "He stands back, attaining a distance suitable for criticism,

the perspective necessary for irony." This attitude of the moralist implies a moral in the writer: attention to conciseness and the virtue of concentration in matters of writing. "The moralist never supplies anything but a *hint*. . . . He will be even more sparing of his speech. . . . He extracts a different reality, checked and ordered by his mind, stylized, a reading, a lapidary 'lesson' which reveals the meaning." Reveal the meaning, without revealing oneself: that is the moralist's motto. The chief "economy" made by the moralist is that of himself, as the basis and support of his discourse; he offers a system or series of statements, without the subject who makes them. Using Benveniste's more exact terminology, he holds a discourse ("any utterance presupposing a speaker and a listener, with the former intending to influence the latter somehow") but in the manner of a *story* ("No one is speaking here; events seem to recount themselves").

Most of the time, our virtues are but disguised vices. The heading of the *Maximes* announces the structure to follow: the Truth states itself, and does not accept anyone (in fact, certain maxims from La Rochefoucauld are interchangeable with certain others of Jacques Esprit or Madame de Sablé). The manner in which they are stated determines their reception: the reader alone takes it in hand, it is his responsibility completely. As soon as he finds a meaning in it he is engulfed in it: it is *made for him*. The text that I decode decodes me. Just as Barthes says so well in his study on La Rochefoucauld, "this maxim passes through three centuries in order to come and tell *me* about me." The aphoristic discourse implicates and explains me; it closes in on me like a trap; to understand it is to be caught in it. Reading the frontispiece is accompanied by its simultaneous translation: *my* virtues are only disguised vices. *I* possess this vicious virtue, I, the reader of the utterance, its object/subject. In the perfect textual machine thus elaborated, brilliant in the admirable rigor of its form, the hidden truth suddenly explodes and strikes me like a thunderbolt.

15.

For the reader/receiver, the maxim is a masochistic instrument (no wonder they call it biting), just like a whip. My ecstasy is proportionate to the pain it inflicts on me, my suffering is the measure of its truth, something Barthes, with his usual intuition, summed up in this statement: "The maxim could only be cruel." His axiom presupposes that of Renan's: the truth is always sad (another maxim). And, naturally, the maxim's creator is subject to the dictates of this truth. The universal validity of the declaration includes the speaker; the *ego* of La Rochefoucauld, Pascal, or Lacan cannot escape this rule: their virtues are but vices in disguise, just like mine, vices which, when all is said and done, go back to that vice which is the fundamental core of *amour-propre*. So

much so that we could say that the textual machine is hermetically masochistic: it functions principally in a closed circuit of self-punishment. Because, as La Rochefoucauld anticipated with such amazing exactitude, *amour-propre* falls under the heading of the death instinct, since "it is recovered in the midst of its own defeat" (MS 1), the maker of *sententia* derives pleasure from the one who condemns him to his own inanity. The art of the maxim, therefore, amounts to the joy or revelry of some Baudelairian Héautontimorouménos: "I am the wound and the knife. . . ." Obviously, such an interpretation is largely false; his contemporaries, who were no dummies, quickly accused La Rochefoucauld of "wickedness" and misanthropy: they reacted to what was aimed at them. We see this reaction in a remarkable comment made by Mme de Maure to Mme de Sablé: "I feel he paints too ugly a picture of man's soul." What was said of La Rochefoucauld will be said of Freud as well. If *amour-propre* deploys an indefatigable self-destructive power that stays within the blind and lethal logic of the repetition compulsion ("if it exists, it really wants to be your enemy," MS 1), we must not forget that La Rochefoucauld is proposing, well before Lacan and at the same time as Pascal, the simultaneous principle of the ego's constitution as idol ["image"] and a relative aggressiveness towards others: "*[amour-propre]* makes men idolators of themselves, and could make them other people's tyrants, if fate were to give them the means." The masochistic textual machine, through another twist, turns into a sadistic machine: if, on the reader's part, there is pleasure in receiving truth as a hurt, there is an equal pleasure in inflicting it. *For whom*, in what instance? Everyone knows that one man's joy is another man's sorrow. Here, the sorrow of our condition makes for the joy of writing, a joy which, in its essence, defines the very art of the aphorism. What this amounts to is that the sadist, naturally, is the *writer*.

16.

Once the victim/executioner pair is reinstated, the maxim functions in a particular pleasure in a type of writing, a type traditionally defined by the quality of its *impact* ["frappe"], its *pointedness*, its *acerbic*, *sharp*, or *penetrating* spirit: it is up to the reader, and that includes the author inasmuch as he reads himself in his own words, to get pleasure from receiving the blow; the scriptor gets his kick from dealing the blow. So, the celebrated splitting of the subject occurs fully in the maxim's subject: the *I*-referred-to enters his discourse; the *I*-referent escapes it, as its source. But, if we look more closely, it escapes it in a very special way: it slips out of it ["il s'en échappe"]. Earlier, we noted the *economy* of aphoristic discourse, empirically defined by its qualities of "brevity" and "conciseness": the economy, for universal utterance, of a singular speaking-subject. "The gain, which blinds some, enlightens others" (M 40). *From whence is this written?* From nowhere. Within the objectivity of the aphorism, no

one is speaking. We are, of course, dealing with sleight-of-hand. The aphorism is a deceit of writing, or, if you prefer, a pure act of trickery. At the exact time when this discourse, through its lapidary quality, formal virtues, enigmatic appearance, attracts attention to what various critics have recognized as a *language on stage*, the speaker of this language is abducted, as it were. The maxim-rabbit jumps out of the volume-hat, all alone. The situation here is not a crude gift but a consummate art of deception: we are aware of how all the attempts at "recovering" the moods, stories, adventures, and avatars of La Rochefoucauld "underlying" his work have culminated in naive or pointless results. What *gain* is there for the scriptor in removing himself from the inscription? We must apply the system of reading the *Maximes* to their writing: "The gain which blinds some enlightens others." The writer's gain is in bringing the *light*, or, more specifically, the *theoria*. Yet, light presupposes its shadow, the theoretical gain, like all the others, its blind spot. It is marvelously defined by maxim 173:

> There are various sorts of curiosity: one of gain, which leads us to want to learn what could be useful to us, and one of snobbishness, which comes from our desire to know what others do not.

This snobbish attitude, narcissistic and aggressive (knowing more than others) is the *primum mobile* of theoretical enterprise, including that of the moralist. The discourse of truth is part of the mystification that it denounces: *every discourse on* amour-propre *is a discourse of* amour-propre. Consequences of this paradox are not altogether lacking.

17.

One of La Rochefoucauld's outstanding commentators, Philip Lewis, has understood the special position of the theoretical discourse, whose articulation finds itself willy-nilly caught in its own utterance: "since the depths of *amour-propre* cannot be fathomed, how can we write about what is happening at those depths?" The paradox is centered around the term: *writing*. The epistemological problem (representing the non-representable, penetrating the impenetrable, etc.), which could be posed, for example, in mathematical terms, is here articulated in the act of writing. The specificity, one might even say the "secret," of aphoristic writing is revealed to us by the same critic a little later on: "The paradox of the maxim, which does not go away when we reflect on it, lies in the complete confidence with which it expresses a relative truth [I shall add: by definition, and in accordance with the aforementioned epistemological paradox], the stamp of certainty that it puts on the problematic." Where does this complete confidence, this trademark of certainty came

from, if not from the very stamp of the verb, called *stilus* in Latin, style? The maxim's style performs a double operation: it makes the reader submit to the weight of the utterance; it relieves the writer of the risk of actually uttering. What speaks is the Truth personified, through its mouth or pen; and we recognize Truth's speech by its structure: *the maxim acts as if it were taking itself to be an oracle.* The oracle's traditional ambiguity has nothing to do with its obscurity; on the contrary, oracular language, like the language of the aphorism, is characterized by its limpidity, its brevity, its transparency. When Pythia declares to Croesus, king of Lydia: "If you go to war with the Persians, you will destroy a vast empire," there is nothing hidden in this message reported to us by Herodotus. It is merely that of Croesus' reading it in accordance with his wishes, giving it the *opposite* meaning: the empire that he will destroy by going to war is his *own.* Croesus' blindness is only the blind spot of *amour-propre;* the error in reading is a moral mistake that defeat will later prove to be true. Having once again consulted the oracle, "after hearing the answer, Croesus realized that it was he who was at fault, and not the god." Like any message the oracular dictum presupposes a sender and a receiver; however, the (human) receiver is always at fault, the (divine) sender always right. The absence of a speaking-subject in the stating of the maxim takes on a specific meaning: that of a *hidden god.* But, whereas the oracular god is out of reach in his empyrean heights, amusing himself by tricking mortals and offering them a truth which he knows they cannot understand, the god of aphoristic discourse is in the middle of the whole affair: human, all-too-human. The maxim is a false oracle; its author, a false god.

18.

The *posture* of a subject who supposedly knows when the act of knowing, by the intangible nature of its object, is impossible, is an *imposture.* Thus, we obtain the law whereby every discourse *on amour-propre* is a discourse of *amour-propre,* partaking as it does of an indissociable clairvoyance and blindness. But we should go still further: *every writing on* amour-propre *is an* amour-propre *writing.* The full brunt of narcissism is stored in *the very act of writing,* in this strange aphoristic machine where the utterance itself procures a masochistic pleasure for the reader, and the act of uttering, a sadistic pleasure for the scriptor: the thrust, points, hallmarks of style cause violence between the discourse of the Other to the other in his discourse. Thus, the maxim produces this maxim: every maxim lowers the one who reads it insofar as it lifts up the one who writes it. Satisfaction from *amour-propre,* in the crudest sense, and at the same time, the most deceiving. Another moralist, La Bruyère, illustrates this truth for us with the apologue of Acis, a sayer of *phébus* (in whose etymology, curiously enough,

we are reminded of the oracles of Phebus Apollo):

> What are you saying? How's that? I don't follow; would you please start over? I follow even less. Now I can guess: you're trying, *Acis*, to tell me that it is cold: Why don't you just say: "It's cold"? . . . Is it so bad to make yourself understood when you speak, and to speak like everyone else? There is one thing that you, Acis, and your fellow sayers of *phébus* don't have . . . brains. That's not all: you possess one quality too many, which is thinking you have more than others. . . .

What an exemplary demonstration of a sleight-of-hand by the writer who, while reproaching Acis for "not speaking like everyone else" and believing "he has more brains than anyone" dis-covers the very essence of his own discourse, paints his self-portrait while thinking he is doing the portrait of his ridiculous double, and yet does not recognize the posture intrinsic to his own style when it comes back to him from Acis' position. Aphoristic writing is a permanent manifestation of the scriptor's *superiority* over the reader, and puts into play and action, through a supreme irony, the flaw which is denounced as the other's primary vice. In order to avoid seeing his reflection in the mirror held up to others, however, the writer must pay the price of *anonymity*. By erasing his scriptural trace (Proust repeated this method), if you prefer, his *imaginary* trace in writing, the celebrated classical "impersonality," to the advantage of the pure utterance of the symbolic law, the moralist's discourse retains a *position of mastery*. How can you teach others, if you are considered their equal? Such is the rule of the game. The latter does not exclude an empty *I* in a false dialogue: "What are you saying? How's that? I don't follow." In fact, this empty *I*, from whence the moralist's speech begins, and his discourse is written, is not at all empty: on the contrary, it is completely filled by his *ego*. Though *I* may not follow, my *ego* does. What La Rochefoucauld conceals from us, La Bruyère admits in a haughty claim:

> Horace or Despréaux said it before you—I believe it because you say so; but I said it as if it were mine.

As if it were mine: rarely have the basic narcissism of writing and its specular capture in the mirror of the other so ingenuously disclosed the law of their operation. It is a question of *reappropriating* a "common ground" for oneself, of making a place for oneself by readjusting things to one's advantage, by diverting the elocutionary banality of the "topos." The writer's originality is immediately perceived as agonistic, a rivalry with the predecessor and model (father or brother). The scriptural ego is constituted by eliminating or subverting the other, an attack not only on the other in the discourse, but on the Other's discourse itself. Writing is at one and the same time language's robbing and raping, violence committed

on common usage by the torture of a peculiar rhetoric. In the case of La Rochefoucauld or La Bruyère, critics have thoroughly displayed and dismantled the refined instruments of this torture: simple or complex antitheses, twisted constructions, tangled repetitions, sudden discordances, false symmetries, so-called blind windows, by which writing is put on the rack of "style." Whether we are speaking traditionally about distance, irony, or reticence à propos of the moralist, what slips away from image of self, from the scriptor's ego goes right back to the very place of *writing*—though this is not true for every writer: the novelist or playwright of the time, Mme de la Fayette or Racine can satisfy their narcissistic need through the ego's projection into imaginary happenings ("situations" of their "characters"), completely without touching the symbolic instrument. In the classical moralist's case, it seems, on the contrary, that the scriptural undertaking, be it of the "witty" or "satire" types, or of any other genre, falls completely into the Freudian category of "tendentious." With that in mind, we can understand Barthes' remark better: "The maxim could only be cruel". Essentially, the moralist has a *hostile* style; his gesture is a graphic sadism, which joins with the reader's masochism. To this, we can only add that *amour-propre*'s ultimate metamorphosis *announces its presence at the precise spot where it is denounced*, and, without fail, *imprints it in the text where it is printed.*

19.

Seen in the mirror of La Rochefoucauld, Lacan's discourse on *amour-propre* is a discourse of *amour-propre* according to Lacan. Again, we should examine this proposition more closely, beyond the simplistic and banal psychological assertion that Lacan has an ego like everyone else and even a little more, and that the theorist's ego is subject to his own theory's precision (or incision). If our analysis is correct, with regard to the human subject, the moralist's position is that of one held by the subject of a knowledge that shatters illusions, a position therefore of the *superiority* (deceiving ["leurré"] to others) of *anonymity* (the refusal to be caught in the ego's discourse), that is, in the final analysis, of *mastery* (a thinking-teacher, prescribing, not just describing, behavior). This position's logic produces in the impersonal and abrupt scintillation of the statement, the actual form of its language: language of the *oracle*. Now here we have a stance taken by the moralist which is, in certain respects, similar to the psychoanalyst's, as Lacan described it: the absence of the analyst's persona (the "ideal of impassibility" which tends to "provide the dialogue with a character as stripped as possible of any individual characteristics," an absence which determines the nature and function of his speech, which readies the "oracular relief that, on this basis of inertia, our interpretative intervention must proceed" (see above). The profound kinship between the lineage of moralists and psychoanalysts, emphasized in the beginning by Lacan, has actually less to do with a doctrinal affinity

than with *language:* the interpretative intervention, such as in the apho-
rism, contains a truth emitted by pole X, whose responsibility and cost
lie with the receiver; in both cases, at first, the decoder of this truth re-
fuses to see himself implicated in it, since it makes his soul "too ugly";
afterwards, having overcome the resistance, he is overwhelmed by the
evidence, which is, in fact, an error in reverse, an inversion of meaning:
"Most of the time, our virtues are but disguised vices." To which the
analytical speaker will echo again and again: "But, what if this love which
you claim so vociferously were really hate?" "And, what if stranger than
your dream, it was your most intimate feeling?" The purest modality
of oracular speech seems hypothetical: "If you go to war with the
Persians, you will destroy a vast empire." Prediction of the future is
submitted to an interpretation; in the play of deciphering lies the margin
of freedom. But the point is precisely that what the asking subject does
not recognize in the oracle's pronouncement is his place in it; he takes
his place to be that of the other. From there comes the idea that the
illusion is an inversion or permutation of terms. That which is hidden is
not profound, it is hide-and-seek. However much of it he may possess,
the analyst speaks from the god's place: his interpretative proposition
affords him a position of mastery, assures or assigns him a status of extra-
territoriality, insofar as the truth that he utters does not come back to
him in order to force him to be judged in his own territory, or at least as
it does not come back in his *personal* utterance. The intersubjective
circuit is interrupted; asymmetrical communication is a pseudodialogue.
One does not argue with the oracle, as its outpouring is a closed book.
Eritis sicut dii: the analyst, however, pays a high price in practice for this
divine position (which, naturally, he denies or repudiates in theory); the
price for his divinity is his silence. "We retire to the background," as
Lacan said. This effacement of the self is an attack on *amour-propre*, a
cruel wound for the ego, which is as much as and more than common sense,
the best-shared thing in the world. In this de-individualized character
that he assumes, the analyst makes a gift of his person to the analysis;
from the minimizing of his particular traits (to which he is attached as
much as anyone) he makes a sacrifice in the therapeutic or truthful
process. However, the analyst is not satisfied with only his silence or his
speech: once he proceeds to *write*, the situation is reversed. He returns
to his full place as a special subject in the realm of language; the text he
signs points to him. He includes himself in the oracle he proposes to
someone else and there is no escape. He participates in the decoy-decep-
tion ballet. Because, if he writes, or so he thinks, since Freud and with
Freud, for the purpose of liberating or freeing the truth, this truth, as
soon as he writes it, becomes *his.* What becomes engulfed in analytical
writing, what pervades it in every aspect, is the *me* of the analyst, whether
it be rejected or contained in the program. If, indeed, according to Lacan,
the Ego is the metonym for desire, and desire the metonym for lack of
being ("The direction of the cure," *Ecrits* 640), then writing is the

metonym for the lack of being of the psychoanalytical Ego. From then on, it assumes all of the ego's sins: "No human sacrifice could possibly liberate its altruism," we learned earlier. By making *style* teaching's supreme bequest ("This path is the only one we could hope to pass on to those who follow us. It's called: a style," *Ecrits* 458), Lacan, in "The Overture to This Collection," had taken the initial precaution of maintaining this "style" in its *oracular* structure *(orare*, to speak, from *os, oris:* mouth):

> We would like to lead the reader from the road for which these writings are the landmarks, and from the style that their distribution creates, to a consequence in which he will have to participate. (10)

It is up to the reader, as the analyzed, to "give of himself" there, since "style" is determined by his *address* (a nice pun):

> Style is the man, would we be poking fun at this truism by just lengthening it: "the man to whom one addresses oneself?" (9)

But the address (of the magician/stylist) is not such that it won't give away the secret of his trick by disclosing *at the other end of the style*, the active presence of the magician. And that, in conclusion, leads us back to the beginning of this essay, where Dupin was quoting La Rochefoucauld, "a case of bluffing us." Deceiving or revealing completely, in other words, *amour-propre* wanting to be invisible, it is Dupin's *amour-propre* which, in quoting La Rochefoucauld, wants to hide itself in the quotation which denounces him, assuming, of course, that "bluffing" is always wishing "to appear to know more than others," a wish shared by both detective Dupin and detector Lacan. The latter, seeming not to detect that the rather odd reproach he, as professor of his Seminar's students, makes—O Irony— on the Ego, is exactly the same one where he shows himself permanently:

> I want to scold all of you for just one thing, if I may, and that is your wanting to appear too intelligent. Everyone knows you are. So why do you wish to look the part? *(Séminaire* 2:39)

We are dealing here with an essential necessity for the agonistic relationship towards others, born of narcissistic passion. La Bruyère taught it to us when talking of the *phébus*, of "the mind": "you possess one thing too many, the opinion that you have more than others." To which La Rochefoucauld added: "There is the source of your pompous rubbish, of your confused sentences." In the weakest sections of Lacan/Acis' discourse, can anyone not see the address of the style sent back to the sender, and returned to its pure complacency? In the strongest parts which are by a great writer, Lacan/La Rochefoucauld cannot escape the law of

moralist writing, which is perhaps simply modern writing:

> La Rochefoucauld or Freud said it before you—I believe it because you say so; but I said it as if it were mine.

Rejected from Lacanian theory, reduced to an imaginary instance, the ego, just as the natural, comes back into writing at a gallop. Or better yet, it returns with a *wallop:* surfeit of a linguistic *mise en scène* where we can read the perverse pleasure of the virtuoso, stamp, points, antitheses, repetitions, preteritions, prosopopeiae, the whole arsenal of *figurae* that explodes in Lacan's *Ecrits,* and of which there is as yet no exact inventory, as if whosoever rubs up against this needle-style were afraid of being pricked. A style which, with its troops of tropes, wants to be a mimesis of the workings of the unconscious, that theory informs us is structured like a language, in other words, like a rhetoric in action. But the sumptuousness of the rhetorical unfolding does not, as a result, abolish the "phrase's personal direction" of which Mallarmé spoke: on the contrary, it designates what the rhetorician's place shall be and where his pleasure shall lie; or, better still, it is not so much written from the Other's place as to prevent Lacan, just like any eventual reader, from putting *of himself* into it. The classical division of roles reappears far beyond the crazed surrealistic generosity that tried to suppress them: the reader of the sibylline pronouncement has the forever-thankless task of deciphering, since it will be, as was Cyrus' interpretation, a naive projection of desire, and therefore, an admission of stupidity; the scriptor has simply to remain untouched within the walls of his oracular fortress. But no writing is immune from the unconscious, even writing about the unconscious by the most cunning analysts: the putting-into-play or shedding-light-of-day onto these processes does not at all constitute seizure. The plethora of rhetorical baggage reveals a joy in parading and prestige, which theory constantly assigns to the guilty pleasure of the ego—a pleasure which La Rochefoucauld, who was more subtle, attempted to take from us by deleting the passage on *amour-propre.* The analyst's narcissistic and aggressive writing moves completely into the *egological register,* which the action of the analysis endeavors to dissipate, a strange opposition, in the psychoanalytic field, of the oral and written. In defense of the latter, one might point out its pedagogic virtues: specifically, all teaching implies the *Master's position,* the center of everything and tyrant of others, as Pascal would have put it. More than mastery of the institution or mastery of the theory, the desire to write establishes the analyst's ultimate goal: spending his time hidden behind the patient, as if in a crouch, when he writes, he stands up and walks in front of the couch. His "style" is his silence's revenge, thanks to which the subject of language hopes to feel like *his master.* The fascinating alter ego, the hated brother of the analyst is, and always has been since Freud, *the writer,* naive and sovereign producer of the word, envied and revered, denigrated and raised up to the heavens.

The simple fact is that, during the session, the analyst is paid for listening: slave of the other's language, that other who alone speaks; his "intervention," however oracular or truthful it may be, can only be an *echo*. The statute of analytic speech is the *quotation*: letting the patient hear his own speech. Thus, we are led back to our point of departure: Dupin scolded by Lacan for having quoted La Rochefoucauld off the subject, that is, on the subject of *Lacan's own desire*, in this, admirable and exemplary in its own way, that he dares exhibit splendidly what, in Freud, is prudently hidden. *Purloined letter:* a letter, in fact, less purloined than turned-away, but also re-turned; mirror-language which, from the Other's place, goes back to Narcissus. Therefore, we have two possible conclusions from which to choose. With La Rochefoucauld: that virtues (of style) are, most of the time, but disguised vices (of theory). Or, with Lacan: "I, the Truth, am speaking," providing we see that the *I-ego* necessarily introduced in the pronouncement of the doctrine, must be understood as: *I, the truth, am writing.*

Translated by Stamos Metzidakis and the NYLF staff

12

Detachment

MICHEL PIERSSENS

> *Pouvons-nous passer d'une*
> *différence entre la pensée*
> *parleuse de*
> *la langue qui se plaît à la*
> *rumeur du rythme-signifiance*
> *et la pensée*
> *chercheuse (. . .) ?*
> *Michel Deguy*, Reliefs

To write piecemeal is a struggle. It has neither the reward of mastery, nor the danger of defeat, but the irony of a question that belies its own answers.

Saving that: writing—background noise. The beauty of language as a "parasite," an "interference" that hides meaning and sputters out information. Can one spend one's life in the intensity of this noise, in its disorder? Yes, as a writer, as a reader, either one or the other, both in the

same. What a prodigious aberration, like that of ascetic saints who use-
lessly let their nails grow as a sign of their folly and of their faith. So
close to love's territory.

Between the vacuum and the plenum—beatitude and unconscious.

Writing is the art of the essential. The giddiness of the insignificant;
formed letter by letter, word by word, question, answer, silence. Writing,
not the fascination of the void or of nothingness, but the intensity of
advancing further to the ever-more-minute detail, even if it is a matter of
making great things arise from it (as Balzac did when he corrected a pre-
position or an article in the midst of a vast historical or social panorama).

The strength of the hesitant affirmation. Silent blind words for which the
things of the world speak. Everything comes into play in meaning, and
in meaning gone astray. Meaning misleading us at the crossroads of lan-
guage. Wanderings, network of roadways, here and there pyramids, about
which only the sphinx knows the secret.

Everything should lead back to the fortune or misfortune of writing. Ink
can create a score or a spot, music or noise, dance or confused milling
about. A single *mot juste*, or single concise sentence, is salvation, a new
beginning. Everything else can crumble, and does crumble. However, the
perfect moment of the word suffices to put everything immediately back
in order, time in motion, the world on its axis. Minute eternity, between
two falls.

Language is therefore memory and ruin. Memory as ruin. The ruination
of knowledge, both collective and individual.

The unvarying great plenty of the real, where everything is in fact equal,
detracts from signification. Language is that which permits us on the
contrary to establish holes and concentrations, reserves and networks, in
this flux of differences, either by means of *obliteration* or *transference*. A
text is nothing more than a permanent translation of this set of processes
with the purpose of establishing reference. It posits the possibility of a
single world, a choice among many others, one whose equivalence and
near indifference it allows to come up to the same level. The imprint of
a circuit on one of the grids of language.

Literature in its role as a test of knowledge: it makes the irreconcilable
enter into discussion, working to make discourses that never meet inter-
sect. It does this by risking the *subject* (the author) whom it empowers to
come forward by means of the supreme authority of its arbitrariness. It
questions and puts forth imaginary solutions endlessly, which are never
reconciliations, but rather the adoption of ironic postures by constricted

discourses. Summarily fixed movements, which one guesses, have done nothing but slow down an instant in order to take off again afterwards, in the unclear focus of hurried silhouettes whose motion beckons us. Poetry is a sign for everything; it makes us aware of possible coherences, of fertile incoherences, of the impossibility of coherence. DuBouchet.

The encounter with reality as inevitable, but always out of phase in a never-more or never-there. The idea of displacement.

Modern culture (all culture in the strong sense, perhaps): a network of symbolic productions and destructions.

How strange it is that, at the very moment when contemporary science is giving its full attention to networks, to structures, systems, sets, organization, etc., "literary" thought is concentrating on the exact opposite—or that which seems to be such—the fragmentary, the unfinished, the unfocused, the distended, the dissonant, etc. How can we understand this back-to-back symmetry? A truly hermetic question, for it is unquestionably a matter of *one and the same thought*.

The opposite of the fragment is not the totality, the "complete" text. Its opposite is the connection, the network, because the text functions by the simultaneous construction of the unit and the total. To write in fragments is to *construct by obliteration*—in a sense, the fragmentary text acts in the same way as neuronic memory, simply as memory. Memory: the "image" of the body of forgetfulness, and, therefore, a metaphor for the text, that is for language. Compare Chomsky's idea of recoverable and non-recoverable deletions. Freud had investigated the possibility of such relationships, but the limits of language used in neurological discourse in 1900 prohibited him from going any farther. The fiction of analysis was born from this lapse.

 Fragment: for what violence is it the mark, the signature? From whence the question of *source*. Metaphorically of extraction, etc. But is not this rather the only birth without violence? Sweetness of detachment, that no other Whole has gone before.

Writing is that which resists the economy of more and of less. One cannot take back an uttered word. A thousand more pages would not have created "Cacanie," nor brought back Combray, nor would have even completed the Book. To allow the fragment is to reveal the statute of that incompatibility. J.-L. Schefer: "ces pages qui ne peuvent s'additionner" (these pages that cannot be added up together) *(L'espèce de chose mélancolie)*.

Characterize the fragment as an end in itself, as necessary, *nec plus ultra* (Friedrich Schlegel. Compare Lacoue-Labarthe et Nancy: *L'Absolu littéraire)*,

the fragmentary as a way of being (not to be, almost not, almost too much, not enough) and fragmentation as a tactic of ideological discrediting (Barthes, *Leçon*).

Fragment: a problem of framework: what fits the fragment? Writing without paragons, or paragons as writing? Compare Derrida.

The break (the interstice and the schism). Somewhere something breaks. The broken line of the nonframework. The broken column, divisibility. The faded framework, indivisibility. Monet: where do the *Nymphéas* (Waterlilies) end? Is it *a* cathedral or are they cathedral*s*?

The fragmentation of chromosomes. Prohibits the reproduction of the Same. However that begins again by mutation. And so it is with verse. Everywhere caesura, therefore rhythm, recovery, rejoinder.

The fragment is a verse. Meter with neither more nor less, but an impossible measure, without other verses to multiply it, other rhythms to divide it (Roubaud). Starting point and finishing point, it is the absent source of all hyperboles, the imperfect equation which would like to be a maxim—*maxima sententia*—the maximum feeling—in order to achieve its completion.

Fragment—nebula. Here and there, meetings of traveling forces and matter, making knots, spots, dispersed aggregates, random and determined (Lucretius, Michel Serres). Suns or planets in formation, already overflowing, looking for that somewhere else that will seduce them, carrying them away towards their disintegration. Cosmic *Witz* (wit). *Vis comica* (comic force), as well.

An energetics of discourse, of the fragment, of the word, indeed of the phoneme. From which the acrobatics of *diction* (Ponge: *Méthodes*). Fragment: jongleur who underscores this miracle with a gesture—the catastrophic balance of a single movement.

Fragment: deictic of the forces of speech, of their circulatory voices. The acupunctor's darts in the body of the text.

Extraction, or detachment? Extraction presses upon the already-written, distorts it, distends it, indefinitely pushes these "pieces" further away one from another, "pieces" which nevertheless float in the space that they invent, that they bring with them, searching to meet, and the adventure of their impossible collision. A thousand jigsaw puzzles mixed together that represent *nothing*. No form, hardly a configuration. A carpet without a figure, the missing thread, neither chain nor anchor. A universal detachment, ataraxia without fever.

Each piece, an island. Archipelago of detached time, vortical presents to recapture, without end. The monumentality of the fragment, because each one becomes a stele *(Segalen)* designating the unparalleled and its death, its dispossession. A unique and always funerary birth. Apollinaire: "Et l'unique cordeau des trompettes marines." The diadem on the crown of disinherited royalty, and therefore unalterable.

An immediate offense—however, pursued. Asyndeton, by means of which the construction changes its own plans at any moment, by leaps and re-bounds, planing. (Barthes).

Fragment: where the enunciation disappears (from where: monumen-tality). Uttered but not *spoken*, the fragment only exists in the written. Litteraly unpronounceable, it will not turn into speech until *quoted*, sewn back on the discourse of another. The passivity of the fragment, like Mallarmé's coin that is passed by in silence. Mutism by detachment.

Where one perceives that everything is *to follow*. Text without a history, nothing is related. Every text is static, *ex-static*.

What is excluded from the fragment is the *narrative*. A text without a story, nothing is related, but it acts as an intermediary to a meeting. The model narrative, *hors d'oeuvre*, outside the work, to which one can prefer the event of speech, its long variations of possibilities, its catalog of postures.

The fragment has always already occurred. It is born as such, straight off. Not as a result of a process, but as a state of nature, other. To be frag-mentary of the given word, which can (in its fundamental passivity) then be accommodated: proverb, enigma, verse, inscription, censure. Raw speech, passed over the cooking fire of enunciation.

There is nothing missing from the fragment. Whereas the narration or fiction always lacks the *n*th possibility.

One cannot not write in verse. And every statement will be a poem, doing away with simple connectivity which would paralyze it in order to connect it to the single chain, establishing on the contrary in its interior space, a space to excavate indefinitely (Mallarmé), the proliferation of its most dense roots.

Every text then would be in demand according to the interlacing of its arborescences, yielding here and there to pressures, submitting to the *work* of fragmentation and participating in it, exposing itself little by little according to the different levels of the fiction.

There is a way of reading that consists of not listening to what the text *wants* to say (for the effort to speak is always there), but consists in going back to the far side of that wish, towards the crux of its hesitations, towards the secret gate of languages which are little by little going to make their inroads, each at its own rhythm, and according to its very own logic, disjointed, forming in its play *the* rhythm and *the* logic that are like the screen upon which the pure spectacle of the will-to-speak henceforth empty would be projected, which is first of all the will-to-be and its self-denial.

The fragment creates a labyrinth—text-ruins, where it suffices to trace the distance covered in order for the ruins to be revealed, erased by the living monument that one had at first forgotten. For every distance is always double, and one never knows what ghosts are our escorts, what night lies buried under the day, what day supports the work of the night. That is what can be read in *Gradiva*, a meditation upon ruins and upon the present, memory and forgetfulness, reality and fiction, myth and its twin. Beneath dead Pompeii, there is still a living Pompeii, but there is also the "real" city where Zoe lives. Beneath the fragments—signs, symptoms and events collected by Hanold which remain opaque to him—there is the blind network which is his own life. Memory is present beneath forget-fulness. Between the fragmentary, the dispersed, the dead pieces, on the one hand; the connected, the reticulated, the living on the other, there exists a single passage, a coupling in the space of time. A reversal becomes possible to anyone who becomes involved in this coupling. Nothing has changed, but nothing is any longer the same. Everything was already there, but now the solitary bursts become bursts of solidarity. It is by means of this impossible passage that Gradiva penetrates the underworld, only in order to reappear at once on the other side—the same—among the living as Zoe Bertgang. The immense distance of the fragments was merely an illusion. But it is necessary—another illusion, doubtlessly perhaps—to short-circuit Eros, to abridge love, so that everything may fall into place and the puzzle be sorted out (waiting in this fashion for the figure, as Sade would say, to come undone). The force of the imaginary (here that of the image) denying the present to promote absence, re-establishes all of a sudden, the unity that we thought was elsewhere, or lost. A new course becomes possible from word to word, because they then cast off their corroding negativity in order to procure, from mouth to mouth, the very relish of truth.

All our intuition (not deducted a priori) of the joining and untying, the fastening or detachment, the being-as-a-whole or being-in-pieces of the things of our world, occurs thus by means of imaginary figures—simulta-neously discourse and inhabited scenes—that shape the dreamed words of architecture in our memory. Equivocal constructions in order to say the constructed and its destruction at one and the same time.

Every cathedral has as its companion a Museum of the "work," to really say well what is at the bottom of things. Capernaum which duplicates it, but also undoes it, offering its pulverized spectre: fragments, excavations, dismantled pieces, anonymous blocks, a pile without order, orphans of the *Gestalt*. What is missing from the work is the cathedral itself, of which the Museum is nothing more than the unoccupied, unworking part. Ruins in the absence of a project; the reverse of which would be the plan, the blueprint, the model, that work before the work that does not quite know the space it occupies, or what identity fits it. Three movements of absence etched in the work, that we know finally how to recognize in the work of texts: sketches, "text," and residue—from the moment we understand that no one of them explains the others, that the three of them delineate a volume of relationships which is the very space where thought plays upon itself, according to the particle of language; prospective, abstract, and fundamentally geometric (topological) work of the imaginary; work with the body in the voluminous substance of matters: the work of the negative on lost identity in the pain of doubt. Three moments that form a cycle, and no one alone "calls attention" to the others: all abundance reproaches itself for lack, all deprivation turns around to become a project, all well-shown enthusiasm molded from reality.

Overflow towards things, as tourism tries to here, caricatures: the ruination, the *making-into-ruins* of sites. Tourism and archeology go together hand in hand. From whence comes the strange impetus to "raise up" the ruins, undo Babel, that is to say remake it—at the risk of time which we deny, slipping in its tracks? Deny time? Withdraw from it, be exempt? Embrace it by plunging into its icy flow? It is a question in any case to live in its madness, to fabricate it stone by stone. Such is language, and all its *monuments*.

> The entrance to the ruins—the blind stare of Orpheus who does not see that death awaits him in the daylight. Gaze that breaks up places, spaces, the sheer weights—to make from them splintered images, the dust of time. The gallery of the torments of form, Vauban's arcade, Strasbourg. The entire length of an arch, deep echoes, linear labyrinth ever the more enclosed, in storehouses closed by strong gates, lets loose a hell of mutilated fragments, lays down reliefs. Pieces of disjointed sculpture, extracted perhaps from an invisible pinnacle, when put there, within hand's reach, all of a sudden seem inordinately larger, like the projections that a microscope would uncover. Screaming sniggering hell, where decapitated angels are restless, where somber conventicles are held among improbable guests around slain Christs. *Opera* without work, where the statues must hold out the phylacteries of a Sadian architect. In reality, an appalling pack of gargoyles standing straight up, stretching

their throats to the sky from the stone of their prison, muzzles from which one wants to scream the madman's cry. Rumbling of stone, as in a zoo of monsters. Alone, his back turned an immense figure, shrouded, meditates at the garret window that faces the river, dreaming perhaps of a feast of stone. But how are we to guess what knowledge is reflected on his absent face?

<div align="right">Translated by Adelaide Russo</div>

13

Philosophy as Rigorous Philology? Nietzsche and Poststructuralism

DAVID COUZENS HOY

Philosophie als strenge Philologie? Nothing could be more opposed to the traditional ideal of *Philosophie als strenge Wissenschaft*, the title of a book by Husserl in which he defends philosophy from the encroachments of relativism, psychologism, and historicism. Yet Nietzsche is rejecting the latter conception of philosophy and embracing the former in saying that genealogy, the closest Nietzsche comes to creating a new philosophical "method," is simply good philology.[1] The rigorous philologist sees through the conscious or surface interpretations of values and beliefs, and deconstructs self-deceptive distortions.

Although this enterprise may be valid and even valuable, it would hardly satisfy thinkers like Husserl as a description of what *philosophy* is. Philosophy as rigorous science aims at discovering first principles to guarantee the possibility of certainty and to provide the secure foundation for all other disciplines. To speak even of *rigorous* philology would thus not be possible until philosophy had first determined what a rigorous science was in the very act of becoming the most basic one itself. So it would be a sad state of affairs if philosophy were reduced to philology, the "softest"

of the academic "disciplines." Philology would seem to be the least rigorous precisely because for it everything is only a matter of interpretation. This outcome would indeed be the relativistic, nihilistic outcome Husserl feared for philosophy in his own time, and which he struggled to prevent.

Yet philosophy on Husserl's continent appears to have swung away from his ideal and back to Nietzsche's. As a result of disillusionment with systematic, foundationalist philosophy, the very idea of first philosophy and a single philosophical method has been supplanted with a hermeneutical conception of philosophy. The insistence on the interpretive character of all understanding has been applied to philosophical understanding itself. This development is not restricted to the revival of an explicitly "hermeneutical" philosophy in Germany by Heidegger, Gadamer, and others, but is also evident in recent, "poststructuralist" writing in France. In fact, Nietzsche has been a more seminal thinker for the French poststructuralists than for the German hermeneutical philosophers, and the French have found it necessary to "rescue" Nietzsche from the influential reading of him by Heidegger.

The interpretation of Nietzsche thus becomes a focal point for the problem of the nature of interpretation, including the sort of interpretation that philosophy itself is. A particular mode of interpretation, namely, philological interpretation of written texts, becomes a paradigm for philosophical self-reflection. But what sort of thing is a text? Is it in turn to be understood as a given reality that can be grasped more or less adequately in a corresponding interpretation? The metaphysical assumptions of this model are disrupted not only by Nietzsche's arguments, but also by his aphoristic, fragmented style. In fact, the paradigm for the interpretation of Nietzsche cannot be the magnum opus, the single Book containing either actually or hypothetically the complete system. Heidegger's conclusion that Nietzsche is a failed metaphysician is certainly due in part to the impossibility of constructing such a thing. Whether Nietzsche himself recognizes this impossibility is a less interesting question than whether his style itself controverts any apparent gesture in the direction of a metaphysical system purporting to reveal the order and nature of things. If we take Nietzsche's style seriously, and particularly the fragmentary character of his writing as we have it (both because Nietzsche intended some of it to be that way and because he could not complete the projects of the last years), we may want to consider as the paradigm of textuality not the Book, a metaphysical construct, but the fragment.

Crucial to the new Nietzsche interpretations are the fragments of the *Nachlass* published by later editors under the title *The Will to Power*. The exercise of interpreting these writings presents special problems and leads readily to reflection on the nature and limits of interpretation. There is often no way to tell whether given entries would have been published much as we now have them or whether they would have been worked into longer sections. Thus, whether a passage is incomplete and is,

therefore, a fragment or is complete and is, therefore, an aphorism may be undecidable. This undecidability raises the question, then, whether it should make any difference in our reading if we take the passage as a fragment or as an aphorism.

The Will to Power works both to minimize the difference between aphorisms and fragments and to maximize the difference in the interpretational assumptions involved in reading aphorisms on the one hand and systematic treatises on the other. In fact, the fragments published as *The Will to Power* do not necessarily represent just one book. Nietzsche may have had several books in mind, and this title is only a possible one. Commentators often note this point, but they rarely say why or whether we as readers would be better off if Nietzsche had been able to finish or at least do more on this potential *Hauptwerk*. Those who prefer books to fragments probably expect that Nietzsche would have worked out a coherent account of ideas that are inconsistent and unclear as they stand now. Those who prefer fragments to books, however, would also have reason to maintain that these expectations would not have been fulfilled in any case, and that we as interpreters are in a perfectly standard and satisfactory situation. They may even suggest that to treat any text as a book is to attribute an underlying unity to it, and that this interpretive strategy is regrettable in that it blinds the reader to the text's discontinuities and repressions. Treating all published works as if they were only fragments, and treating fragments as if they were works published in precisely that way, can be useful interpretive strategies, and this fact is itself a revealing feature of interpretation.

Philosophy that sees itself as rigorous science will invariably think of interpretation, if it thinks about it all, as an attempt to describe the text "faithfully," using objective procedures to produce the "one right interpretation." Because Nietzsche's conception of philosophy as rigorous philology is aimed against the metaphysical realism of such objectivistic theories of science, what he means by interpretation must thus be quite different. Several French poststructuralists have written extensively on this other way of taking both Nietzsche's and their own philosophical outlook, and they have done so by appealing to the concept of the fragment as the paradigmatic kind of text. Examining their attempts to rethink the question of the limits of interpretation and therefore of understanding will help me to argue against the general tendency to conflate Nietzsche's theory of interpretation and his theory of truth. I shall maintain that his theory of "rigorous philology" can be stated independently of his paradoxical perspectivism, and that rigorous philology is potentially a better basis for Nietzsche's research program of using genealogical procedures to study the hypothesis of the will to power.

Foucault, Blanchot, Derrida

In the poststructuralist reading, Nietzsche is not trapped in metaphysics but has indeed escaped its toils. He has done so specifically by

refusing to grant an exclusive privilege to the Alexandrian, Socratic man of theory *(The Birth of Tragedy*, Section 18). Theoretical conceptualization, including the activity of metaphysics, is merely one mode among others of infinite play. Play, furthermore, is not yet another metaphysical concept because it does not entail a systematic, foundational way of establishing the necessary connections between all the rest of our concepts. Rather, it allows for multiple ways of rearranging these concepts. Moreover, it does not make itself into a privileged concept, and is not "first philosophy," because it is not categorical.

The poststructuralists are not the first, of course, to emphasize that Nietzsche's emphasis on play carries him beyond the confines of traditional metaphysical thinking. In *Nietzsches Philosophie* Eugen Fink also makes this point in exploring Nietzsche's "cosmic metaphor" of play.[2] The French poststructuralists, however, are the first to put Nietzsche's playful philosophy into practice, so to speak, by investigating its consequences for philosophy, historiography, psychoanalysis, literary studies, and both cultural and social criticism. To group various thinkers such as Derrida, Foucault, Blanchot, and others together under the rubric of poststructuralism is to ignore substantial and personal differences between them. The label is justified only from the standpoint of a perhaps aloof philosophical overview that sees them all as pursuing Nietzsche's project of substituting for Platonic-Cartesian metaphysics a philosophy of interpretation. To be consistent about the thought that there are only interpretations, this approach should not attempt to supply an alternative ontology or epistemology. "There are only interpretations" is not an ontological theory about what there is but, rather, the claim that ontology as such is pointless. As a philosophy of interpretation, then, poststructuralism can be considered a development of hermeneutical philosophy.

Just as "interpretation" can mean different things, so can there be different philosophies of interpretation, and different hermeneutics. In one essay, "Nietzsche, Freud, Marx,"[3] Foucault identifies his own approach as a kind of hermeneutics (although in other places he tends to be critical of hermeneutics as it is traditionally conceived). One respondent to Foucault in the ensuing discussion even concludes that for Foucault traditional philosophical questions are to be succeeded and replaced by questions about techniques of interpretation. Foucault implies as much by allying himself with Nietzsche's view of philosophy as a "philologie sans terme," as interminable philology (188). For Nietzsche there is no end to interpretation because there is no beginning. Foucault puts this paradoxically by saying that "if interpretation is never finished that is simply because there is nothing to interpret" (189). By this he means nothing absolutely first, nothing given independently of our way of taking it: "there is never an *interpretandum* that is not already *interpretans*" (189).

Nietzsche's famous interest in the claims that there are no facts but only interpretations, and that words or concepts are only ever metaphors,

thus leads Foucault to maintain that it would be the death of interpretation if there were something primary that an interpretation could eventually recapture. The mistake of the nineteenth-century hermeneutic theories is precisely to consider the goal of interpretation to be the recovery of the work's (or the Word's) profound, hidden meaning. Foucault prefers to avoid talk about "meaning" and instead speaks of signs. Unlike Paul Ricoeur, however, he does not want to fuse hermeneutics with a semiology positing "primary signs" that are the origin and end point of interpretation.[4] His insistence on the infinity of interpretations is a recognition of the inevitability of the hermeneutic circle. The interpretation must interpret itself and "repasser là où il est déjà passé"—a return that is perhaps, but not necessarily, eternal.[5]

Yet is Foucault correct in his claim that it is not the "death" but the "life" of interpretation "to believe that there are only interpretations" (192)? The traditional view would maintain instead that the very concept of interpretation entails that there is something being interpreted. To believe that interpretation is *only* of other interpretations would seem to make it pointlessly regressive. If there is nothing to interpret but interpretations, the traditionalist would also infer that any interpretation is as good as any other. And if anything at all can be said, then nothing seems worth being said.

The peculiarly Nietzschean twist of thought comes into play at this point. While Nietzsche might follow this reasoning up to the very end, at that point he would infer not that nothing is worthwhile being said but, rather, that only then is it worthwhile to say anything. Can anything at all be said? Can everything? These puns on the logical quantifiers do need to be explained, but Nietzsche's ethical affirmation is clear: we become what we in fact say and do. Our interpretations of the world do have value for us. The further question of whether an interpretation has value "in itself" and not merely "for us" does not make sense, for there is no such thing as "value in itself." Since the "for us" is *always* implicit, it would be redundant and pointless even to add it as a qualifier.

Maurice Blanchot explains this Nietzschean twist in explicating a rich fragment where Nietzsche says that one has no right to ask "Who interprets?"[6] The idea of an interpreter, a subject behind the interpretation, is only a hypothesis, a fiction. If there is no subject, there is also no object of interpretation. This is not to say that there is no world, though, but rather that the world is itself only the "infinity of interpretation." Nietzsche sometimes speaks as if he were making an ontological claim, namely, that the infinite play of interpretation is all there is, but Blanchot recognizes the paradox. Blanchot perhaps only compounds it, however, by speaking of interpretation as "être sans être" (where this can mean either "not to have being" or "to be, but in a way not characterized by being"). He even speaks of "le mouvement neutre d'interpréter qui n'a ni objet ni sujet, l'infini d'un mouvement qui ne se rapporte à rien qu'à soi-même (et c'est encore trop dire, car c'est un mouvement sans identité), qui en tout cas n'a

rien qui le précède à quoi se rapporter et nul terme capable de le déter-miner" (the neutral movement of interpretation with neither object nor subject, the infinity of a movement which relates itself to nothing other than itself [and that is already to say too much, since it is a movement without identity], or in any case which has nothing preceding it to which to relate itself and no end *[nul terme]* capable of determining it") (247). He is correct if he is suggesting that instead of making an ontological claim Nietzsche is trying to undercut ontology by exposing the metaphysical fiction of "*the* world" as a determining ground or *hypokeimenon*. But whether we can make sense of interpretation as a "movement without identity" is problematic, for it must be possible to identify any interpreta-tion as an interpretation (as *one* interpretation), and there would have to be cross-interpretational identity for conflicting interpretations to compete, as they sometimes do.

That competition and conflict are facts of existence would not be denied in a philosophy of the will to power. For conflict to be possible, it must also be possible to identify and individuate the competing elements. What Blanchot, speaking of interpretation as "passion et devenir de la dif-férence" (247), probably means to reject is not identity but unity. Unity is both an esthetic and metaphysical notion implying a totality of related parts, a whole. The main thrust of this essay by Blanchot on "Nietzsche et l'écriture fragmentaire" is to say that the fragmentary character of Nietz-sche's writing is not arbitrary. It is neither a personal idiosyncrasy nor a historical accident. Given the way Nietzsche thinks about the inevitability and infinity of interpretation, writing is ever only fragmented and frag-mentary. So if Nietzsche thinks of the world as a text, this is clearly a metaphor, but we must be sure not to interpret traditional connotations into the metaphor. We should not think of the world as an absolute text to be reconstructed from fragments (Blanchot, 248). Interpretation is not the unveiling of a hidden truth, a single meaning, or the one world, but is rather "lecture d'un texte à plusieurs sens," polysemous reading (232). The fragments are already complete in themselves, or at least they are complete in their incompleteness. The fragmentary, says Blanchot, is a "parole non suffisante, mais non par insuffisance, non achevée (parce qu'étrangère à la catégorie de l'accomplissement)" (word that is not suf-ficient [but not through insufficiency], not completed [because it is alien to the category of accomplishment]) (229). This "parole plurielle" is essentially discontinuous and is not founded on a prior unity. Nietzsche exposes the ontological and theological associations by dismissing the "Dieu Un" and the "dieu Unité" (231). He moves from the fragmentation of God to a position where fragmentation becomes a god: "La fragmenta-tion, c'est le dieu même, cela qui n'au nul rapport avec un centre, ne supporte aucune référence originaire et que, par conséquent, la pensée, pensée du même et de l'un, celle de la théologie, comme de toutes les façons du savoir humain (ou dialectique), ne saurait accueillir sans le fausser" (Fragmentation is itself a god; that which has no relation to a

center and supports no originary reference could not be welcomed without thereby being violated *[fausser]* by Thought—thought of the one and the same, of theology as of all forms of human knowledge, or dialectic) (235).

This last remark makes the central difficulty clear. If Nietzsche is thinking in an entirely new way (and he is certainly questioning what the conditions would be for the very possibility of thinking in a new way), then it would seem impossible from the old standpoint to interpret or even to understand the new one. The old language and the old categories could never express that thought without falsifying it. Blanchot's analyses of Nietzsche's fragments show that the fragments do point beyond the old thinking precisely because they cannot be reduced to and understood in the old terms. If the aphorisms work, they do so by using the old metaphysical or onto-theo-logical terms in the very act of revealing their inadequacy.

The incompleteness of fragments forces thought to move off in multiple directions, and the interpretive process of connecting fragments to other fragments is part of this movement. Blanchot's own essay is a fragmentary series of reflections on some Nietzschean fragments, but its own admitted "nonsufficiency" is due in part to its tacit allusions to other texts that are Nietzschean but not Nietzsche's. To see Nietzsche as the philosopher of discontinuity and difference is to be aware of his importance not only for Foucault's studies of historical discontinuities, but especially for Derrida's discussion of differance.

Derrida's interpretive procedure of deconstruction or dissemination has affinities with genealogy, and he himself has applied it to Nietzsche's texts in several places, most notably in *Spurs: Nietzsche's Styles.*[7] Toward the end of this essay a particular fragment enters the discussion in an apparently offhand way. The fragment is from the *Nachlass*, and is simply a scrap of paper found in Nietzsche's desk on which is written, "I have forgotten my umbrella." This example quickly becomes a paradigm for Derrida for precisely the reasons that would have caused most interpreters to ignore it. It has, says Derrida, "no decidable meaning." There is no way even to determine whether the fragment is at all significant. Its fragmentary character, and the fact that it is written with quotation marks, make it contextless and undecipherable. What pleases Derrida in this example is that it frustrates the traditional hermeneutic interpreter who searches for the "hidden meaning," the underlying totality of texts, but who in this case could not decide whether the text is hiding something, and whether it is in fact a "text," that is, a candidate for philological study. Derrida plays with the possibility of elevating this "text" to the status of a paradigm, suggesting that the same conditions hold for all of Nietzsche's (and Derrida's) texts, and perhaps for all writing as such.

Clearly, however, Derrida's own "reading" of the fragment operates by finding significance in its very insignificance. The interest of this reading is heightened, furthermore, by the fact that any text, by being a text, inheres in an intertextual network. An example of intertextuality is pro-

vided by any interpretation, which is just the conjunction of two texts, the interpreting and the interpreted ones. Derrida's own discussion of this fragment occurs in the context of criticizing Heidegger and rescuing Nietzsche's texts from Heidegger's readings of them. This particular fragment is especially interesting because of another text in which Heidegger, in explicating his central concept of the forgetting of Being, mentions and dismisses as an example, a philosophy professor's forgetting his umbrella. Neither could Nietzsche have read Heidegger's text, nor Heidegger Nietzsche's, but "forgetting" is for Nietzsche a concept with a special use that Heidegger also takes over. So once the fragment is "read" in this intertextual network, its fragmentary character is not dissolved, but its "readability" is increased. In another essay I have suggested that the intertextual web is even more complex, as Heidegger's views are spelled out in the course of criticizing Nietzsche and rejecting his analysis of the origins of philosophy, an analysis which turns on the reading of single-line fragments by Heraclitus and Anaximander.[8] On Heidegger's account, that Nietzsche is the last of the metaphysicians is indicated by Nietzsche's blindness to what is suppressed in these writings at the very beginning of metaphysics. That our access to the origin and end of metaphysics is only through fragments is perhaps a historical accident, but one that is of seminal importance for twentieth-century writers such as Heidegger and Derrida.

Metaphilology

The poststructuralist philosophical program represented in Derrida's critique of Heidegger is mirrored in contemporary French Nietzsche scholarship. Two of the best books on Nietzsche in recent years are Jean Granier's *Le Problème de la vérité dans la philosophie de Nietzsche* (Paris: Seuil, 1966) and Sarah Kofman's *Nietzsche et la métaphore* (Paris: Payot, 1972). The short period of time between the appearances of these books belies a significant ideological difference, produced by a marked change in the intellectual climate in Europe. This difference is brought out sharply in Kofman's review of Granier's book in *Critique*.[9] Despite the fact that Granier adds to his book an appendix criticizing Heidegger's reading of Nietzsche, Kofman thinks Granier is still overly caught up in the Heideggerian problematic. As a result he makes a crucial mistake in interpreting Nietzsche's theory of interpretation. The question is, what is the goal of rigorous philology as Nietzsche sees it? Granier traces a potential antinomy in Nietzsche's various statements about the interpretive character of genealogy. On Granier's reading Nietzsche seems to swing from a perspectivistic phenomenalism according to which there is only a multiplicity of interpretations, to the notion of rigorous philology whereby the task is to read through to "*the* text of nature" (Granier, 322-23). The only criterion for justifying interpretations on the former account would be utility whereas the latter implies that there is an original and single truth about the text.

Kofman objects to Granier's view that the will to power transcends

itself toward the "text" of Being by means of rigorous philology (that is, genealogy). The goal is not an "unveiling of Being in its truth" and it is impossible to separate the text from its interpretations (Kofman, 369-72). Granier tries to solve the antinomy between dogmatism and relativism by arguing that although there could be no exact interpretation and no verification of any given interpretation, interpretations could nevertheless be falsified (323). But on Kofman's account Granier is still thinking ontologically in maintaining that the text of Being constitutes the interpretations. Kofman suggests the reverse, that the interpretations constitute the text, and thus constitute "Being" as text (by making chaos intelligible):

> L'être n'est donc pas "une intelligibilité brouillée" Ce sont les interprétations qui le constituent en texte et en intelligibilité; ce sont elles qui sont multiples, brouillées, contradictoires, et qu'une bonne philologie doit débrouiller.

> Being is therefore not "a scrambled intelligibility" *[une intelligibilité brouillée]* The interpretations are what constitute it as a text and as intelligible. They are what are multiple, scrambled *[brouillées]*, contradictory, and what a good philology must unscramble *[débrouiller]*. (373)

If the goal of rigorous philology is not to sort out the original, uninterpreted text from its interpretations, if it is true that "le texte sans interprétation n'est plus un texte" (Kofman, 377), how can the good philologist prefer certain interpretations (including his or her own) to others? Kofman's response depends upon distinguishing the conditions that hold for first-order interpretations from those of second-order interpretations. The first-order interpretations are the immediate result of the instinctual need to make life intelligible. The second-order interpretations of these first-order ones often mask the interpretive character of the first (373). A strict philology should thus be honest with itself. It should present its own interpretation not only as an interpretation but also as an interpretation of an interpretation. The "spirit of justice" that pervades this new philology thus for Kofman has nothing to do with an open but passive reception of "Being," as Granier implies. The mood of the Nietzschean genealogist is not Heideggerian *Gelassenheit*, the attitude of "letting Being be," but rather an active "multiplying of perspectives" in order to enrich and embellish life (378).

This solution has the advantage of showing that Nietzsche's conception of genealogy as rigorous philology does not necessarily readmit the metaphysical notion of a unique and univocal "text of Being." Genealogy cannot be accused of smuggling in the dream of the philosophical method which, as rigorous science, aspires to the "one right interpretation." Yet does it avoid the complete relativism that Husserl and other proponents of philosophy as rigorous science fear? Whereas Granier could

see no middle ground between dogmatism and relativism, Kofman identifies what she thinks is a satisfactory one, namely, the pluralism that can discriminate between healthful and sick, life-affirming and life-abnegating interpretations. Although her interpretation is faithful to Nietzsche's language, it obscures the basic difficulty. For to say that the life-affirming interpretations are those that multiply rather than inhibit the formation of other perspectives or interpretations is simply to prefer pluralistic interpretations of interpretation to nonpluralistic ones. Insofar as "multiplying perspectives" is only a criterion for discriminating among second-order interpretations, it does not serve the philologist in critical evaluation of first-order interpretations.

Kofman's Nietzsche would appear to be advocating what Paul Feyerabend (in *Against Method*, for instance) calls the principle of proliferation: "the more theories the better." Feyerabend also expresses his methodological anarchism with the slogan, "anything goes." But saying that "anything goes" is surely not what Nietzsche had in mind. For Kofman to explain rigorous philology as "permettant une interrogation indéfinie et une multiplicité indéfinie d'hypothèses" (380) has the advantage of saving Nietzsche from the paradox that would result if his new philosophy were a new ontology. Genealogy cannot be claiming that the idea of the will to power is the "essence of Being" or the fundamental reality behind all appearances if Nietzsche's project is to undercut such metaphysical notions by showing their hypothetical character. Kofman stresses that several of Nietzsche's texts indicate that the will to power is to be taken not as a dogmatic truth, but only as an interpretive hypothesis (379). Hypotheses must be testable, however, and must have a determinate utility. Thus, a hypothesis having only the effect of "permitting an indefinite interrogation and an indefinite multiplicity" of further hypotheses could be abandoned for that very reason. Although Kofman's analysis captures clearly what Nietzsche means by an *honest* philology, it does little to explain how philology can be rigorous or how genealogy can be critical. To prefer proliferation to truth as a criterion for discriminating among theories of interpretation does not clarify but in fact makes problematic the effectiveness of Nietzsche's genealogical, deconstructive criticisms of such phenomena as slave morality and Christianity.

Deconstruction and Reconstruction

The poststructuralist readings of Nietzsche continually run up against a problem, one that is also likely to obtain for the various attempts to implement the Nietzschean notion of infinite play. Looking at this discussion from an Anglo-American perspective, however, can be instructive. Nietzsche's remarks about interpretation, of course, have been noticed before because they are closely connected with his much-discus-

sed perspectivism. But what has not been sufficiently noticed in either the francophone or anglophone literature is that Nietzsche's talk about rigorous philology, and his projection of what is essentially a new hermeneutics, offer an *alternative* to his talk about perspectivism, one that is less likely to fall into the epistemological paradoxes accompanying the concept of multiple perspectives.

Perhaps Nietzsche's perspectivism has received so much more attention from anglophone philosophers than has his idea of faithful philology because their readings have been blinded by the proximity of Nietzsche's perspectivist philosophy of science to that of the pragmatists. Past philosophers can often be conveniently explained if they exemplify familiar, contemporary concerns, and Nietzsche's theory of truth certainly has affinities with American pragmatism and Humean skepticism.[10]

Given the recent emergence, however, of a distinctly hermeneutical philosophy, that is, a philosophy emphasizing the interpretive character of all understanding and taking the understanding of written texts as a basic philosophical model, Nietzsche's analogy between his genealogical philosophy and rigorous philology becomes interesting in its own right. To think that thought's relation to reality is more like that of an interpretation to a text has an important advantage over perspectivism. Our normal intuitions are that there is less likely to be a "fact of the matter" or a "thing-in-itself" in the interpretation-text relation than in the perspective-thing relation. In the latter case, realist intuitions will lead to saying that there is a true state of affairs because there is a thing that is independent of the various perspectives. Of course, a text also consists of black marks on pages, but most of us will not quibble about the claim that when we read the text we do not first see black marks and then reconstruct them into what can be called a meaning component. Instead we are first already conscious of meaning components in ways that will vary from reading to reading.

There are problems with the concept of interpretation, but they are not the same as the problems with the concept of perspective. The question how can I know I am seeing the same table as you are if it looks different to both of us calls for philosophical clarification of, for instance, what "same" or "know" could mean here. Yet when I play a record of Mozart's horn concertos, I know I am playing the same record, and the same performance of the same concertos. It also makes sense to say that I hear the concertos differently each time, and that this claim is not incompatible with the prior claim.[11] No philosophical clarification is required, for these claims are not metaphysical ones and involve no special epistemological or ontological commitments.

The matter is not essentially different when the question is whether you are reading the same text as the one I am reading (or writing). Presumably the fact that you are reading on a printed page at a later time what I read in typescript at an earlier time is irrelevant. A text is not a given in the same respects that a physical object is. It would be awkward

to say that a text (as distinct from the printed page) has properties independent of possible readings, or interpretive understandings of it, whereas the philosophical literature indicates that it seems to many more natural to speak of the physical object having certain (primary) qualities whether or not it is seen.

A good example is a fragment. A fragment of a physical object, for instance, a pottery shard, has determinate qualities whether or not it is recognized as pottery, or more specifically, as Etruscan pottery. Derrida's example of Nietzsche's "I have forgotten my umbrella" serves to show, however, that although the words can be recognized as a sentence (or more precisely, as the name of a sentence, since the sentence is in quotation marks), whether it is recognized as a text depends upon giving it an interpretation. This is at least the Nietzschean thought that Kofman expresses when she says that "a text without an interpretation is no longer a text" (377). Nothing like idealism is entailed by this way of speaking, and it shows that Nietzsche's notion of rigorous philology is a way of avoiding the paradoxes he encounters in expressing his theory as perspectivism.

If there are difficulties with the new genealogical hermeneutics, they are at least different ones. Derrida's example of the umbrella fragment itself questions the intelligibility of its own suggestion of treating every text as a fragment of a lost or incomplete context. In parentheses he notes, "The concept of fragment, however, since its fracturedness is itself an appeal to some totalizing complement, is no longer sufficient here."[12] The suggestion that Nietzsche's books and his *oeuvre* may not form a coherent, unified totality is, of course, a reasonable interpretive hypothesis. More troublesome is the suggestion of eliminating *any* "appeal to some totalizing complement." Jonathan Culler has also argued that a literary work such as a poem need not be a harmonious totality, and he appeals precisely to the concept of the fragment to make his case. But he maintains further that understanding a fragment requires that the *reader* try to project such a totality: "And poems which succeed as fragments or as instances of incomplete totality depend for their success on the fact that our drive towards totality enables us to recognize their gaps and discontinuities and to give them a thematic value."[13] Culler uses the notion of the successful fragment to support his theory that poetry is determined as such by strategies of reading rather than by intrinsic linguistic features of the text.

Is the "drive towards totality" a necessary moment of reading? This is an intelligible question, and a good one to illustrate the different kinds of issues raised by the philological rather than the perspectivist analogy. One possible answer is to say that any reading must involve both the attempt to construct a comprehensive totality and a certain healthful skepticism about the possibility of complete success in doing so. Reading would thus be the interplay between construction (or rational reconstruction) and deconstruction. The latter moment would be necessary to guard

against reading familiar expectations into the text, and would have the benefit of allowing the strangeness of the text to appear.

As an account of the poststructuralist position this answer is likely to seem facile. Reading Derrida with a Nietzschean "spirit of justice" forces the recognition that the poststructuralist program of deconstruction or dissemination, based on the notion of infinite play, is more radical. Deconstruction explores the periphery of a text's self-understanding in order to bring out the elements of uncertainty, the unsaid that decenters a discourse. Even the discourse that tries to be coherent and complete can do so only by ignoring what it does not want to see. Deconstruction makes this process of repression evident, and it calls attention to the "marginal" things the discourse makes essentially inessential.

A moment of construction might seem to be necessarily involved in any deconstructive reading, of course, insofar as it reads any text as part of a larger system. This system would be formed both by the exclusions of the text itself and by the text's inherence in an intertextual web (since any text is itself only an interpretation). Construction would then be implicit in any successful act of reading, as reading could occur only insofar as it identified the text as part of a whole.

Against this "hermeneutic, all too hermeneutic" inference the post-structuralist metaphor of the infinite play of differences, when pushed to its limit, would imply that it is neither necessary nor possible to understand the whole before understanding the part. Reading would not be a part-whole relation, and there would be no hermeneutic circle. Any text would be only a fragment, and a fragment of a disseminated system. This system is not thought of as an organic whole, with beginning and end, but rather as the interplay of generative differences, open-ended in all directions. As the system can continue to generate new sentences, even the genealogical deconstruction will never reach an ultimate ground, not even in postulating will to power.

The poststructuralist conception of texts and interpretations as the play of differences in multiple, disseminated systems can claim to be healthful and life-affirming if the proliferation of interpretations is indeed the life and not the death of interpretation. But is it? Interpretations conflict and compete, and some must be preferred to others. The principle of proliferation, however, is too thin to account for this feature. It cannot be used to decide which interpretations are better, but at most only to reject a specific second-order interpretation of interpretation, namely, the dogmatic theory that asserts the necessity of being able to grasp any text that is a comprehensible work in a single correct reading. The principle of proliferation cannot even be used to reject dogmatic first-order interpretations that assert of any given text that it must be read in just this way. In fact, the principle seems forced to controvert its intention by saying, "the more of these dogmatic readings the better." Proliferation thus appears to lack survival value, and this in itself provides a Nietzschean reason for rejecting it. The principle of proliferation may

well be one that is asserted only by the philosopher sitting in an armchair, not by the working genealogist. The image of the armchair philosopher, moreover, is for Nietzsche an illusion that will surely not deceive the rigorous philologist.

Notes

1. The intimate connection between genealogy and aphorism, which is paradigmatic for genealogy both as a means of expression and as an object of analysis, is asserted in the Preface to the *Genealogy of Morals*, trans. Walter Kaufmann (New York: Vintage), 1969, pp. 23-24, where I render *Auslegung* as "interpretation" rather than "exegesis" only because this choice better suits present purposes:

> ... people find difficulty with the aphoristic form: this arises from the fact that today this form is *not taken seriously enough.* An aphorism, properly stamped and molded, has not been "deciphered" when it has simply been read; rather, one has then to begin its *interpretation*, for which is required an art of interpretation. I have offered in the third essay of the present book an example of what I regard as "interpretation" in such a case—an aphorism is prefixed to this essay, the essay itself is a commentary on it. To be sure, one thing is necessary above all if one is to practice reading as an *art* in this way, something that has been unlearned most thoroughly nowadays—and therefore it will be some time before my writings are "readable"—something for which one has almost to be a cow and in any case *not* a "modern man": *rumination.*

For an extensive presentation of Nietzsche's remarks on philology, "the art of reading well," see Jean Granier, *Le Problème de la vérité dans la philosophie de Nietzsche* (Paris: Seuil, 1966), pp. 314 ff.

2. Eugen Fink, *Nietzsches Philosophie* (Stuttgart: Kohlhammer, 1960, 1973), p. 188.

3. Michel Foucault's paper is an address delivered in July 1964 and published in 1967 in *Cahiers de Royaumont, Philosophie Numéro VI: Nietzsche* (Paris: Les Éditions de Minuit).

4. For Ricoeur's notion of the hermeneutic "arch," see my discussion in *The Critical Circle: Literature, History, and Philosophical Hermeneutics* (Berkeley: University of California Press, 1978), pp. 84 ff.

5. Foucault, p. 192.

6. Maurice Blanchot, *L'Entretien infini* (Paris: Gallimard, 1969), p. 245.

7. B. Harlow, trans. (Chicago: University of Chicago Press, 1979).

8. I analyze Foucault's and Derrida's theories in greater detail in the following essays: "Forgetting the Text: Derrida's Critique of Heidegger," *Boundary 2* (Fall 1979), 8(2):223-35; "Taking History Seriously: Foucault, Gadamer, Habermas," *Union Seminary Quarterly Review* (Winter 1979), 34(2):85-95; "Must We Say What We Mean? The Grammatological Critique of Hermeneutics," in *Contemporary Literary Hermeneutics and Classical Texts*, S. Kresic, ed. (Ottawa: University of Ottawa Press, 1981).

9. *Critique* (April 1970), 26 (275):359-81. Page references will be given for this printing. The article has also been reprinted as an appendix in Kofman's Nietzsche book. Her own exposition of the relation between "rigorous philology" and the will to power is found on pages 120-45 of that book, and she concludes with some penetrating comments on the aphorism (pp. 166-71).

10. See Mary Warnock, "Nietzsche's Conception of Truth," in *Nietzsche: Imagery and Thought*, ed. W. Pasley (Berkeley: University of California Press, 1978); also, Arthur Danto, *Nietzsche as Philosopher* (New York: Macmillan, 1965), especially Chp. 3, "Perspectivism" reprinted in *Nietzsche: A Collection of Critical Essays*, ed. Robert Solomon (Garden City, N.Y.: Doubleday, 1973). Even Jean Granier speaks

frequently of Nietzsche's "pragmatisme vital" but he sees this as the dialectical opposite of Nietzsche's rigorous philology (see Granier, *Le Problème*, p. 464 ff.).

11. I owe this example to a discussion with Donald Kalish.

12. Derrida, *Spurs*, p. 125.

13. Jonathan Culler, *Structuralist Poetics: Structuralism, Linguistics, and the Study of Literature* (Ithaca, N.Y.: Cornell University Press, 1975), p. 171.

PART 5

SPARE PARTS
AND
WHOLE BODIES

14

The Aesthetics of Gender: Zeuxis' Maidens and the Hermaphroditic Ideal

JOEL BLACK

Ex parte enim cognoscimus, et ex parte prophetamus.
Cum autem venerit quod perfectum est, evacuabitur quod ex
parte est.

—Corinthians 13:9,10

Darum wurden sie zuletzt einig, dass, da sie keinen zum Kopf
gehörigen Körper wahrnehmen könnten, es auch keinen
gäbe, nur meinte der Doktor, die Natur habe sich, als sie
diesen Giganten ausgesprochen, einer rhetorischen Figur, einer
Synekdoche bedient, nach der ein Teil das Ganze bezeichnet.
—E. T. A. Hoffmann, "Die Doppeltgänger"

Then on the verge of Beulah he beheld his own Shadow;
A mournful form double; hermaphroditic: male & female
In one wonderful body. And he entered into it
In direful pain . . .
—William Blake, Milton

The Composite Ideal: Representational and Representative Aesthetics

From antiquity at least until the neoclassic era, artists have persistently aspired in their works to depict an ideal of supreme beauty. This pursuit has taken different forms—the artist sometimes seeks the ideal he has as an "idea" in his mind, and sometimes as a living presence in nature.[1] In the latter quest, however, the artist rarely finds the paragon of beauty realized in a complete form. On the contrary, as abundant examples in classical literature suggest, the ideal is widely distributed throughout nature and displays itself only in intermittent premonitions and in diverse fragmentary forms. Socrates, for instance, observes to the painter Parrhasius that the artist does "not easily come upon a human being who is faultless in all his parts."[2] The artist who seeks a model of ideal beauty is therefore obliged to scour nature, selecting fragmentary traces of the beautiful and combining them in a total representation which surpasses nature's partial charms.

Perhaps the most popular example of this procedure is the widely reported account of the artist Zeuxis and the Crotoan maidens.[3] Unable to find a woman embodying his conception of ideal beauty to model for his Helen, Zeuxis assembled the five most beautiful virgins of Croton, each of whom showed to perfection one particular feature—shoulders, legs, breasts, and so forth. By combining these component charms in his representation, Zeuxis was able to create a masterful rendering of the feminine ideal which transcended any specimen of womanly beauty appearing in nature.

The most notable feature of the Zeuxian ideal of beauty is that it is a composite configuration in which the artist relies on several flesh-and-blood models to derive his singular representation of the ideal. Such a procedure may strike us as being strange; indeed, it seems to be precisely the reverse of a familiar practice of many modern artists who depict the same object a number of times on different occasions and under varying conditions, as in Monet's series of paintings of Notre Dame or as in Cézanne's serial views of Mont Sainte-Victoire.[4] Zeuxis' finished work, by contrast, is a unique representation based on multiple models; it is what may be called a "holotype," or a type-specimen abstracted from a variety of individual specimens found in nature. What is remarkable is that the holotype comes to be regarded as a kind of ideal form to which those natural specimens on which it was originally modeled are paradoxically expected to con-form. In effect, the artist's ideal creation would ultimately become, like Pygmalion's Galatea, its own model.

Zeuxis' ideal Helen, however, does not—and indeed cannot—embody all its constituent models in their individual totality. Rather, the artist selects representative *parts* from the living Crotoan maidens at his disposal, and proceeds to recombine them into a new, unique totality. That is to say, Zeuxis' representation does not merely *represent* an ideal Helen, but it is also *representative* of the real, singular charms of the Crotoan virgins. In this respect, Zeuxis' procedure of idealization actually has less in common with our customary notions of representation in aesthetic theory

Fig. 10. *Zeuxis Selecting Models for His Painting of Helen of Troy* by Angelica Kauff-mann (Annmary Brown Memorial, Brown University, Providence, Rhode Island) offers a contrast of Zeuxis' classical method of constructing his composite ideal (multiple models/single representation) with the opposite approach commonly used by impressionist artists (single model/multiple representations).

than it has to do with analogous conceptions in political theory. For in "aesthetic representation," a discrete image simply "stands for" an object in a medium different from that of the object (e.g., a painted image of ideal Helen); in "political representation," on the other hand, a select group of individuals organizes itself as a compact whole or "fair sample" which in turn "acts for" a larger constituency or "body politic" (e.g., the selection and recombination of the fairest features of each of the living Crotoan virgins).[5] This second representational mode in which selected parts act for the whole is properly composite. In instances of this kind, the medium of the representing and represented bodies is not substantially different and hence not really a determining factor in the central activity of mimesis as it is in conventional kinds of aesthetic representation. Instead, the essential activity in political representation consists in a combination of elements of basically the same nature into a new whole which is intrinsically the same as the body it represents, but only more compact, efficient, refined, "active." Clearly, the Zeuxian composite ideal has less to do with Aristotle's mimetic conception of representation in the *Poetics* where art is discussed "with respect to the medium of imitation" (1.3) insofar as an object in one medium stands for an object in another medium, than with his concise expression of composite representation in the *Politics:* "Great men are distinguished from ordinary men in the same way as beautiful people from plain ones, or as an artfully painted object from a real one, namely, in that that which is dispersed has been gathered into one."[6]

Winckelmann and the Hermaphroditic Ideal

The story of Zeuxis and the similar account in the dialogue between Socrates and Parrhasius frequently reappear in neoclassical art theory. Perhaps its most influential appearance is in the introduction of Giovanni Pietro Bellori's *Le vite de' Pittori, Scultori et Architetti moderni* (1672), entitled "L'Idea del Pittore, dello Schultore e dell'Architetto, Scelta delle Bellezze Naturali Superiore alla Natura" (The Idea of the Painter, Sculptor and Architect, Superior to Nature by Selection from Natural Beauties), which was first delivered as a lecture in 1664.[7] With reference to Zeuxis and Parrhasius, Bellori argues that only by attending to nature and carefully selecting models from among her diverse but imperfect forms can the artist enable nature to overcome herself, as it were, in conformity with his divinely originating idea.

Bellori's insistence on the artist's need to consult nature in order to combine her fragmentary beauties into an ideal, compact whole is assimilated and developed in the eighteenth century by the renowned German art scholar, Johann Joachim Winckelmann. In his pathbreaking *History of Ancient Art* of 1764, Winckelmann draws a clear distinction between individual and ideal beauty which actually relies less on a conventionally aesthetic concept of representation than on a political one: "The shape of

beauty is either *individual*, that is, confined to an imitation of one individual,—or it is a selection of beautiful parts from many individuals, and their union into one which we call *ideal.*"[8] The ideal for Winckelmann is "the highest possible beauty of the whole figure, which can hardly exist in nature in the same high degree in which it appears in some statues; and it is an error to apply the term to single parts, in speaking of beautiful youth" (205-6). Winckelmann accordingly supports Zeuxis' ancient principle of an *ars combinatoria* whereby the artistic ideal is achieved through a combination of natural parts:

> But nature and the structure of the most beautiful bodies are rarely without fault. They have forms which can either be found more perfect in other bodies, or which may be imagined more perfect. In conformity to this teaching of experience, those wise artists, the ancients, acted as a skilful gardener does, who ingrafts different shoots of excellent sorts upon the same stock; and, as a bee gathers from many flowers, so were their ideas of beauty not limited to the beautiful in a single individual, —as at times are the ideas of both ancient and modern poets, and of the majority of artists of the present day,—but they sought to unite the beautiful parts of many beautiful bodies. (204-5)

Winckelmann praises the aesthetic techniques of Parrhasius and Zeuxis, and he rebukes Raphael and Bernini (205-6) for their failure to credit the combinatory procedure of idealization as practiced by the Greeks whereby the "selection of the most beautiful parts and their harmonious union in one figure produced ideal beauty . . . for beauties as great as any of those which art has ever produced can be found singly in nature, but, in the entire figure, nature must yield the palm to art" (205).

As one reads Winckelmann further, however, it becomes clear that the German art historian entertains a composite concept of the ideal which even surpasses that of Zeuxis. Whereas Zeuxis represented ideal feminine beauty through a studied selection and combination of particular features of five beautiful maidens, Winckelmann implies that in order to represent ideal beauty in its totality, such natural selection and artificial recombination should not be restricted to a pool of models representing only one sex.[9] Through their use of eunuchs as models, Greek sculptors were able to achieve an ideal form of indeterminate sexuality, a form which is "nevertheless, always distinct, as well from that of man, as that of woman; it is intermediate between the two" (207). The Greek ideal of beauty, for Winckelmann, "consists in the incorporation of the forms of prolonged youth in the female sex with the masculine forms of a beautiful young man" (208). The only "fair sample" for a true combinatory art of the ideal, in other words, would be a constituency including men and women from which the "fairest samples" of both sexes could then be solicited by

the artist in his representation of certain deities to whom, as Winckelmann observes, "the ancients gave both sexes, blended with a mystic significance in one" (208).

Thus it was, in specific sublime instances, that the ancients achieved ultimate success in overcoming the deficiencies of nature in their artistic representations of beauty by depicting a hermaphroditic ideal:

> Art went still farther; it united the beauties and attributes of both sexes in the figures of hermaphrodites. The great number of hermaphrodites, differing in size and position, shows that artists sought to express in the mixed nature of the two sexes an image of higher beauty; this image was ideal. . . . Hermaphrodites, like those produced by sculpture, are probably never seen in real life. All figures of this kind have maiden breasts, together with the male organs of generation; the form in other respects, as well as the features of the face, is feminine. (208)

Taken to its logical extreme, Zeuxis' combinatory procedure allows the artist to reorganize the beautiful parts in nature distributed between the sexes into a "collective representation" that transcends the natural realm. Through this combinatory art which transposes nature's fragments into an ideal whole, the ancients presided over an aesthetic mystery whereby nature ultimately overcomes and redeems itself in the unearthly form of the hermaphrodite.

The Ideal and the Surreal: Schlegel's Arabesques and Zeuxis' Grapevine

The successful assimilation of partial samples of natural beauty into a composite whole as envisioned by classical and neoclassical theorists was subtly but radically revised by the romantics, who located ideal beauty beyond the pale of the representable. This important shift vastly enlarged the scope of the function of the fragment. As wholeness itself was held by the romantics to be unrepresentable, the fragment came to be recognized, especially by German romantic authors such as Friedrich Schlegel and Novalis, as the all-important representational form and epistemological mode of authentic psycho-spiritual inquiry. A characteristic feature of romanticism, then, is its replacement of a composite by a fragmentary—or what could be called a *synecdochic*—aesthetic in which ideal wholeness can only be represented by a part, rather than by a combination of parts.

As a necessary consequence of this shift from a composite to a synecdochic representation of ideal wholeness, neoclassical representations of sublime beauty as embodied, for instance, in Winckelmann's hermaphroditic ideal, were perceived by romantic artists and theorists in an entirely different light and as part of a significantly altered aesthetic configuration. Perhaps it was Winckelmann's intimation of a hermaphroditic

Fig. 11. Reproduction of a classical head from Winckelmann's *Collected Works*. The suggestion such a figure gives of characteristically feminine beauty recalls an observation made by Montaigne in his essay, "De trois commerces": The true advantage of the ladies lies in their beauty; and beauty is so peculiarly their property that ours, though it demands somewhat different features, is at its best when, boyish and beardless, it can be confused with theirs.

ideal that the leading theorist of German romanticism, Friedrich Schlegel, had in mind when he composed the following (easily overlooked) exchange in the seminal *Dialogue on Poetry* (1800):

> ANDREA. I beg you to honor the old gods.
> LOTHARIO. And I ask you to remember the Eleusinian mysteries. . . . Only through the extant mysteries have I come to understand the meaning of the ancient gods. I would like to think that the view of nature prevalent there would illuminate many things for present-day scholars, if they were ready for it. The most daring and powerful, indeed I am tempted to say the wildest and most enraged, expression of realism is the best. Remind me, Ludovico, at least to show you the Orphic fragment which starts with the bisexuality of Zeus.
> MARCUS. I remember a hint in Winckelmann from which I would assume that he values this fragment as much as you do.[10]

The key to an understanding of Schlegel's passing cryptic allusion to an obscure Orphic fragment supposedly mentioned by Winckelmann and referring to the "bisexuality of Zeus" ("das orphische Fragment . . . welches von dem doppelten Geschlecht des Zeus anfängt")[11] lies in our recognition that the Orphic passage referring to Zeus' bisexuality is itself a fragment, a designated passage of a larger text which is presumably lost and irretrievable. It is precisely this incomplete nature of the fragment that makes it such a powerfully suggestive form of expression and medium of visionary insight. Only through the fragmentary trace are we capable of rendering the ancient mysteries and that most obscure enigma of Zeus' bisexuality. For Zeus' participation in both sexes, an enigma which, as in the case of Tiresias, leads to supreme wisdom, is centered in the mystery of wholeness, an ideal plenitude that can only be acknowledged through the natural conditions of partiality and deficiency. In our natural lives as individual men or women, we are each but a part, positioned in an implicit synecdochic relationship with an ideal polymorphous sexuality, a condition of androgynous wholeness from which we are now separate and a-part.[12]
In this light, the passage on Zeus' Orphic bisexuality exemplifies Schlegel's powerful theory of the fragment, developed in his *Dialogue*, according to which the only means of representing completeness is through intentional incompleteness; the only means of representing the ideal whole is through the natural part which in its shattered condition of a-partness is a sign of Platonic participation in wholeness. Only in self-conscious fragments can we hope to penetrate what Schlegel elsewhere in the *Dialogue* calls "a mystic discipline of the whole" ("eine mystische Wissenschaft vom Ganzen").[13]

There is an important difference to be noted between the ancient

Orphic fragment on Zeus' bisexuality which Schlegel refers to in the *Dialogue* and the fragmentary form of Schlegel's own critical writing. As Schlegel himself observes, "Many works of the ancients have become fragments. Many works of the moderns are fragments at the time of their origin" ("Viele Werke der Alten sind Fragmente geworden. Viele Werke der Neuern sind es gleich bei der Entstehung").[14] Schlegel's fragments are not arbitrarily but necessarily incomplete because they originate in the romantic awareness of the synecdochic nature of all representation. For the major theorists of romanticism, a synecdochic aesthetic of representativeness in which a rarified part acts for the whole would necessarily be more authentic than a composite aesthetic of representativeness in which a combination of parts acts as a condensed totality, and a fortiori, more authentic than a conventional, holistic aesthetic of representation in which one whole simply stands for another. The part that *acts for* the whole in a romantic aesthetic does not *act as* that whole; the part is still not necessarily the whole itself. It would therefore not be correct to claim that the romantics maintained the Zeuxian principle that ideal wholeness might itself be represented as a composite form by means of the recombination of its most select parts. Rather, romantic aesthetic theory subtly reinterpreted the composite character of Zeuxian idealization, and emphasized that it was only through the fragment *as fragment* that one even appeared to have access to the whole. And in a similar way, the serial studies of a single subject by such postromantic artists as Monet or Cézanne emphasize the partial, incomplete character of any individual representation of that subject—a complete reversal of Zeuxis' achievement of the composite ideal.

In short, Schlegel's theory of romantic irony advises the artist to practice self-restraint—that is, to be wary of the illusion of wholeness, the compulsion to complete, because romantic poetry's "peculiar essence is that it is always becoming and that it can never be completed" ("Die romantische Dichtart ist noch im Werden, nie vollendet sein kann").[15] Romantic discourse will appear intrinsically fragmentary; it defies closure because, like life itself, in its radical openness it is susceptible to, and even invites, closure at every stage of its development: "Even a friendly conversation which cannot at any given moment be broken off voluntarily with complete arbitrariness has something illiberal about it."[16] In its efforts to comprehend the whole of Being, "the always fragmentary character of poetic intuition"[17] necessarily communicates itself in a seemingly arbitrary, incomplete composite expression of ideal presence. The more limited and restrained the form of communication, the greater and more free the communicated content; the more partial and incomplete the fragment—as in the example of the Orphic text—the more mystical and larger than life the subject—Zeus' bisexuality.

Having duly noted the significant synecdochic relationship in the *Dialogue on Poetry* between the form of the Orphic fragment and the content of Zeus' bisexuality, and having recognized this relationship as an instance of the romantic recognition of the necessarily partial nature of

representations of the ideal, how can we interpret Lothario's claim in the same passage from the *Dialogue* that "the most daring and powerful, indeed I am tempted to say the wildest and most enraged expression of realism is the best"? What is such a demonic cult of Dionysian realism, and how is it related to Orphic bisexuality and romantic aesthetic programs to represent the ideal?

Here it is useful to return to the spirit of Zeuxis hovering over the present study. Aside from his success with the Crotoan virgins and his composite art of the ideal, Zeuxis was also famed for his lifelike realism, and in antiquity the story was common that he had painted grapes which were so real in appearance that the sparrows were deceived and tried to eat them.[18] Thus the ancient master of idealization is also the master of realism; his superb Helen, the feminine ideal, complements his deceptively real grapes. It is revealing that when Zeuxis paints the human figure of Helen, he strives to depict the ideal; when he paints merely natural nonhuman objects such as grapes, he aims at achieving a realistic representation. Evidently, the notion of an ideal grape is as absurd as a realistic representation of the human is banal. In the Zeuxian aesthetic, natural, nonhuman, vegetative forms appear to be the appropriate subjects of realistic art.[19]

Schlegel affirms Zeuxis' aesthetic realism in this regard. Throughout his *Dialogue*, Schlegel has his characters advocate a concept of Dionysian realism which is explicitly indebted to a Spinozistic pantheism. And indeed, Schlegel's "realism" promotes an aesthetic of natural forms which he calls *arabesques* and which are "the oldest and most original form of human imagination,"[20] "a very definite and essential form or mode of expression of poetry."[21] The arabesque for Schlegel is an organic form belonging exclusively neither to the realm of nature nor that of art. It is a developmental, open-ended, vegetative form, directly related to Zeuxis' grapevine, always tending toward some recognizable, complete state but never achieving it. In certain contortions, this natural form may be said to approximate the human, and under these conditions it would anticipate the ideal. But it always manages to remain natural, incomplete and undefined—in short, prehuman.[22] Because such an arabesque form never achieves a final condition of closure, it cannot quite be called a work of art in the classical sense of an ideal whole; it can properly be designated a whole only in a very restricted sense where it would correspond to Schlegel's fragment or to what Jan Mukařovský has more recently called a "torso."[23]

Zeuxis' grapes, the vegetative, intoxicating form of the arabesque—a term which Schlegel significantly associates with the burlesque and grotesque—may well be the form Lothario has in mind when he speaks of "the wildest and most enraged expression of realism." This aesthetic is characterized by natural, indefinite, incomplete, Dionysian turbulence on the verge of becoming fixed formally as a representation of the human figure and hence of the ideal. And as witnesses of the arabesque, we feel déjà vu; we are repeatedly teased with the prospect of identification, we are always on

Fig. 12. Classical grotesque figure reproduced in Winckelmann's *Collected Works.*
Montaigne's essay, "De l'amitié," begins with an apposite anecdote:

As I was observing the way in which a painter in my employment goes about his
work, I felt tempted to imitate him. He chooses the best spot, in the middle of each
wall, as the place for a picture, which he elaborates with all his skill; and the empty
space all round he fills with grotesques; which are fantastic paintings with no other
charm than their variety and strangeness. And what are these things of mine, indeed,
but grotesques and monstrous bodies, pieced together from sundry limbs, with no de-
finite shape, and with no order, sequence, or proportion except by chance? *Desinit
in piscem mulier formosa superne* (A beautiful woman that tails off into a fish).

the verge of recognition. In the Headless Horseman's enchanted forest, we see a tendril becoming what we think is an arm, a root extending itself like a leg, a stump shaping itself into a torso. But the anticipated representation of the ideal whole—of nature animated and spiritualized—invariably recedes back into the partial, the unidentified, the merely natural, leaving us with the intense impression of the all too real.

The Androgynous Ideal

Although Winckelmann and Schlegel share esteem for the Orphic fragment celebrating Zeus' supernatural sexual condition, there is a significant difference between their two responses to this fragment. It appears that for Winckelmann the Orphic fragment of Zeus as a composite representation would be exemplary of the ideal, whereas Lothario's—Schlegel's— appreciation of the fragment as a fragment—i.e., as a partial representatem—would be motivated by its ability to conjure up an extreme realism. We could say that the two theorists would have responded to different, perhaps incompatible, aspects of Zeuxis' legendary art. Whereas Winckelmann would have admired Zeuxis for transcending nature through art in his composite, anthropomorphic, Apollonian representation of Helen's ideal beauty as synthesized from the natural charms of the Crotoan virgins, Schlegel would have esteemed Zeuxis for his partial, zoomorphic representation of natural phenomena such as Dionysian grapes depicted in such an ultrarealistic manner that the distinction between nature and art is finally obliterated. Granted this is so, one crucial question remains: if Winckelmann regards the fragment representing double-sexed Zeus as an instance of his concept of idealization and Schlegel regards the same fragment as an instance of his concept of ultrarealism, what would the bisexual figure of Zeus look like for each of them?

We recall that for Winckelmann, all the beautiful parts of the human body should be represented—or rather, should have representation—without regard to sex in order to produce a transsexual rendering of ideal beauty. Beyond the ideal representation of deities abstracted from shapely male figures, captivating eunuchs, and alluring females, was the possibility of an ideal depiction of certain hermaphroditic deities: "For to some of these [deities] the ancients gave both sexes, blended with a mystic significance in one." It appears that Winckelmann supposed some mystical transformation to have occurred here whereby through a process of combinatory magic, nature would transcend itself as the ideal, and what was formerly a-part would at long last be whole. [24] As the exemplar of such a transformation from the part to the whole, Winckelmann's hermaphroditic ideal would be a mysterious creature beyond all time, not to be found in nature with its repetitive cycles of sexual procreation and reproduction, and its fragmented forms of the beautiful which are divided between the polarized sexes. In short, Winckelmann's description of the hermaphrodite, based on late classical renderings in sculpture (see the accompanying

reproductions) conveys a sense of a beautiful, albeit otherworldly, harmonious figure. According to Winckelmann, antique representations of hermaphrodites are beautiful, just as representations of satyrs and fauns are.[25] The popular notion that ancient sculptors depicted fauns as misshapen and ugly is, as Winckelmann claims, "a heresy in art" (213). We may presume that another such heresy would be the notion that hermaphrodites are repulsive, that they are not harmoniously depicted, but rather a single form with a twin set of markedly differentiated sex features and organs (the classical hermaphrodite, as Winckelmann observed, possesses only male genitals). Yet wouldn't a truly androgynous creature in whom the genitalia of both sexes "have equal representation" be the result if the combinatory idealization practiced by Zeuxis—a procedure which apparently succeeded so admirably with the Crotoan virgins—were to be applied, as Winckelmann suggests it could and should, to a mixed group of beautiful men and women in order to achieve a bisexual ideal? Wouldn't the enigmatic figure of bisexual Zeus in the Orphic fragment cited by Schlegel and, it seems, by Winckelmann, have been such a full-blown androgyne in whom both sexes have complete representation at once, and not a delicate hermaphrodite of merely ambiguous sexuality?

Following Winckelmann's aesthetic to its logical conclusion, it seems that there must be an ideal that surpasses the beautiful even in its most ideal state, an ideal that is no longer beautiful. And in fact, this is precisely what Winckelmann himself acknowledges in a passage, the first part of which I have already cited:

> The shape of beauty is either *individual*,—that is, confined to an imitation of one individual,—or it is a selection of beautiful parts from many individuals, and their union into one, which we call *ideal, yet with the remark that a thing may be ideal without being beautiful.* (201)

An example of this ideal that surpasses the beautiful is the androgynous form of bisexual Zeus, referred to in the Orphic fragment. Such an ideal figure cannot be appealingly represented in a visible, closed plastic form, but only in an invisible, open-ended dithyrambic fragment. The highest manifestation of the ideal which may be visibly represented in a plastic medium and still remain beautiful and complete is the figure of the hermaphrodite. Beyond this, the ideal becomes fully androgynous and may only be represented in an incomplete form.

This may account for the following curious observation which appears elsewhere in Winckelmann's treatise:

> In a few figures of Apollo and Bacchus, the genitals seem to be cut out, so as to leave an excavation in their place, and with a care which removes all idea of wanton mutilation. In the case of Bacchus, the removal of these parts may have a secret

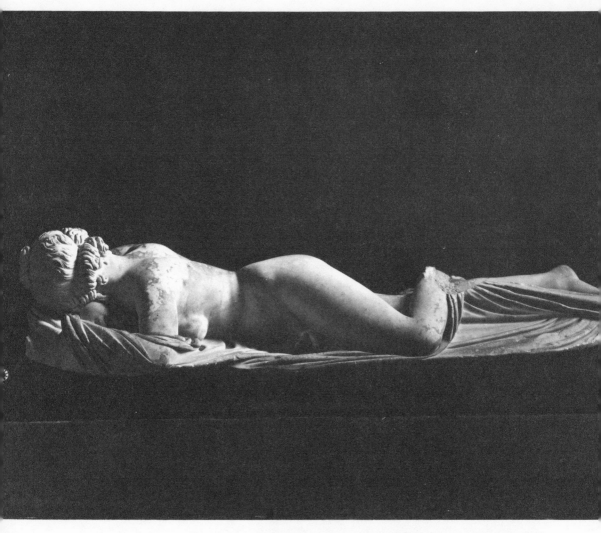

Figures 13 (above) and 14 (right). Sleeping herma-
phrodite, front and rear views (Museo Nazionale delle
Terme, Rome). Contrast the repose of the Hellenistic
hermaphrodite sculpture with the apocalyptic frenzy
of androgynous sexuality described at the conclusion
of Carlos Fuentes's historical fantasy, *Terra nostra:*
([. . .]) you sink into the woman's flesh, the woman
blends into man's flesh, two in one, one in two [. . .]
you make love to yourself, I make love to myself, I
fertilize you, you fertilize me, I fertilize myself, my
male and female selves [. . .]). *Courtesy Alinari/Edi-
torial Photocolor Archives*

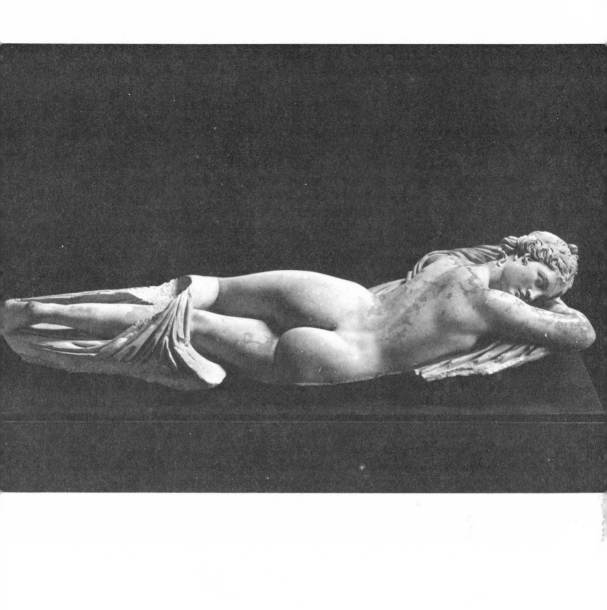

meaning, inasmuch as he was occasionally confounded with Atys, and was emasculated like him. Since, on the other hand, in the homage paid to Bacchus, Apollo also was worshipped, the mutilation of the same part in the figures of him had precisely the same significance. (296-97)

Winckelmann here implies that classical artists attempted to represent the purest form of the ideal, not in lovely hermaphroditic figures of indeterminate sexuality but in forbidding deities of dual sexuality such as the Orphic Zeus, and that in order to do so they intentionally left out the genitals as an unrepresentable fragment. For the androgynous ideal cannot be depicted through Zeuxis' aesthetic which is at most applicable in representations of the hermaphroditic ideal in which a transposition of beautiful parts creates an even fairer supernatural whole. In attempts to represent the androgynous ideal, a new combination of parts does not result in the whole; some transformation—and beyond this, some transsubstantiation not unlike that featured in the ancient Eleusinian mysteries —is required in which a *part* of the body, unknown in nature and unrepresentable in art, must be called forth. If we try to render such an anthropomorphic androgynous ideal in a visible medium here using Zeuxis' method—if we insist that the fairest samples (i.e., the most characteristic and individualized anatomical features) be represented in the ideal body-aesthetic, and that the vital particulars of the human figure all have representation in the ideal form of the body-politic—then we must expect a strange alteration in our presentiment of ideal beauty. For in limiting ourselves to a composite form with multiple sex-features, a creature of multistable sexuality whose appearance would be dramatically unlike the restful beauty of Winckelmann's hermaphrodite, a grotesque and lecherous creature which would be the very opposite of Winckelmann's lovely faun—we would in effect be confronted by a monster.

The uncanny similarity between the beautiful and the grotesque is, of course, a key recognition of artists whom we may call romantics, both in the visual arts (e.g., Fuseli, Blake, Munch) and in literature (namely, Hoffmann, Poe, Gautier, Baudelaire, Balzac).[26] Moreover, the grotesque is inextricably associated with the sinuous curves of the arabesque as a key aesthetic category in Friedrich Schlegel's *Dialogue:* "we should cultivate in ourselves this sense for the grotesque."[27] In Schlegel's romantic ultrarealism—grounded in the necessarily partial, hybrid forms of the grotesque and arabesque—the classical enterprise of idealization cannot be immediately achieved, but the ideal must be progressively rendered in the real until it is finally sur-rendered in the sur-real. In the light of such a romantic aesthetic, we may rightly wonder whether a composite representation of the ideal such as Zeuxis' Helen would appear ultimately as ideal beauty or as grotesque beast.

As we ponder this conundrum, we ought to bear in mind that we are no longer concerned here merely with the difference between the ordinary

and the extraordinary, the plain and the beautiful—in short, the distinction between the norm and the paragon which for Aristotle consisted in the fact "that that which is dispersed has been gathered into one." We are concerned rather with the paragon as one manifestation of multiple modes of abnormality, and hence with the difference between radically opposed extremes which are ultimately indistinguishable—the opposition between the ideally beautiful and the grotesque, between the hermaphroditic god and the androgynous monster, between the partial and impartial, the different and indifferent. In the context of this implicit radical reformulation of the Zeuxis legend whereby the parts do not recombine into the whole, but where the whole is only recognized in its condition of decay and a-partness, the romantics' probable response to the question of the beauty or monstrosity of the ideal seems inescapable: in its divine beauty and complete wholeness, the anthropomorphic ideal is unrepresentable and can only be suggested by a fragment, a torso, or a limb. The idea which suggests and which in turn is suggested by such a fragment may be a presentiment of supreme androgynous splendor. But conceived in its immediate actual, physical totality—as a fragment or compilation of fragments—the ideal is hardly the becoming hermaphrodite admired by Winckelmann, but rather a grotesque, un-becoming monster.

As a fragmentary postscript, it is of interest that what is perhaps the most dramatic expression of the romantics' criticism of the naive classical dream of canvassing all the fair samples and assembling them in the fairest and most representative sample of them all, is not to be found in the writings of a romantic, or in the work of an artist or art theorist for that matter, but in a passing observation made by a scientist. Complaining about the patchwork labors of his fellow theoreticians in evolving a model of the universe, our author writes:

> Nor have they been able thereby to discern or deduce the principal thing—namely the shape of the Universe and the unchangeable symmetry of its parts. With them it is as though an artist were to gather the hands, feet, head and other members for his images from diverse models, each part excellently drawn, but not related to a single body, and since they in no way match each other, the result would be a monster rather than man. So in the course of their exposition, which the mathematicians call their system, . . . we find that they have either omitted some indispensable detail or introduced something foreign and wholly irrelevant.

This negative reference to the composite ideal of beauty in art is made by Nicholas Copernicus in the Preface to his epochal *De Revolutionibus Orbium Caelestium* of 1543.[28] Here, the Polish astronomer responds to what Thomas Kuhn calls a "crisis state" in which the failure of competing

scientific efforts to repair the foundering Ptolemaic system and to organize a cogent model of the planetary system created a chaotic account of the universe that might well be called a "monster."[29] It is interesting to note, however, that despite the fact that Copernicus deplores the hodgepodge of cosmological theories in his day, he believes the existing knowledge about the planetary system can ultimately be incorporated in a unified holistic model. The problem for Copernicus is that "some indispensable detail" was always omitted from other scientists' theories, or else they "introduced something foreign and wholly irrelevant."

Herein lies the key difference between Copernicus' Renaissance outlook and Schlegel's later romantic insight. Copernicus claims to have removed all that was irrelevant from his theory; Schlegel claims that precisely what seems to be irrelevant and separate from the main body, the torso, of cumulative knowledge of the world is of value: "A fragment ought to be entirely isolated from the surrounding world like a little work of art and complete in itself like a hedgehog."[30] Copernicus believed, moreover, that he had found the missing part of the cosmological puzzle which would make all the other parts fit harmoniously together and be "all of a piece." Schlegel had always held this "missing" fragment; what proved tantalizingly—because necessarily—irretrievable, however, was the puzzle itself to which the piece belonged.

Notes

1. For a comprehensive study of the concept of the idea in art theory through the neoclassical period and its significance for aesthetic representations of ideal beauty, see Erwin Panofsky, *Idea: A Concept in Art Theory*, trans. Joseph J. S. Peake (Columbia: University of South Carolina Press, 1968).

2. Socrates' observation is reported by Xenophon *(Memorabilia* 3.X.2) and is cited in Panofsky, p. 15.

3. Panofsky (p. 184 n. 16) cites as sources Pliny, *Natural History* 35.64; Cicero, *De Invent.* 2.1.1; and Dionysius of Halicarnassus, *De priscis script. cens.* 1.

4. I am presently preparing a study on this historical shift of the model's function in the visual arts.

5. Following this line of inquiry, it is suggestive to consider different political forms of representation from the viewpoint of aesthetics. In a monarchy, for instance, a single individual rather than a group would presumably be representative in a dual sense: the monarch would represent the populace *and* divine authority. Similarly, the artist has typically been regarded as having two roles—on the one hand he represents objects in his art, and on the other he is representative as an artist of man in general. See Emerson's discussion of major figures in *Representative Men*, and his observation that "the poet is representative. He stands among partial men for the complete man" ("The Poet"); see also Ruskin's concept of "generic beauty" where the individual is the ideal representative of its species *(Modern Painters*, vol. 2, pt. 1, chap. 13). The distinction between representation as "standing for" and "acting for" I take from Hanna Fenichel Pitkin's *The Concept of Representation* (Berkeley: University of California Press, 1967), chaps. 4-6.

6. Aristotle, *Politics* 3.6.5; cited in Panofsky, *Idea*, p. 15.

7. Panofsky presents a bilingual text of Bellori's introduction (Appendix 2, pp. 154-77).

8. Johann Joachim Winckelmann, *History of Ancient Art*, 2 vols., trans.

Alexander Gode (New York: Ungar, 1969), p. 201. Citations from this edition will hereafter be followed by the page number in parentheses.

9. Cf. Winckelmann, p. 206:

> The attention which the Greek artists paid to the selection of the most beautiful parts from numberless beautiful persons did not remain limited to male and female youths alone, but their observation was directed also to the conformation of eunuchs, for whom boys of handsome shape were chosen.

10. Friedrich Schlegel, *Dialogue on Poetry and Literary Aphorisms*, translated, introduced, and annotated by Ernst Behler and Roman Struc (University Park: Penn State University Press, 1968), p. 91.

11. *Kritische Friedrich-Schlegel-Ausgabe*, ed. E. Behler (Zürich, 1967), 2:326.

12. Another way of visualizing this synecdochic aesthetic is through an analogy with the drama. An actor is said to "play a part," meaning that he enacts one of several roles which, when taken together, constitute the play as a composite whole. Since Pirandello, however, we know that dramaturgy is also intrinsically synecdochic: the actor who plays a part in effect enacts a representative, but nevertheless partial, span of the entire imagined "life" of the character he portrays. Such a life is, of course, unrepresentable in its entirety, and can only be per-formed in (and as a) part. Whence we may conclude that "taking a part" is (merely by putting "a" and "part" together) "taking apart."

13. Behler/Struc, 90; *Kritische Ausgabe*, 2:325. In an essay of 1795, *Über die Diotima (Kritische Ausgabe*, 1:70-115), Schlegel takes Plato's reference in the *Symposium* to Socrates' reported interchange with the seer Diotima as an occasion to praise androgyny as a cultural ideal. Schlegel denounces separate developmental programs for men and women, arguing that *Bildung* consists of a reintegrative effort on the part of the human race to overcome its culturally-conditioned sexual disunity. Mircea Eliade refers to Schlegel's essay in the context of a broader discussion of the androgynous ideal in German romanticism; see *Mephistopheles and the Androgyne: Studies in Religious Myth and Symbol*, trans. J. M. Cohen (New York: Sheed and Ward, 1965), pp. 101-3.

14. Behler/Struc, 134; *Kritische Ausgabe*, 2:169 (*Athenäum Fragment* 24). Curiously, in his essay on the androgynous ideal, *Über die Diotima*, Schlegel metaphorically compares his own reconstruction of the Greeks' conception of the feminine from scattered textual references to the restoration of a sculpture from its surviving fragments:

> So wie es oft nicht unmöglich gewesen ist, aus den kleinsten Bruchstücken einer zerstückelten Statue, und bei beträchtlichen Lücken, das Ganze des Bildes wiederherzustellen; so zeigt sich auch hier ein Leitfaden, das Verlorne zu ergänzen, das Zerstückte wieder zusammenzusetzen, und die Hoffnung zu einer nicht ganz unvollständigen Geschichte der Griechischen Weiblichkeit. (*Kritische Ausgabe*, 1:72)

15. Behler/Struc, 141; *Kritische Ausgabe*, 2:183 (*Athenäum Fragment* 116).

16. Behler/Struc, 125; *Kritische Ausgabe*, 2:151: "Selbst ein freundschaftliches Gespräch, was nicht in jedem Augenblick frei abbrechen kann, aus unbedingter Willkür, hat etwas Illiberales" (*Lyceum Fragment* 37).

17. Behler/Struc, 18 (Introduction).

18. See Panofsky, *Idea*, pp. 14 ff.

19. Curiously, this type of naturalistic form is perhaps the most significant expression of the beautiful for Immanuel Kant insofar as the forms of natural phenomena such as flowers and birds seem to have an indeterminate purpose. The closest parallel to natural forms in art is nonrepresentational ornament which pleases in itself: "So also delineations *à la grecque*, foliage for borders or wall papers, mean nothing in themselves; they represent nothing—no object under a definite concept—and are free beauties" (Immanuel Kant, *Critique of Judgment*, trans. and intro. J. H. Bernard [New York: Hafner, 1951], p. 66 [sec. 16]). Such "free beauty"

(pulchritudo vaga) which inheres in mere indefinite form is contrasted to the dependent beauty *(pulchritudo adhaerens)* found for instance in human representation which always involves a definite purpose of perfection. This leads Kant to "distinguish the *normal idea* of the beautiful from the *ideal,* which latter . . . we can only expect in the *human* figure" (ibid., 72; sec. 17). This, by the way, would presumably be Kant's explanation for the fact that Zeuxis excelled in an ultrarealistic as opposed to an ideal representation of grapes.

20. Behler/Struc, 86; *Kritische Ausgabe,* 2:219: " . . . gewiss ist die Arabeske die älteste und ursprüngliche Form der menschlichen Fantasie." The standard study of Schlegel's concept of the arabesque is K. Polheim's *Die Arabeske: Ansichten und Ideen aus Friedrich Schlegels Poetik* (Munich-Paderborn-Vienna, 1965). It is noteworthy that the major source of the romantics' interest in the arabesque is Raphael's decorative art with its distorted forms.

21. Behler/Struc, 96; *Kritische Ausgabe,* 2:331: " . . . ich halte die Arabeske für eine ganz bestimmte und wesentliche Form oder Ausserungsart der Poesie."

22. Cf. Hegel: " . . . life in its development had necessarily to proceed to the human form as the one and only sensuous appearance appropriate to spirit" *(Aesthetics: Lectures on Fine Art,* trans. T. M. Knox [Oxford: Clarendon Press, 1975], 1:78).

23. Jan Mukařovský distinguishes between three different kinds of wholeness, involving an awareness of what he calls configuration, contexture, and structure respectively, and he maintains that "a literary work preserved incompletely as a fragment, a torso, as it were" is neither a "compositional whole" or a configuration, nor is it "a closed contexture," but rather a *structure* in which "wholeness does not appear to us as closure, or completeness . . . but rather as a certain correlation of components" ("The Concept of the Whole in Art," in *Structure, Sign, and Function: Selected Essays by Jan Mukařovský,* trans. and ed. John Burbank and Peter Steiner [New Haven, Conn.: Yale University Press, 1978], p. 75).

24. The romantic philosopher F. W. von Schelling directs his criticism of Winckelmann's classical ideal precisely at this moment of supposed transformation when the figure of ideal beauty is somehow expected to transcend and differ fundamentally from its component parts in nature. Winckelmann's conception of the ideal does not embody wholeness but, on the contrary, it manifests an unintended incompleteness since it denies the characteristic particular which, for Schelling as well as for Schlegel, provides the only access to representations of wholeness:

> Who can say that Winckelmann had not penetrated into the highest beauty? But with him it appeared in its dissevered elements only: on the one side as beauty in idea, and flowing out from the soul; on the other, as beauty of forms. . . . The miracle by which the limited should be raised to the unlimited, the human become divine, is wanting; the magic circle is drawn, but the spirit that it should enclose, appears not, being disobedient to the call of him who thought a creation possible through mere form.

(On the Relation of the Plastic Arts to Nature, in *The German Classics,* trans. J. Elliot Cabot, [New York, 1913], 5:106-36.) Against Winckelmann's composite formalism, Schelling—like Schlegel—appears to advocate a dynamic realism, a "sublime equipoise of beauty," as the only authentic means of representing the ideal, insofar as such representation is possible.

25. Cf. Winckelmann, p. 213: "The young Satyrs or Fauns are all beautiful, without exception, and so shaped, that each of them, if it were not for the head, might be taken for an Apollo."

26. Gautier explicitly exploits the theme of uncertain sexuality in *Mademoiselle de Maupan,* while Balzac treats the theme in "Sarrasine," as Roland Barthes has exhaustively described in *S/Z* (trans. Richard Miller, with a preface by Richard Howard [New York: Hill & Wang, 1974]). Interestingly, Balzac also treats the related theme of the fragment in aesthetic representation in his story "Le Chef-d'oeuvre inconnu."

27. Behler/Struc, 97; *Kritische Ausgabe,* 2:332: "Wir haben noch einen äussern

Grund diesen Sinn für das Groteske in uns zu bilden, und uns in dieser Stimmung zu erhalten."

28. The translated text from the *De Revolutionibus* is cited in Thomas Kuhn, *The Copernican Revolution: Planetary Astronomy in the Development of Western Thought* (Cambridge: Harvard University Press, 1957), p. 139.

29. Thomas S. Kuhn, *The Structure of Scientific Revolutions*, 2d ed., (Chicago: University of Chicago Press, 1970), p. 69.

30. Behler/Struc, 143. (I have substituted "fragment" for "aphorism" in Behler and Struc's translation); *Kritische Ausgabe*, 2:197: "Ein Fragment muss gleich einem kleinen Kunstwerke sein wie ein Igel" *(Athenäum Fragment* 206).

15

He Asked for Her Hand in Marriage-or the Fragmentation of Women

JENNIFER R. WAELTI-WALTERS

Standing round JACQUES SON, ROBERT FATHER *anatomizes his daughter with the help of* JACQUELINE, JACQUES MOTHER, ROBERT MOTHER *and the* GRANDPARENTS.

ROBERT FATHER. She's got feet! And they're stuffed!
[JACQUELINE *lifts the bride's gown so that* JACQUES *can see for himself.*]
JACQUES (*with a slight shrug of the shoulders*). Nothing unusual.
JACQUELINE. But they're to walk with.
JACQUES MOTHER. To walk with!
JACQUES GRANDMOTHER. Why, yes. And to tickaddle you with!
[ROBERTA *does, in fact, walk with her feet.*]
ROBERT FATHER. She's handy, too! . . .
ROBERT MOTHER. Show. . . .
[ROBERTA *shows one hand to* JACQUES, *almost poking her fingers into his eyes.*]

JACQUELINE. To wipe up with . . .

JACQUES. So she has! So she has! Anyway, I guessed as much.

ROBERT FATHER. And toes to boot.

JACQUELINE. To wiggle with!

JACQUES MOTHER. Yes, yes, my child!

ROBERT FATHER. And a taper waist.

JACQUELINE. For the dishes and plates?

JACQUES MOTHER. What else do you think!

JACQUES GRANDMOTHER (*no one listens to her*). Do you want my advice?

ROBERT MOTHER. And look at her calves—What I call a calf!

JACQUES GRANDMOTHER. Why yes, just as in my days . . .

ROBERT FATHER. She's got hips . . .

JACQUES MOTHER. All the better to eat you with, my child!

ROBERT FATHER. And then she's got green pimples on a beige skin, red breasts on a mauve ground; a strawberry navel, a tongue in tomato sauce; shoulder of lamb, and all the beef-steaks required for the kindest regards. What more do you want?[1]

Ionesco's description of Jacques's prospective bride, amusing as it may be in this context, is illustrative of the way a woman's sense of identity is systematically fragmented by traditional upbringing leading to marriage. Physically she is seen as a pair of hands to work in the house, a pretty face to decorate the living room on special occasions, and the necessary sexual organs to give pleasure to her husband and produce his children. Indeed she must adhere to an image foisted upon her from outside, even if it be necessary for her to be shattered in the process.

We find a growing number of such descriptions, some of them of an extremely sadistic nature, in works of male authors who write in French.[2] These descriptions may be at least in part a response to the writings of those women who are exploring the same image, who show their heroines in such a situation. Of these women, one of the most outspoken to date is Jeanne Hyvrard, who explores the way words themselves are used to fragment women and thus destroy any possible power they might hope to attain on any level, social or personal.

Society operates an oppressive double standard through its language. Love, happiness, marriage, life, do not have the same meanings when applied to men and to women, yet this forked-tonguedness is never allowed to come to the surface, never defined. Thus language is a major factor in the oppression of women, in the justification of the status quo and in the confusion clearsighted women feel as they compare the descriptions they are given of the world with their experiences of it. Are they falling to pieces? Are they going mad?

This is the problem that Jeanne Hyvrard faces when she says: "Je

te dirai le moi fracturé'' (I will recount my fractured self). Her novel, *Les Prunes de Cythère*, purports to be the monologue of a madwoman, Jeanne, who finds in herself fragments of the histories and personalities of her grandmother, mother, and child as well as of herself and the Negro servant, and who is searching desperately for wholeness through the formulation of a language in which she can express her anguish and the causes and form of her madness.[3] She needs to arrive at a description of her identity and situation before she can escape from the division of self caused by the confusion of opposites in which she is caught. Her madness is the language of this refusal and of her suffering. A language of her body and behavior is all she has to use, as the word-language used by the people around her is the source of her confusion, the direct cause of the conflict between her image of herself and the image others demand of her. Language has a double standard of which she is victim, for there exist at least two conflicting meanings, two usages for each word: hers and the one accepted by the consensus around her—represented primarily by her mother—and they belong to totally different value systems. It is because of this problem with language that Jeanne is labeled mad.

At first, when young, she does not learn to read or write, nor will she speak French properly. As she is not allowed to express herself in any other way, her thoughts are impeded—silenced—by external linguistically based control until she refuses to speak at all:

> I will save you from words. Everything is clear. Speak. Be quiet. Not those words. Your sentence is not correct. One does not say. One says. Language is an instrument. Words have an exact meaning. Father, father, help. Come now, don't teach her those words. You'll do her wrong. Now, now, that isn't pretty coming from a little girl's mouth. Try to smile instead. Speak softly. You'll make a little conversation. Above all be very polite. Be quiet. Let me have the last word. Answer when you're spoken to. Come to me and I will rid you of words. (28-29)

Clearly the acquisition of a certain sort of language and speech is a major part of learning and playing a specified role.

> She's the one we prefer because she's the prettiest. She's the one who speaks best. (85)

It is an initiation into marriageability through which a girl is put by her mother and against which Jeanne struggles with all her strength. At first, in her "delirium," she repeats her mother's instructions:

> I must say I've rarely seen anyone as aggressive as you are. You realize that if you go on like that you'll never manage to

get married. You'll stay an old maid. Make an effort. Come on, speak quietly now. A woman must smile. Control yourself. You know, when your father is about to come home *I* put fresh rouge and powder on. . . . Not that dress, it's not your style. You're like me, see. You're wide from here. (17)

In the girl's eyes this upbringing is a deliberate and progressive mutilation. Gradually the crippling becomes overt, as first Jeanne has her legs cut off, then is deprived of her hands and arms, followed by her mouth, tongue, voice, womb. Her body is forbidden to her. She is not allowed to dress it as she wishes, not touch it, nor, above all, talk about it, for there is no accepted language, indeed no language at all in which to do so.

> . . . since I am death.
> You have broken in yourself everything that could have helped me escape you one day. You've cut off my hands so that I should not touch a body. You have pierced my throat so that I should make no sound. You did not teach me to speak in case I should say no. Mother Earth, you have turned me into death because you are time. You thought to make me your domain because they had taken everything from you Mother Earth, I have come to be like you. Like all of us who have only a self, giving birth to each other for ever, in search of time, in search of everything. (188)

Jeanne sees herself as an amputee, a prisoner-victim of her mother's life of frustration passed on from generation to generation. To other people, however, she is ill and her mother is to be pitied.

Jeanne's confusion begins here in the multiple implications of the word *mother*, the polar opposite it contains. Mother is both danger and safety. She tries to kill her daughter at birth rather than let her go, then stifles her by the love and restrictions imposed upon her. The child is the mother's only source of power, her only outlet. Her feelings and actions are translated by Jeanne into the dominant language as the abuse they are:

> Then she lay on top of me and stuffed her phallus into my mouth. Stop, mother, I'm not hungry any more. I don't want any more of the sperm of your love that's choking me. (46)

Yet this same mother is the ultimate security, for she is the womb to which her daughter wishes to return. But she denies the comfort that is hers to give and rejects her daughter constantly. This rejection, felt at all levels, is here directed specifically at her daughter's sexuality. Because of her mother's lack of support, Jeanne has an abortion and loses both child and capacity to have children. This mutilation, symbol of the refusal of

her female status, is a sign that Jeanne both refuses the kind of power her
mother wields and all the social attributes of womanhood.

> A little wedding veil. Who doesn't dare to say no. Who
> doesn't dare to say, I want to live free. A well-brought up
> young girl. Who is waiting for the solemn handing over of the
> keys. The official transfer of power. The enthronement of the
> new master. Not me. (229)

Her revolt against the slavery of marriage, pregnancy, and a life of domes-
tic servitude is symbolized by the loss of her womb. The symbol is
double, however, like the others, and is also a sign of Jeanne's lack of
inner security. She has broken out of her prison but has no other place to
go back to. She has shattered the old role and all that is left is her anguish.

The only images she has of herself are the one her mother wants her
to resemble, which she refuses, and the one she feels is true, which her
mother rejects. The movement from the one to the other is symbolized
by the passage through a mirror. Sometimes she goes back through it
towards the house and safety—to her mother's desired image. Sometimes
she goes away from it. The mirror is the door between Jeanne and the
living. It is the door into madness which she goes through when values
shift around her and it is also the door through which her mother calls
her when her lover brings her body to life, thus breaking the taboo by
which she is bound.

Jeanne holds her mother responsible for the lack of grasp she has on
herself and the world, the ambiguity of her relationship to other people
and to words that bring the anguish that finds its expression in her mad-
ness. She accuses her mother of stealing the language and pleads with her
to teach her the one she needs to know, the one that was forbidden. But
her mother either has no time to talk to her because of household tasks or
tells her stories that add to her insecurity.

Her mother offers Jeanne two alternatives only: marriage or mad-
ness. By Jeanne's definition to accept either is to be dead. Indeed, if we
examine the various uses of "dead" and "death" in the novel we find that
they apply to every facet of a woman's role known to our narrator. To
be mad is to be dead; the mental hospital is called the "city of the dead."
But death is also slavery: it is being in someone else's power, being vul-
nerable to atrocities and torture, be they electric shock treatment in the
hospital, rape or whipping by a slave driver, garments that prevent action,
or education that impedes thought. This is the situation of most women,
and Jeanne sees them as dolls playing at being alive. She is dead when she
refuses to be an acceptable woman, but those who play the game are dead
too. In fact, for men, women are death itself:

> But you don't know that women are death. Mother
> Death. Between our thighs they are trying to talk to you. They

are so afraid that they say we are life. As if they want to
ward you off. (94)

Women are dead and bring death but this truth is taboo. They are
described as living and bringers of life; this word-magic for men, this
reversal is the cause of the constant repression of women and the origin
of the confusion of which Jeanne feels herself the victim and the embodi-
ment. Thus she sees herself as the symbol of woman's condition:

> They have turned me into death. And it's to them that,
> trembling, they say: you are alive.
> Yes, my beloveds, I am the living-dead . . .
> I will stifle you so well that you will join us again, for we
> are the world matrix.
> You are alive, says man to Death. (189)

She will continue to be deprived of her potential power by such word-
magic until she finds her own voice. Married women, slaves, or mad-
women are one and the same; all are silent people. Hyvrard links them all
constantly by the interchangeability of the women in Jeanne. Jeanne
herself is treated as a "sale petit nègre" (dirty little nigger) when she
speaks patois. The black servant is accused of letting the baby die and is
taken to prison. Jeanne's baby dies and Jeanne accuses her mother of
trying to kill her. Both mother and grandmother work like servants. The
conclusion is that women are "black," women are "slaves"—inferior mem-
bers of society on both counts and deprived of all identity.

The symbol slaves and women have in common is that of blood
spilled: blood that carries the opposite messages of shame and pride. For
the slaves it is pride when they kill their masters and so gain self-esteem in
victory, shame when they are whipped and mutilated. For Jeanne, pride
is in her menstrual blood, proof of her womanhood, of her self. That
blood is the sign of maturity, sexuality, ability to love and to give birth,
all of which are denied by her mother.

> I have my festivities, she would say then as she went to
> sleep happy, in the dampness between her thighs. One doesn't
> talk about such things girl. You have your affairs, she asks,
> ready to mark the calendar. Shh, that isn't talked about. But
> mother why not parade your great joy? Why not flood the
> sheets with this happy blood? Daughter, you're dirty. You will
> be ashamed of your body, of your sex-blood.
> And I am dead. (21)

And her blood becomes the blood of mutilation, of suffering, of rape and
violence against her womanhood.

The man with the motorcycle goes away leaving her in the grass. Tell me Mummy how can genitals bleed? Come now, little daughter, we don't talk about that. The man goes away buttoning his trousers. How can genitals hurt? Ask your mother. . . .

The man puts his hands on her breasts. She's frightened. She will never speak again. But you're at your most beautiful like that. The soldiers cover the body on the stretcher. Do you understand why anyone would jump out of a window? (116-17)

Women's blood bears a taboo. It is a source of fear and shame, and has only one acceptable place in the world of the others—as a sign that the bride was a virgin and proof that the groom was not cheated in the exchange.

Blood, then, carries a variety of opposing meanings throughout the text: death and life, abortion and birth, sexuality denied and enjoyed. It is the sign of womanhood lived and rejected, the taboo of the body at its most powerful. To speak of blood, therefore, is to revolt against the whole established system. Blood is the metaphor of revolt, the only voice that has not been taken away from Jeanne. All the symbols come together as blood creates disorder and life. Disorder is madness and madness is the revolt against the humiliating order society and mothers together impose upon daughters. It is the refusal of a doll-like disposability in an attempt to gain a real life, to gain entrance to the forbidden garden and have access to the plum tree of Cythera: the tree of life.

So we find that madness is death and also life. Life (as lived by others) is death. Death (in the form of woman in coitus) is life. The terms spin in eternal confusion, eternal clarity. Jeanne's values are different from those of the people around her because in each case she looks at the situation and not at the term applied to describe it. Thus marriage is obviously slavery and "death" no matter what she is told to the contrary, and she is on her way to life by means of her "madness." Life comes when she is accepted for what she is: as herself, whole.

She has a husband/lover who accepts her most of the time, but his role too includes the oppositions found in the others. Sometimes he does not recognize her. Sometimes they cannot communicate. Sometimes he merges with her mother, sometimes with her father, and her father is the one person who she feels could have saved her from the death-madness out of which she must now struggle. He could have told her she had a right to be alive, been her model for life.

Her state of revolt—like her menstruation—is regarded as illness, and it is hoped that she will be cured. Here again we are faced with two conflicting definitions of the cure. The first, Jeanne's, is that she should manage to shake free of all the schizophrenogenic sex-role conditioning inflicted upon her:

> I shall not tell you I am beginning to be cured as long as I
> haven't vomited Cinderella and Monroe together. Pierrette
> and the pot of milk. Red Riding Hood going through the wood.
> Sleeping Beauty waiting for Prince Charming. Snow White
> doing housework. And Garbo and Dietrich. All those women
> you brought us up for, resigned foils, future exemplary mothers,
> killing themselves trying to be. Tormented, adulterous women,
> fearful, betrayed women. . . . Virgins terrorized after twenty
> years in a cloister. Married on the best day of their lives. Deliv-
> ered of I hope it's a son. . . . Turned into statues. Framed.
> Limp rags. I shall not say I am beginning to be cured as long as
> I have not spit in your faces. (233-34)

Her mother's and husband's definition of the cure is that she should come
to behave like other people and accept the mutilations and restrictions
imposed upon her; that she should give up trying to reconcile herself to
her social role.

The text is circular because the revolt has not been accomplished
totally. Jeanne's monologue is the monologue of her confusion. In it
we hear all the voices that have made demands upon her or have given her
conflicting images of herself.

> I am the cry of the mad woman being locked up, the
> furious one being stifled, the condemned man guillotined, the
> adolescent castrated . . . the girl to be married being dressed in
> flounces and furbelows. (48-49)

Through the broken sentences, questions, juxtapositions of words and
incomplete phrases, the linguistic ambiguities of all kinds, we feel Jeanne's
struggle to achieve some kind of unity.

There are two indications that success is possible. The first is the
story of Tom Thumb, which runs as a refrain through the text:

> Tom Thumb who is lost. Tom Thumb whose mother has
> eaten him. (63)

> You watch in the rocking chair, ready to tell me the story
> of Tom Thumb who collected pebbles so that he wouldn't get
> lost. (56)

> You tell me the story of Tom Thumb eaten by his mother.
> But now you no longer know the end and you can't invent it.
> (58)

> I am telling you the story of Tom Thumb who set off
> towards life. (222)

The story, a symbol of confusion and engulfment in the beginning, becomes more helpful and changes totally when Jeanne takes control and tells it herself. Not only has the wicked mother been set aside, but the hero steps out towards success gained by his own efforts—words. (It is interesting to note Jeanne has chosen a male model, tiny and weak as he may seem. All the fairy tales about girls are violently rejected as part of the mother's preparation for her daughter's repression.)

The second hopeful sign is, of course, the text itself. This monologue by Jeanne the madwoman is a testimony to her creation of a description of herself, no matter how chaotic. Indeed, its very disorder and apparent lack of logic is an active part of her revolt against "correct" behavior and "correct" language. It is her refusal. She says:

> I want nothing to do with your world. Nor your logic. Even less to do with your language which has so many words missing. (113)

It is also her act of self-discovery, in which dying takes on its full meaning of life in resurrection.

> Write to get better, write to reconcile two worlds. To finish being born to myself. Agree to die to be able to live at last. (200)

This time in active affirmation of woman's status of "other," Jeanne assumes the repression, fragmentation, and humiliation that have been woman's lot and then, in the rejection of them, emerges as an active being. If not yet a whole, a unified woman, she is at least one able to describe herself in her assumed world in her own words.

It is now clear that for women fragmentation, language, and power are intimately related; that mutilation and muteness are characteristics of a slave, as are anonymity and a doll-like availability. Women are therefore divided the better to serve men. After all, enemies who have been chopped up have long been believed to have been deprived of their power forever. We have examples of this from the myth of Osiris and from the punishment of hanging, drawing, and quartering.

However, we see in such works as Marguerite Duras's *Les Viaducts du Seine et Oise* that sometimes the pieces have a disconcerting habit of coming together again to control the life of the butcher-victor. So it is with women today. Although divided by language they are reassembling themselves and gaining power through the appropriation of language to themselves.

The first stage, as illustrated by Jeanne Hyvrard's novel, can be found also in many of the texts of Quebecoise writers such as Nicole Brossard, Madeleine Gagnon, and Monique Bosco.[4] A second stage—that of the total refusal of such shattered identity—is developed throughout Louky

Bersianik's novel *L'Euguélionne (The Bearer of Good Tidings)* in which
the new female savior, having taken over the most powerful description of
our world, the Bible, and retold it so that the misogyny in our society
becomes apparent, refuses to become the ultimate victim in the manner of
Jesus Christ her predecessor.[5] Like Him she preaches a farewell sermon
and like Him she is betrayed, but as the Euguélionne's farewell speech
draws to a close in a demand for justice and equality, a Judas-woman
throws a stone and soldiers shoot the Euguélionne who shatters into a
thousand pieces which stay suspended in the air. Like many other women
Bersianik describes, she is man's target, but the fragmented Euguélionne
reassembles:

> 1349. Euguélionne then reappeared: all her pieces fit back
> together as in a moving puzzle, filmed at accelerated speed or as
> in a film of destruction played backwards.

Her death is a denial of the time when women were destroyed by men.
She is the sign of the new order of the indestructibility of women, an
order in which women believe in their lives and have control over them—
are no longer fragmented, no longer victim, no longer "dead."

To escape from their situation women must break and not be
broken. "It is good to resist . . . it's better to transgress" (verse 1019).
Bersianik's women break the laws men have made to women's disadvant-
age; thus they reject the male description of society and provide their
own in their own language. Made in the image of the Euguélionne, they
reassemble their fragments and move on.

In the writings of French-speaking women today the major symbols
of the dominant order have been transformed. No longer should it be
possible to present a bride as hands to clean with and hips to eat you with
as Ionesco did with Roberta. Women with a sense of self and a language
are able to describe themselves and defend themselves against the offen-
sive descriptions thrust upon them. By their new descriptions they are
changing the world, changing the state of marriage, and refusing all possi-
ble threat of fragmentation in the future.

Notes

1. E. Ionesco, *Théâtre*, trans. Donald Watson (London: John Calder, 1958),
1:131-32.
2. For example, A. Robbe-Grillet, *Project for a Revolution in New York*, trans.
Richard Howard (New York: Grove Press, 1972 [Evergreen Black Cat Edition]),
pp. 159-60; Hubert Aquin, *Hamlet's Twin*, trans. Sheila Fischman (Toronto:
McClelland and Stewart, 1979), p. 194.
3. J. Hyvrard, *Les Prunes de Cythère* (Paris: Les Editions de Minuit, 1975).
Page references are to this edition, and all translations are my own.

4. See, for example, "Femme et langage," *La Barre du Jour* (Winter 1975), no. 50, and the English version of many of the texts published in *Room of One's Own* (1978), vol. 4, nos. 1-2.

5. Louky Bersianik, *L'Euguélionne* (Montreal: La Presse, 1977). All translations are my own.

16

The Dismantled Man: Diddler and Victim

ARTHUR KAY

The literature of diddling is as old as literature itself. It is at least as old as the Old Testament with its evil and subtile serpent or the good, plain man Jacob, himself subtile enough to acquire his brother's birthright. But the figure of the diddler or confidence man has flourished particularly well as an American myth, as an indicator of our humor—in more than one sense of that word. Indeed, as Constance Rourke demonstrated, "there is scarcely an aspect of the American character to which humor is not related, few which, in some sense, it has not governed." And, she goes on to say, this humor is by no means a merely incidental element in our literature, but "a force determining large patterns and intentions." Furthermore, practices of deception, disguise, the notorious "poker face" —these are present from our very beginnings. Rourke writes of that prototypical taciturn Yankee and his protective mask: "In a primitive world, crowded with pitfalls, the unchanging, unaverted countenance has been a safeguard, preventing revelations of surprise, anger or dismay." But of course this mask the legendary Yankee peddler hides behind must become something more than a mere defensive device:

He [the Yankee] was said to have sold a load of warmingpans
in the West Indies, and when he arrived in a Canadian village
with a load of fashionable white paper hats and found no
market because of the cholera, he ground them up in a mortar
and made them into pills.[1]

"Man is an animal that diddles, and there is *no* animal that diddles
but man," wrote Edgar Allan Poe.[2] Indeed there is no culture where "the
science and pastime of skullduggery," as Faulkner's V. K. Ratliff terms
it, has enjoyed such a central and enduring role. One of its earliest mani-
festations is in the original tale of *The Sotweed Factor* (1708) by
Ebenezer Cooke. This narrative poem is in effect a hudibrastic overture to
that persistent strain in American literature of protest, protest against a
perceived betrayal of America's early hopes and promises. The particulars
of the young hero's experience are pertinent: He arrives with expecta-
tions of a new life and an escape from an old world of oppression and
poverty. But he is soon cheated out of the proceeds of his tobacco crop.
He engages a lawyer who is—perhaps after John Smith himself—one of
the first in the long line of American confidence men and sharpers. This
creature, much like his descendants the Duke of Bilgewater and the
Dauphin, is easily versatile at impostureship. He is ready wherever the
main chance beckons, "an ambodexter Quack,"

> Who learnedly had got the knack
> Of giving Clysters, making Pills
> Of filling Bonds, and forging Wills

So with such assistance our innocent factor is done out of all he has and
leaves the new world for the known evils of home with a bitter caution
for "Any youngster who might cross the ocean" and a curse for "This
Cruel, this Inhospitable Shoar."[3]

Cooke's poem is but the first small bead in the long string of con-
fidence game narratives running through America's literature and her folk
and popular culture as well. The family of diddlers is prolific: there are
Sam Slick and his Yankee trader brothers and all their Southern cousins
from Hooper's Simon Suggs to the clan of Snopes in Faulkner's Missis-
sippi; there are Mark Twain's immortal pair of rascals and Herman
Melville's confidence man in all his myriad shapes and disguises; even
Henry James's prototypical innocent American, Christopher Newman, is
an adept poker player and, worse, a successful tycoon. Later we en-
counter the likes of Ralph Ellison's mysterious Rinehart, he of the
smoked glasses, and the outrageous Milo Minderbinder, supply sergeant
and superdiddler of Joseph Heller's *Catch-22*. In the popular media, the
general fascination with players of the game is evidenced in an often
benign and sympathetic way; for example in Charlie Chaplin's *The Kid*, in
which Charlie is in the business of repairing windows broken by pre-

arrangement with Charlie's little partner. So it is in the typical roles played by Groucho Marx or by the appearance of W. C. Fields in the musical comedy *Poppy*, in which Fields, as Professor McGoggle, sells patent medicines. Witness more recently the popularity of such movies as the *Paper Moon* and *The Sting*, in which the more congenial and human diddlers triumph at skullduggery over their unprepossessing, hard-hearted rivals.

It may be that this confidence theme in American culture found natural sustenance in an egalitarian, frontier environment. "It is good to be shifty in a new country," advises wily Simon Suggs. One is reminded of Frederick Jackson Turner's theory that the American character was formed, in all its coarseness and vitality, acuteness and acquisitiveness, by the frontier experience. Such a society, with its fluidity, its population of mysterious strangers and transients, its absence of credentials or any established badges of status or office, its licensed behavior beyond the reach of the arm of the law, was a happy hunting ground for the diddlers and dodgers of a land "vaguely realizing westward." "What was your name in the States?" was the question sung during the Gold Rush. "Did you murder your wife? Did you run for your life? What was your name in the States?"

Here is another point to be considered: the diddler implies, of course, the diddled; the confidence man has always his innocent victim, his "mark." This is to invoke that oft-repeated theme—American Innocence. We are not surprised to find writers such as Hawthorne, Melville, and Poe—those nay sayers (in thunder or otherwise)—writing stories of deception, disguise, and sham, and of most dangerous innocence. They question the sunnier views of American transcendentalism. They recognize "the power of blackness." They have perceived that this famous innocence belies a blurred vision, befuddled and blind to ambiguities. So we have the great expectations and country cockiness of Hawthorne's Robin in "My Kinsman, Major Molineux" and the vulnerable, fatal generosity of Melville's Captain Delano in "Benito Cereno." Delano is "a man of such naive simplicity as to be incapable of satire or irony, a person of singularly undistrustful good nature,"[4] and he misinterprets the most sinister scenes and incidents as he observes them "through a blunt-thinking American's eyes." Deliberately and significantly Melville identifies his captain as "the American," calling him this in the story as often as he uses his surname.

The patterns and scenarios of deception in the national memory are various and familiar: the innocent victims are bilked by legal or medical mountebanks. They buy barren desert land or swamps, gilded stock in nonexistent gold mines or the Brooklyn Bridge. They are taken at the gaming tables, purchase carnival tickets to seedy and disappointing wonders, render up their virtue to seducers with false promises. We all

know such litanies. But I should like here to focus on one particular
bizarre motif that turns up frequently in literature and in popular and folk
imagination as well. A popular parody of a waltz tune might serve for a
beginning:

> After the ball was over,
> Lucy took out her glass eye;
> Stood her cork leg in the corner;
> Put up her bottle of dye;
> Put her false teeth in some water;
> Hung up her hair on the wall.
> What there was left went to bye-bye,
> After the ball.

Here is a common enough little comedy, and no doubt many could
supply their own versions and examples that use the joke. Henri Bergson
has even theorized that the essence of the comic lies in the perception of
mechanical or machinelike qualities in the human person or conduct.

Nor need we be surprised to see that such a motif, involving decep-
tion in a person who is not entirely human, entirely organic, a person who
has false or artificial parts, has turned up often even in the writings of
"classical" American authors. One case in point is Nathaniel Hawthorne's
little story, "Mrs. Bullfrog" (1837). In this tale, the delicate, exquisitely
sensitive Thomas Bullfrog (in common with the protagonists of some of
Hawthorne's more somber stories, for example, Aylmer of "The Birth-
mark") cannot abide any deviation from his standard of absolute beauty
and perfection. As he puts it,

> So painfully acute was my sense of female imperfection, and
> such varied excellence did I require in the woman whom I could
> love, that there was an awful risk of my getting no wife at all,
> or of being driven to perpetrate matrimony with my own image
> in the looking-glass.

Nevertheless this bachelor's fastidiousness is overcome. Bullfrog manages
to overlook "a few trifling defects," the inexpressibly charming Laura
becomes Mrs. Bullfrog, and the blissful couple set out upon their wedding
journey in a stagecoach. Alas, there is an accident; the coach overturns,
and Mr. Bullfrog recovers from his shock and confusion only to hear a
strange hoarse voice berating the driver. There are the sounds of a beat-
ing being administered:

> The blows were given by a person of grisly aspect, with a head
> almost bald, and sunken cheeks, apparently of the feminine
> gender, though hardly to be classed in the gentler sex. There
> being no teeth to modulate the voice, it had a mumbled fierce-

ness, not passionate, but stern, which absolutely made me quiver like calf's-foot jelly. Who could the phantom be?

We expect Thomas Bullfrog's ensuing consternation and dismay when he discovers that his beautiful bride has come apart. But Hawthorne gives a common sort of humorous tale a turn of the screw, for the story has, after all, a happy—if somewhat cynical—ending: at least there is no mistake or deception about Mrs. Bullfrog's five thousand dollars. That will serve nicely to stock Bullfrog's dry goods store. Thus his final pronouncement: "Happy Bullfrog that I am!"[5]

It is a slight thing and Hawthorne himself deprecated it,[6] in agreement with most of his critics. But if we take "Mrs. Bullfrog" along with similar stories by his illustrious contemporaries, we discover an intriguing and perhaps significant recurring motif. The comic device of depicting a character as a physical counterfeit of a human being is employed frequently for its pure comic value, but it may be seen also as symbolic of an ambiguous and deceitful world. The yarn that George Washington Harris' Sut Lovingood spins about his friend Robert B. Dawson may exist entirely for the comedy, but we might bear in mind that it comes out of "a new country" like Simon Suggs. Mr. Robert B. Dawson, just like Hawthorne's Bullfrog, marries with the greatest of expectations, and he too is devastated by reality. It is the wedding night and his bride begins her preparations for bed:

> That self-poised, deliberate swindler, now Misses Robert B. Dawson, ontied her garter, an' drew from between her stockin' an' her laig, the counterpart of a dried codfish, made of muslin stuff't with something—bran suggested itself to me at the moment— and as she did so, her stocking fell limp, in a pile around her shoe mouth, and her laig looked like pint aind ove a buggy shaft, with nearly the same crook to it.

Predictably, the dismantlement continues horrendously. The wooden leg's removal is followed by that of two "palpititytators" from the area of her bosom, her teeth are laid on the table "gapin' open an' facin' me . . . like a saw tooth'd rat trap, ready set to ketch another dam fool." In the final step, the bride, "with her fore finger, bounced out one of her eyes and put it in her mouth, while she lifted her whole head of hair, leavin' her skull, white an' glossy as a billiard ball."[7]

Outrageous, but still lighthearted in the tradition of Mark Twain's "Story of the Old Ram," where Old Miss Wagner borrows a wooden leg, a wig, and a glass eye. Herman Melville, however, provides a blacker, grimmer application of the dismemberment theme. In chapter 13, "The Operation," of *White Jacket*, we come upon the grisly Surgeon of the Fleet, Cadwallader Cuticle, M. D. Surgeon Cuticle is clearly a symbol of death, and, more particularly, he is related to Hawthorne's Faustian

scientists. He performs an operation upon an injured sailor, and it is indeed a "performance"—an arrogant demonstration of his knowledge and skill with complete disregard of the frightened patient's feelings or for his life. As a performance, the operation is very much a success. But the patient dies.

However, we must take note of a certain prelude or ritual to this medical execution: it involves the prior dismantling of the physician himself. "I must be perfectly unencumbered, Surgeon Patella," he tells his assistant, "or I can do nothing whatever."

> These articles [his coat and neckerchief] being removed he snatched off his wig, placing it on the gun deck capstan; then took out his set of false teeth, and placed it by the side of his wig; and, lastly, putting his forefinger to the inner angle of his blind eye, spirited out the glass optic with professional dexterity, and deposited that, also next to the wig and false teeth.[8]

Whereupon the unencumbered surgeon proceeds to describe "the highly interesting operation I am about to perform," illustrating his lecture by dismantling a skeleton hanging behind him—the symbol, as it were, of our symbol.

We can see then how dismantling may represent, in a Dr. Cuticle, not simply death, or death-in-life, but the type of man dehumanized, a mechanized mind with a mechanical body, materially inorganic. Hawthorne's Ethan Brand with his marble heart, Faulkner's Flem Snopes with eyes "the color of stagnant water," who is free of such human weaknesses as lust or love of drink, who wears factory-made black bow ties, machine tied, that clip on at the back, or the Popeye of *Sanctuary*, with eyes "like little rubber balls"—these are some of the members of the species. The poet E. E. Cummings warns us against "that busy monster, manunkind."

> pity poor flesh
> and trees, poor stars and stones, but never this
> fine specimen of hypermagical
> ultraomnipotence.

Here too the connection is made between man's heartless, dangerous intellectuality and inorganic barrenness. "A world of made/ is not a world of born."[9]

A slight variation on this concept is the dismantled figure as a hollow man, one whose prepossessing exterior is a disguise for nothingness in the soul. Thus Marlow, in Joseph Conrad's *Heart of Darkness*, describes the agent at the ivory station:

> I let him run on, this papier-mache Mephistopheles, and it

seemed to me that if I tried I could poke my forefinger through him, and would find nothing inside but a little loose dirt, maybe.[10]

Edgar Allan Poe introduces his reader to that "truly fine-looking fellow, Brevet Brigadier-General John A. B. C. Smith" in his sketch "The Man That Was Used Up." In keeping with his imposing title and name, the general has, Poe's narrator reports, "a singular commanding presence." And, despite a certain "primness, not to say stiffness, in his carriage" and "a degree of measured . . . rectangular precision attending his every movement," General Smith is portrayed in considerable detail as a supreme, superb specimen of military leader with a distinguished, although somewhat obscure record of heroic service. So impressed, the narrator pays a visit to the general's home for an interview. He arrives early, but is shown into the bedroom where the general is "dressing." But all he can see in the room is "a large and exceedingly odd-looking bundle of something which lay close to my feet on the floor." He gives the thing an exploratory kick and is startled to hear a voice issuing from the bundle squeaking in protest at such treatment.[11] It is, of course, the hero himself. We are then treated to a reverse version on the theme of dismantling; that is, we are privy to the *assembling* of the parts and accoutrements that go to make up the public image, actually the hollow symbol, of military glamor and glory.

Another tale of Hawthorne's, "Feathertop," utilizes this idea. Here the old witch, Mother Rigby, creates a fine gentleman out of the materials of a scarecrow. "The glittering mockery of his outside show" is a matter of considerable mirth to the witch.

> My poor, dear pretty Feathertop! There are thousands upon thousands of coxcombs and charlatans in the world, made up of just such a jumble of wornout, forgotten, and good-for-nothing trash as he was! Yet they live in fair repute, and never see themselves for what they are. And why should my poor puppet be the only one to know himself and perish for it?

For perish he does when Feathertop is given the wit to see what he is; and so he sinks down upon the floor, "a medley of straw and tattered garments, with some sticks protruding from the heap, and a shrivelled pumpkin in the midst."[12]

The dismantled figure, then, need not be confined to exist as the agent and perpetrator of deception—as the diddler. It may be symbolic of the deceiver, or it may even be symbolic of the victim, a manifestation of passive falseness. So it is with Mark Twain's feckless child of misfortune in "Aurelia's Unfortunate Young Man." The devoted young lady, Aurelia, sees her young intended virtually disassembled "piecemeal,"

before they can be married: his face is marred by smallpox; he fractures his leg, which is then removed at the knee; one eye is lost to erysipelas. It goes on: he loses one arm to a cannon misfire, the other to a carding machine; then he is scalped by the Owens River Indians. Somewhat discouraged, the patient Aurelia has written to the author for some fatherly advice. She loves her Breckenridge—what is left of him—but her parents are raising difficulties, oppose the match. What to do? The advice is what she must have wished:

> If Aurelia can afford the expense, let her furnish her mutilated lover with wooden arms and wooden legs, and a glass eye and a wig and give him another show; give him ninety days without grace, and if he does not break his neck in the meantime, marry him and take the chances.[13]

Both sweethearts might appear to be victims of a fortune that delights in practical jokes. Perhaps more suggestive of some transcendent significance is John Crowe Ransom's doughty Captain Carpenter, of the poem of that name. This quixotic hero has his nose removed by a lady he "had played so sweetly with before." After an unchristian-looking stranger breaks his legs, Satan's wife proclaims that he shall bear no more arms and, nastily literal-minded, she proceeds to bite them off at the elbows. One black devil cuts off the captain's ears while another plucks out his sweet blue eyes. The poet concludes with a curse upon all of those

> That shore him of his goodly nose and ears
> His legs and strong arms at the two elbows
> And eyes that had not watered seventy years.[14]

Our last sight of the poor victim includes the image of kites whetting their beaks before consuming the rest of him.

Certainly the most deliberate and thoroughgoing application of the dismantled symbol and victim theme to be found in American literature is Nathanael West's *A Cool Million, or The Dismantling of Lemuel Pitkin*. This is West's parody of the Horatio Alger myth, in which the progress from rags to riches deteriorates into a series of calamitous encounters with confidence men, charlatans, spies, political windbags, and various other grotesques, creatures and monsters of the American Dream gone mad. From the time he leaves his mother's "humble dwelling" to his death by assassination, "our hero" is subjected to a sporadic but relentless dismemberment—all of which he accepts with the patient innocence of his ancestor, Candide. Falsely accused and thrown into prison, Lemuel suffers both indignities and mutilations. His teeth are all pulled out, as a cure for "criminal tendencies." Also as a piece of preventive dentistry: "Because you have never had a toothache does not mean that you will

never have one," the warden explains. West is surely a forerunner of a later wave of humorists of the absurd. When Lemuel is released from prison, Purdy, the warden, shakes his hand "in a hearty farewell" and congratulates him for his good fortune throughout in terms that any Horatio Alger reader will recognize: after all, Pitkin has come out with a profit. He has had twenty weeks, free board and room in prison, thus saving him about one hundred and forty dollars. Furthermore, it would have cost him at least two hundred to have his teeth extracted and his prison set of teeth was worth at least fifteen dollars—would have been worth twenty had they been new. So Lemuel is ahead by a handsome amount—"Not at all a bad sum for a lad of your age to save in twenty weeks."

The scene is typical of Pitkin's encounters throughout the story. In the end, the dismantled and martyred Lemuel proves to be more useful that way to his superpatriot manipulators. Pitkin's Birthday becomes a national American holiday. In his honor, the youth of America parade down Fifth Avenue. Shagpoke Whipple, the former president and present dictator of the United States, perorates upon the new American hero-martyr: It was the right of every American boy to receive fair play and a chance to make his fortune by industry and probity. But—

> Alas, Lemuel Pitkin himself did not have this chance, but instead was dismantled by the enemy. His teeth were pulled out. His eye was gouged from his head. His thumb was removed. His scalp was torn away. His leg was cut off. And, finally, he was shot through the heart.

Thus we have the dismantled man a scapegoat culture hero. "He did not live or die in vain!" cries Dictator Whipple. "Hail, Lemuel Pitkin!" "All hail, the American Boy!"[15]

Eyes and teeth come out. Arms, legs come off. Hair and scalps are removed. Metal, wood, glass, plastic, paint are used to deceive, to disguise, to hide age, ugliness, inner corruption and hollowness. These phenomena recur often enough in our literature to interest that faculty in us that perceives patterns. As a motif or device, dismantling can be viewed as one idea subsumed as part of the great American theme of innocence illusioned and deceived. Its effect is more often comic than profound, but there is sometimes a bitter, deeply critical intention. At any rate, it appears frequently enough and at all levels of our culture. Hawthorne's illusory Mrs. Bullfrog has her counterpart in folklore's "The Wealthy Old Maid."

> There once was a lawyer they called Mr. Clay.
> He had a few clients but they wouldn't pay.

At last of starvation he grew so afraid
That he courted and married a wealthy old maid.

He's a very unfortunate, a very unfortunate, a very
 unfortunate man.
He's a very unfortunate, a very unfortunate, a very
 unfortunate man.

She went to the washstand to bathe her fair face.
Thus she destroyed all her beauty and grace.
The rose in her cheeks it grew very faint
And he saw on the towel it was nothing but paint.

She went to the mirror to take down her hair.
When she had done so her scalp was all bare.
Said she, "Don't be frightened to see my bald head.
I'll put on my cap when I get into bed."

She hung her false hair on the wall on a peg.
Then she proceeded to take off a leg.
Her trembling husband thought sure he would die
When she asked him to come and take out her glass eye.

The husband was biting his quivering lips
While she was removing her counterfeit hips.
Just then her false nose clattered down on the floor
And the poor lawyer screamed and ran out at the door.

Now all you young men who would marry for life,
Be sure to examine your intended wife.
Remember the lawyer who trusted his eyes
And a little while later got quite a surprise.

With all the variations, the essential message is the same—Beware! And,
though some may no longer see America as a new country, the last words
of Herman Melville's book *The Confidence Man* still seem appropriate:

Something further may follow of this Masquerade.

Notes

1. Constance Rourke, *American Humor: A Study of the National Character*
(New York: Doubleday, 1931), pp. 9, 21, 16.
2. "Diddling Considered As an Exact Science," in *Complete Stories and Poems
of Edgar Allan Poe* (New York: Doubleday, 1966), p. 358.
3. *The Art of American Humor,* ed. Brom Weber (New York: Harper, Row,
1962), pp. 72, 74.

4. "Benito Cereno," *Billy Budd, Sailor and Other Stories*, ed. Harold Beaver (Baltimore, Md.: Penguin Books, 1970), p. 217.

5. *Mosses from an Old Manse*, in *The Complete Works of Nathaniel Hawthorne* (Boston: Houghton, Mifflin, 1838), 2:150, 152, 158.

6. "[I]t did not come from any depth in me—neither my heart nor mind had anything to do with it" *(Complete Works, 9:239).*

7. *Sut Lovingood's Yarns*, ed. Thomas Inge (New Haven, Conn.: 1966), pp. 279, 280.

8. *White Jacket*, in *The Standard Edition of the Works of Herman Melville* (New York: Russell & Russell, 1963), p. 324.

9. "pity this busy monster, manunkind," *Poems 1923-1934* (New York: Doubleday, 1954), p. 397.

10. *Heart of Darkness*, ed. Robert Kimbrough (New York: Norton, 1963), p. 26.

11. Poe, *Complete Stories and Poems*, pp. 351, 356.

12. Hawthorne, *Selected Tales and Sketches* (San Francisco: Rinehart, 1970), p. 399.

13. *The Writings of Mark Twain* (New York: Harper, 1906), 19:336-37.

14. Ransom, *Selected Poems* (New York: Knopf, 1969), p. 46.

15. In *Two Novels by Nathanael West* (New York: Noonday Press, 1934), pp. 90, 99, 179.

17

Duane Hanson: Truth in Sculpture

NAOMI SCHOR

> *Devant un objet tiré de la nature, et représenté par la sculpture,*
> *c'est-à-dire rond, fuyant, autour duquel on peut tourner libre-*
> *ment, et, comme l'objet naturel lui-même, environné d'at-*
> *mosphère, le paysan, le sauvage, l'homme primitif, n'éprouvent*
> *aucune indécision; tandis qu'une peinture, par ses prétensions*
> *immenses, par sa nature paradoxale et abstractive, les inquiète*
> *et les trouble.*
>
> Charles Baudelaire, *Salon de 1859*

Hanson/Balzac

Duane Hanson is the Balzac of twentieth-century American sculpture, a creator of types (namely, *Supermarket Woman, Tourists, Hard Hat*) rendered in highly particularized and ideally transparent detail: "not a line around the mouth, wrinkled pouch beneath the eyes, discolored skin on the neck, stubble on the chin, or frayed cuff is shown that does not betray

its bearer's sex, age, health, social class, diet, occupation, character, idio-syncrasies and personal habits. From such a compendium social historians could *reconstruct* a convincing model of the society in which the subject lived."[1] This total synecdochic plenitude fulfills one of Balzac's most cherished ambitions, which was not so much to emulate Cuvier's paleonto-logical triumphs himself, as to provide an inexhaustible lode for some future social historian. Balzac wrote always from the posthumous vantage point of the archeologist, preventatively packing as much information about his society into every virtual fragment, so that some day *après le déluge*, one would have only to unpack the shards of this dead civilization to reconstruct it as a living whole. Balzac invokes this unassailable scien-tific concern on more than one occasion to legitimate his extended archi-tectural descriptions, for there is a definite though unarticulated connec-tion between (an excess of) descriptive details and the archeological stance: if a fragment is to ground a projected reconstruction, it must exhibit a high density of details, and, at the same time, a plethora of details ensures the survival of at least some trace of a civilization always conjugated in the future anterior:

> It so happens that human life in all its aspects, wide or narrow, is so intimately connected with architecture, that with a certain amount of observation we can usually *reconstruct* a bygone society from the remains of its public monuments. From relics of household stuff, we can imagine its owners "in their habit as they lived." Archaeology, in fact, is to the body social somewhat as comparative anatomy is to animal organiza-tions. A complete social system is made clear to us by a bit of mosaic, just as a whole past order of things is implied by the skeleton of an ichthyosaurus. Beholding the cause, we guess the effect, even as we proceed from the effect to the cause, one deduction following another until a chain of evidence is complete, until the man of science raises up a whole bygone world from the dead, and discovers for us not only the features of the past, but even the warts upon those features.[2]

The rhetorical strategy deployed by the art critic in his *éloge* of Hanson —"not a line . . . " —echoes, unwittingly, though not coinciden-tally, the one adopted by Balzac in his defense of the detail —"*Une* mosaïque révèle *toute* une société . . ."—for hyperbole is the figure of the realist's mimetic, which is also to say hermeneutic hubris. Underlying both Balzac's and Hanson's archeological enterprises there lies the bed-rock of the realist's confidence in man's capacity, indeed duty to per-meate phenomena with meaning: reconstruction implies recuperation. By their investment in transparent, meaningful details, Balzac and Hanson are opposed to artists such as Flaubert, whose opaque, detotalized details serve to produce what Roland Barthes has termed a "reality effect,"[3]

Fig. 16. *Supermarket Woman* (1970) by Duane Hanson. *Photo by Eric Pollitzer Courtesy O. K. Harris*

that extreme form of mimesis which derives from the inscription of details as resistant to hermeneutic recuperation as nature itself. And yet —and it is this initially puzzling observation which I should like to interrogate in this fragment of a larger study on the detail— unlike Balzac's, Hanson's use of details provokes another effect, a "shock" effect remarked upon by nearly all of his critics. I quote from the jacket of the widely disseminated monograph that served as catalogue for the first major exhibition of Hanson's works to travel across the United States: "Encountering a Hanson . . . is shocking; it violates our sense of reality"; "Hanson's sculptures cause one shock after another. They are so realistic that they are thrilling, almost frightening."[4]

The shock effect created by Hanson's lifelike sculptures is one we know better under a different name: the uncanny, *das Unheimliche*. Indeed, it would appear that if one is to account somehow for the thrilling terror, the *frisson* universally produced by Hanson's "sharp-focus" realism, one must (re)read Freud's classical essay of 1919, "The 'Uncanny.' "

Freud/Jentsch/Cixous

As often in his writings on esthetics, Freud is from the outset at great pains to position himself very modestly in the field. In this instance he begins by qualifying his "claim to priority" by a double disclaimer: "As good as nothing is to be found upon this subject in comprehensive treatises on aesthetics . . . I know of only one attempt in medico-psychological literature, a fertile but not exhaustive paper by Ernst Jentsch (1906). But I must confess that I have not made a very thorough examination of the literature . . . so that my paper is presented to the reader without any claim of priority."[5]

Jentsch, it turns out, serves not merely as a bibliographical alibi, but also as a psychological foil for Freud's psychoanalytic investigation. Once one becomes aware of the polemical thrust of Freud's essay, Jentsch appears to haunt the text, creating an uncanny effect of his own, what I will call the *Jentsch-effect*. Transcoded into the idiom of "The 'Uncanny,' " Jentsch functions as a sort of double —the archdouble in a text crowded with doubles— or, better yet, as a repressed that insists upon returning. In Hélène Cixous' words: "When the *Unheimliche* forces back the Jentschian motif, is there not, in fact, *a repression of the repressed?* Does not Jentsch say more than what Freud wishes to read?"[6]

(Here I must interrupt myself, expose the fictive linearity of my expository narrative, and repeat Freud's inaugural gesture; my paper too is presented to the reader without any claims of priority, for what I have just described as the Jentsch-effect —that form of the uncanny peculiar to the scholarly enterprise— surprised me in the very act of writing this text, in which I, like Freud, have ventured outside my own field of expertise [literature] into an unfamiliar branch of esthetics [sculpture]. No sooner

had I uncovered what I assumed to be the heretofore unsuspected significance of the Freud/Jentsch relationship, than I discovered with a dismay tempered by a perverse delight in the wondrous workings of the uncanny, that my claim to priority was rendered null and void by Cixous' remarkable gloss of Freud's text, "Fiction and Its Phantoms: A Reading of Freud's *Das Unheimliche* [The 'Uncanny'] ." Inevitably then, given the logic of the uncanny, in what follows a Cixous-effect reduplicates the Jentsch-effect I shall be studying.)

Two questions now arise: what exactly is the Jentsch-effect, and what bearing does it have on our attempt to explain the uncanny effect produced by Hanson's sculptures? The Jentsch-effect is the uncanny impression evoked in the reader by the insistent recurrence throughout Freud's text of allusions to his predecessor's theory —a theory which Freud does everything in his power to discredit, but which exhibits a remarkable resistance to analytical annihilation. That theory assigns privileged status to lifelike three-dimensional figures.

Although the Jentsch-effect relies on repetition, rather than note all of Freud's explicit and implicit references to Jentsch, I shall confine myself to Part 2 of "The 'Uncanny,' " because it is there that Freud's engagement with his double is most clearly bodied forth.

Having devoted an inordinate amount of space and effort in Part 1 to demolishing Jentsch's equation of the uncanny with the unfamiliar, by deconstructing the very opposition between the unfamiliar and the familiar on which Jentsch's equation is posited, Freud surprises the naive reader who had given Jentsch up for dead by opening Part 2 with a passage praising Jentsch for his choice of a particularly suitable example of the uncanny as a starting point for his investigation: "Jentsch has taken as a very good instance 'doubts whether an apparently animate being is really alive; or conversely, whether a lifeless object might not be in fact animate'; and he refers in this connection to the impression made by waxwork figures, ingeniously constructed dolls and automata" (Freud 17:226). This praise is, however, mere puff; in an ambivalent gesture which characterizes Freud's relationship to Jentsch, as Cixous (para)-phrases it:

> Scarcely does he appropriate Jentsch's example (in the manner of children: this doll belongs to me) when he declares himself the true master of the method since his predecessor did not know how to make proper use of it. The way in which he misappropriates betrays a stinging boldness and the ploy of a fox! On the one hand, Freud quotes the Jentsch citation about the Sand-Man beginning with the character of the automaton, the doll Olympia. At the same time, he discards Jentsch's interpretation. The latter links the *Unheimliche* to the psychological manipulation of Hoffmann, which consists in producing and preserving uncertainty with respect to the true nature of

Olympia. Is she animate or inanimate? Does Freud regret the psychological argument? So be it. He takes advantage of it to displace the *Unheimliche* of the doll with the Sand-Man. Thus, under the cover of analytical criticism and uncertainty, the doll which had been relegated to the background is already, in effect, in the trap. (Cixous 532)

Cixous' analysis is compelling and convincing, but nonetheless misleading; by relying on Freud's paraphrase of and selective quotations from Jentsch, she compounds his already skewed reading of Jentsch with her own, leaving the reader with the erroneous impression that Jentsch explicitly cites "The Sand-Man," and specifically the doll Olympia, in support of his theory of intellectual uncertainty. If, however, one rereads the relevant passage from Jentsch as quoted by and then commented upon by Freud, it quickly becomes apparent that Jentsch never mentions "The Sand-Man," or, a fortiori, the doll Olympia. Freud's misappropriation of Jentsch's example is then even craftier than Cixous suggests; in order to set his predecessor/rival up as a straw man, Freud fraudulently attributes to him an interpretation of a text he never even cites by name. Or, to complicate this already complicated scenario even further: because Freud wants to propose an interpretation of "The Sand-Man," and because he cannot get around (or over) the fact that Jentsch had already made the connection between Hoffmann and the uncanny, Freud takes advantage of the brief break between paragraphs to transform a general statement into a pointed reference:

Jentsch writes:

> In telling a story, one of the most successful devices for easily creating uncanny effects is to leave the reader in uncertainty whether a particular figure in the story is a human being or an automaton, and to do it in such a way that his attention is not focused directly upon his uncertainty, so that he may not be led to go into the matter and clear it up immediately. That, as we have said, would quickly dissipate the peculiar emotional effect of the thing. E. T. A. Hoffmann has repeatedly employed this psychological artifice with success in his fantastic narratives.
>
> This observation, undoubtedly a correct one, refers primarily to the story of "The Sand-Man" in Hoffmann's *Nachtstücken*, which contains the original of Olympia, the doll that appears in the first act of Offenbach's opera, *Tales of Hoffmann*. But I cannot think—and I hope most readers of the story will agree with me—that the theme of the doll Olympia, who is to all appearances a living being, is by any means the only, or indeed the most important, element that must be held responsible for the quite unparalleled atmosphere of uncanniness evoked by the story. . . . The main theme of the story is, on the

Fig. 17. *Tourists* (1970) by Duane Hanson. *Photo by D. James Dee. Courtesy O. K. Harris*

contrary, something different, something which gives it its name, and which is always re-introduced at critical moments: it is the theme of the "Sand-Man" who tears out children's eyes. (Freud 17:227)

To return to Jentsch's text is not only to become aware of the tendentiousness of Freud's reading, it is to discover the extent of his misreading, and to understand better the uncanny resistance of the Jentschian text to Freud's incursions. For if Jentsch is not, as Freud would have it, primarily concerned with The Sand-Man and Olympia, one might well ask: what is his prime concern? And the answer seems forthcoming: he is concerned with a particularly effective technique Hoffmann uses, an "artifice," to distract the reader's attention from the source of his uncertainty, and thereby maintain it as long as possible. Freud, in his eagerness to set Jentsch up, neatly sidesteps the issue of decentering that Jentsch is raising, and directs our attention to the doubt-producing automaton, only to say that the real source of the uncanny lies elsewhere. In other words, by deliberately misreading Jentsch, Freud seems to have fallen precisely into the trap Hoffmann had set for him; instead of focusing on his uncertainty, he focuses on the Sand-Man. It has, of course, not gone unnoticed by Cixous that the theme of "The Sand-Man" is blinding as well as blindness. Now, according to Cixous, it is we the readers who are blinded by Freud: "We get sand thrown in our eyes, no doubt about it" (532). But, what if the sand were in Freud's eyes, Freud who at the very beginning of the essay —indeed in one of his initial references to Jentsch— confesses to a "special obtuseness" (17:220) in the matter of the uncanny, Freud who either scotomizes Olympia where she is present (see Cixous), or hallucinates her presence, where she is in fact absent (see above).

Here I must part company with Cixous, who attempts to explain what I would call Freud's "Olympia complex" psychoanalytically, not because of any fundamental disagreement, but simply because in my perspective her analysis is not complete. It seems to me quite possible that Freud's conspicuous inability to successfully integrate Jentsch's work into his own can be attributed in large measure to his failure to make the same critical distinctions between media, as he makes between literary genres (the fairy tale and the realistic narrative), or, for that matter, between fiction and real life. One of the reasons why "the theme of the doll" is never dealt with adequately is that Freud consistently occults its specificity, not only its sex (see Cixous 538), but more importantly its three-dimensional form. By overemphasizing Jentsch's interest in Hoffmann, Freud does more than displace Olympia in favor of the Sand-Man; he displaces sculpture in favor of literature.[7] If we are to further our inquiry into the differences between the uncanny in these two domains, we must *return to the repressed*, which is to say Jentsch's text, and in particular to the passage pertaining to "wax-work figures, ingeniously

constructed dolls and automata" which Freud alludes to but does not quote:

> The disagreeable impression easily aroused in many people upon visiting wax-museums, wax-works, and panoramas is well-known. It is often difficult, especially in the half-darkness, to distinguish a life-size wax figure or similar figure from a person. Such a figure, for some impressionable individuals, has the power to prolong their discomfort, even after they have decided whether or not the figure is animated. It is probably a matter here of a half-conscious secondary doubt, automatically and repeatedly provoked by the renewed examination and observation of the finer details, or perhaps it is only a vivid after-vibration of the recollection of the initial painful impression. The fact that such wax-figures do often represent anatomical details may indeed contribute to the intensification of the intended emotional effect, that is, however, by no means the main thing: a genuine anatomical cadaver does not have to look remotely as disgusting as the corresponding wax-figure.[8]

Jentsch's integral text provides valuable confirmation of our initial hypothesis, namely that realistic sculptural details play a significant role in producing and protracting uncanny effects. The "finer details" which catch and hold the spectator's gaze are the plastic equivalents of the psychological artifice so successfully employed by Hoffmann: the fascination they exert on the spectator prevents him from focusing on his doubt. But Jentsch takes us a step further by introducing an important qualification: anatomical details are not the privileged purveyors of the uncanny. The question then becomes: if anatomical details are not primarily responsible for enhancing the disagreeable uncanny impression, is there another category of details which is? One has only to turn to some of the most thoughtful criticism written about Hanson's works to discover the answer: the shock effect produced by Hanson's sculptures is due not to their anatomical verisimilitude, but rather to their vestimentary realism. In an article comparing Hanson to John de Andrea, whose plastic figures are naked, Joseph Mashek states: "Duane Hanson's people are clothed. The nature of their dress, in fact, grants them a truly realistic quality of exemplarity"[9]; similarly, in his review of the "Sharp-Focus Realism" exhibition, held at the Sidney Janis Gallery in 1972, Harold Rosenberg writes: "Of the sculptures in the show, Hanson's *Businessman* comes closest to fooling the eye, no doubt through the assistance of authentic posture and clothing; de Andrea's *Sitting Black Boy* is, by being naked, unable to rise to this level of deception."[10]

Derrida/Kant

Clothed statues are, as Jacques Derrida emphasizes in his recent

translation and gloss of Kant's third *Critique*, the paragon of *parerga:*

> "And even what we call *ornaments [Zierathen:* decorations, trimmings, embellishments] *(Parerga),* that is that which does not belong intrinsically to the whole representation of the object as its integral part but only as an external addition *(was nicht in die ganze Vorstellung des Gegenstandes als Bestand-stück innerlich, sondern nur äusserlich als Zuthat gehört)* and increases the pleasure of taste, does so nevertheless only by its form: like the frames *(Einfassungen)* of paintings or the clothing on statues, or the columns surrounding sumptuous buildings."[11]

Now for Derrida the *parergon* in general and in particular the "example of examples, the clothing on statues *(Gewänder an Statuen)*"[12] are highly problematic because in point of fact it is not nearly so simple a matter to know the clothing from the statue as Kant's formulation implies: "Where does a *parergon* begin and where does it end. Is every piece of clothing a *parergon*. G-strings and others. And what of completely transparent veils."[13] At this juncture Derrida swerves away from his paradigmatic example, the clothing adorning sculptures, and shifts to an example more germane to his subject, truth in painting:

> And how is the enunciation to be transposed into painting. For example, one of Cranach's Lucretia's holds only a slight strip of transparent veil over her genitals: where is the *parergon* located? Should one consider as a *parergon* the dagger which is not a part of her naked and natural body and whose tip she holds turned against herself, touching her skin (only the tip of the *parergon* would then be in contact with her body, in the middle of a triangle formed by her two breasts and her navel)? A *parergon* the necklace around her neck?[14]

Hanson's clothed figures stand at the opposite end of the spectrum: it is the opacity of their apparel (rather than their transparency), the excess of their accoutrements (rather than their scarcity), that make it impossible to distinguish the ornamental from the essential. Or rather: in Hanson's works, the ornamental has become the essential: the accessory, which is to say the detail, has been promoted to a radical centrality. The uncanny effect in sculpture arises from a generalization of the supplement, a reversal of the traditional clothes-statue relationship; in a word, it is a "frame-effect,"[15] to borrow once again from Derrida.

But, one might well ask: is it art? Are the disagreeable impressions provoked by these clothed statues and esthetic pleasure compatible? What, after all—Freud never does say—is the pleasure of the uncanny? If we return to Jentsch, we find that he concludes his remarks regarding wax-

Fig. 18. *Hard Hat* (1971) by Duane Hanson. *Photo by Eric Pollitzer. Courtesy O. K. Harris*

figures and the like by a curiously prescient critique of hyperrealistic sculpture:

> Incidentally it is interesting to note by means of this example how true art, in wise moderation, avoids the absolute and complete imitation of nature and living things, knowing full well that they provoke slight feelings of uneasiness: the existence of polychromatic sculptures in wood and stone does not in any way alter this fact, no more than does the possibility of preventing to some extent such disagreeable side-effects, if this mode of representation is nevertheless chosen. Moreover, the production of the uncanny can, of course, be attempted in true art, but again with artistic means and intentions.[16]

Neither Hanson's artistic means nor intentions are today any longer in question. Indeed, it has been convincingly argued that far from being the unrepentant realist we have been making him out to be, Hanson is in fact a conceptual artist. What Jentsch could not have anticipated is that taken to its logical conclusion (and beyond), realism in sculpture can only self-deconstruct, give rise to a sort of metasculpture that comments on its own means of deception. As Gerritt Henry has put it: "The viewer's search for the esthetic reasonableness of Duane Hanson's work ends, then, with the recognition of the joke behind it. Unlike the joke behind much conceptual art, Hanson's is not on the viewer, or on art in general, but it is a joke *on the joke* of fallacious and single-minded ways of perceiving, and the results, both artistic and human, of those fallacies."[17] Finally then, the pleasure of the uncanny effect produced by Hanson's figures is the pleasure of the after-effect, the infantile pleasure that comes from taking the doll apart and seeing how it is made, in other words, the pleasure of the critic.

Notes

1. Michael Greenwood, "Current Representational Art: Five Other Visions," *artscanada* (December 76-January 77), 210-11:24.
2. Honoré de Balzac, *The Quest of the Absolute*, trans. Ellen Marriage (New York: A. L. Burt, 1899), p. 2.
3. Roland Barthes, "L'Effet de Réel," *Communications* (1968), 11:84-89.
4. Brian O'Doherty, *Art Forum*, and Jürgen Beckelmann, *Erlanger Tagblatt*, as quoted by Martin H. Bush, *Duane Hanson* (Wichita, Kans.: Wichita State University Press, 1976).
5. Sigmund Freud, "The 'Uncanny,' " in *The Standard Edition of the Complete Psychological Works of Sigmund Freud*, trans. James Strachey et al (London: Hogarth Press, 1955), 17:219-20. All subsequent references to this edition are included in the text.
6. Hélène Cixous, "Fiction and Its Phantoms: A Reading of Freud's *Das Unheimliche* (The 'Uncanny')," trans. Robert Dennomé, *New Literary History* (Spring 1976), 7:534. All subsequent references to this article are included in the text.
7. An inexplicable move on the part of the author of *The Moses of Michelangelo*. Indeed, Freud's failure to deal specifically with the uncanny in sculpture is

all the more regrettable as in his single essay devoted entirely to a work of sculpture, the status of the detail is very much in question. His (re)interpretation of the enigmatic stone figure rests on nothing more substantial than the revalorization of two details: "Now in two places in the figure of Moses there are certain details which have hitherto not only escaped notice—but, in fact, have not even been properly described" (Freud 13:222). And these details are very emphatically sculptural details, which is to say convexities which stand out and catch the onlooker's eye: the "loop of the beard" (224) and "a protuberance like a horn" (226) on the bottom of the Tablets of the Law. It is no coincidence that it is in his unique essay on sculpture that Freud deals most explicitly with the hermeneutics of the detail, because the sculptural detail enjoys paradigmatic status—unlike the literary detail whose prominence relies on stylistic effects (the form of the expression) and/or derives from an extratextual connection (the form of the referent) and is thus in some way mediated, the sculptural detail stands out directly, can be apprehended by both the eye and the hand.

 8. Ernst Jentsch, "Zur Psychologie des Unheimlichen," *Psychiatrisch-Neurologische Wochenschrift* (1906), 22:198.

> Bekannt ist der unangenehme Eindruck, der bei manchen Menschen durch den Besuch von Wachsfigurencabinetten, Panopticis und Panoramen leicht ensteht. Es ist namentlich im Halbdunkel oft schwer, eine lebensgrosse Wachs- oder ähnliche Figur von einer Person zu unterscheiden. Für manche sensitive Gemüther vermag eine solche Figur auch nach der vom Individuum getroffenen Entscheidung, ob sie belebt sei oder nicht, ihre Ungemüthlichkeit zu behalten. Wahrscheinlich handelt es sich hier um halbbewusste secundäre Zweifel, die durch die erneute Betrachtung und die Wahrnehmung der feineren Einzelheiten immer wieder von neuem automatisch ausgelöst werden, vielleicht auch nur um ein blosses lebhaftes Nachschwingen der Erinnerung an den ersten peinlichen Eindruck. Dass solche Wachsfiguren oft anatomische Einzelheiten sur Darstellung bringen, mag zur Steigerung der gedachten Gefühlswirkung beitragen, ist aber durchaus nicht die Hauptsache: ein wirkliches anatomisches Leichen präparat braucht nicht entfernt so widerwärtig auszusehen, als die entsprechende Modelirung in Wachs.

The translations of Jentsch are my own; I do want, however, to thank my colleague William Crossgrove for his help in elucidating some tricky details. Although the greater part of Jentsch's two-part article is concerned with what one might call the uncanny in everyday life, it forms an essential complement to Freud's text and should be translated in its entirety.

 9. Joseph Mashek, "Verist Sculpture: Hanson and de Andrea," *Super Realism: A Critical Anthology*, ed. Gregory Battcock (New York: Dutton, 1975), p. 196.

 10. Harold Rosenberg, "Reality Again," *Super Realism*, p. 139.

 11. Jacques Derrida, *La Vérité en peinture* (Paris: Flammarion, 1978), p. 62.

> "Et même ce que l'on nomme *ornements [Zierathen:* décoration, agrément, enjolivement] *(Parerga),* c'est-à-dire ce qui n'appartient pas intrinsèquement à toute la représentation de l'objet comme sa partie intégrante mais seulement comme additif extérieur *(was nicht in die ganze Vorstellung des Gegenstandes als Bestandstück innerlich, sondern nur äusserlich als Zuthat gehört)* et augmente le plaisir du goût, ne le fait toutefois que par sa forme: comme les cadres *(Einfassungen)* des tableaux ou les vêtements des statues, ou les colonnes autour des édifices somptueux."

The translation is my own.

 12. "exemple parmi les exemples, les vêtements des statues *(Gewänder an Statuen)* ..." (Derrida, p. 66).

 13. "Où commence et où finit un *parergon*. Tout vêtement serait-il un *parergon*. Les cache-sexe et les autres. Que faire des voiles absolument transparents" (Derrida, p. 66).

 14. Et comment transposer l'énoncé dans la peinture. Par exemple, telle Lucrèce de Cranach ne tient qu'une légère bande de voile transparent

devant son sexe: où se trouve le *parergon?* Doit-on considérer comme un *parergon* le poignard qui ne fait pas partie de son corps nu et naturel et dont elle tient la pointe retournée contre elle, au contact de sa peau (la pointe du *parergon,* seule, toucherait alors son corps, au milieu d'un triangle formé par ses deux seins et son nombril)? Un *parergon* le collier qu'elle porte à son cou? (pp. 66-67).

15. Ibid., p. 85.
16. Jentsch, p. 198:

Es ist nebenbei bemerkt von Interesse, an diesem Beispiel zu sehen, wie die echte Kunst in weiser Mässigung die absolute und vollständige Nachahmung von Natur und Lebewesen, wohl wissend dass bei einer solchen leicht Missbehagen entstehen kann, vermeidet: die Existenz einer polychromen Plastik in Holz und stein ändert nichts an dieser Thatsache, ebenso die Möglichkeit, solchen unangenehmen Nebenwirkungen, falls diese Art der Darstellung dennoch gewählt wird, einigermaassen vorzubeugen. Uebrigens kann die Erzeugung des Unheimlichen in der echten Kunst zwar auch versucht werden, aber immer nur wieder mit künstlerischen Mitteln und in künstlerischer Intention.

17. Gerritt Henry, "The Soho Body Snatcher," *ARTnews* (March 1972), 71:61.

PART 6

FILMS: SIGNS INTO MEANING

18

"Reading" a Film

ANDREW SARRIS

The problem of "reading" a film did not exist until very recently because no one from the most esoteric esthete to the most venal publicist was willing to admit that the cinema had achieved its ultimate form. For the greater part of the first half of the twentieth century, the relatively few theoreticians in the field were obliged to serve also as prophets and visionaries. The thousands and thousands of movies that were actually made and shown merely served as clues to the ideal film of the future. The poet Vachel Lindsay (1879-1931) preached the gospel of the cinema's becoming a phosphorescent art gallery of sublimely mobile canvases spreading beauty across an untutored continent. For Lindsay, the D. W. Griffith cineportraits of Lillian Gish and Mae Marsh performed the same civilizing function as did Leonardo's Mona Lisa. For his part, Harvard philosopher and psychologist Hugo Münsterberg proposed back in 1916 that the transition from stage to screen involved an esthetic voyage into the moviegoer's mind, but he counseled patience with the primitive motion pictures of his time: "It has too often been maintained by those who theorize on the photoplay that the development of character is the

special task of the drama, while the photoplay, which lacks words, must be satisfied with types. Probably this is only a reflection of the crude state which most photoplays of today have not outgrown. Internally, there is no reason why the means of the photoplay should not allow a rather subtle depicting of complex character."[1]

Curiously, Münsterberg's very perceptive distinctions between theatrical pantomime and silent movie-acting seemed to exclude the technological evolution of a talking film. For Lindsay and Münsterberg both, the eventual visual sublimity and psychological profundity of the medium did not require the addition of speech. Indeed, the coming of the talkies was to cause a traumatic crisis in film esthetics the world over. Through the late forties and early fifties, the study of film was drenched with nostalgic tears for the lost glories of the silent era. Yet there is no trace of any serious attempt to "read" the silent cinema through the years in which it was alive and flourishing. The scholarship of myths, genres, and archetypes was nonexistent. Until very recently there had not even been any adequately descriptive records in print of the silents in the twenties, the decade of the last creative spasm of the speechless cinema. As William Everson has noted in his authoritative study, *The American Silent Film*, only a small percentage of the films from that period have survived the ravages of time.[2]

The consequences of this vast gap in the archives have been varied. Because of the survival of a disproportionately large number of genuinely innovative silent films, there has arisen the false legend of an all-classical cinematic antiquity. In refined circles, at least in the English-speaking world, it was widely believed as late as the mid-fifties that the artistic development of the medium had ended around 1929. In film courses sound and speech were still treated as the vile seducers of a virginally visual art. Music was tolerated only in very small doses. In this professionally pessimistic atmosphere, there was little intellectual incentive to attempt a definition of cinema as a whole, much less a "reading" of individual films. As if to fill the resultant theoretical vacuum, sociological criticism with its political preconceptions and naturalistic biases became the dominant mode of analysis. Siegfried Kracauer's *From Caligari to Hitler* became for a time the model for all film scholarship.[3]

In retrospect, however, the cinema was beset from the very beginning by a bewildering variety of contradictions in its very essence. But there were few, if any, trained dialecticians in attendance at either the first Edison peep-shows or the epochal screen exhibition of the Lumière brothers' *cinématographe* at the Grand Café on the Boulevard des Capucines in Paris on December 28, 1895. With the benefit of prolonged hindsight, one can now speculate on the dialectical tension between the circular movement of the film in the projector with the rectangular shape of the screen. In this most efficient of transformations of a circle into a square, time invades space, motion blurs picture, decomposition nullifies composition, and a material substance dissolves into an ephemeral illusion.

The cinema is still a long way from Griffith and Murnau and Eisenstein and Stroheim and Flaherty and Chaplin and Keaton and Lang and Pudovkin, but, already, extraordinarily significant decisions are being made intuitively, pragmatically, thoughtlessly, crassly, but almost never systematically or academically. Lumière's painterly realism gives way for a time to Mélies's magic and fantasy, but the ultimate mandate of the cinema is never made entirely clear. The potentially "fine" art of animation is shunted aside to a secondary role, and live-action cinematography becomes the dominant mode of cinematic expression to this day. Nonetheless, live-action cinematography itself is complicated by cinema's shadowy relationship with reality on one hand, and its ancestral ties to drama and narrative on the other. For that matter, the cinema as art form never seemed able to escape entirely from the reproductive responsibilities of the cinema as medium.

In 1895 there seemed to be a world out there waiting to be photographed. The early cinematographers doubled as travel agents and explorers for their avidly curious and hitherto provincial audiences. Hale's Tours and Scenes of the World created the illusion of train travel at the 1903 Saint Louis Exposition (commemorated in Vincente Minnelli's *Meet Me in St. Louis* in 1944). The theater was disguised as a railway carriage, and the scenery was projected on the apparently open end of the carriage with footage shot by a motion picture camera mounted on the front of a moving train. (A precinematic equivalent of the Hale's Tours effect appears in Max Ophuls's *Letter from an Unknown Woman* in 1948). Surviving footage from this supposedly "naive" period of film history is infinitely precious to us today as imprints on the vanished sands of time. There is no problem in "reading" this footage because film grammar and syntax have not evolved beyond the most rudimentary stage. Obviously, personal style is not yet a factor in film. The few conventions that have emerged are commonly shared. The noninvolvement of the camera itself in the illusion of the spectacle is one of the earliest and most enduring conventions of the cinema. The earliest players learn to perform as if the camera did not exist. Dogs, children, and passersby tend to violate this convention with an effect that is both amateurish and heartrendingly authentic. Dziga Vertov set out to demolish this convention in 1928 with *The Man with a Movie Camera*, and Jean-Luc Godard has devoted many of his films to little jokes on his own cinematographic self-consciousness. And, of course, there are a countless number of comedies in which the performer turns to the "audience" for whom the camera lens is the immediate surrogate.

The convention still remains in force for the most part in all but a very few non-avant-garde narrative films. This is an indication that the cinema has continued to defy Cézanne's modernist dictum to the effect that he was painting pictures, not apples. The movies have blithely continued to paint apples, and they have continued to confound modernist estheticians by persistently denying the materiality of their medium by

providing their audiences with as undistracting and as undistanced a flow of illusionist images as contemporary standards of projection (and projectionists) will allow.

The "invisible" camera movements—invisible, that is, by virtue of their being completely functional—devised by the Hale's Tours cinematographers and their earlier counterparts for the Lumière brothers did *not* become commonplace in the very early narrative cinema. Camera movement as an element of film style remained dormant for decades as editing (or montage) leaped forward as the most fashionable criterion of technical sophistication. With refinements in editing, the cinema learned to lie with impunity. Reality, so naively and so sincerely integral in space in the Lumière era, could now be fragmented and recombined in so many different combinations that the filmmaker's subjective intentions could prevail over the medium's objective capabilities. It was now necessary to "read" these intentions instead of accepting them as self-evident in the images themselves. In any event, the "lies of art" had come to the once truthful cinema, and the narrative film became the chief beneficiary.

Vachel Lindsay and Hugo Münsterberg never gave much consideration to the options of documentary, animated, "pure" or "experimental" or "poetic" cinema. But then neither did such later theoreticians as Eisenstein and Pudovkin. Eisenstein could capture reality in his camera, but only to reshape it into ideology in his cutting room. Pudovkin heightened reality to increase the emotional impact of the narrative linkage of shots. Eisenstein, Pudovkin, Kuleshov, and their less theoretical contemporaries around the world labored long and hard to construct a metaphorical dimension for the naively "literal" images of their "primitive" predecessors. The enlightened moviegoer could "read" these metaphors in much the same way, or so Eisenstein himself suggested, as this enlightened moviegoer could read a poem by Pushkin. The educated "line" in this era was that the cinema was progressing ever upward toward cultural literacy through its use of metaphorical montage—flying bird evokes human aspiration for liberty, cattle herded to slaughter evoke workers under capitalism, cackling hens evoke gossiping housewives.

Even the influential Scottish filmmaker and esthetician John Grierson, who invented the term "documentary" to describe Flaherty's achievements with *Moana* in 1926 and earlier with *Nanook of the North*, deplored Flaherty's exotic escapism and lack of dynamic intervention to give his material an ideological shape. But something odd was happening amid all the esthetic ferment of the twenties and early thirties. Even as the cinema was supposedly developing in a "dynamic" manner, largely through the refinements of montage, the screen image itself was becoming less ambiguous. It hardly seems necessary to "read" *Potemkin* when its ideology is so clearly and so vividly and so forcefully spelled out. Nor would Eisenstein have considered it desirable for an academic reading to be required for the full comprehension of his spectacle.

Any contemporary "reading" of *Potemkin* would focus not on its

professed ideology, but on the discordance between this professed ideology and the romantic "formalism" of the artist: *vide* the mysteriously expressionist mirror on the Odessa steps. A particularly probing form of psychoanalytical auteurism might concentrate instead on the artist's homosexuality and misogyny. But if we "read" *Potemkin* at all, it is not with Eisenstein's consent, nor in accordance with any of his esthetic testaments. Of course, our contemporary structuralists and semiologists who profess to "read" films as if they were "texts" much prefer to construct "models" of their own analysis from the words they use to describe the "texts" perceived on the screen than to let the film itself shape their analysis. But the signs they seek on the screen must somehow exclude the notion of Sergei Eisenstein's indispensable uniqueness in the filmmaking process. In practice, structuralists and semiologists dispense with biography and historical perspective altogether. There is no room in the "model" for such distracting irrelevancies. What is so appealing about structuralism and semiotics to increasing numbers of academics and their students is that the almost impenetrable jargon of these disciplines makes it possible for its practitioners to postulate answers before asking any questions. Whereas many of the learned film scholars who clustered around Eisenstein's banner in the twenties agitated for the cinema to change the world, the children of Lévi-Strauss and Barthes seek to explain the lack of change in the world by describing the manner in which bourgeois cinema has manipulated the masses.

I stand with an intermediate generation, reacting against Eisensteinian and Griersonian esthetics in the name of a largely unrecognized classical Hollywood cinema, and reacting against structuralism and semiotics in the name of a romantically individualistic auteurism that I still find critically fruitful on the highest levels of direction and creation. The auteurist generation, however, must accept some of the responsibility for opening the cinema up to revisionist analyses through the fifties and sixties. We auteurists were for the most part concerned not so much with "reading" a film as with "reseeing" and "rehearing" it in the process of discovery and rediscovery. We were concerned also with establishing new contexts and new categories by auteur, by genre, by period, and then discovering new cultural associations to describe the ecstasy of our excavations. It occurred to me in this era to rephrase my dislike and distrust of Eisenstein not in terms of realist esthetics, e.g., he "lied" about history, but more in terms of Northrop Frye's insight into genres contained in his observation that we have all been influenced by Homer's *Iliad* to treat the fall of an enemy as a tragic rather than a comic event. By contrast, Eisenstein treats the fall of an enemy in both *Potemkin* and *October* as a comic rather than a tragic event.

My biggest nuts-and-bolts complaint about the semiologists and structuralists who have ventured into film is that they do not seem to have seen enough movies, or at least do not seem to have taken enough movies into account in constructing their "models" of analysis. The celebrated *Cahiers* analysis with all its Marxist grotesqueries about the influences of

the American banking system on John Ford's treatment of the Lincoln legend could have been profitably replaced by an analysis of the very liberal and very reluctant and very neurotic Lincoln on view the year after *Young Mr. Lincoln* in the John Cromwell-Robert Sherwood *Abe Lincoln in Illinois.*

Similarly, Umberto Eco's very witty and graceful piece on *Casablanca* in *Decade* of January 1979 suffers not only from an unmistakable condescension to its subject, but also from a lack of reflection on the full context of the genre to which *Casablanca* belongs.[4] Seeking an explanation for the enduring success of *Casablanca*, Eco develops the idea of a configuration of clichés by which *Casablanca* has remained the archetypal Hollywood Resistance film. Eco's idea is ingenious, but false. *Casablanca* is not the most cliché-ridden of Hollywood Resistance films if only because it contains one gleaming spark of originality, which is one more gleaming spark of originality than any other Hollywood Resistance film can claim. The great art critic Erwin Panofsky spotted this spark when he wrote approvingly of the close-up of the empty bottle of Vichy water hurled in the wastebasket. And what is now the most famous, and most often-quoted line from the movie, more often quoted even than "Here's looking at you, Kid" or "Play it again, Sam"? The line in question is "Round up the usual suspects," and it is uttered not by Humphrey Bogart or Ingrid Bergman or Paul Henreid, but by Claude Rains, that most remarkable of character actors, who here plays a venal, lecherous opportunist, and who undergoes a moral transformation at the last moment comparable to that of Vittorio De Sica's bogus general in Roberto Rosellini's *Il Generale Della Rovere*. What is so remarkable about the Rains characterization is that it was conceived in the Manichean atmosphere of wartime Hollywood. In that same year George Colouris's venal opportunist is killed in cold blood by a very self-righteous "antifascist" played by Paul Lukas in Lillian Hellman's *Watch on the Rhine*. In the political atmosphere of that era *Watch on the Rhine* was considered a more serious film than *Casablanca*, but it was *Casablanca* that was more strikingly original in suggesting that even a collaborator could be spiritually salvaged by the spectacle of a self-sacrificing love. It is this "switch" on the clichés of an overly conventionalized genre that has made *Casablanca* such an authentic classic, and it is switches such as this that have made the American sound film so dangerous for structuralists and semiologists who set out to "read" films without having seen and heard nearly enough of them.

Notes

1. Hugo Münsterberg, *The Film: A Psychological Study* (New York: Dover, 1969).
2. William Everson, *The American Silent Film* (Oxford: Oxford University Press, 1978).
3. Siegfried Kracauer, *From Caligari to Hitler* (Princeton, N. J.: Princeton University Press, 1947).
4. Umberto Eco, *Decade*, January 1979.

19

Dream Gaps in Cinematic Language: Rohmer's *The Marquise of O...* and Resnais's *Providence*

HANNA CHARNEY

In Eric Rohmer's film *The Marquise of O . . .* and in Alain Resnais's film *Providence*, drink, creation, dream, and sleep compose a cinematic theme that includes language in its conception, so that Resnais's writer speaks and speaks, and, in *The Marquise of O . . .* , a highly formal text speaks its splendid prose. In both cases, in a foreign tongue: English in the one, German in the other. "The characters in this script cannot be French. They must speak English," Resnais said.[1] Drink, in *Providence*, is a recurrent sign, announced from the beginning of the film, as the old writer's hand reaches for a bottle, and shattering glass is followed by a loud curse. In *The Marquise of O . . .* , Rohmer introduces the drink motif as the only specific change brought to Heinrich von Kleist's novella.

The main source of Kleist's *The Marquise of O . . .* , Montaigne's essay on drunkenness, might seem to hover over both films. In "De l'Yvrongnerie," Montaigne starts out with a strong condemnation of drink—"Or l'yvrongnerie, entre les autres, me semble un vice grossier et brutal" (Now drunkenness, among the others, seems to me to be a gross and brutal vice), then executes an about-face to end on a eulogy of mad-

ness. Montaigne cites Aristotle on the measure of madness in every excellent soul, a doctrine drawn from Plato's *Ion* and *Timaeus*, and then says:

> Platon argumente ainsi, que la faculté de prophetizer est au dessus de nous; qu'il nous faut estre hors de nous quand nous la traittons: il faut que nostre prudence soit offusquée ou par quelque maladie, ou enlevée de sa place par un ravissement céleste.[2]

> (Plato reasons thus, that the faculty of prophesying is above us; that we must be outside ourselves when we deal with it: our reason [prudence] must be blinded either by sleep or by some illness, or lifted out of its place by a celestial ravishment.)

The essay contains the story of a chaste young widow, who, finding herself pregnant, issues a statement in her church that she would forgive, and marry, if he so wishes, whoever declares himself responsible. A young farmhand claims that he had found her, deep in a drunken sleep, "ayant bien largement prins son vin" (having abundantly partaken of her wine) on a feast day, and that she looked so indecorous that he had taken advantage of her without waking her. "Ils vivent encore mariez ensemble" (They still live married together).

In Kleist, the Marquise simply faints, after the Count rescues her from the brutish soldiers. In Rohmer's film, she is given a potion—an idea which has a vast resonance but which also reestablishes the link with Montaigne. If another, somewhat fanciful excursus may be permitted, we might go one step further into textual recesses: to Plato's *Timaeus*, from which Montaigne quotes. In Montaigne's passage, Plato talks about the liver as the seat of divination, as a "foolish part of man" can sometimes be the seat of wisdom.[3] Whether or not one argues for the bibulous connotations of "liver," the word strikes the note of "foolishness" persuasively and decisively.

Certainly, Resnais's writer is wise in foolish ways—he reverses the traditional father-son conflict, or perhaps continues the comic tradition in which a frivolous father opposes an austere and serious son. The Marquise, on the other side of the generational gap, clashes with her parents through a kind of virtuous ignorance. In another one of Plato's images—from the *Republic* (Book 10) this time—she will eventually cross the River of Forgetfulness and come out whole, avoiding the "two extremes," and, in Plato's words, her "soul will not be defiled."

The main dramatic question, in both films, can be seen against the background of Plato's sequel to the sentence on prophetic truth and inspiration:

> And he who would understand what he remembers to have been said, whether in a dream or when he was awake, by the prophetic

and inspired nature, . . . must first recover his wits. *(Dialogues 2:50)*

It is the recovery of one's wits that may be the central concern in both works, a concern that encompasses memory, forgetting, and action, in their relations to the past, the present, and the future, and also the telling of the tale and the meanings that language is empowered to give it. In both films, language has a literary significance. The text of *Providence* is studded with quotations and allusions (which multiply with the critics' associations too): Graham Greene and Hemingway, who are mentioned specifically, Young, Coleridge, Tourneur, Webster, Pinter, and, of course, Shakespeare.

In Rohmer's *The Marquise of O . . .*, from the first scenes in their neoclassical proportions, with the characters placed in their assigned poses among the high marble columns, it is Kleist's text, literally, that speaks and is allowed to move and play in different dramatic and cinematic forms.[4] Some passages in indirect discourse are shown on the screen; others, direct and indirect, are spoken by the actors. It is as if all the effects of the film breathed through the text. The archaizing style of Kleist's novella introduces another ironic dimension—remove upon remove—as if the hard, high columns of language and visible meaning were but the landmarks in a vast space in which events will unfold through a will of their own.

These events unfold in stately sequences (that have reminded several critics of a Mozart composition, although no music is played) in which images impose themselves in the inevitable colors and designs of paintings. Vincent Canby (in his review of October 18, 1976) speaks of David, "whose 'Madame Récamier' seems to have been the principal inspiration for Nestor Almendros [the director of photography]"; Pierre J. Capretz, in his interview with Rohmer, mentions the treatment of candlelight that is reminiscent of Georges de la Tour.[5] But in that same interview (held on the occasion of the showing of the film at Yale) Rohmer said that the only painting that inspired him directly is Fuseli's *The Nightmare*, not only in the shots in which the Marquise is shown dressed in a white night-gown against a red background during the dreams brought about by the sleeping potion, but in the whole scene, which is not in Kleist.

The nightmare, indeed, seems to start in the opening sequences with the attack of the Russian troops on the Kommandant's castle; it is announced by the words of the Kommandant to his family—"dass er sich nunmehr verhalten würde, als ob sie nicht vorhanden wäre"[6] (that he would henceforth conduct himself as if they did not exist)—words uttered in direct speech in the film. This moment becomes particularly dramatic— it severs the link with the family, the old order, the comfort of organized society and familiar words: fire, flames, and chaos follow immediately.

The Marquise, after her nightmare, recovers from her fainting spell and quickly reaches for social sanity upon learning that her family is safe

and sound. Her most urgent wish is to thank the Russian officer who rescued her from the brutal attacks of the soldiers, the Count who appeared like "ein Engel des Himmels" (an angel from Heaven). This wish recurs with insistence, but circumstances will not allow her to fulfill it at the time. The Marquise still tries to "knit up the ravelled sleeve" of her life, to knit up the fabric of social, philosophical, and emotional customs which have been holding her life together thus far. The attempt is pursued as long as possible as she reintegrates herself into her parents' household with her own children and tells her trusting and trusted mother about the first signs of her pregnancy. But her mother, even though she can accommodate more unsettling thoughts than can her husband the Kommandant, casts her daughter away:

> Julietta! rief die Mutter mit dem lebhaftesten Schmerz. Willst du dich mir entdecken, willst du den Vater mir nennen? Und schien noch zur Versöhnung geneigt. Doch als die Marquise sagte, dass sie wahnsinnig werden würde, sprach die Mutter [. . .]: geh! geh! du bist nichtswürdig! Verflucht sei die Stunde, da ich dich gebar! und verliess das Zimmer. (112)

> (Julietta! cried out the mother in the most vivid pain. Do you want to reveal yourself [uncover, tell the truth] to me, do you want to tell me the father's name? And still seemed inclined to a reconciliation. But when the Marquise said that she would become mad, the mother said: go! go! you are worthless! Cursed be the hour in which I bore you! and left the room.)

"Entdecken" (uncover); "nennen" (name); "wahnsinnig" (mad) strike the notes of the conflict that brings about the clash and the renewed break. If rational causalities and identities cannot be observed, madness prevails and rejection is the only way out. The mother's rejection echoes the Kommandant's initial warning, confirmed by his chasing his daughter away, and is taken up again by the Marquise in her decision to leave, consecrated by a lyrical sentence which is used as a caption in Rohmer's film:

> Durch diese schöne Anstrengung mit sich selbst bekannt gemacht, hob sie sich plötzlich, wie an ihrer eigenen Hand, aus der ganzen Tiefe, in welche das Schicksal sie herabgestürzt hatte, empor. (114)

> (Made known to herself through this beautiful effort, she suddenly raised herself, as if by her own hand, from the whole depth into which fate had precipitated her, and arose.)

Self-knowledge arises from the depths of an acceptance, the acceptance of

conflict, and the acceptance of mystery; it could not be produced by a rational search for cause and effect.

The nightmare was the break. It now turns into the mystery which will give birth to a child, a mystery which will take its course and which no language of rational discourse can elucidate. The scene of the nightmare, the faint, the possible or probable rape is the gap from which the future springs. It is into this crucial scene that Rohmer introduced a change.

Reviewers who tend to disagree on most things—Andrew Sarris, Pauline Kael, John Simon—unanimously take for granted that Rohmer designates the Count as rapist.[7] I cannot concur in this interpretation. Certainly, in her deep slumber on the bed, the Marquise, in the setting and colors that call forth David's painting, is presented as a seductive spectacle. The Count comes by to look; he is framed in an open doorway. In cinematic language this kind of signal could indeed function as a shorthand explanation for an action we never witness. But I do not think that it is meant in this restrictive way here. The ambiguity of these scenes translates the textual ambiguity of Kleist's narrative into cinematic and spatial terms—the openness and accessibility of the place where the Marquise is lying, the silent contemplation in the Count's smiling eyes, the gaps in the cinematic time that follow—all leave the moment open to speculation. Also, an anonymous servant comes to cast a lascivious look. He may or may not be the same person as the young Leopardo who will much later be used by the Marquise's mother to trick her daughter in order to test the truthfulness of her protestations of innocence. Leopardo is a hauntingly ambiguous reminder of Montaigne's farmhand who marries the young widow.

This openness in the film corresponds to a passage in Kleist which, on first reading, seems to have no ambiguity at all: the Count hits the last remaining brute in the face with the handle of his sword and escorts the Marquise politely to a wing of the palace,

> wo sie auch völlig bewusstlos niedersank. Hier—traf er, da bald darauf ihre erschrockenen Frauen erschienen, Anstalten, einen Arzt zu rufen; versicherte, indem er sich den Hut aufsetzte, dass sie sich bald erholen würde; und kehrte in den Kampf zurück. (95)

> (where she sank down completely unconscious. Here—he made arrangements, since soon after her frightened women appeared, to call a doctor; assured them, while putting on his hat, that she would soon recover; and returned to the battle.)

If there is a gap, it must be inferred negatively: through the dash after "hier"[8] and the adverb "bald darauf" (soon after). The scenes of the film seem to work around these two ambiguously used adverbs, "here" and "soon after."

The modification that Rohmer made, the drinking of the sleeping potion, plunges the Marquise into "die ganze Tiefe" (the whole depth), from whence she rises above herself—and there is a rising motion when the Marquise sets out in a carriage with her children, as we read on the screen about her decision and her elevation. But the nightmarish images, events, and scenes remain as real as any truth. What has happened has happened. The mystery is never unveiled by words, which turn around it in widening dramatic circles.

The mystery remains the start of a dialectical movement which transcends its oppositions to produce a third term. The "awesome third," the third of the month when the father of the Marquise's child is asked to declare himself, may announce a third incarnation of the Count. First, he is angel; as such he dies—he is reported dead, only to reappear to the utter astonishment of the Kommandant's family—in a disappearance that seems to parallel the Marquise's faint and deep sleep. Then he becomes a devil in the Marquise's eyes: paradoxically, she could accept anyone but him as her child's father, but also she could accept no one but him. Only after he becomes—existentially and through the legal responsibilities that he takes upon himself—the father de facto will he slowly become a real husband and father again. This turning of the events and meanings towards the future also corresponds to the time it takes for these transformations. They do not take place overnight after a dream-filled sleep which interprets a past that can be reinterpreted the next day.

Another transformation and another conflict have to be lived through before the Count can become husband and father. The Kommandant has to relinquish his incestuous hold on his daughter. After the reconciliation scene between father and daughter—a scene in the film which, for unfathomable reasons, some reviewers did not find explicit enough—the Kommandant, solemn and somewhat withdrawn, hands his daughter over to the future.

Providence is turned mostly to the past. The future figures as an ironic sequel in the last shots of the film, where a quickly waning sunlight fills the screen and cheerful family harmony and social order prevail as if to belie the long nightmare that preceded. But most of the narrative is framed by the first dream scene, set at the start: the dark, Gothic house with a yellow light burning in a window, signaling the insomniac writer's battle with the night; alluding perhaps, as has been suggested, to H. P. Lovecraft, "sick and confined to his room," as Beylie said, in Providence, Rhode Island.[9]

Resnais, according to Gaston Bounoure, is obsessed with the oneiric,

> which in his case always shows a simple thought, proceeding first by associations of images, by sensorial breaks. . . . As in these violent alternations of shadows and lights As in these abrupt passages from the colors of the present to the grey of the past.[10]

In *Providence*, black and white, mellow dark colors, chiaroscuro, and especially a blue light pervade the mood until the last scenes in the garden outside the house. Partly open windows, a polished staircase, geometric forms in a room, further define a claustrophobic space in which phobic themes play themselves out. The father's antagonism and resentment towards his children, especially towards his barrister-son, Claud, are contrapuntal with his fight for life. Drink is the father-writer's paradoxical affirmation of selfhood, authority, and independence. Its ambivalence is characteristic. The white wine that Clive regularly pours himself may seem like a parody of creative madness as it gives rise to dreams and fantasies—for instance, about the old man-beast or wolf-man killed by the good son or some such figure; it is a self-chosen, hedonistic weapon, which blurs the edges of conscious memory and yet evokes memory on its own terms and in its own forms. The protagonist sees pain also as a reminder of mortality as well as affirmation and life.

Clive Langham's children move in a black-and-white world of hard, opposed, and opposing values which threaten the father's painfully comforting world of bed, bottle, and words. Just as they cut dry bread on a wooden board, they speak dry words in often monosyllabic utterances. Are they the stuff that dreams are made of? They are, of course, in the sense that they are the projections of the writer's closed view, the figures on the stage of his mind. And they also dream, in a way that echoes and mirrors the father's. In the bread-cutting scene in the kitchen at night, Claud speaks about waking and dreaming:

> SONIA. Avec toi . . . non, je ne dirais pas que j'ai connu
> l'ennui . . . mais je me suis fait transparente, oui . . .
> CLAUD. Au réveil . . . après un rêve . . .
> SONIA. Je m'en suis remise à toi.
> CLAUD. Je ressens une profonde tristesse . . .
> SONIA. Je m'en remets toujours à toi.
> CLAUD. . . . comme si le songe était la vraie vie.
> SONIA. . . . je suis une vue de l'esprit . . . de *ton* esprit![11]
>
> (SONIA. With you . . . no, I wouldn't say that I have known
> boredom . . . but I have made myself transparent, yes . . .
> CLAUD. On waking . . . after a dream . . .
> SONIA. I trusted you.
> CLAUD. I feel a deep sadness . . .
> SONIA. I still trust you.
> CLAUD. . . . as if dream were really life.
> SONIA. . . . I am a view of the mind . . . of *your* mind!)

Claud recalls the "intensity" of dream, an intensity which further isolates him from his wife in this dialogue, and which in turn reflects Clive's intense isolation as well as his creation of Claud as a view of *his* mind.

The characters, in a space confined and limited to himself, describe the meanings assigned to them by their author, their progenitor.

Clive's projected novel is a play of the imagination, just as *Providence* was conceived, in Resnais's words, as "un grand jeu de l'imaginaire."[12] Imagination is a key word in Resnais. In answer to several interviewers (much before the work on *Providence*) he indicated his preference for the word "imaginaire" or the word "conscience" to "mémoire," which has seemed to many critics as the crucial theme in many of his films.

> J'ai toujours protesté contre le mot "mémoire," mais pas contre le mot "imaginaire," ni contre le mot "conscience." L'imaginaire joue un rôle considérable dans notre vie. Il me paraît, dans tous les cas, un sujet idéal pour le cinéma.[13]
>
> (I have always protested against the word "memory," but not against the word "imaginary," nor against the word "consciousness." The imaginary plays a considerable part in our lives. It appears to me, in any case, as an ideal subject for cinema.)

Also: "Plutôt que d'oubli et de mémoire, je préfère parler de conscience et d'inconscience"[14] (Rather than about forgetting and memory, I prefer to speak about consciousness and the unconscious). But the "imaginaire" can be banal, Resnais says; it can be "beneath reality."[15] Presumably, it can also have varying relations to truth and dream.

In *Hiroshima mon amour*, for example, where forgetting and remembrance are so splendidly orchestrated, the modulations and variations of "lived memory" are constantly brought into play. Forgetting is necessary, said Resnais—"si on n'oublie pas, on ne peut ni vivre, ni agir"[16] (if one doesn't forget, one can neither live nor act)—and he may have thought so in *Hiroshima*, but remembering, there, becomes crucial too with its concomitant obligations to the truth of experience, no matter how compromised.

In *Providence*, by contrast, Clive does not seem to forget, nor, particularly, to remember. By that I mean that he brings forth memories, summons up characters—his other, illegitimate son, his own wife, Molly, who committed suicide—makes interpretations and judgments or leaves them out, refreshes himself with scenes of champagne and pink shrimp on the Riviera, apparently according to his whim and in a mode of consciousness dulled by drink which functions as a repeated reminder of his attenuated awareness. Consciousness is echoed by insomnia, which makes dreaming impossible. But the sleep that Clive longs for is again paradoxically related to his will. What he hankers for, is it not the "Sleep that knits up the ravelled sleeve of care"? That is, does he not want to weave the uninterrupted fabric of his fabrications? The film presents the process of fictional creation, as has been pointed out; but it is a process that blurs and slurs the demands of dream and imagination just as the wine blurs and slurs consciousness.

Providence tells the story that the writer tells, a story held together by his narrative voice, which runs through the film (until the last scenes) in its theatrical, eloquent, grandiloquent, defensive, and accusatory tones. Clive speaks omnipresently. He speaks the language of Shakespeare but through Gielgud's glorious voice of the novelist enunciating David Mercer's text; so that the language distances the work, but is forced through a narrow personal channel. At the end, the narrative voice stops: presumably the nightmare of Clive's hostile view is over. This does not occur through any transformation but really through sleight-of-hand. A sudden change of perspective ironically restores natural colors to reality, showing the rest of the film for what it was: a bad dream, in the sense of an illusion, a deception, an artifice of the imagination.

The two main problems in Clive's life that are alluded to are never fully confronted: his relation to Molly, who killed herself, and his relation to his son Claud. An incestuous motif appears—the actress who plays Clive's wife Molly (Elaine Stritch) also plays Claud's mistress—but the conflict seems to be presented in a narrow range with questions of power and authority reducing the emotional charge. It seems to indicate that in Clive's eyes the only real wife-woman figure is his own—so that in the last scenes in the garden his daughter-in-law acts as a pleasantly harmless and solicitous daughter, even though the conjugal relation of the children is emphasized in words.

Words, words, words seem indeed to be the main problem of *Providence.* Molly Haskell says:

> It's interesting that the so-called dream imagery of modern cinema . . . bears so little resemblance to real dreams. . . . The images in Mercer's screenplay seem to spring neither from his own brain nor that of his central character, but secondhand, from the stockpile of British modernist drama.[17]

This judgment, which does deal with a central issue, is nevertheless, I believe, too harsh. If we take the film at its word, and do take Clive's dreams as they are given, they constitute an old-fashioned narrative with a carefully established "point of view." Molly Haskell raises the same question as do some other reviewers—are Resnais and David Mercer deliberately presenting a parody of a writer? They decline to answer, and rightly so. Authorial intention can hardly be the crux of the matter. *Providence* seems to point to the powerlessness of power, and the inadequacy of words handled by an ironically omnipotent, "provident" voice.

Did Resnais really dream of making a film in Providence, Rhode Island—perhaps about Lovecraft or, as has been suggested, about Jean Ray, the Belgian author of *Le Temple de Fer?* Could then the title of his film be a covert reference to this unrealized dream? If so, could we take it as an intertextual promise that Resnais might go on, from the interesting failure of *Providence,* to a work where the wisdom of the past,

seated in whatever Platonic organ, will meet, as Montaigne says, "la faculté de prophetizer"?

At any rate, we are glad to see the writer survive—one critic thought it highly moving to see Clive at the end of the film, dressed in his elegant light suit, reclining in his garden chair—even if his strength is as reduced as his authenticity. And here, he sips a drink again. But, unlike the Marquise, he has never drunk deep. He has lost his power to dream; he speaks too much. Perhaps he is Resnais's counterpart of The Man Who Knew Too Much, the man who knew too much and knew too little, who, in any case, was not able to heed Pope's counsel:

> A little learning is a dangerous thing;
> Drink deep, or taste not the Pierian spring:
> There shallow draughts intoxicate the brain,
> And drinking largely sobers us again.
>
> *(Essay on Criticism)*

Notes

1. Interview with Rex Reed *(Sunday News,* "Leisure" section, August 8, 1976).

2. Michel de Montaigne, *Essais* (Paris: Gallimard, Bibliothèque de la Pléiade, 1950), p. 385.

3. *The Dialogues of Plato,* trans. B. Jowett, 2 vols. (New York: Random House, 1937), 2:50.

4. This literalness can be interpreted in opposite ways. Professor Dorrit Cohn, in a brilliant and spirited attack on Rohmer (in a lecture delivered at the Kleist Centennial Conference at Dartmouth College, Fall 1977) accused the filmmaker of being too faithful to the letter of Kleist's novella and of having "greatly transformed its spirit."

5. Pierre J. Capretz, "Eric Rohmer et *La Marquise d'O . . . :* Ironie et sentiment," *The French Review* (April 1977), vol. 50, no. J.

6. Heinrich von Kleist, *Die Marquise von O . . . ,* in *Erzählungen* (München: Deutscher Taschenbuch Verlag, 1970), p. 94. Subsequent references to pages in this edition are given in the text. The translations are my own.

7. Dorrit Cohn also finds that Rohmer, after removing the "depth-psychology" of the moment, "pointedly indicates premeditation on the Graf's part."

8. This dash, "surely the most pregnant graphic sign in German literature," is the starting point of Dorrit Cohn's discussion in "Kleist's 'Marquise von O . . . ': The Problem of Knowledge" *(Monatshefte,* 1975, 67 [21]), a richly suggestive study of conscious and unconscious knowledge in Kleist's novella far beyond the scope of the present remarks.

9. Claude Beylie, "Racines et ramifications de *Providence,*" *L'Avant-scène* (Nov. 1, 1977).

10. Gaston Bounoure, *Alain Resnais* (Paris: Seghers, 1962), p. 33. The translation is mine.

11. Beylie, "Racines et ramifications."

12. Resnais, interview with Claude Beylie, *Ecran* (Feb. 15, 1977), 77.

13. Resnais, interview with Robert Benayoun, Michel Ciment, and Jean-Louis Pays, *Positif* (Oct. 1966), no. 79.

14. Resnais, interview with Claude Edelman, *Arts* (March 20, 1963).

15. Resnais, interview with Benayoun et al.

16. Resnais, interview with Sylvain Roumette, *Clartés* (Feb. 1961), no. 33.

17. In *The Village Voice* (Feb. 7, 1977).

20

Contours, Fragments, Gaps: The World of Marguerite Duras

GERMAINE BRÉE

"On va mourir ainsi d'avoir oublié morceau par morceau, temps par temps, nom par nom, la mort.

Marguerite Duras

What we cannot speak about, we must pass over in silence.

Wittgenstein

What representation can one give of a 3 dim'l space in a 4 dim'l continuum?

Marcel Duchamp

"We hesitated to publish these conversations in this state. We know that we are taking a risk in leaving them exactly as they were said. They are teeming with repetitions, detours, unfinished sentences left dangling or picked up later in another mode, another tone, and gaps." So Xavière Gauthier describes her five interviews with Marguerite Duras, and justifies

the decision not to edit the script in any manner: to edit the script "would have been an act of censorship which would have masked what is probably the essential; what one hears in the many silences, what can be read in what has not been said, what was being interwoven unbeknownst to us The essential, what we did not intend to say, but which was said without our knowing it, in the lapses, in clear, limpid and facile words, in all the slips of the tongue."[1]

Les Parleuses (The Speakers) is not, I think, the best introduction to Marguerite Duras's work but it does stress one of her most characteristic traits: the increasingly bold esthetic use she makes of the sudden "faults," —breaks in level—of the blanks and discontinuities embedded in everyday discourse. Her revolt against syntax is well known. Indeed, often her principal characters themselves have dropped out of the "normal" train of everyday life: as Duras puts it, a link has broken in that chain. Discontinuity and heterogeneity fragment the homogeneity and continuity of the characters' inner time and space. The narrative progresses uncertainly toward regions no longer bounded by the stable constructs of a coherent literary language, with its "security of a carefully circumscribed story" which, having had a beginning, "moves with certainty toward the pleasure of an ending, even an unhappy one."[2] "Territories of the feminine" these Duras regions have been called. However that may be, this is unmistakably Durassian territory, with its own recurrent topography, its toponymies, whether real or imagined, and the recurrent "hiatus," as Duras calls it, the opening through which they flow into and emphasize the gaps in the disjunctive language of the text. It is the infrastructures of fiction that Duras more and more determinedly attempts to undermine.

Spoken language, as transcribed in *Les Parleuses*, with its breaks and inconsistences, its anacolutha and penchant for parataxis, its slippages and elusive contexts, has been widely used by writers intent on breaking away from the representations and fictions of the "literary." But, in the case of Marguerite Duras, such usage is only the surface manifestation of deeper crumblings and cracks within the narrative structure, as illustrated by her conception of the "characters" themselves—of their relations with each other, with the reader-spectator, and with the world they disclose. There is no other writer today whose fictional creations so consistently lure the reader into a space of their own, a space whose contours are perceived only dimly and fragmentarily through the encounters of the personae who enter it and the often enigmatic words they exchange. As has Beckett, Duras has given herself the paradoxical task of giving the incoherent a literary form.

Toward that end, Marguerite Duras has been progressively shaping her narrative techniques for close to forty years. From the first traditionally realistic novels to her latest "text-theater-film" scripts, she has persistently carried out a revolution not so much in the elements of her narrative fiction as in the manner in which she links these elements to one another. One of the most characteristic features of her writing is the

fascination certain of her personae hold for her: she works and reworks the fictional material they secrete. She does not progress by what has been called "surrealistic house razing,"[3] but rather, as she herself describes it, by an exploratory penetration into a territory glimpsed in the interstices of a previous narrative and lost in its penumbra. What haunts the reader is the recurrence of certain personae, "magically" named, moving within spatially separate, more-or-less distinct configurations, from which they are both absent and undetachable. The spatial configurations, like layers deposited by time, vaguely refer us to an underlying, shifting, fading topography, a continuum, yet one riddled with gaps and breaks. For instance, it is in the interstices of S. Tahla, the seaside resort, that Anne-Marie Stretter, "the woman in black," first appears; it is in the setting of *The Ravishing of Lol V. Stein* (1964) that the S. Thala of *L'Amour* (1971) appears: the strangely deserted stretch of sand, bordered by an ocean, a river, a phantasmal resort town, along which a "woman in black" endlessly paces.

L'Amour, Duras tells us, "fait partie de," i. e., is an integral part of *Lol V. Stein*. But S. Thala and the "woman in black" are also part of the film *La Femme du Gange* (1973—The Woman of the Ganges). And so through great gaps in the reader's blurred memory, these earlier texts come to rejoin the delta of the Ganges. The silhouettes of Lol V. Stein and Anne-Marie Stretter haunt a similar yet different setting of sea, river, river mouth, beach and island or headland: a fragment of what continent? on the border of what beyond? But within the fictional world of Duras's separate novels, after their brief initial encounter in the novel *Lol V. Stein*, the two women never actually meet again. The space in which they dwell, the reader's memory (the author's too perhaps), unlike the separate books they occupy, is porous and not compartmentalized. Just as S. Tahla, for instance, becomes S. Thala, a fragmented and slightly uncertain toponym through the gaps of which Duras finally discerns a forgotten "Thalassa," so the figures may appear together in memory out of the void of oblivion. At the end of *Lol V. Stein*, the narrator speaks of the story, and Lol with it, as "engulfed," erased, ended. Yet this is a statement that the writing of *L'Amour* qualifies. For there it seems Lol reappears; the story of Lol V. Stein is also a fragment of another story, that of Anne-Marie Stretter. She too leads another life, a fragmented life, in the memory of Duras's readers. Curiously, in Duras's own memory, Lol V. Stein so "prostituted," that is, belonging to any and all, is a remote figure: "I can only show her hidden, when she is like a dead dog on the beach, covered with sand."[4]

Duras is a rarity among fiction writers in France today in that her own existence is deeply intertwined with that of her characters, at least with those whom she loves, "deeply loves," like Lol V. Stein[5]. Another such, even more central, is Anne-Marie Stretter, who is inextricably linked to the event that propelled Lol V. Stein into the space of Duras's fiction, the ball at S. Tahla. Anne-Marie Stretter's wanderings from book to book

and from book to film belong to one of the more enigmatic of those fictional regions that have emerged progressively in Duras's writing over the years, like lost pieces of a never-completed puzzle. Anne-Marie Stretter dominates a famous quintet of narrative and films—*Lol V. Stein, The Vice-Consul, La Femme du Gange, Son nom de Venise dans Calcutta désert* (Her Venice Name in the Desert of Calcutta) and *India Song* Written or filmed between 1964 and 1976, they spiral back to the poverty-stricken childhood Duras lived at Phnom Penh, Sadec, and Vinhlong in Cochin China. There her "Ganges" was the Mekong River. The vague contours of an occulted region sustain the tensions in each story. The narrative structures seem to circumscribe and straddle a psychic gap whose two "edges," so to speak, the Oriental and the Occidental, never quite manage to fit together. The developing situations pertain to different layers of Duras's own developing and often puzzled understanding of her activity as writer. That development is inscribed in the formal character-istics of each narrative; and it determines what the characters and the world they inhabit become from story to story. No other fate or pre-ordained design connects the "woman in black" of *L'Amour* to Lol V. Stein, or indeed to Anne-Marie Stretter. A peculiar time mode emerges, a fluid architecture which, paradoxically, opens up spatial dimensions like unexpected vistas beyond and between the separate pieces. Between 1943, the date of her first novel, and 1980, Duras's narrative techniques have changed drastically and often. The total field of significance of the work, however, seems to be taking shape only very gradually. One accedes to it by gradients, as it were, and from different angles. It requires that we, as readers, undertake a form of internal migration to Duras's hidden Orient.

 India Song was written in 1972 for the London National Theatre and published in 1973, then filmed by Duras in 1975. At this writing it has been followed by only three other texts: *Le Camion, L'Eden Cinéma* and *Le Navire Night.* Of these three, *L'Eden Cinéma* is a dramatic version of the early novel *Barrage against the Pacific.* *Le Camion* and *Le Navire Night* are quite definitely film scenarios. I shall consider *India Song* as the last of Duras's narrative fictions to date. It is related to the two earlier narratives, *Lol V. Stein* and *The Vice Consul,* which it absorbs into its own time-space continuum. The film, like the narrative itself, is, in my opinion, one of Duras' most successful ventures. I shall refer to it only incidentally as one can hardly discuss a film adequately from memory. I take both narrative and film to be a culmination of her previous work. *India Song* marks a major change in Duras's narrative techniques: the suc-cessful displacement of the narrative from its adherence to the two-dimensional page and the linearity of the book, as well as its total detach-ment from the mimetic. More striking still is the fragmentation of the narrative voice.
 It was, Duras notes, through her experience in the filming of *La*

Femme du Gange, carried on at approximately the same time, that she discovered by what "means" to "penetrate and uncover an unexplored region" of *The Vice-Consul;* in addition, and more important, how to let anonymous memories, other than the author's own, draw the narrative out of the void and on to the page. The locus of the narrative and its enactment are relayed to the reader through a variety of "voices." The book is divided into five parts. In part 1 two young female voices slowly begin to tell the story of the lovers of the Ganges—Anne-Marie Stretter and Michael Richardson; their story intersects with that of Anne-Marie Stretter's encounter with the Vice-Consul and her subsequent death. The two female voices are linked by their own shared love story. Sometimes they speak of that deeply felt love, theirs. Most of the time they speak of "that other love, that other story" (10). In parts 3, 4, and 5, two male voices relay the female voices, then mingle briefly with them; through them the "end" of the story unfolds, the end that was already there at the beginning:

> VOICE 2. After her death, he left India. . . . Her grave is in the English cemetery. . . . *(pause)*
> VOICE 1. Died over there?
> VOICE 2. In the islands. *(hesitation)* Found dead. One night. *(silence)* (17 and 109)

So framed, part 2, almost entirely narrated in dialogue form by the fictional characters in *Le Vice-Consul*, is the replay, condensed and altered, of the central incident of that novel: the reception at the French embassy in Calcutta, where the encounter of Anne-Marie Stretter with the Vice-Consul takes place. In *India Song* another narrating voice is heard throughout, an objective "camera-eye" voice giving form to the spatial setting, the silhouettes and scenes to which the dialogues refer. During part 2 the voices are mute as the scene, dimly discerned through the words of the dialogue, becomes autonomous, peopled with the characters at the embassy ball.

Technically, then, the story is given as though through many memories. Some, like the first voices, are quite distant, situated "elsewhere" in time, in space; others, like the male voices, are more closely in touch, it would seem, with the events and the society that witnessed those events, which at the core reflect an already fictionalized world. *Through* the voices, as well as through the central reenacted scene, we, like the voices, "see" fragments of the tale reenacted. Past episodes of that tale presumably live in the reader's more-or-less awakened memory along with other fragments. Gaps have opened in the older text, and new articulations suggest new networks of connections. A kind of "sacred legend" is being ritually "recited" and reconstituted, from differing perspectives. Between what really happened and its verbal reactualizations there is a solution of continuity. The characters, their acts, and their

world are removed from the historical reality in which they seemed to be existentially involved—India in the thirties—and are "relocated" within a different spatial and temporal scheme. *India Song* then functions as a form of anamnesis. "The story of that love, the voices have known or read it, long ago. Some remember it better than others. But none remembers it completely nor has anyone completely forgotten it" (146). We are in the world of myth. It is the locus that Anne-Marie Stretter, Michael Richardson, the Vice-Consul of France in Lahore now inhabit somewhere behind the polyphonic "variations" on their story.

What then is the story? "It's the story of a love, lived in India during the thirties in an overpopulated city on the banks of the Ganges" (147). "A love story immobilized at the culmination of passion. Surrounding it, another story, of horror—of famine and leprosy mingling in the pestilential humidity of the monsoon—immobilized too in a daily paroxysm" (book jacket). There are in fact several axes to this story, several planes. They all pass through the absent figure of the woman "dressed in black," Anne-Marie Stretter, dead how long ago?

There is first the mythical topography that connects that lonely landmark—the tomb of Anne-Marie Stretter in the English cemetery on an island in one of the loops of the Ganges—to that other fabulous territory, S. Thala—situated where? Perhaps on some European coast. The voices recite the litany—imagined?—of Anne-Marie Stretter's wanderings before her passage through S. Thala.

> You find her in Pekin
> Then in Mandalay
> In Bangkok
> You find her in Bangkok
> In Rangoon. In Sydney
> You find her in Lahore
> Seventeen years. (43)

A fragmentary topography-chronology is uncovered: Venice, first, the point of departure of she who was once Anne-Marie Guardi; then Savannakhet, Laos, "married to a French colonial administrator"; then an elopement with Mr. Stretter, a French secretary of state; then the seventeen years' passage through the Asiatic capitals of southeast Asia; now the embassy in Calcutta, Bengal: locus of her death. She was eighteen, we learn, when she married; seventeen years a diplomat's wife, with a gap —how long?—in between. Anne-Marie Stretter was probably in her late thirties when she died, consumed by what? Passion. Four crucial "stations" mark that life: first Venice, the world of "music" and of her adolescence, then Savannakhet:

> VOICE 1. From Venice. She was from Venice.
> VOICE 2. Yes. Music, that was Venice

A hope of music.
Then Savannakhet on the banks of the Mekong.
VOICE 1 *(remembering)*. A yes . . . a river . . .
. . . she is sitting facing a river.
Already . . .
She is looking at it.
VOICE 2. The Mekong.
VOICE 1 *(after a pause)*. She is silent?
Crying?
VOICE 2. Yes. People say: "She cannot become acclimatized,
they'll have to send her back to Europe." (40, 41)

Third, S. Thala, where the fatal meeting with Michael Richardson took place that has brought him to Calcutta. And finally the embassy in Calcutta where the last act is played out.

Three axes connect this mythical topography to the three characters who share one aspect of what we might call the "passion" of Anne-Marie Stretter. The first is the most immediately obvious, the Calcutta-S. Thala axis, the axis of a passion that unites Anne-Marie Stretter to Michael Richardson. It is the story of the amnesia that this passion caused in Michael Richardson, and which erased and destroyed his fiancee Lol V. Stein. It treats a legendary theme of the Occidental world. The story of the "lovers of the Ganges" coalesces with that of other celebrated couples, the "lovers of Venice" or, more pertinently, the "lovers of Verona." But it concerns more than a couple; a "crime" the voices call it: the destruction of the world of secure convention which S. Tahla seemed to represent. Anne-Marie Stretter lives in an absolute; beyond convention.

The other axis is the Venice-Lahore-Calcutta axis that tells of the passion of absolute despair that overwhelms the Vice-Consul of Lahore, the man who, like Anne-Marie Stretter, "cannot bear" the horror of the human misery that surrounds the closed parks of the European enclave. But whereas she lets the misery flow through her like the river itself, the Vice-Consul seeks a double and violent destruction—his own and that of the lepers.

The third axis leads from Savannakhet to Calcutta. It connects Anne-Marie Stretter to the young beggar woman from Laos whose song, now called "le chant de Savannakhet," had already been heard throughout *The Vice-Consul*. To these three planes belong the three musical themes that blend with the emerging story: the fourteenth variation of Beethoven's "Variations on a theme by Diabelli"; *India Song*—the "blues" that had haunted the Vice-Consul since his childhood; and the beggar-woman's "song of Savannakhet," called in the earlier novel "Battamberg" and sung in a language only Anne-Marie Stretter understands.

Michael Richardson, the Vice-Consul, the beggar-woman who haunts the park of the embassy, Anne-Marie Stretter—all are strangers to the social life of their community, to the official ball with its sentimental

waltzes and tangos. Michael Richardson is self-excluded from S. Tahla; the Vice-Consul is estranged from his own life by the suffering he cannot share. In the extremity of his despair he shoots at the lepers who crowd around his official residence in Lahore and at his own image in the mirror. The beggar-woman is the stranger par excellence, who had been chased from her village when only a child because she was pregnant. The voices recall her legend too: the prostitution, the twelve children abandoned on the way, the ten years of wandering that ended in Calcutta. All four of these characters have been "dislodged" by desire, by passion, or by necessity from the secure precincts of social life. Thence the fascination their stories exercise over the imagination of the "voices," the onlookers and readers. Thence the "danger" that accompanies the fascination.

But the main theme of *India Song* is Calcutta: "the world focus of absurdity; the central furnace of absurdity, that insane agglomeration of hunger, illogical famine."[6] This is the reality that seeps through the railings of the parks and dismantles the structures erected by the whites. It consumes Anne-Marie Stretter who finally abandons herself to the rising tide of the delta and to the oblivion to which it relegates individual lives. "I don't know if it is suicide . . . she goes back to the Indian Ocean, as to a kind of elemental matrix. . . . She cannot live elsewhere and she lives through that place, she lives off the despair that India, Calcutta, secrete daily and she dies of it, she dies as though poisoned by India."[7] Here the voice of Marguerite Duras mingles with the "voices" of the text, opening yet another fragmentary perspective upon the legendary. The traditional love story, the story of individual passion on the model of Tristan and Isolda, simply dissolves.

Structurally, as in the earlier *Détruire*, the story is made up of people watching others and one another. But, as I have noted, the position of the watchers in time and space and the intensity and nature of their attention are variable. The central and absent trio can inspire in the watchers different forms of desire: from the passionate absorption of Voice 1 to the anguish of Voice 4. Not only does the story of Anne-Marie Stretter relate a "gesta" already present in the familiar love-death myth of Western imagination; it also aims at something beyond, at the ultimate destruction of that myth. To this the voices are not attuned. It is still the myth of love they recapitulate. Duras however is not writing about love but about elemental human suffering, the overwhelming presence that submerges, fascinates, and destroys.

Anne-Marie Stretter is a figure who belongs not only to fiction but to a deep layer of Duras's childhood:

> I lived a long time at Sadec and Vinh-Long. . . . Yes, on the Mekong. Those are white districts, districts with perpendicular gardens, railings, then the river, the French club; the tennis courts, and Anne-Marie Stretter, I think, yes, at Vinh-Long, the

wife of the French administrator. . . . I'm not sure that it wasn't her real name, Stretter; I don't think I invented that name. . . . She was a red-haired woman, I remember, who did not use makeup, who was very pale, very white, and who had two little girls. . . . I never spoke to her. . . . It's very far away. . . . A short while after her arrival we learned that a young man had committed suicide out of love for her, for love of her.[8]

The shock, Duras notes, was overwhelming, because the woman appeared so ordinary, so quiet, that she seemed to the young girl to incarnate two incompatible powers: the power to give death; the power to live an everyday life. "Sometimes I tell myself I wrote because of her."

This fragmented semi-imaginary figure—death-giving and quietly quotidian—exercised its fascination over Duras's imagination, inspiring a deep "love." In her recollections Duras speaks of this administrator's wife as having become for her the archetypal woman. She was both herself and an endless figure: doubly silent, first in the distance of memory and again in the greater distance of the timeless; "the fascination still lasts . . . it is a real love story." To transpose it into fiction is to destroy it, to "prostitute" that love, as Duras puts it. But, realized in book and film, the "fictional love-story" is transmuted into another. The old theme of love and death is absorbed into another, for the figure of Anne-Marie Stretter cannot be dissociated from other fragments of experience that inhabit Duras's memory. These are related to the tropical world of her Vietnamese childhood, with its terrors—particularly the fear of the Pacific tides—and the poverty shared with roaming bands of ill-fed children. Like the beggar-woman's monody, the child's life was free from the searing knowledge that destroys the Vice-Consul. *India Song* has deep roots in the realm of Duras's unconscious memories, fragmentary memories of a kind of primeval freedom and disorder. Anne-Marie Stretter is a heraldic figure of disorder, a passionately desired primal disorder.

India Song relates a tale that does away with the story as romance. Romance is effaced along with Anne-Marie Stretter's "hope" in music but still echoes in the name "Venice." "I think," says Duras, speaking of *India Song*, "of our disappearance, of the disappearance of Europe, it is not only the death of the story which is inscribed in *India Song*, told in *India Song*, it is the death of our history."[9] Leprosy and hunger are already seeping through the stories' decaying structures: the end towards which Europeans are wandering, in Duras's terms, would be a rendezvous with the beggar-woman in the reality of the leprosy-ridden Calcutta. Behind our railings it is we who, like the guests at the French embassy, are becoming fictional. Only Anne-Marie Stretter can meet the beggar-woman's gaze steadfastly: for she is dead.

What, then, is the nature of *India Song?* I should be tempted to call it "an extant part of a lost text, a fragmented text," if one gives credence

to Duras's comments upon it; and that is itself the definition of a receding myth.

From the critic's point of view, what is most interesting perhaps is that, helped by her experience with the screen, Duras has devised for *India Song* narrative techniques that give a segment of her work the dimension of myth. All the processes of fictionalization are put to work in *India Song:* former stories are drawn together, melded in a unity of tone, without recourse to the "security" of a carefully circumscribed point of view or coherent development. It is the "song of Savannakhet" that most closely parallels that sustained tone. The poetic imagination at work here has affinities with the ritualized world of myth and memory, the world of a Gérard de Nerval. *India Song* is the destruction and partial redemption, through the dream-figure of the dead Anne-Marie Stretter, that cousin to Nerval's Aurélia or Sylvie, of an obsessional inner world that cannot be abolished. And, as with other Duras stories, its strange and disruptive elements—unspoken or only semiarticulated—keep the reader or spectator in a state of acute unease and esthetic fascination.

Notes

1. Robert Henkels, Jr., *Robert Pinget* (University, Ala.: University of Alabama Press, 1979), p. 9.
2. Marguerite Duras, *Les Lieux de Marguerite Duras* (Paris: Editions de Minuit, 1976), p. 100.
3. Ibid., p. 91
4. Duras, *India Song* (Paris: Gallimard, 1973), p. 43. Subsequent references to pages in this edition are given in the text.
5. *Les Lieux de Marguerite Duras*, p. 177.
6. Ibid., p. 78.
7. Ibid., pp. 63-65.
8. Ibid., p. 78.
9. On the problem of "distancing" in narrative fiction see David Hayman, "Double-distancing: An Attribute of the 'Post-modern' Avant-garde," in *Novel* (Fall 1978), 12 (1):33-47.

PART 7

TEXTS
AND
DOCUMENTS

21

An Interview with Jasper Johns

ROBERTA BERNSTEIN

Introduction

Throughout his career, Jasper Johns has used found objects, signs and patterns taken out of their original environment, and brought them into the context of the work of art. As a result, each of his works suggests that we are seeing fragments of experience transformed into something with a unity and completeness of their own.

In the following interview, Johns discusses the idea of the fragment and how it appears in his work. The conversation focuses on Johns's use of fragmented images of the human figure and the fragmented, discontinuous composition and structure of most of his works since 1960. I will briefly introduce Johns's remarks by presenting some general thoughts on the role of the fragment in his art and describing specific works he mentions.

Although Johns is known primarily for his paintings and sculptures of flags, numbers, lightbulbs, and other common objects and signs, the human figure has also been an important subject for him, from his earliest

known works (1954-55) to the present. His figures are presented most often in the form of casts and imprints. They never appear whole, always as fragments, and their identities and meanings are usually left ambiguous. Johns's figures appear as plaster casts of anatomical parts in his first Target paintings from 1955. *Target with Plaster Casts* is a large construction with a red, yellow, and blue target image painted in encaustic and collage. Above the target is a row of nine boxes with hinged wooden lids, each painted a different color. Seven boxes contain plaster casts of parts of the human body painted the same color as the boxes in which they are placed: a purple foot, white face, red hand, pink breast, orange ear, green penis, and yellow heel. There is also a black box with a bone and an empty blue box. In *Target with Four Faces*, done shortly after, Johns places four almost identical plaster casts of faces in boxes with a single lid. The casts, painted orange, are incomplete faces, cut off above the nose. In both works, the casts are displayed in a matter-of-fact way, like objects on a shelf. This objectification counteracts the obvious unsettling effect of seeing the human body broken into fragments, especially when juxtaposed with a target image.

There is a brief but significant period after these Targets when Johns does not include images of the human figure at all. During this time he focuses on exploring the nature of the art object, and he consciously excludes any emotionally or autobiographically suggestive elements. When the figure reappears in his work during the early 1960s, it is usually in the form of body imprints made with hands, feet, faces, and other body parts. These imprints, made in paint and charcoal (and in lithographs and etchings using various graphic techniques), range from slight traces of the figure—a single fingerprint, handprint, or footprint—to more complete body images. The latter include *Studies for Skin* (1962), showing the artist's hands and face; *Diver* (1962), using multiple hand- and footprints to indicate the diagrammatic positions of a diving figure; and *Skin I and II* (1973), displaying the imposing image of Johns's naked torso.

Both imprinting and casting are techniques for rendering the human figure without the use of illusionistic devices. This is one aspect of their appeal to Johns, who always has been committed to the literal presentation of images. Both techniques also lend themselves to the creation of fragmented and incomplete images that have an emotionally charged presence.

In 1964, Johns resumed the use of casts in paintings. A wax cast of the legs of a seated figure appears upside down in *Watchman*. In *According to What* (1964), the same fragment is attached to the painting with its hollow side facing out. A fragment of this same figure is found in *Passage II* (1966) and again, reproduced photographically, in *Decoy* (1972). The disorientation and fragmentation of this upside-down seated figure suggest one of the major themes in Johns's art: that the viewer's familiar habits of perception should be shaken up in confronting a work of art.

Johns's most recent use of casts is in a large painting, *Untitled*

Fig. 19. These etchings by Jasper Johns, *Four Panels (ABCD)*, *(BCDA)*, *(CDAB)*, and *(DABC)*, show the four panels of *Untitled* (1972)—the "stripes," "rocks," and "casts"—arranged in their four possible consecutive combinations. From *Foirades/Fizzles* [1975-76]). *Courtesy Petersburg Press, London and New York*

(1972). The imagery in this painting has also been the subject of many of Johns's graphic works of the 1970s, including his etchings for a collaboration with Samuel Beckett, *Foirades/Fizzles* (1975-76). The painting has four separate panels joined together: one with a stripe pattern, two with rock wall images, and one with casts attached to boards which criss-cross the canvas. The panel with the casts contrasts abruptly with the other three, which are based on decorative patterns and have none of the overt emotional connotations of the fragments. The casts are mostly parts of a woman's body (taken from at least four different people): face, in profile, hand and foot and sock on floor, buttocks, torso with breast and navel, back of calf, and knee. Johns originally intended to have silkscreened target images on the canvas with the casts. Although he discarded this idea, this reference to his first use of casts illustrates the continuity of the theme of the fragmented figure in his work.

The painting as a whole has a fragmented appearance because the stripes, rocks, and casts do not seem to fit together, and each panel functions as a discrete area within the larger painting. This kind of fragmented or discontinuous composition or structure is characteristic of most of Johns's works since the early 1960s, and follows a shift at that point to more diverse kinds of imagery in his work. Until 1960, Johns almost exclusively used single objects or signs presented as unified and contained images. From 1960 on, he uses many objects and motifs in single works—disparate things are juxtaposed in unexpected ways. For example, in *According to What*, there are several panels containing many different kinds of objects: the upside-down seated cast; a hinged canvas with Marcel Duchamp's profiled self-portrait; the words "red," "yellow," and "blue"; a color chart; a silkscreened newspaper; and a coat hanger and spoon. Another feature of Johns's works since 1960 is that the boundaries of the canvas no longer define the limits of the imagery. Things are cut off at the edges and there is a sense of openness that was not present in the earlier works.

INTERVIEW ON "THE FRAGMENT": JANUARY 18, 1980

RB. Could you talk about what the fragment suggests to you in your own work?

JJ. One can take many approaches. One can think of all of one's work as a fragment of something else. Usually in working I tend to take something that has seemed to be a whole and put it in a context in which it becomes a fragment. And I do the opposite: take an aspect of something and treat it as a whole. What one does is affected by the focus of one's thought at the time.

RB. I thought of two things in particular concerning the subject of the fragment in your work: first, your use of fragments of the human figure and also the fragmented structure of many of your works.

Fig. 20. *Leg and Chair*, lithograph from *Fragments—According to What* (1971). The upside-down, seated figure fragment is an important image introduced by Johns into his works in the mid-1960s. *Courtesy G. E. L., Los Angeles*

JJ. What do you mean by fragmented structure?

RB. For example, critics usually refer to your 1972 *Untitled* paint-
ing as a fragmented work because it's made up of different panels that
don't seem to go together. To me the painting suggests the idea of discon-
tinuity—of one thing not seeming to cohere with the rest. And I thought
you could talk about when you started using that kind of structure.

JJ. I don't know how to reply to that, although I can understand
what you're saying about that work. If you think of other things in the
world, many are made up of developments that may become interesting
when separated from the form that contains them. It's like a newspaper
where the subjects are very different. But you wouldn't say that a news-
paper is fragmented or would you?

RB. You could talk about the idea of discontinuity in that it isn't on
one theme.

JJ. You could talk about it that way or you could talk about the
way the paper is folded and the typography . . .

RB. And in that sense its continuity.

JJ. Yes.

RB. I see *Diver* [1962] as a turning point in your work, because for
the first time your use of separate panels suggests a sense of discontinuity,
as if the painting is made up of discrete areas, with different kinds of
imagery. But at the same time you provide links that establish continuity.

JJ. There's no way to avoid that thought, I suppose. There are kinds
of images that make a single impact and there are kinds of images that
express themselves as a multiplicity. And there are multiple images that
can't be sensed at once, that have to be sensed separately in time as you
focus on this thing or that thing. Such a changing sense of time and focus
reinforces any indications of fragmentation.

RB. I think a major shift in your work occurred around 1960 when
you changed from using things like the flag, target, and numbers to the
map, for example. The map of the United States can be seen as an entity
in and of itself, but the way you painted it was as part of a larger map.
It seemed, at a certain point, that the canvas wasn't confining things the
way it was before; and there was a sense, not so much of incompleteness,
but of seeing part of a whole, and in that sense a fragment. And the same
with the "device" images: as if those stretcher bars and rulers were meant
to imply movement beyond the canvas edge—to continue and complete a
full circle. Or in your more recent work, the rock wall which is part of a
larger wall; especially in *Untitled 1972* where you use two different
segments of the same wall. That seems like a big change from the earlier
work to me—that there's an interest in suggesting that what you're
presenting is a fragment.

JJ. Well, the earlier pictures were whole and singular because the
limits of the painting as an object coincided with the limits of the described
image. The image and the object are more or less the same thing. The

Fig. 21. For Jasper Johns, photographs and casts are both suitable as nonillusionist artistic techniques as illustrated by his photoscreen etching *Torse*. (From *Foirades/Fizzles* [1975-76]) *Courtesy Petersburg Press, London and New York*

Fig. 22. In this version, the cast *Torso* of Jasper Johns's fragment from *Untitled* (1972) is presented as "empty" or "negative" space, and, therefore, as a more ambiguous and abstract image than the photograph in *Torse. Courtesy Petersburg Press, London and New York*

effect is different when aspects within the painting refer to things outside the painting.

RB. So it was really a choice of moving from concentrating on the idea of a single image . . .

JJ. I wouldn't exaggerate the idea of choice. I'm not sure what's chosen. It's what I did; it's what I've done. I've moved in that way. I don't know if it's out of choice or out of necessity—how my mind must move.

RB. What about the fact that the human figure has always been presented as fragmented and incomplete in your work?

JJ. In part, I think, it has been determined by a psychological pre-disposition, and partly by convenience. It is simple to cast a part of the body in the way that I do it, but a complete figure would require an enormous amount of time and a technique that I don't have. I have nothing against the total figure!

And if I had a complete cast to work with I might use it, but nothing I've wanted to do has required my making that kind of effort.

RB. But it seems to me that the fragments are so expressive *as* fragments.

JJ. But isn't that always true of any fragment of the human form? There's a kind of automatic poignancy connected with the experience of such a thing. Any broken representation of the human physique is touching in some way; it's upsetting or provokes reactions that one can't quite account for. Maybe because one's image of one's own body is disturbed by it.

RB. It struck me in reading Beckett's essays in *Foirades/Fizzles* [1975-76] that his presentation of the individual as fragmented and isolated conjures up feelings and reactions similar to your fragments in *Untitled* 1972. Were you thinking of that similarity when you decided to use images from that painting in your collaboration with Beckett?

JJ. Yes, when I had the opportunity of doing the project with Samuel Beckett, I realized that that particular painting provided images which I felt could comfortably associate with his writing even though, as you know, the painting was finished before the book was suggested.

RB. Right. You said to me once that you had read a lot of Beckett before the collaboration with him, and I was wondering if, especially in doing that project, you could see a connection between your thinking and Beckett's?

JJ. Only intuitively. The way one dumbly thinks of another person: "I know just how you feel." After agreeing to do a book with Beckett, but before I knew what text he would use, I went to L. A. to work at Gemini, G. E. L. I wanted to make a series of lithographs based on my *Untitled* 1972 painting. As soon as I began the lithographs it occurred to me that the painting contained images suitable for the Beckett project. I completed the lithographs and decided to continue reworking the imagery of the painting in etching techniques. That's what I did. I think it works

as well as anything I could have done for the book. And as you know, the etchings don't illustrate the text, but in some odd way there are occasional overlappings of images.

RB. I remember you told me when I was talking to you about the collaboration with Beckett, that Beckett called his essays "fragments." You said when you read them, you realized they were polished essays.

JJ. Certainly from my point of view they are polished. I had asked him, didn't he have some little fragments of writing, thinking of phrases or short sentences. *Foirades/Fizzles* is what he sent.

RB. Each one is so beautifully complete in and of itself, and it occurred to me that the painting *Untitled* is similar because each panel is kind of a polished painting. It's the same kind of structure as in the Beckett essays in your book.

JJ. Yes, perhaps.

RB. Going back to the 1955 Targets and your first use of casts of body parts, they seem to come out of Dada and surrealism. Were you conscious of works by some of those artists? I'm thinking particularly of Picabia, Cornell, Duchamp and mostly Magritte. When you did those first casts was it with an awareness of that artistic context?

JJ. Not consciously. It's probably around that time that I saw the first Magritte show at the Sidney Janis Gallery. I'm not sure when.

RB. It was [March] 1954.

JJ. And just about that time I saw my first Cornells. But I think I made no connection. I could see that you might place the Targets in that context, but I wouldn't. Though, of course, it's difficult to remember the kinds of thoughts I actually had at that time. Some of the plaster casts were in my studio before I thought to make either painting and had been intended for another purpose. I think I've told you before, that the first Target originally was to have been a sort of piano. The lids of the boxes would have been keys prepared in such a way that touching them caused noises from behind the painting.

RB. I didn't know that, but I always think it looks like the Toy Piano *[Construction with Toy Piano*, 1954].

JJ. Yes, exactly. At some point it changed and the wooden keys became lids covering the boxed casts. In both plans, and in the *Target with Four Faces*, it was necessary that one come near the painting to manipulate the keys or lids. This aspect has been lost now that the pictures have become more museumized, but it was important at the time. I thought that what one saw would change as one moved toward the painting, and that one might notice the change and be aware of moving and touching and causing sound or changing what was visible. In such a complex of activity, the painting becomes something other than a simplified image. I don't want to say that I didn't understand thoughts that could be triggered by casts of body parts, but I hoped to neutralize, at least for myself, their more obvious psychological impact. Earlier, the casts were of unpainted white plaster and seemed clinically or photo-

graphically morbid. I decided to paint each a different color to counter that impression.

RB. I always think one of the powers of your work conceptually is that there are so many different directions to your thinking, so many ambivalent, even conflicting meanings. And I find, even with the counteracting elements, there is something about those fragments that creates a disturbing quality.

JJ. I think that's true and I think that I focused on neutralizing that aspect. Of course the fact that I felt that need indicates something about the state of affairs at the time. But it's important to see that another person in the same situation could have taken a different point of view and could have attempted to give it greater intensity, to make it a stronger part of a statement. I was trying to let the thing itself have whatever meaning it had and at the same time move in a sense against the grain of its psychological implications.

RB. Which is the same thing that happens with the fragments in the 1972 *Untitled* painting.

JJ. But in a different way I think. It's on a different level.

RB. The disturbing effect of those fragments to me is stronger because they show a more complete figure.

JJ. Most of those casts are larger and the colors are more naturalistic; they more openly suggest flesh.

RB. It's also a female figure.

JJ. Only in part.

RB. Only part, but that's what seems most striking. Especially with the green high heel shoes on the feet. One cast—the hand, foot, and sock on the floor—is very different from anything else in your work, in that it seems to be part of a scene or event. It seems like a fragment out of something that happens in time.

JJ. Yes. It's the only one of those fragments that seems attached to an environment outside the rest of the painting.

RB. And it suggests a piece of a story or anecdote.

JJ. Or something happening.

RB. I think it's important to mention because it's a fragment from experience in a different way from any others you've used. Another thing I wanted to discuss is the series of lithographs called *Fragments—According to What* [1971]. What was it about the painting *According to What* [1964] that made you feel it was appropriate to take those parts and make separate works of art out of them?

JJ. The painting was made with a desire to put things in it. That was the way I thought of the painting: that I would put *this* into the painting and then I would put *this* into it. Maybe I could have thought of even more things to put into it than I finally did. Once you have the idea that things exist and you put them into a space, then you can have the idea that you can take them out of that space again.

RB. And that they would then work artistically as separate things?

Fig. 23. This fragmented imprint of Jasper Johns's own face reflects the mood of Beckett's essay in *Foirades/Fizzles* which develops the theme of the impossibility of man's search for the self. (From *Foirades/Fizzles* [1975-76]) *Courtesy Petersburg Press, London and New York*

JJ. Yes. It seemed that it should be possible to find or show what had been a thought that at one time didn't exist just in the painting, but separately. A thought in itself, even though it later functions only as a thought in the picture. It was a detail that could be looked at and studied and measured.

RB. It seems to me with the prints *[Fragments]*, you wouldn't make each selected detail an independent work of art, if it wouldn't stand as such on its own. That is apart from the fact that some, maybe most, of your audience would know the painting and therefore the context of each "fragment." Wouldn't each of the "fragments" have to have a sense of completeness of its own?

JJ. Well, there could be a sense of a complete description of the detail, or a sense of a particular kind of description. Of course artists traditionally have focused on a detail. Say, a hand that was going to be part of a portrait, to study as a thing in itself, even though it would eventually function in another context of the larger scene. And much thought in art is of that nature. You take a detail and study it in preparation for locating it in its proper place in a larger scene. But a lot of modern experience is of an opposite nature: you take a larger situation and extract from it some bit which you examine with great attention.

RB. A last point I want to mention: it seems to me that you prefer a sense of the complete in your work. That you don't like the idea of something not being complete or connected to something else that it belongs with. For example, in *Decoy* [1972] where the spectrum letters get cut off at two edges. It's as if they are going to connect or that they are part of the same continuous string of words. Or with the title of *Fool's House* [1962], the way it's cut off and then comes back to complete itself. There's a sense of wanting to connect things, to see them as part of a continuum. Whereas another artist would make the point that something cut at the edge means that it's incomplete, that we don't know what's beyond the edge.

JJ. I hear what you're saying. I can't think of it in a way . . . I don't know, when you think of something being complete or incomplete, that's an idea, isn't it? When is it complete and when is it not complete? I don't think one can say what one longs for.

22

A Conversation with Robbe-Grillet

TOM BISHOP

TB. Have you ever been interested in the fragment from a theoretical point of view?

R-G. Of course. I distinguish two concepts that are diametrically opposed—*fragmented writing* [fragment de l'écriture] and *writing a fragment* [l'écriture du fragment]. Fragmented writing is very fashionable nowadays. Consider, for instance, Barthes's method when he was asked to do his autobiography. Theoretically, an autobiography is a totality that reconsiders, or attempts to reconsider, the important events of one's life in a chronological or causal sequence; yet Barthes chose to provide fragments. And this is only one example among many. The fragment definitely is accepted as a current style. As far as I'm concerned, my first reaction to this is one of mistrust, because there is a certain facility in this kind of limited presentation. Besides, it is somewhat deceptive. You notice almost right away when reading Barthes (and fragments, in general, such as he has constructed them), that his fragments are not really fragments, but totalities unto themselves. This brings to mind the

seventeenth-century genre of the maxim, in which it seemed the whole world, as it were, could be concentrated into a maxim.

TB. The maxim, then, was a total and finite entity, contained within inself?

R-G. It is a total and finite thing and it works *as* a totality.

TB. And then Barthes, in fact, takes over the same formula, only nowadays it seems a lot less obvious.

R-G. Yes, he takes it over in the cunning way that he does everything. Although I am simplifying the issue, I do remember a heated confrontation with him at the Barthes Colloquium at Cérisy in 1977 about this very notion of the fragment. I had pointed out that, for me, his fragments represented in fact a kind of moralistic hoax. The fragment, when you come down to it, often disguises a hidden spirit of morality, as in the seventeenth century. It contains hidden moral presuppositions because the very idea of siating the totality of anything in a maxim is in fact already a moralistic idea. This is true even of the *Caractères* of La Bruyère; they are little sketches that are solitary worlds in themselves and, in the end, are an image of the larger world in microcosm. All La Bruyère does, in fact, is reproduce in miniature the totality of the world.

TB. Would you agree then that they are short pieces rather than fragments.

R-G. Yes. They are brief images of the totality of the world; this, for me, is not modern. They belong to the category that I call "fragments of writing." What I call on the other hand "fragmented writing" is something that belongs to modernity and is exactly the opposite. You can see it in the contrast between novels like Sartre's *La Nausée* and Camus' *L'Etranger* and the novels of Balzac. When Balzac describes objects, they are fragments in the sense that we have been discussing, that is to say, in the sense of the past. These objects are limited, like a discourse that is limited, but they are an image of the world. When an object is presented by Balzac, it is linked by its meaning to the totality of the world. His objects are signs of character, of temperament, of social status and so on. They define themselves as symbols of the world. Yes, they are no longer pieces, but synecdoches, and the whole world lies behind them! The screws in the coffin in *L'Etranger* or the hand in *La Nausée* [when the character speaks of his own hand] are completely different, precisely because here the fragment is marked by a break [coupure]. It is no longer the synecdoche of any global world, but rather a mark of fragmentation, that is, a sequence of ruptures that prevents the world from becoming a significant whole. In short, the first fragment is transcendent and the second one is not; it is, in fact, antitranscendent. If you prefer, the objects in *La Nausée* are contingent, while Balzac's objects are transcendent.

TB. Then we find ourselves with a signifying structure of the fragmentary.

R-G. No, no. Here we have what I call not the "fragment of writ-

ing," but "fragmented writing." This is the aspect that interests me, and it is this one that is modern. One can identify the same distinction in painting. When a medieval artist paints a portrait, it is a fragment of the human body. But this portrait is a face; it is the synecdoche of a body that is itself a representation of the world. This portrait then contains the wholeness of a world that is totalized. When Jasper Johns shows us a torso—take, for example, the series that he calls *Torsos*—it is on the contrary, broken. His "portraits" are fragments that cease to signify in terms of a totality and which, as a result, no longer have self-meaning as fragments.

TB. In *L'Absolu littéraire*, the authors, Philippe Lacoue-Labarthe and Jean-Luc Nancy, stress the quality of incompleteness that defines the fragment, and they thus exclude from the realm of the fragment precisely those genres of the seventeenth century, including the pensée and the maxim, that are not unfinished in any way but are, on the contrary, very complete. But then Jasper Johns's *Torsos* could in fact be considered as incomplete.

R-G. Personally, I think that I would class the incomplete object on the side of the maxim, because incompleteness can be a ruse of meaning [un piège à sens]. When in the eighteenth century a maxim is well-rounded and neatly packaged, it clearly and openly shows that it is meaningful and has a total, unquestionable significance. When during the same period one comes across incompleteness, it suggests once again a totality because of its gaping openness. One leaves it as it is, as if indeed afraid to reduce it too drastically. Quite often something incomplete has an even greater all-encompassing effect on me than a well-formed maxim, a greater effect precisely because the piece has been left open so that the ineffable may be included.

TB. I see incompleteness in a slightly different way—incompleteness in the sense of something that belongs to a whole, but refuses to be completed. Not a sketch that one would return to, if it were good, in order to complete it, but rather something that cannot be finished.

R-G. Who can't complete it? Give me an example.

TB. Well, let's take an example from your own work. It seems to me in this sense that one might speak of your own idea of the fragment in *La Maison de rendez-vous*, for example. I tend to think that the definition of "fragment" that would be most valid in relation to your own work is that which cannot be completed.

R-G. Well, let's go a step further. To finish with the examples which I mentioned regarding *L'Etranger* and *La Nausée*, there is something else that is quite remarkable in these books, and that is the fragmentation that is due to the use of the *passé composé*. The *passé simple* of the eighteenth and nineteenth centuries is really the verb tense of wholeness, where everything is related and linked chronologically through causal relationships. One of the most curious things about *L'Etranger*, that makes it such a successful book, is precisely the attention that is drawn to

fragmentary objects, stripped of meaning and cut off from any relation with the rest of the world, like the screws in the coffin. This is tied to the fact that everything is seen in the first person of the *passé composé*, which in fact serves to prevent the pieces from constituting any continuity or meaning.

TB. It seems to me that this is what you do as well.

R-G. Since the time when these books were written, the whole modern period, the "new novel" and the new "new novel" in particular, have leaned in this direction. It is not all by chance that I was able to work with Rauschenberg or with Jasper Johns; it is because all their works are an assemblage of pieces.

TB. Which imply the impossibility of finishing them, not the lack of will, but the lack of desire to finish them.

R-G. The desire to prevent them from being finished. That is to say, a sort of system of aporia as opposed to the function of completion that the reader always tends to seek out. How does one achieve this? Well, by putting together fragments that are incompatible. As long as the fragments are compatible among themselves, the gaps can be filled in by the reader. But then the aspiration to incompleteness no longer operates since the reader can introduce his entire metaphysical system into this gap and consequently rearrange the pieces to form a system of completion.

TB. Isn't this already at play in the surrealist image? The putting together of incompatible fragments?

R-G. Yes, it does come into play in the surrealist image, but it is a little different. It is more an appeal to a new sense that has not yet been perceived and of which one will suddenly become aware if two objects are juxtaposed that do not belong together. The shock of seeing them together creates a kind of opening onto potential meaning. My own present experiments, for example, stem from these two tendencies. On the one hand *La Nausée* and *L'Etranger*, and on the other, surrealism; I recognize this double paternity. And so incompatible fragments may be two versions of a same piece, as when in a story for which one has been given almost all the pieces, there is one piece too many that may be a new version of one of the pieces one has already been given. In this case, the fragment is a fragment in the modern sense; an object that is not in any way a symbol of the totality of the world but which appears itself as impossible to be linked to anything else. It works by virtue of its presence rather than through a meaning. It is very interesting to see that this presence is felt all the more strongly as the meaning is increasingly effaced or minimized.

TB. You have already mentioned Jasper Johns and Rauschenberg. Is this idea of the fragment implicit in the collage?

R-G. No.

TB. What is it then that is special about Rauschenberg and Johns?

R-G. I think that in the case of Jasper Johns it is particularly clear, because he has attacked the human body. There are many paintings of

Fig. 24. Alain Robbe-Grillet. *Photo by Chantal Regnault*

Jasper Johns which are *pieces* of human bodies and there is even a whole series that contains numerous pieces of a body that might indeed be the same one throughout. Perhaps you recall the series of paintings in which you can see the back of the canvas. On that side, pieces of bodies have been pasted together. One could easily imagine that on the other side of the canvas there is a Renaissance painting of a real body that is completely whole. The pieces that are visible on the canvas could in no way belong to that sort of painting. In the conjunction of the reverse side and the fragment there is something that is very significant, very *modern* in the full sense of the word. There are many other examples in Jasper Johns' work, even in the large paintings like the American flag. This American flag is made up of a collage of little pieces that create a kind of scattered effect. This, however, is no longer a surrealist collage as we see in the work of Max Ernst. In Ernst, we have the creation of new meaning—the body of a man, the head of a bird and the hands of a frog, for example. This is another type of collage, but these are no longer fragments; it is the reconstitution of an entity that does not exist in nature, but which in fact could.

TB. You have done some texts to accompany pictures, indeed some surrealist paintings too, if I am not mistaken.

R-G. Yes. When I worked with Magritte, for instance, it was his themes that I used. When I worked with Jasper Johns on the catalogue for Beaubourg, I had a strong impression of being inspired creatively by his structures and not just by his themes. Of course I copied some of his themes as well—numbers, pieces, the shoe, etc.

TB. And what about your work with Rauschenberg?

R-G. First I must point out, since Rauschenberg's work is so vast, that it was the period where he was interested in cutouts from magazines —*Paris-Match*, *Life*, things like that—cutouts that were organized on a page to create a plastic composition. So at that time, the work I was doing with him was inspired and excited by the conjunction of disparate images. He would put together one or another object, for no obvious reason, and their coincidence was presented to me as a given entity. In short, he would work on the cutouts, the ruptures, and my work, on the contrary, was concentrated on working on the meaning. You must realize that this type of work with the fragment and with rupture never works in one direction only. There is the temptation, on the one hand, to fragment global objects in order to cut them off from their meanings, and on the other, to produce meaning by the association of objects displaced from their respective contexts. This is what I think is going on in all my latest novels; there is a kind of *découpage* of the global world and a recomposition of the fragments in order to produce other types of meaning.

TB. That's already obvious in *La Maison de rendez-vous*, and also in *Souvenirs du triangle d'or*.

R-G. In *La Maison de rendez-vous*, as in many of my recent films and

novels, there is the prop warehouse which is very important to me; it is as if all the fragments had been first cut out and then arranged on display. In *La Maison de rendez-vous* there's a kind of theater courtyard where all the old stage sets and objects are kept, and these are all the objects of the novel. It's just like the prop warehouse in *Glissements progressifs du plaisir*, where I filmed a good number of scenes in the enormous warehouse that serves all of French cinema. It's a huge structure where hundreds of brass beds are arranged according to category, along with hundreds of Louis XV chairs, and hundreds of pianos, and so on. The prop warehouse is fragmentation carried to a maximum, since here all the objects that could not exist individually in a given story are, on the contrary, multiplied by 50, 100, and more, to open up different possibilities for the producer who will choose one.

TB. After you made *Eden*, is it true that you used the unused pieces of the film to make the movie *Eden et après?*

R-G. Not exactly. I included unused pieces, but also some of the same pieces that were then edited differently. When a movie is filmed, one has a certain number of fragments that are generally put together in an order that is decided from the outset. But there is nothing that obliges one to do this. In the experiment with *Eden et après* I wanted to work with the two great a-causal forms of modern music, seriality and aleatory or chance movement, which stand in complete contrast to the tonal or causal system. The relation between the notes in Bach's scale is hierarchal; there is a tonic, a dominant, a leading note, a subdominant, and so on. This hierarchy is of a causal order as the notes have between them a relation of order. Meanwhile, modern music has experimented with two forms of "disorder." The series breaks all causality and causal effects and the principle of chance movement decrees that the same pieces are played at random and placed in the order in which they appear by chance.

TB. It's an experience of fragmentation.

R-G. It's an experience both of fragmentation and reconstitution, of another meaning made possible by the fragment. First we have the fragment, and then, in addition—contrary to what most people say about films done in this manner—the meaning that is produced through the reorganization of the fragments into a new order which is, nevertheless, a mockery. On the one hand it recovers only stereotypes, and on the other, it doesn't manage to recover at all the entirety of the fragments that are shown. There is a kind of meaning that runs, for example, in *Eden*, through the speech of the young girl who repeats the anecdote of a possible adventure. If you watch the film carefully, you will see that at any given moment there are fragments in the film that are completely useless and, indeed, troublesome to its development. There's another kind of experiment that was done by Butor in *Faust*, with a chance combination of a certain number of possible fragments. Personally, I once had a project for a film called *Piège à fou rire*. I imagined that the film would very often seem to be in its final state, in nine reels, but the permutations

of the reels would have been calculated by the authors. That would have allowed a very great number of possibilities—too many for me, perhaps, because in reality, I like to be in control.

TB. Personally, I can't see you writing a novel that is left entirely to chance.

R-G. Nor even less a film.

TB. It seems to me that randomness is not an essential quality of the fragment.

R-G. No, except in the surrealist fragment or collage. The "cadavres exquis" of the surrealists were accidents of chance.

TB. Could you explain briefly the nature of the fragment in the collective text you did, *Topologie d'une cité fantôme?*

R-G. Yes, that is another example of the fragment used as generating principle. After I had completed *Projet pour une révolution à New York* in 1970, I wrote a long story which is now two novels, *Topologie d'une cité fantôme* and *Souvenirs du triangle d'or.* In this long two-volume story, I chose to use, as a generating principle, images fabricated by producers of images, both painters and photographers. Among the painters were Delvaux, Magritte, Jasper Johns and Rauschenberg. Among the photographers, Irina Ionesco and David Hamilton. And I also used as "generators" my own films of that period, *Glissements progressifs du plaisir* and *Le jeu avec le feu.* I chose these painters and photographers probably because I recognized in their work a certain number of familiar creative constants that moved me or that related to my own creative work. Some of these creative constants were merely thematic. In the case of David Hamilton, it was purely the young women in bloom that made me decide to use him. Do you remember Stendhal's idea of crystallization? He says that when a passionate feeling has reached its point of maturity, anything one meets will crystallize with it. I wouldn't say "anything" (I don't think even Stendhal said "anything") but there is a moment when one starts picking out elements left and right that feed one's imagination at the time. At that time, these elements were images.

TB. One last question that I must ask you, since you are a novelist: For you, does the fragment have anything to do with the relation between *Instantanés* and your novels? Just because there are short texts in *Instantanés*, should they be considered fragments of novels?

R-G. No. Almost the opposite, I would say. In the collection entitled *Instantanés*, there are some texts that are indeed fine examples of fragmentation—the one called "Le mannequin," for instance. Others, however, like "La plage," create a kind of continuity.

Translated by Sima Godfrey and the NYLF Staff

Bibliography

A SELECTED LIST OF RECENT TITLES ON THE FRAGMENT
by Lawrence D. Kritzman

Axelos, Kostas. *Héraclite et la philosophie*. Paris: Minuit, 1962.

Barthes, Roland. "Littérature et discontinu." In *Critique*, 18 (1962), 817-29.

———. *Roland Barthes par Roland Barthes*. Paris: Seuil, 1975.

Blanchot, Maurice. *L'Entretien infini*. Paris: Gallimard, 1969.

Collison, Robert. *Encyclopedias: Their History throughout the Ages*. New York: Hafner, 1964.

Compagnon, Antoine. *La Seconde Main*. Paris: Seuil, 1979.

Culler, Jonathan. "Paradox and the Language of Morals in La Rochefoucauld." In *Modern Language Review*, 68 (1973), 28-39.

Dällenbach, Lucien. "Du fragment au cosmos." In *Poétique*, 40 (1979), 420-31.

Damisch, Hubert. "La partie et le tout." In *Revue d'esthétique*, 23 (1970), 168-88.

Davidson, Hugh H. *The Origin of Certainty. Means and Meanings in Pascal's Pensées*. Chicago: University of Chicago Press, 1979.

De Man, Paul. "The Rhetoric of Temporality." In *Interpretation: Theory and Practice*. Edited by Charles S. Singleton. Baltimore: Johns Hopkins University Press, 1969, pp. 173-209.

Derrida, Jacques. *La Vérité en peinture*. Paris: Flammarion, 1978.

Donato, Eugenio. "The Ruins of Memory: Archeological Fragments and Textual Artifacts." In *Modern Language Notes*, 93 (1978), 575-98.

———. "Topographies of Memory." In *Substance*, 21 (1978), 37-48.

Feyerabend, Paul. *Against Method: Outline of an Anarchist Theory of Knowledge*. Atlantic Highlands, N.J.: Humanities Press, 1975.

Fragment, Le. In *Etudes Françaises*, 11 (1975).

Galay, Jean-Louis. "Problèmes de l'oeuvre fragmentale: Valéry." In *Poétique*, 31 (1977), 337-67.

Goldmann, Lucien. *Le Dieu caché*. Paris: Gallimard, 1959.

Gombrich, Ernest H. J. *The Sense of Order. A Study in Psychology of Decorative Art*. Ithaca: Cornell University Press, 1979.

Hamon, Philippe. "Qu'est-ce qu'une description?" In *Poétique*, 12 (1972), 465-85.

Jenny, Laurent. "La Stratégie de la forme." In *Poétique*, 27 (1976), 257-81.

Josipovici, Gabriel. "Linearity and Fragmentation." In *The Lessons of Modernism*. Totowa, N.J.: Rowman and Littlefield, 1977, pp. 124-39.

Kahler, Erik. *The Disintegration of Form in the Arts*. New York: Braziller Press, 1968.

Kermode, Frank. *The Sense of an Ending*. New York: Oxford University Press, 1966.

Kritzman, Lawrence D. *Destruction/Découverte: Le Fonctionnement de la rhétorique dans les 'Essais' de Montaigne*. Lexington: French Forum Monographs, 1980.

Lacoue-Labarthe, Philippe, and Nancy, Jean-Luc. *L'Absolu littéraire*. Paris: Seuil, 1978.

Lerner, Daniel, ed. *Parts and Wholes*. New York: Free Press, 1963.

Lewis, Philip E. *La Rochefoucauld: The Art of Abstraction*. Ithaca: Cornell University Press, 1976.

Mac Kenzie, Louis A., Jr. "The Misery of Logical Ends: Pascal on Time and Reason." In *French Forum* 3 (1978), 113-24.

Marin, Louis. "Pascal: Text, Author, Discourse. . . . " In *Yale French Studies* 52 (1975), 129-51.

Meckel, Christoph. *Ueber das Fragmentarische*. Wiesbaden: Franz Steiner Verlag, 1978.

Miller, J. Hillis. "Ariadne's Thread: Repetition and the Narrative Line." In *Critical Inquiry* 3 (1976), 57-77.

Mukařovský, Jan. "The Concept of the Whole in Art." In *Structure, Sign, and Function*. Translated and edited by John Burbank and Peter Steiner. New Haven: Yale University Press, 1978.

Orr, Linda. "The Limit of Limits: Aphorism in Char's *Feuillets d'Hypnos.*" In *Symbolism and Modern Literature: Studies in Honor of Wallace Fowlie*. Edited by Marcel Tetel. Durham: Duke University Press, 1978, pp. 248-63.

Reszler, André. *L'esthétique anarchiste*. Paris: Presses Universitaires de France, 1973.

Richard, Jean-Pierre. *Micro-lectures*. Paris: Seuil, 1979.

Schapiro, Meyer. "Field, Vehicle and Frame." In *Semiotica* 1 (1969), 223-42.

———. *Words and Pictures*. The Hague: Mouton, 1970.

Schor, Naomi. "Le Détail chez Freud." In *Littérature* 37 (1980), 3-14.

Schuller, Marianne. *Romanschlüsse in der Romantik: zum fruhromant. Problem von Universalität und Fragment*. Munich: Fink, 1974.

Spitzer, Leo. *La Enumeración caótica en la poesía moderna*. Translated by R. Lida. Buenos Aires, 1945.

Todorov, Tzvetan. "La Crise romantique." In *Théories du symbole*. Paris: Seuil, 1978.

Ungar, Steven. "Parts and Holes: Heraclitus/Nietzsche/Blanchot." In *Substance* 14 (1976), 126-41.

Von Poser, Michael. *Der Absechweissender Barzähler.* Bad Hamburg
 v. d. H.: Max Gehlen Press, 1969.
Wind, Edgar. *Art and Anarchy.* London: Faber and Faber, 1963.
Ziolkowski, Theodore J. *Disenchanted Images.* Princeton: Princeton
 University Press, 1967.

About the Authors

ANNA BALAKIAN, professor of French and chairman of the department of comparative literature, New York University, is author of *Literary Origins of Surrealism, Surrealism: The Road to the Absolute, André Breton,* and numerous articles on modern poetry.

ROBERTA BERNSTEIN is assistant professor of art history at State University of New York at Albany. She has published several articles on Jasper Johns.

TOM BISHOP, chairman of the Center for French Civilization and Culture, New York University, is a member of the Légion d'Honneur and winner of the Obie Award (1979). He has published *Pirandello and the French Theatre* and numerous articles on modern French theater and television.

JOEL BLACK teaches in the program of comparative literature at the University of North Carolina at Chapel Hill. He has published articles in *Comparative Literature* and *Boundary 2*. He is currently preparing a book on the fragment and the rhetoric of digression.

GERMAINE BRÉE, Kenan Professor at Wake Forest University, has been chairman of the French and romance languages departments of Bryn Mawr and New York University, president of the Modern Language Association of America, and Vilas Professor at the Wisconsin University Institute for Research in the Humanities. She is the author of more than a dozen books on Proust, Gide, Camus, and Sartre.

HANNA CHARNEY is professor of French and comparative literature at Hunter College and the Graduate Center, City University of New York. She is author of *Le Scepticisme de Paul Valéry, The Detective Novel of Manners,* and numerous articles in scholarly journals, such as *Comparative Literature, Romantic Review, French Review,* and *Symposium*.

SERGE DOUBROVSKY, professor of French at New York University, is author of a number of critical works including *Corneille et la dialectique du héros, Pourquoi la nouvelle critique, La Place de la madeleine: écriture et fantasme chez Proust,* and *Parcours critique*. He has also written several novels: *Le Jour S, La Dispersion,* and *Fils*. He is currently working on a study of Freud and Sartre.

DAVID COUZENS HOY, is senior lecturer in philosophy at Barnard College, Columbia University, has published articles on Kant, Hegel, Nietzsche, Heidegger, Derrida, Foucault, Lukács, and Habermas as well as a book entitled *The Critical Circle: Literature, History, and Philosophical Hermeneutics.* He is now working on a book on hermeneutics and poststructuralism.

ARTHUR KAY teaches in the department of English at the University of Arizona. He has written numerous articles on the analysis of fiction, Joseph Conrad, and American humor and has also directed and produced a series of recordings of American literature. He is currently director of a graduate program of literature of the United States for the international student.

LAWRENCE D. KRITZMAN is assistant professor of French at Rutgers University. He is author of *Destruction/Découverte: Le Fonctionnement de la rhétorique dans les 'Essais' de Montaigne* and of articles on Rabelais, Montaigne, Jean Lemaire de Belges, the *Tel Quel* group, and problems in literary theory. As a recent Andrew W. Mellon postdoctoral fellow at Duke University, he began preparing a book on rhetoric and sexuality in the Renaissance.

PERRY MEISEL, associate professor of English at New York University, is author of *Thomas Hardy: The Return of the Repressed* and *The Absent Father: Virginia Woolf and Walter Pater.* He is also editor of *Freud: A Collection of Critical Essays.*

WALTER MOSER, who has taught at Yale and Zurich, is currently associate professor in the program of comparative literature at the University of Montreal. His principal research interest is in the interaction between literary and nonliterary discourse mainly in the enlightenment and early romantic periods. Among his publications are *De la Signification d'une pensée insignifiante, Pour et contre la Bible, croire et savoir au XVIIIe siècle, Les Discours dans le discours préliminaire, Herder et la toupie des origines,* and *Kant: Origin and Utopia.*

MICHEL PIERSSENS teaches French literature and literary theory at the University of Michigan. He is author of *Tower of Babel* (originally *La Tour de Babil)* and has recently completed a book of Lautréamont and philosophy. He is the founder and co-editor of *Sub-Stance.*

STEVEN RENDALL, professor of romance languages at the University of Oregon, is associate editor of *Comparative Literature* and has published many articles on sixteenth- and seventeenth-century French and Spanish literature, literary theory, and philosophy and rhetoric. He has been a visiting scholar in rhetoric at the University of California, Berkeley, and an NEH fellow at the School of Criticism and Theory at Irvine. His current projects include books on the problematics of writing Montaigne's *Essais* and on persuasion in literature.

ALAIN RENOIR is professor of English at the University of California, Berkeley, where he teaches medieval literature and history of the English language. He has published a book on John Lydgate, and his

essays on classical and medieval Latin and medieval English, French, German oral-formulaic composition have been published in the United States and abroad. He is also co-author of the Lydgate section of *Manual of the Writings of Middle English*.

DAVID ROSAND is professor of art history at Columbia University where he is chairman of the Society of Fellows in the Humanities. He is author of *Titian* and co-author of *Titian and the Venetian Woodcut*. He is currently completing a book with Robert Hanning entitled *The Equivocal Muse: Themes in the Art and Literature of the Renaissance*. His articles have been published in *The Art Bulletin, Art News, Arts, The Burlington Magazine, New Literary History, Pantheon, Social Research*, and *The Second Coming Magazine*.

ANDREW SARRIS, professor of film at Columbia University, is the film critic for *The Village Voice* and author of numerous books including *The Films of Josef von Sternberg, The American Cinema, Confessions of a Cultist, The Primal Screen, The John Ford Movie Mystery*, and *Politics and Cinema* as well as many articles on contemporary cinema.

NAOMI SCHOR is associate professor of French studies at Brown University. The author of *Zola's Crowds* and articles on Flaubert, Maupassant, and Freud, she is currently working on a book on the detail.

ROGER SHATTUCK, formerly professor of French at the University of Texas and currently commonwealth professor of French literature at the University of Virginia, is the author of *The Banquet Years* and *Proust's Binoculars*. He is also editor of *Selected Writings of Guillaume Apollinaire* and translator of works by Valéry, Jarry, and Daumal. His study *Marcel Proust* was winner of the National Book Award in 1974.

JOHN TYTELL is professor of English at Queens College and editor of the *American Book Review*. His essays have appeared in *The American Scholar, Partisan Review, Studies in the Novel, Modern French Studies*, and *Studies in the Twentieth Century;* he is also author of *Naked Angels: The Lives and Literature of the Beat Generation*.

JACK UNDANK, professor of French at Rutgers University, recently added his contribution to volume 23 of the new critical and international edition of Diderot's *Oeuvres complètes*. He is author of a book entitled *Diderot, inside, outside, and inbetween* and is currently working on a study of the language of the enlightenment.

JENNIFER WAELTI-WALTERS teaches French and women's studies at the University of Victoria, British Columbia. She has published *Alchimie et littérature, étude de Portrait de l'artiste en jeune singe* and *Michel Butor 1954-1974*.

ABOUT THE STAFF

JEANINE PARISIER PLOTTEL spent a sabbatical year as a National Endowment for the Humanities fellow. She teaches French at Hunter College and the C. U. N. Y. Graduate Center, writes about literature, and publishes the *New York Literary Forum.* Her publications include a book about Paul Valéry and numerous articles on surrealism, Raymond Roussel, psychoanalysis, autobiography, and poetics.

JANE ROGERS TONERO has a graduate degree from Ohio State University where she was a Scholar. She was an editor at Crowell Collier and Grolier, a manager of research and development at McGraw-Hill, and vice president and editor for Mason/Charter Publishing Company.

CECIL GOLANN received her Ph. D. degree in Greek and Latin from Columbia University and spent a year in Italy on a Fulbright grant. Since then she taught English and the classics at Hunter College, worked as an editorial researcher for NBC-TV, and served on the editorial staff of Macmillan Publishing Company.

DOLLY STADE does free lance copy editing, proofreading, and indexing for many university presses.

ADELE GREEN has a degree in French from Wellesley College and from the Sorbonne University, Paris. She writes book reviews and articles of literary and horticultural interest. Her articles have appeared in various publications, including *The New York Times* and *Horticulture.*

MARGO VISCUSI, a writer and editor for the Commonwealth Funds, spent many years in Paris where she was a writer and editor for a number of well-known authors.

ABOUT THE TRANSLATORS

SIMA GODFREY teaches in the department of romance languages at the University of North Carolina at Chapel Hill. She has published on nineteenth-century French poetry and semiotics.

STAMOS METZIDAKIS is a graduate student in the department of French and romance philology, Columbia University. He is preparing a thesis on the prose poem.

ADELAIDE RUSSO is assistant professor of French at Louisana State University. She has written on twentieth-century French poetry.

ACKNOWLEDGMENT: Grateful acknowledgment is made to Gerta Glatt, Roberta Goldberg, Milika Mitrovska of the C. U. N. Y. Graduate Center, Prof. Rizel Sigele of Sarah Lawrence College, and Macy Spaniel.

Index

Production and Design: Editorial and Graphic Services
Calligraphy: Jeanyee Wong

OTHER VOLUMES AVAILABLE

Comedy: New Perspectives LC 77-18626 ISBN 0-931196-00-0
Intertextuality: New Perspectives in Criticism LC 77-18628
 ISBN 0-931196-01-9
André Malraux: Imagination and Metamorphosis LC 77-18629
 ISBN 0-931196-02-7
The Occult in Language and Literature LC 77-18630 ISBN 0-931196-03-5
Shakespearean Comedy LC 79-52616 ISBN 0-931196-07-8

IN PRESS
Collage and Patchwork Aesthetics LC 79-52613 ISBN 0-931196-04-3